You will see, in the future I will live by my watercolors.

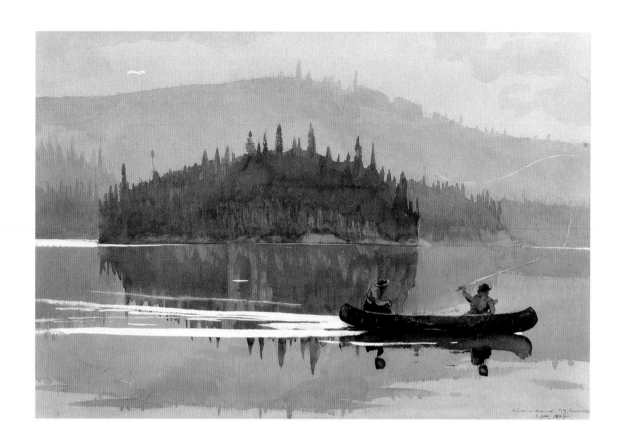

1 *Two Men in a Canoe, 1895*

Winslow Homer Watercolors

Helen A. Cooper

National Gallery of Art, Washington · Yale University Press, New Haven & London

The exhibition *Winslow Homer Watercolors*
and this book,
celebrating the 150th anniversary
of the artist's birth,
were made possible by a grant from the IBM Corporation.

EXHIBITION DATES
National Gallery of Art, Washington
 March 2 – May 11, 1986
Amon Carter Museum, Fort Worth
 June 6 – July 27, 1986
Yale University Art Gallery, New Haven
 September 11 – November 2, 1986

Cover: Detail of *Key West, Hauling Anchor*, 1903 (fig. 218)

LIBRARY OF CONGRESS
CATALOGING-IN-PUBLICATION DATA

Cooper, Helen A.
 Winslow Homer watercolors.

 "Exhibition dates: National Gallery of Art, Washington,
March 2–May 11, 1986; Amon Carter Museum, Fort Worth, June 6–
July 27, 1986; Yale University Art Gallery, New Haven, September 11–
November 2, 1986"—T.p. verso.
 Bibliography: p. 11
 Includes index.
 1. Homer Winslow, 1836–1910—Exhibitions. I. National Gallery of
Art (U.S.) II. Amon Carter Museum. III. Yale University Art Gallery.
IV. Title. ND1839.H6A4 1986 759.13 85–29696
ISBN (paperback) 0–89468–087–0; (clothbound) 0–300–03695–7

Contents

Foreword

We are pleased to celebrate the 150th anniversary of Winslow Homer's birth with an exhibition of his most beautiful and important watercolors. Although other fine exhibitions of his work in the medium have been presented in the past, never until the present exhibition has Homer's incomparable achievement in watercolor been so comprehensively available.

The exhibition and this book are the work of Helen A. Cooper, Curator of American Paintings and Sculpture at the Yale University Art Gallery. Both endeavors are marked by her superb connoisseurship, judgment, and knowledge. We are very grateful to her, and to the many individuals in each institution who have tirelessly worked toward the success of this project.

We acknowledge with particular gratitude the generosity of the IBM Corporation, which supported the exhibition and this book, and made possible the illustration of an unprecedented number of works in color.

The National Gallery, the Amon Carter Museum, and the Yale University Art Gallery, partners in past similarly happy and fruitful projects, are pleased to collaborate once again.

Above all, we are most profoundly grateful to our lenders, who have deprived themselves of treasured and delicate objects. This exhibition of watercolors from their collections, public and private, from all parts of the country, forms a fitting tribute to one of America's greatest artists.

J. Carter Brown
DIRECTOR
National Gallery of Art

Jan Keene Muhlert
DIRECTOR
Amon Carter Museum

Anne Coffin Hanson
ACTING DIRECTOR
Yale University Art Gallery

Preface

Few American artists have been more highly praised than Winslow Homer. His place in the history of American art is well established, as are the facts of his biography, thanks to the pioneering work done by Lloyd Goodrich over forty years ago. Later scholars and writers have continued to add to our understanding of Homer's life and art. Although his watercolors are universally acknowledged to form an important part of his artistic production, there has not been a sustained, close examination of these works on their own terms. This book focuses on Homer's watercolor career, with a special emphasis on the development of his technique as it relates to subject and meaning.

This book and exhibition owe a profound debt to many people. I am grateful for the opportunity to acknowledge here their contributions. My first thanks must go to Mr. Goodrich and the late Edith Havens Goodrich who shared with me not only their love for Homer's watercolors but generously made available the results of decades of painstaking record keeping. Mr. Goodrich is presently preparing a catalogue raisonné of all of Homer's work. Theodore E. Stebbins, Jr., John Moors Cabot Curator of American Painting, Museum of Fine Arts, Boston, first suggested the watercolors as a topic for separate discussion while I was a graduate student in his course at Yale. His continued interest has been of inestimable value to me, as have been his standards of scholarship and connoisseurship. Jules D. Prown, Paul Mellon Professor of the History of Art, Yale University, offered important counsel and support throughout the process of research and writing. I have benefited greatly from contact with his approach to American material culture.

Many curators, dealers, friends, and collectors challenged my thinking, shared their knowledge, helped me understand the watercolor medium, showed me through their collections, or led me to previously unlocated works. In particular, I thank Henry B. Adams, John Boon, John Caldwell, Marjorie Cohn, Beth Dunbar, Theresa Fairbanks, Jerald D. Fessenden, Linda Ferber, Richard S. Field, Kathleen A. Foster, Abigail Gerdts, Judith Hayward, Robert L. Herbert, John C. Howat, Dr. Ray Layton, Nancy Little, Kenneth McConkey, Judy Metro, Ralph Morrill, M. P. Naud, Sue Reed, Barbara Shapiro, Natalie Spassky, Stephanie Loeb Stepanek, and Andrew Wilton. I am especially grateful to Sheila Schwartz whose insightful comments and suggestions helped clarify my ideas and significantly improved the manuscript at various stages.

My experience with the staff of the National Gallery has been a rewarding one and I thank them for their many kindnesses. J. Carter Brown, director, extended every courtesy and assistance. I am particularly indebted to John Wilmerding, deputy director, who is himself a Homer scholar, who read the manuscript and was unfailingly helpful throughout the planning of the exhibition. The myriad problems of coordinating the exhibition among the three institutions were handled with grace and apparent ease by another Homer scholar, Nicolai Cikovsky, Jr., curator of American art. Linda Ayres, curator of paintings at the Amon Carter Museum, set the exhibition on a firm foundation during her tenure as assistant curator of American art at the National Gallery. For their support in the various tasks necessary in bringing the exhibition to fruition, I am grateful to Ann Bigley, Cheryl Hauser, Franklin Kelly, Rosemary O'Reilly, Hugh Phibbs, and Mary Suzor. Gaillard Ravenel and his staff are responsible for the elegant design of the exhibition. This book has benefited immeasurably from the involvement of Frances Smyth, whose wise guidance was critical at every phase of the book's production. Mary Yakush was an ideal editor. Her sensitivity to the material, sharpness of judgment, and meticulous respect for language have informed every page.

My colleagues at the Yale University Art Gallery have rendered every assistance. I began this project when Alan Shestack, director, Minneapolis Institute of Arts, was director of the Yale University Art Gallery. I am grateful to him for his enthusiastic support and for having made possible a research leave. Special appreciation goes to Sarah Buie for her sensitive exhibition design; and to Louisa Cunningham, Rosalie Reed, and Robert Soule and his staff for their administrative and technical support. For their research assistance I am indebted to the following graduate students: Rebecca Bedell, Wendy Greenhouse, Barbara Heins, and Ann Temkin. David Steinberg, my former curatorial assistant, also provided important information. A large debt of gratitude is owed to Paula B. Freedman, assistant curator of American paintings and sculpture, who proofread the galleys and compiled the list of illustrations; and to Christina Kita, who typed innumerable drafts of the manuscript and organized the gathering of the illustrations. They brought to every phase of the project an extraordinary loyalty. Elise K. Kenney took on the task of verifying the footnotes, proofreading the galleys, and preparing the index. She was tireless in her pursuit of accuracy and precision. The book was designed by Greer Allen whose talent is evident and whose respect for the watercolors, standards of excellence, and firm supervision of the production made this beautiful volume possible. I acknowledge with warmest thanks his patience, energy, and good humor.

My largest debt is owed to my husband and children for countless generosities. It is to them and to my father and the memory of my mother that this book is dedicated.

H. A. C.

Note to the Reader

After the first full reference to a source in a note, all subsequent citations are shortened within the chapter. Frequently cited sources are always abbreviated as follows:

Beam 1966
> Philip C. Beam, *Winslow Homer at Prout's Neck* (Boston, 1966)

Bowdoin
> Homer Archives, Bowdoin College Museum of Art, Brunswick, Maine

Cohn 1977
> Marjorie B. Cohn, *Wash and Gouache: A Study of the Development of the Materials of Watercolor* (exh. cat., Fogg Art Museum, Boston, 1977)

Downes 1911
> William Howe Downes, *The Life and Works of Winslow Homer* (Boston, 1911)

Foster 1982
> Kathleen A. Foster, "Makers of the American Watercolor Movement: 1860–1890," Ph.D. diss., Yale University, 1982

Goodrich 1944
> Lloyd Goodrich, *Winslow Homer* (New York, 1944)

Goodrich/Whitney Museum Record
> Transcriptions of original letters in various private collections; The Lloyd Goodrich and Edith Havens Goodrich/Whitney Museum of American Art, Record of Works by Winslow Homer, New York

Hendricks 1979
> Gordon Hendricks, *The Life and Work of Winslow Homer* (New York, 1979)

Knoedler Archive
> Original letters to M. Knoedler & Co.; collection of M. Knoedler & Co., New York

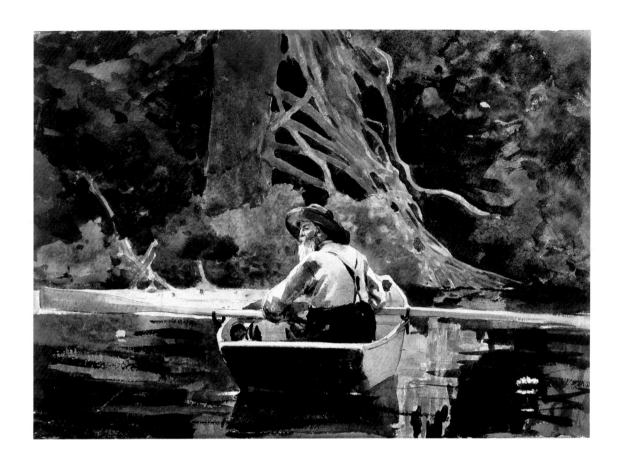

2 *The Adirondack Guide, 1894*

Chronology

The titles cited below are for selected oils, and are intended to provide points of reference to the watercolors, within the context of Homer's career.

1836 Born 24 February, Boston, the second of three sons of Charles Savage Homer (1809–1898) and Henrietta Benson Homer (1809–1884).

1842 Homers move to Cambridge, Massachusetts.

1854 or 1855 Begins apprenticeship in the lithography workshop of John Bufford and Sons, Boston. First work is for sheet music covers.

1857 Leaves Bufford's. Begins free-lance work for *Ballou's Pictorial Drawing-Room Companion* and *Harper's Weekly*.

1859 Moves to New York City. Continues free-lance work. Attends evening classes at National Academy of Design until about 1861. Moves to New York University Building, Washington Square. Studies oil painting briefly with Frédéric Rondel.

1862 In Virginia with the Union Army for a time. First serious oil painting. First Civil War subjects for *Harper's Weekly*.

1863 Begins exhibiting regularly at the National Academy; receives favorable reviews.

1864 Elected associate of National Academy.

1866–1867 Shows *Prisoners from the Front* (1866; The Metropolitan Museum of Art, New York) at the Academy to great critical acclaim. Elected academician. December 1866, sails for France, where he remains for ten months. *Prisoners from the Front* and *The Bright Side* (1865; The Fine Arts Museums of San Francisco) included in Universal Exposition, Paris, which opens in April 1867.

1867 Returns to New York in late fall.

1868–1869 Continues as free-lance illustrator for *Harper's Weekly*, *Appleton's Journal*, *Galaxy*, and other periodicals and book publishers. Regular summer visits to New England countryside.

1870 First visit to Adirondacks. Sends one work to American Society of Painters in Water Colors (later, American Water Color Society).

1872 Moves to Tenth Street Studios, New York.

1873 June and July at Gloucester, Massachusetts. First watercolor series.

1874 Summer visits to Adirondacks; East Hampton, New York; Walden, New York. Watercolors.

1875–1876	First visit to Prout's Neck. Visits to Virginia. Oils and watercolors of black subjects. Last illustration for *Harper's Weekly*. Becomes member of American Water Color Society.
1877	Founding member of the Tile Club.
1878	Summer at Houghton Farm, Mountainville, New York. Watercolors.
1879	Summer at West Townsend and Winchester, Massachusetts. Watercolors.
1880	Summer at Gloucester, Massachusetts. Watercolors.
1881	To England in the spring, for twenty-month stay at Cullercoats, Northumberland. Watercolors.
1882	Returns to New York, November.
1883	Completes watercolors based on Cullercoats subjects. Summer in Prout's Neck. Watercolors.
1884	*The Life Line* (1884; Philadelphia Museum of Art) exhibited to acclaim at National Academy. Mother dies in April. Settles in Prout's Neck. Trip with the herring fleet to the Grand Banks off the coast of Newfoundland.
1885	In Nassau and Cuba in January and February. Watercolors. *The Herring Net* (The Art Institute of Chicago); *The Fog Warning* (Museum of Fine Arts, Boston).
1886	In Florida in January. Watercolors. *Eight Bells* (Addison Gallery of American Art, Phillips Academy, Andover, Massachusetts); *Undertow* (Sterling and Francine Clark Art Institute, Williamstown, Massachusetts).
1886–1889	Executes seven etchings. Watercolors, 1887. Civil War illustrations for *Century Magazine* (1887–1888).
1889	In Adirondacks in summer and fall. Watercolors.
1890	In Florida in February. *Sunlight on the Coast* (Toledo Museum of Art), first pure seascape in oil.
1891	In Adirondacks in summer and fall. *Huntsman and Dogs* (Philadelphia Museum of Art); *West Wind* (Addison Gallery of American Art, Phillips Academy, Andover, Massachusetts).
1892	In Adirondacks in summer and fall. Watercolors. *Hound and Hunter* (National Gallery of Art, Washington).
1893	*The Fox Hunt* (Pennsylvania Academy of the Fine Arts, Philadelphia). Shows fifteen paintings at the World's Columbian Exposition, Chicago. Visits Quebec.
1894	In Adirondacks in June. Watercolors. *Below Zero* (Yale University Art Gallery, New Haven); *The Artist's Studio in an Afternoon Fog* (Memorial Art Gallery, University of Rochester).
1895	In Quebec, August and September. Watercolors. *Cannon Rock* and *Northeaster* (both The Metropolitan Museum of Art, New York).
1896	*The Wreck* (Museum of Art, Carnegie Institute, Pittsburgh) wins a five-thousand-dollar prize at the Carnegie Institute. *The Lookout—"All's Well"* (Museum of Fine Arts, Boston).

1897 In Quebec, summer. Watercolors. *A Light on the Sea* (The Corcoran Gallery of Art, Washington); *Wild Geese* (Portland Museum of Art, Maine).

1898–1899 August, father dies in Prout's Neck. To Nassau, December (to February 1899). Watercolors. To Florida, February. Thomas B. Clarke sale. Begins *The Gulf Stream* (The Metropolitan Museum of Art, New York). In Bermuda, December 1899 into early 1900. Watercolors.

1900 In Adirondacks, June. Watercolors. Wins Gold medal at Paris Exposition. French government buys *A Summer Night* (1890; Louvre). *On a Lee Shore* (Museum of Art, Rhode Island School of Design, Providence); *Eastern Point* and *West Point* (both Sterling and Francine Clark Art Institute, Williamstown, Massachusetts).

1901 Bermuda. Watercolors. *Searchlight, Harbor Entrance, Santiago de Cuba* (The Metropolitan Museum of Art, New York).

1902 In Quebec, August. Watercolors. *Early Morning after a Storm at Sea* (Cleveland Museum of Art).

1903 In Florida, December through February 1904. Watercolors.

1904 *A Summer Squall* (Sterling and Francine Clark Art Institute, Williamstown, Massachusetts). In Adirondacks, early summer. *Kissing the Moon* (Addison Gallery of American Art, Phillips Academy, Andover, Massachusetts). To Florida, December through January 1905. Last watercolor.

1906 Long illness, summer. Metropolitan Museum buys *The Gulf Stream*.

1908 In Florida, January and February. Suffers paralytic stroke, May. In Adirondacks, June and July. Begins *Right and Left* (National Gallery of Art, Washington), November; completed January 1909.

1910 Dies in Prout's Neck, 29 September.

Early Years

Winslow Homer's watercolors have, almost from the time they were made, been ranked among the greatest achievements in American art.[1] Executed over a period of more than thirty years, between 1873 and 1905, these works are unsurpassed for their direct statement, luminosity, and economy of means. Unlike his oils, which took up the major portion of his time (he produced approximately 300 paintings during his career) and were worked on over long periods in the studio, in New York, and later in Prout's Neck, Maine, the watercolors were created primarily during working vacations at the New England seaside, in the Adirondacks, Quebec, the Caribbean, and Florida—specific places chosen for specific subjects. Despite the relatively short time he spent in these places— anywhere from one week to several months— his output was prolific— at least 685 watercolors are known. The easy portability of watercolor and its quick-drying character make it a natural medium for the traveling artist, stimulating a spontaneity of expression often lost in the heavier oils. In oil, Homer's touch was powerful, exploiting the weight and density of the medium. In watercolor, it was exquisite, full of sensuous nuance. The liquid pigment called forth in him a private and poetic vision that otherwise found no place in his art. Suffused with a special awareness of the beauty of nature, the fluid, audacious brushwork and saturated color of the mature works in particular have had a wide and liberating influence on much subsequent American watercolor painting.

Homer's exposure to watercolor began at an early age. As a boy in Cambridge, Massachusetts, he was first taught by his mother, Henrietta Benson Homer, a gifted amateur who specialized in simple flower and bird studies based on, or perhaps even copies of, flower prints from books (fig. 3).[2] Later, as a young artist in Bufford's lithography shop in Boston from 1855 to 1857, he learned to use washes and gouache along with the other materials of the illustrator's craft— crayon, graphite, pen, and burin. During the 1860s and early seventies, as a free-lance illustrator in New York City for *Harper's Weekly*, *Appleton's Journal*, *Galaxy*, *Hearth and Home*, *Every Saturday*, and other publications, the requirements of black and white illustration taught him an artistic style of bold contrasts of light and dark, crisp outlines, and simplified details.[3]

In these years, Homer used watercolors, more accurately described as wash drawings, as preparations for wood engravings. But the absence of even a single known Homer water-

color or wash drawing identical with a wood engraving suggests the transfer process was not photographic; rather, that Homer drew directly on the wood block, combining elements from two or more pictures already executed in oil or pencil and wash.[4] Within firm outlines, he clearly defined areas of local color and shadows, painting them in broad, flat monochromatic washes of india ink in two or three tones. There could be no ambiguities to confront the engraver. The drawing would subsequently be destroyed in the cutting and printing.[5]

Homer began to use watercolor as a separate means of artistic expression only after he had been a professional artist for almost twenty years. Not until 1873, when he was thirty-seven years old, earning a living as an illustrator, and with a considerable reputation as a painter in oils, did he first apply himself seriously to the medium in which he would become preeminent.

The slowness with which Homer adopted watercolor reflected contemporary attitudes toward the medium. Until the late 1860s, the market for watercolors in America was limited. Although the medium enjoyed widespread popularity among amateurs, it rarely received the attention of collectors. Thus, there was little incentive for artists to create finished works. Public opinion about the value of watercolor as a serious partner of oil painting took a more positive turn with the founding in 1866 of the American Society of Painters in Water Colors (in 1877 renamed the American Water Color Society).[6] The Society held annual exhibitions and undertook vigorous promotional campaigns to educate the public and the critics.

At the same time, printing techniques for reproducing illustrations were becoming subtler. By the early 1870s, the linear style in reproduction was giving way to a more tonal, painterly expression. To many commercial illustrators and engravers, the medium that best conveyed the new sensibility was watercolor. Consequently, the professional use of watercolor and gouache increased. Due in part to the energetic efforts of the Society, growing numbers of fine artists began working in watercolor, and although critical opinion still called much of the work decorative, watercolors gained respectability and visibility, their domestic scale and low price finally making them popular with collectors.[7]

By 1873 Homer was at a critical point in his career. Although reasonably well known as an illustrator, the early promise of outstanding success as a painter had not been realized. Largely self-taught, he had achieved his first recognition in 1863 for two paintings of Civil War scenes, *The Last Goose at Yorktown* (location unknown) and *Home, Sweet Home* (Private Collection); both were exhibited at the National Academy of Design. During the next few years he exhibited his oils to generally favorable reviews. *Prisoners from the Front* (The Metropolitan Museum of Art, New York), completed in 1866, made him famous. Shown that year at the National Academy, it created a sensation and won more praise than any genre picture in recent years. Homer was hailed as "the youngest among the men to whom we look for a high order of excellence in the treatment of American subjects"[8] and was immediately elected a full member of the National Academy, a signal honor. He was further honored when *Prisoners from the Front* and another war

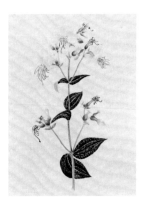

3 *Henrietta Benson Homer. Wildflowers*

subject, *The Bright Side* (1865; The Fine Arts Museums of San Francisco), were included in a small group of American pictures at the Universal Exposition in Paris in the spring of 1867, and received favorable reviews from European critics.[9] Homer had gone to Paris for the Exposition opening. In high spirits he remained in France for a year, a young American "star" in the company of French and American artists.[10]

When Homer returned to America in late 1867, he must have had every expectation that he was on the verge of greater triumphs as a painter. To his disappointment, none of his subsequent paintings arrested the attention of the critics or the public as had *Prisoners from the Front*. The reviews he received were mixed, the praise often qualified by strong criticism for his colors and lack of traditional finish. "He has invention, he is fresh and just in his observation," wrote the artist-critic Eugene Benson. "He has . . . to attain the beautiful to become our master figure-painter."[11] Neither was he a financial success. Although he sold his most important oils (the prices were modest in order to stimulate sales), many others remained in the studio. And he derived little sense of achievement from his commercial work, bitterly describing the life of an illustrator as a "treadmill existence" and a form of "bondage."[12] He may also have been influenced by the fact that the illustrators' profession was not highly regarded: magazine and newspaper draftsmen were generally categorized as lower class artisans.[13]

Homer was restless and ambitious. He had been called "a promising young artist" for many years and he was, he said, "tired of it."[14] Then, in February 1873, an event of considerable importance to the American art world occurred which must have made Homer (and others) suddenly see watercolor in a different light. The American Society of Painters in Water Colors sponsored an international watercolor exhibition which opened in New York with close to six hundred European and American watercolors and drawings on view. The entire National Academy building was used for the exhibition. One huge gallery displayed two hundred contemporary British watercolors collected by Henry Blackburn, the celebrated English art critic and entrepreneur. The exhibition was a landmark, surpassing in size and appeal all previous American watercolor exhibitions. By establishing beyond question watercolor as a serious medium, it gave a tremendous impetus to the cause of watercolor painting in America. Among those who would respond to its message was Winslow Homer.

Notes

1 Contemporary appraisals are quoted in Goodrich 1944; Albert Ten Eyck Gardner, *Winslow Homer, American Artist: His World and His Work* (New York, 1961); Hendricks 1979. Theodore E. Stebbins, Jr., *American Master Drawings and Watercolors* (New York, 1976) places Homer's watercolors in the context of those produced by his contemporaries.

2 To the end of his life, Homer cherished his mother's watercolors. They were the only artworks other than his own that hung in his studio in Prout's Neck; Beam 1966, 36–38.

3 A complete listing of Homer's magazine engravings is found in Philip C. Beam, *Winslow Homer's Magazine Engravings* (New York, 1979).

4 See, for example, Lloyd Goodrich, *The Graphic Art of Winslow Homer* (exh. cat., Museum of Graphic Art, New York, 1968), figs. 15 and 16.

5 Homer's drawing on the block was described by a younger colleague at *Harper's*, William Allen Rogers, in *A World Worth While* (New York, 1922), 235–236: "The boxwood color is of a light, warm tone and this Homer used as his lightest gray, deepening it with a wash of India ink and painting in one or two high lights with white. There were not more than two or three tones in the picture— just broad, flat washes and uncompromising outlines. All that was there was true, but nothing unnecessary or fussy found a place in the drawing. His method was not unlike that of the Japanese artist, Hiroshigi . . . strong and clear, because of its concentrated and clarified truth." No block with the drawing intact is known to be extant. A cut block exists for the watercolor *International Tea Party* (c. 1876; Cooper-Hewitt Museum, New York) at the Sterling Memorial Library, Yale University. No print of *International Tea Party* is known; probably none was ever executed, for the block seems untouched by ink. The woodblock was discovered by the author in 1980 among those engraved by William James Linton who worked for many publications in the 1870s and 1880s.

6 Ralph Fabri, *History of the American Watercolor Society* (New York, 1969). It has been said that Homer was one of the founding members of the Society; see, for example, Hereward Lester Cooke, "The Development of Winslow Homer's Water-color Technique," *Art Quarterly* 24, no. 2 (Summer 1961), 191 n. 6, citing Downes 1911, 278, and Theodore Bolton, "The Art of Winslow Homer: An Estimate of 1932," *Fine Arts*, April 1932, 18. But the evidence is to the contrary: on 5 December 1866, the very day that the original group of eleven artists met in New York and joined together to form the Society, Homer set sail for Europe from Boston. He did not become a member until 1876 (see p. 38 below).

7 For a full and thoughtful discussion of the changing attitude toward watercolor in America in the 1860s and 1870s, see Foster 1982.

8 Thomas Bailey Aldrich, *Our Young Folks* 2 (July 1866), 396.

9 "This is a painting which is tightly conceived and precise, in the manner of Gérôme, but with less dryness," wrote Paul Mantz in the *Gazette des Beaux-Arts* 23 (September 1867), 230, about *The Bright Side*. "These works are real: the artist paints what he has seen and known," said the London *Art Journal* (29 November 1867), 248. The most praised painting in the Exposition was Frederic E. Church's *Niagara* (1857; The Corcoran Gallery of Art, Washington), which was awarded a silver medal. The Exposition was one of the first official occasions when a group of American paintings was seen in Europe. For a discussion of the American works of art in the show, see Carol Troyen, "Innocents Abroad: American Painters at the 1867 Exposition Universelle, Paris," *American Art Journal* 16, no. 4 (Autumn 1984), 2–29.

10 Sixteen or seventeen paintings are known from Homer's stay in France; about six were done in Paris, the others in the country, including several in Picardy; Goodrich 1944, 39, and Hendricks 1979, 74. Three engravings of Parisian subjects appeared in *Harper's Weekly*: *A Parisian Ball— Dancing at the Mabille, Paris*, 23 November 1867; *A Parisian Ball— Dancing at the Casino*, 23 November 1867; *Art-Students and Copyists in the Louvre Gallery, Paris*, 11 January 1868; also *Homeward Bound*, 21 December 1867, showing a view on board the *Ville de Paris*, the ship on which Homer returned to America.

11 *Putnam's Magazine* 5, no. 30 (June 1870), 704. See also, for example, *Nation* 6 (7 May 1868), 377; *Nation* 8 (29 April 1869), 341; *Harper's Weekly* 14 (14 May 1870), 307.

12 Quoted in George W. Sheldon, *American Painters* (New York, 1879), 27.

13 For a discussion of the status of illustration and illustrators in America between 1855 and 1875, see Foster 1982, 50–54.

14 Quoted in Augustus Stonehouse, "Winslow Homer," *Art Review* 1, no. 4 (February 1887), 12. The conversation took place in the 1870s.

First Watercolors

1873–1877

He is almost barbarously simple, and . . . he is horribly ugly;
but there is nevertheless something one likes about him.

—Henry James, 1875

In June of 1873, Homer went to Gloucester, Massachusetts. He took rooms in the Atlantic Hotel at the corner of Main and Washington Streets, opposite the wharves and Town Landing, the center of what was at that time one of the most active fishing ports in the world.[1] Perhaps inspired by the much discussed international watercolor exhibition in New York earlier that year, he now applied himself seriously to watercolor for the first time.[2] In the previous decade he had produced watercolors better described as colored wash drawings. But now his watercolor technique suddenly took a great leap forward. Some of these watercolors would later serve as the basis for engravings; most, however, were probably done for sale.

In these first works, Homer depicted the local children playing in dories and along the wharves. Most sheets are small in size (approximately 8 x 14 inches) but, like *Boy in a Boatyard* and *How Many Eggs* (figs. 6 and 8), they have the directness of observation and vigorous, clear design that are characteristic of almost all of Homer's works.

During this time, Homer was still working as an illustrator, and the needs of the wood engraver are met in these watercolors through their flat, single washes, sharp sense of pattern, precise outlines, and preoccupation with light and shadow. For the areas of brightest light, the artist used two methods: applying opaque white watercolor or gouache to the sheet as in the highlights on the boys' hats in *Three Boys on the Shore* (fig. 9), or reserving the area from any wash whatsoever, thereby allowing the white of the paper itself to become the brightest part, as in *The Berry Pickers* (fig. 7), where the dresses and shirts of the children appear struck by sunlight. Homer's interest in light and atmosphere extended to his drawings of this period as well. In *Schooners in Gloucester Harbor* (fig. 12), using graphite on tan paper, he sketched three boys lounging on the rocks, watching the schooners pass; then, taking a brush loaded with white gouache, his hand moved across the sheet to illuminate the forms and give life to the scene. Henry James would later say that Homer's great merit was that "he naturally sees everything at one with its envelope of light and air."[3]

From the beginning, Homer's brushwork was relatively broad, unlike the miniatur-

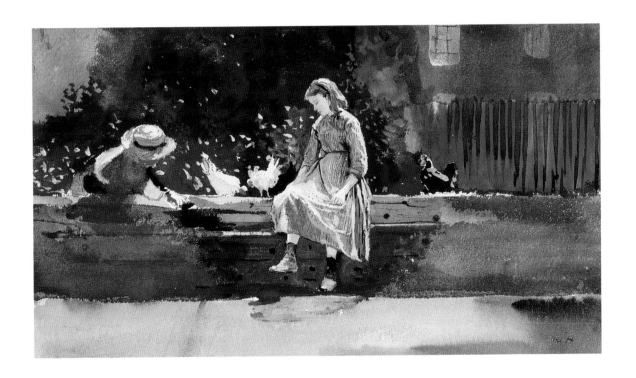

4 *The Farmyard Wall, 1873*

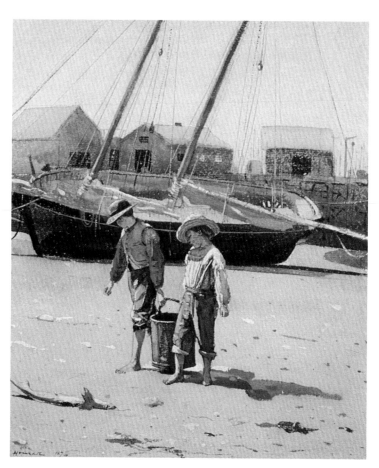

5 *A Basket
of Clams, 1873*

6 *Boy in a Boatyard, 1873*

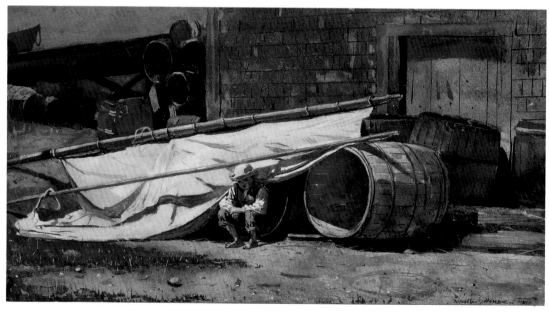

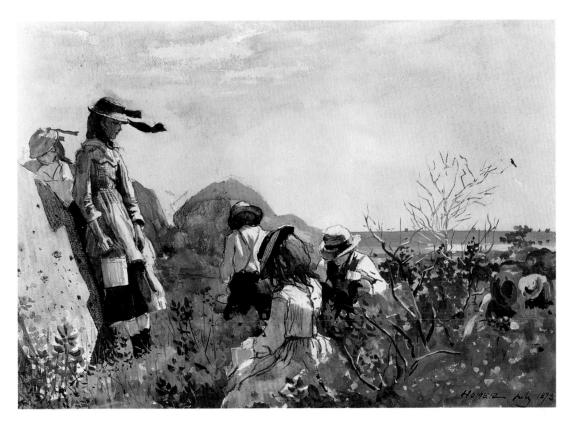

7 *The Berry Pickers, 1873*

istic, Pre-Raphaelite technique of tight brushwork and careful finish that characterized such well-known contemporary watercolorists as John William Hill and Henry Farrer. And even at this early point in his career, Homer surpassed his American contemporaries in his use of transparent pigments and the exploitation of the white paper itself.[4]

Gouache or opaque color nonetheless played a prominent part in many of Homer's watercolors of this period. Not only was it easier to control than transparent washes, but it allowed him to build up forms in the manner of the oil painting he was accustomed to— that is, from dark to light rather than light to dark. *Watching the Harbor* (fig. 10) is executed largely in gouache; *The Farmyard Wall* (fig. 4) has transparent washes, but the sharp, clear delineation between lights and darks is achieved through generous amounts of white gouache in the background leaves, in the boy's shirt and hat, the girl's dress, the chickens, and on the top of the wall.

As for color, even at this early stage of his watercolor development, Homer had a freer, more experimental attitude than in his oils of the same period. *Three Boys on the Shore* (fig. 9) is an essay in bright blues, rust-oranges, and pale browns and yellows, its hot palette conveying the warmth of the noonday sun on the rocks, the boys' backs and hats, and the sea.[5] *Waiting for the Boats* (fig. 11) has the same palette as *Three Boys on the Shore*, but the execution is less finished and the tones more highly keyed. It is an oddly disturbing work, in part because of the conciliatory gesture of the boy at the right with his hand

8 *How Many Eggs, 1873*

on the other boy's shoulder; in part through the free handling in the heavily streaked sky, the shaft of dazzling light through the center of the composition (achieved by allowing the white of the paper to show through), and the interlocking forms of figures, boat, pier, buildings, and hanging nets.

Homer's first critical assessment as a watercolorist was for these Gloucester works. Early in 1874 he sent ten sheets from the previous summer to the Eighth Annual Exhibition of the American Society of Painters in Water Colors. From the start, his watercolors were considered original, albeit eccentric. The watercolors of the other participants (including William Trost Richards, Louis Comfort Tiffany, and Alfred T. Bricher) were generally criticized for being "pretty" and "not alive," and too "anxious about details." Homer, on the other hand, had a "manner of his own which sprung from the artist's individual way of looking at Nature, not from his way of looking at some other man's pictures. . . . These . . . mere memorandum blots and exclamation points . . . are so pleasant to look at, we are almost content not to ask Mr. Homer for a finished piece."[6] That his watercolors had vigor but seemed unfinished or stopped in their course was a criticism Homer would hear often for years to come.

The Gloucester watercolors established what would be, with few exceptions, Homer's lifelong pattern in watercolor: concentrating for a particular period of time on a single

9 *Three Boys on the Shore, 1873*

theme suggested by a particular locale. His interest would last for the duration of his stay; on returning to his studio he would put the subject aside, often developing the idea further on subsequent visits.

Throughout the 1870s, Homer's subject matter embodied the ideal of simple and reassuring pleasures in union with nature itself. The Gloucester watercolors expanded on a theme Homer had touched on only occasionally in his paintings— that of rural childhood.[7] The Civil War subjects of the 1860s had been followed by scenes of fashionable young women at leisure, playing croquet, or at the seaside. At Gloucester, and for some years afterward, children figured prominently in his compositions. The novelty of watercolor as a medium for artistic expression may have suggested to Homer the need for a fresh subject as well. That he chose childhood, however, and not any other theme of quotidian American life, is not surprising.

No stage of life was so exalted in nineteenth-century art and literature, especially after the Civil War, as childhood. Louisa May Alcott and Mark Twain enjoyed great success with, respectively, *Little Women* (1868) and *Tom Sawyer* (1876). To some artists and writers, it was the child, untouched by worldly experience, who seemed most in tune with natural forces; to others, childhood symbolized a lost past.[8] Homer's paintings such as *Snap the Whip* (1872; The Metropolitan Museum of Art, New York) and the dozens of Gloucester watercolors reinvent childhood, merging nostalgia for his own boyhood in

10 *Watching the Harbor, 1873*

Cambridge, Massachusetts, with memories of a bygone world of warmth, trust, and shared experiences. But unlike many of his contemporaries, Homer did not portray children in relation to parents; rather, he conceived of childhood as a distinct, individual period of human life in which adults played little or no part. That Homer was also responding to the notion of childhood as a symbolic stage is clear from his selectivity: nowhere in his oeuvre do we find the urban children who were right outside his New York City studio; nowhere is there a depiction of the dangerous and growing social problem that preoccupied many critics and reformers— large numbers of children, existing in the congested squalor of tenements, who lived as thieves, prostitutes, or pickpockets.[9]

Homer's images speak of a simpler world. Perhaps more than any other period since the Civil War, the 1870s were a curious blend of old and new elements in American society and thought.[10] The burgeoning technology of the new industrial environment had brought with it a sense of dislocation and an awareness that the world was becoming a more complicated and treacherous place. Whitman described these years as a "sea of seething currents" and believed that "never was there . . . more hollowness of heart than at present."[11] Faced with economic woes and an uncertain future, thwarted and frustrated by a society that moved too rapidly, low on options and morale, people cherished their illusions.[12] "Those halcyon days of innocence and purity will never return again," wrote one contemporary observer, lamenting not only a lost personal past but a historic one as well.[13] The antebellum years were perceived of as an age of innocence and hope

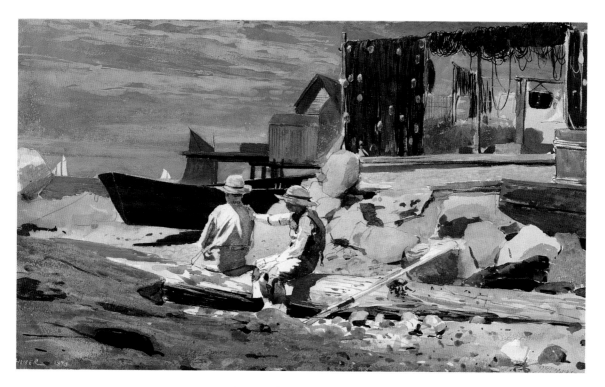

11 *Waiting for the Boats, 1873*

and the postwar desire to return to them so as to erase the trauma of the war was strong. Homer's portraits of childhood evoke a happy and uncomplicated past.

In the late spring of 1874, in the company of his painter-friend Eliphalet Terry, Homer made his second visit to the Adirondacks.[14] During his month's stay at the Thomas Baker farm near Minerva, in Essex County, New York— a site he would return to often— he produced several watercolors that show the Adirondacks woodsmen who would later figure strongly in his work. Instead of clearly delineating between the lights and darks, as in the Gloucester watercolors, Homer reduced the illustrative characteristics and attempted to evoke the filtered light of the woods through a more suspended and diaphanous approach. Pale washes in delicate pinks and blues and layerings of watery greens and browns in *Man in a Boat Fishing* (fig. 13) and *Trappers Resting* (fig. 14) reveal his struggle to achieve the effect of light through greater transparency.

Following his stay in the Adirondacks, Homer moved on to Walden, Orange County, New York, to the summer home of Lawson Valentine, the business partner of Homer's older brother, Charles. At Walden he painted young men and women in scenes of farm life. *Fresh Eggs* (fig. 15) is one of a series of small sheets showing a young woman engaged in egg gathering; all are subtle in design, finely drawn, especially in the faces and heads, and animated throughout by short brushstrokes, highlighted with touches of gouache, and full of gold and amber colors.[15] Homer's sense of design, well-developed through his experience as an illustrator, is evident in compositions like *Rustic Courtship* (fig. 17),

12

12
*Schooners
in Gloucester Harbor, 1873*

13
*Man in a Boat
Fishing, 1874*

14
Trappers Resting, 1874

13

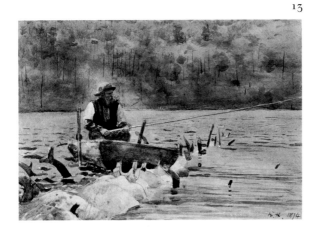

14

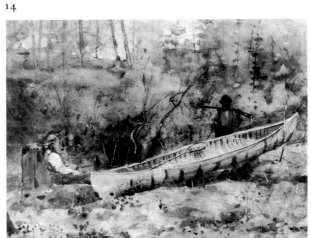

where the reiteration of crisply defined rectilinear and circular forms, and the strong contrasts of color and light, give to the work a poise and monumentality that belie its small size.

In the Garden (fig. 16), executed largely in single washes of transparent colors, shows Homer's early approaches to the medium. The figure of the young woman in a glowing pink dress is carefully painted and the details of her flower-sprigged costume are clearly articulated. The landscape background is achieved through small pools of wash that were sponged in certain areas and lifted out in others. In the foliage, he employed simple complementary colors to intensify the effect— strokes of red on green, blue on yellow, and purple on green. This sense of complementarity may have come from Michel B. Chevreul's famous treatise, *The Laws of Contrast of Color* (1859), a copy of which Homer had received from his brother Charles in 1860. Late in life Homer told his friend John Beatty, "You can't get along without a knowledge of the principles and rules governing the influ-

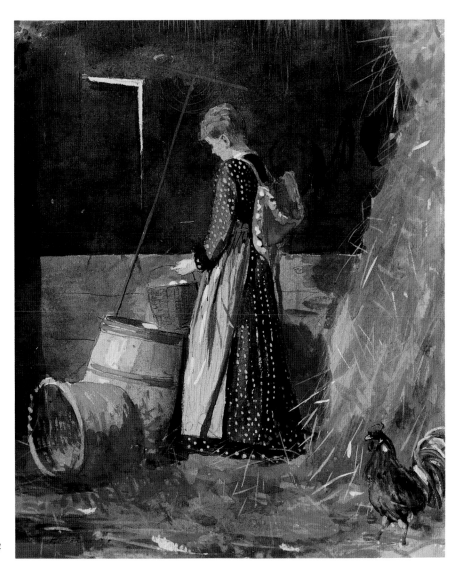

15 *Fresh Eggs, 1874*

ence of one color upon another. A mechanic might as well try to get along without tools."
Asked about Chevreul's book, he said "It is my Bible."[16] Color would become increasingly
important in Homer's work, reaching its most expressive power in the mature works,
where jewel-like rarities of tone, unique to the watercolor medium, were achieved less by
such obvious, side-by-side contrasts as those of *In the Garden* than by transparent layers of
complementary or related colors.

In the spring of 1875, Homer sent twenty-seven watercolors and six black-and-white
drawings to the current American Society of Painters in Water Colors exhibition. Includ-
ed were works from the previous summer, as well as a number of 1873 sheets from
Gloucester. These seaside and rural *plein-air* scenes brought him his first wide exposure
as a watercolorist.[17] The critics praised the works for their boldness, vigor, and originality,
but again took Homer to task for what they considered inartistic execution and lack of

16 *In the Garden, 1874*

finish.[18] Although writers such as Samuel G.W. Benjamin, a pioneering watercolor critic, called for pure transparent pigments and free washes without the use of opaque color,[19] for many critics the official standard of excellence was the lavish use of gouache, or opaque body color, stippling (the application of paint by repeated small touches), and the careful finish favored by Victorian artists. Such technique denied the inherent properties of liquid color— its transparency, fluidity, and spontaneity.

It is not difficult to see how the abrupt cropping, economy of means, and comparatively broader brushwork of a watercolor like *A Basket of Clams* (fig. 5), for example, could be perceived as raw or incomplete to a public accustomed to the prevailing taste for countless tiny strokes of color. Quick graphite lines create the masts and background buildings and define the forms of the boat and the two fisherboys carrying a basket as they swerve away at the sight of a strange fish. Clear, thin washes of browns and grays set the overall color scheme, allowing the gouache-highlighted brilliant vermilion, blue, and white of the shirts to be the focus of the sheet. Unimportant details are played down, and the whole is seen not in terms of lines but in broad, unbroken masses.

17 *Rustic Courtship, 1874*

Although most reviewers focused their criticism on Homer's brushwork, what really troubled many of them was the commonplace subject matter. While they were prepared to accept such themes in Twain, Homer's psychological clarity and close-up, objective view unsettled an audience accustomed to the picturesque productions of so many of the Society's exhibitors. Even Henry James, who found the Homer watercolors "the most striking pictures in the exhibition," detested the

little barefoot urchins and little girls in calico sun-bonnets. . . . Mr. Homer's pictures . . . imply no explanatory sonnets; the artist turns his back squarely and frankly upon litera- ture Mr. Homer . . . cares not a jot for . . . the distinction between beauty and ugliness. . . . He is almost barbarously simple, and . . . he is horribly ugly; but there is nevertheless something one likes about him. . . . He has chosen the least pictorial features of the least pictorial range of scenery and civilization; he has resolutely treated them as if they were pictorial, as if they were every inch as good as Capri and Tangiers; and, to reward his audacity, he has incontestably succeeded.[20]

18 *Blossom Time in Virginia, probably 1875*

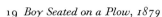

19 *Boy Seated on a Plow, 1879*

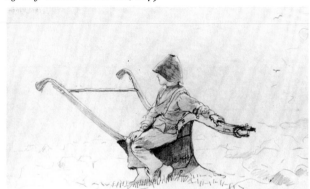

The critics' emphasis on finish and "serious" themes in watercolor was undoubtedly inspired by contemporary English art, from the influence of John Ruskin's aesthetic philosophies in the 1860s (seen in the work of the Hills— John W. and John Henry— and the American Pre-Raphaelites) to the enduring legacy of Joseph M. W. Turner in the 1870s (most apparent in the watercolors of Thomas Moran).[21] Moreover, critics had long praised English watercolors for their serious subjects as well as for their technical brilliance. "Our American artists . . . are too fond of the merely pretty," wrote Clarence Cook in 1875.[22] At the Philadelphia Centennial, John Ferguson Weir found English art to be superior to that of any other national school because it "is formed by moral ideas, and . . . is poetic, pure, and sincere in character."[23] Homer's watercolors puzzled the critics precisely because they defied such classification. The slight awkwardness, unpretentious honesty, and directness of his subject matter (seen by James and by others as "American") were further emphasized by a *plein-air* painting technique. The result was a peculiar originality.

Whereas Homer's pictorial motifs were uniquely American, his painting style was derived from earlier English sources. In the mid-1870s, as the taste for a more poetic naturalism came gradually to supplant the Pre-Raphaelites' so-called plain, faithful recording of nature, works by such established older masters as David Cox, Richard Parkes Bonington, Peter DeWint, and William Müller— artists whose bold and confident landscape style relied on loose, overlaid washes on dry paper— were beginning to be held

20 *Harrowing, 1879*

up as models.[24] "Our artists have not attained . . . the mastery of detail and luminous coloring of the excellent English painters," wrote a reviewer in the *New York Daily Tribune*.[25] English watercolors are "entirely different," claimed the *Nation's* critic. "The suddenness and felicity of water-color effects— the ease . . . with which a broad wash struck upon a coarse paper will secure transparency and atmosphere . . . bathed in fluidity and light: all that water-color need usefully attempt is explained or indicated here."[26]

Homer's familiarity with the techniques of English academic watercolor practice is evident from his earliest works. Watercolor handbooks, like those printed annually by Winsor & Newton to accompany their paint catalogues, described a full battery of techniques and gave explicit instructions on how to achieve them. The basic English method involved building up a painting with transparent, overlapping washes of color and creating a variety of effects through a range of subtractive techniques— scraping, sponging, blotting, re-wetting and lifting, and erasing. In *Blossom Time in Virginia* (fig. 18), one of a series of watercolors from his trip to Virginia in 1875, Homer scraped away the painted surface to expose the white paper beneath, thereby creating a lighter, brighter white in the blossoms. He employed this method with increasing authority over the years, using it to greatest effect in the Adirondack watercolors of the 1890s.[27]

Paper texture is considered crucial to produce effects peculiar to watercolor,[28] and most manuals advocated paper of a medium smoothness— as did Homer. Throughout

his career Homer usually favored J. Whatman machine-made white paper, of medium or heavy weight, which he purchased in pre-cut tablets of standard dimensions, often editing the size of these sheets by trimming. Most of the early watercolors were produced on 10 x 14 inch paper; in later years he would regularly use the 20 x 15½ or 22 x 17½ inch size. On occasion, he used gray and tan papers for certain gouache drawings; this allowed him to set out the lightest areas quickly. In the later 1870s, especially, he also experimented with papers of rougher texture or "tooth."

Homer drew continuously in these years, and though he sometimes used a chalk or graphite study as a preparatory sketch for a watercolor, as in *Boy Seated on a Plow* (fig. 19) for *Harrowing* (fig. 20), more often he applied watercolor directly on a rudimentarily drawn scaffolding.[29] Unlike many of his contemporaries, who began a watercolor by first washing the sheet with clear water, Homer, in true sketch style, began painting on a dry sheet. With this method, the brush draws the color across only the highest points of the sheet's surface, leaving tiny pinpricks of white in the fine grain that create a sparkling effect. Further, Homer's graphite lines do more than merely establish outlines or guide the wash. Line and wash in his watercolors usually have two distinct functions: lines that do not separate one tone or color from another are drawn in graphite; washes are reserved for the expression of tonal areas.[30] For example, in *Four Boys on a Beach* (fig. 23), a single wash is used for the shirt of the boy at right, and the linear folds are drawn in graphite, whereas the dappled wrinkles in the sleeve of the boy at left are defined by washes around reserves of white. In Homer's mature watercolors, the washes became more saturated, fluid, and complex, but the principle of separate functions for line and wash remained.

In 1875, shortly after the close of the Society's exhibition, Homer left Harper Brothers and abruptly abandoned commercial art.[31] The growing public interest in watercolor— thanks to the efforts of the Society— must have encouraged him to believe it would be possible both to support himself and to enhance his reputation through watercolor. The decision could not have been easy, for despite the generally cordial critical response to his watercolors, he sold only a modest number during these years (he would continue to have difficulty finding patrons until the early 1880s). It proved to be a wise decision, for it was as a watercolorist that he achieved widespread fame.

The next year, Homer showed fourteen watercolors at the Society's exhibition.[32] Among them were *Taking a Sunflower to the Teacher* (fig. 22) and *The Busy Bee* (fig. 21), from a series of watercolors showing young black boys that was probably inspired by Homer's trip to Virginia the previous summer.[33] Subjects like these were well within the Victorian mainstream, both in content and style: J.G. Brown's and Thomas Waterman Wood's seemingly endless parade of newsboys and bootblacks, and Eakins' *Study of Negroes* of a few years later (1878; The Metropolitan Museum of Art, New York) are similar genre pieces. The *New York Times* called *The Busy Bee* the best of Homer's work that year; despite the "crude" color and "careless" finish, "Homer appears to more

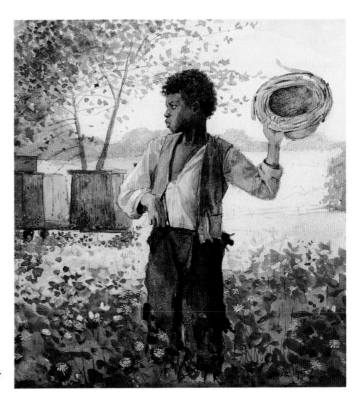

21 *The Busy Bee, 1875*

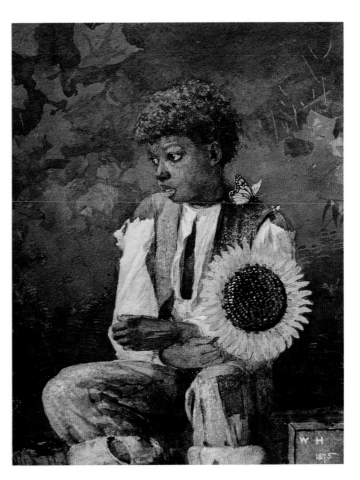

22 *Taking a Sunflower*
to the Teacher, 1875

advantage in watercolors than in oils."[34] The foreground of the almost square sheet is alive with flowers, some created through flecks of white, pink, and red gouache, others through the common watercolor technique of lift-out.[35] Delicate graphite drawing articulates the shirt and vest. Neither sentimental nor in any sense a caricature, *The Busy Bee* and other watercolors in the series preface the artist's more complex and subtle oils of Virginia subjects from the same period.[36]

When Homer began to work seriously in watercolor, the influence on his oils was immediately apparent. Until the summer of 1873, his oil palette had been essentially one of the actual color of the object, uninfluenced by the reflected light or relative color. Afterward, he translated the often high-keyed tones of many of the watercolors into oil; the fresh rose-pinks and vivid blues of the watercolor and gouache *Gloucester Harbor* (fig. 24), for example, appear in the 1873 oil *Gloucester Harbor* (fig. 25). His oil painting style was also affected. In *Butterfly Girl* (1878; The New Britain Museum of American Art) he built up the foliage using the exact method he employed for the foliage in the watercolors, superimposing increasingly dark tones of green over lighter ones. The "sketchiness" of his watercolor technique also influenced the brushwork in oil: rapid strokes now became a graphic means, communicating the impression of action and life. The result in oil is a fresher, more direct, more painterly touch than before.

At the same time, watercolor and oil called forth subtly different artistic statements. In some cases, the heavier medium seemed to demand a more solid compositional structure. The early watercolor *Longing* (fig. 26), for example, shows a young boy looking out to sea, perched casually on the bow of a beached boat. Rendered in flat, single, clear washes, the compositional structure is plain, the sense of light and atmosphere strong, and the overall effect uncomplicated. In the oil *Dad's Coming* (fig. 27), Homer added a young

23 *Four Boys on a Beach, c. 1873*

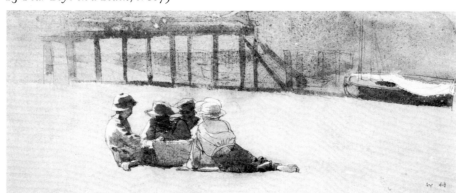

24 *Gloucester Harbor, 1873*

25 *Gloucester Harbor, 1873*

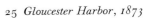

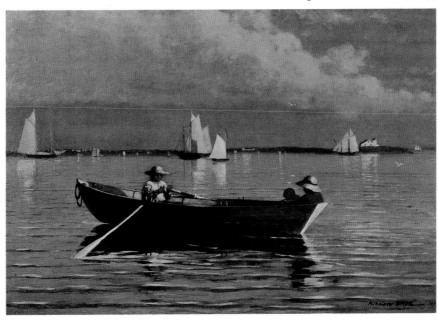

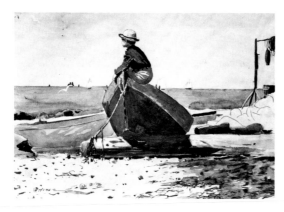

26 *Longing, 1873*

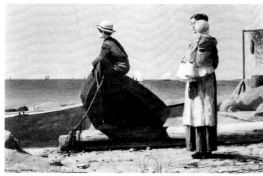

27 *Dad's Coming, 1873*

woman and child. He strengthened the outlines and built up all of the forms so that they became more potent geometric shapes. The spatial separation of the major figures and elements creates a tension and sense of psychological isolation (characteristic of most of Homer's oils of the 1860s and early 1870s) that are not found in the watercolor. The result is a darker, more profound response to the sea.

Even in those few cases where an oil seems to be based exactly on a watercolor, there is a significant difference in the visual experience of the two images. Watercolor, by its very fluid and transparent character, is especially suited to the evocation of movement. In *Sailing the Catboat* (fig. 28), probably executed during Homer's first visit to Prout's Neck in May 1875, the washes and gouache glide across the sheet in free, loose strokes— Homer never stopped for details. The gesture of the brush itself suggests the light, quick movement of the boat as it skims across the water. By contrast, the oil *Breezing Up* (fig. 29) is solidly painted; the brushwork, though vigorous, is less gestural and immediate. *Breezing Up* depends on bright colors, strong diagonal forms, animated silhouettes, and subtle attention to such details as the placement of the tip of the boat just above the horizon line to convey the exhilarating fair-weather moment. The watercolor recreates the spontaneous experience; the oil sums up the idea.

Homer was elected a member of the American Society of Painters in Water Colors at the close of the group's 1876 exhibition. It was about this time that his watercolors took on a somewhat more finished studio character. The critics' repeated complaints about his

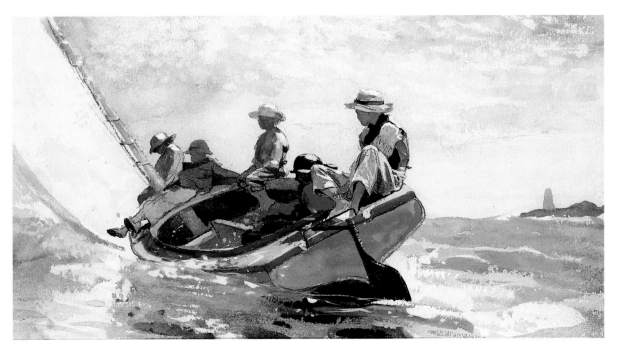

28 *Sailing the Catboat, probably 1875*

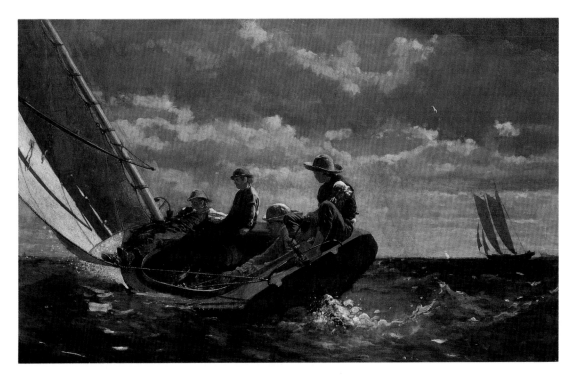

29 *Breezing Up, 1876*

hastily painted sketches may have persuaded him to change his style. Perhaps, too, in answer to the criticism, he showed only five watercolors at the Society's 1877 exhibition, among them *The New Novel* (fig. 30), *Blackboard* (fig. 31), and *Woman Peeling a Lemon* (fig. 32)— each one larger and more elaborate than anything he had previously exhibited.[37] The subjects were also more conventional— young women engaged in genteel, fashionable activities. With such watercolors, Homer joined the artistic mainstream, both in content and style.

A comparison between these finished works, which are among the first great high points of his watercolor career, and earlier sheets like *In the Garden* (fig. 16), reveals how much more subtle, purposeful, and technically complex Homer's watercolors had become. *The New Novel* is executed in layers of transparent wash and a richer palette than ever before. Homer clearly loved the image of this woman, for there is an unprecedented perfection and sensuality in his touch, as if the art slowly took over his hand, as if he had wandered into a dream of color. Against a background of warm and cool greens, and yellows of uncommon shades, the glowing warmth of the woman's red hair and dress, achieved through layerings of various orange-reds, creates a contrast of material and texture, the whole combination keyed by the touches of vermilion at either end of the figure and emphasized by the deep gray-blues of the book and pillow. A mosaic-like pattern of warm pinks and blues of nearly equal values caresses her face, while languid strokes of deeper blue outline her features.[38]

The relative ease of the watercolor medium seemed to encourage Homer to take a freer attitude toward color. As if setting himself a series of challenges, he executed a small group of watercolors in which each sheet is an essay in essentially one or two colors. *Woman Peeling a Lemon* (fig. 32) is accomplished in variations of yellow and pink, the colors echoed and reinforced through compositional devices. The curvilinear design underscores the circular motion of peeling the lemon; the young woman's pink lips are drawn to a pucker as if in anticipation of the taste of the lemon she pares; and the lemon is precisely in the center of the sheet, where it acts as the pictorial focus. Homer orchestrates tones of yellow that range from the pale lemon-colored background (now much faded), to the muddy tan in her blouse, to the bright yellow of the lemon peel and the bench tacks, while every tint within the pink spectrum seems to be spread upon her dress, defining the broad light and shade of her figure. Homer's artful use of color extends to his signature, which he inscribed in the same rose-brown as the Empire stool, echoing in the *H* of his own name the curved form of the ottoman's wood base.

Blackboard (fig. 31) is executed almost completely in grays, with repeated spongings to achieve a myriad of warm and cool tones. It is a subtle, elegant example of Homer's growing mastery of the relationship between color and subject. The monochromatic scheme, derived from the white chalk and the blackboard, creates a serious mood, while the compositional structure, made up of rectangles, triangles, and circles, is an elaboration of the geometric symbols inscribed on the board: the form of the woman's head adjoins and reiterates the circle; her arm bent across her back bears the same relation-

30 *The New Novel, 1877*

ship to the triangle. Each element thus enhances and reaffirms the other, underscoring the quiet, abstract nature of the activity depicted. Homer again inserts his presence, signing his name on the blackboard.[39]

The critics were quick to see the difference between these watercolors, exhibited in 1877, and Homer's previous ones. They considered the new works to be a marked advance and lauded the artist for his precise handling of the medium, a quality regarded as entirely in accordance with the work of foreign watercolorists. But Homer's adverturesome use of color was less universally appreciated. Whereas the *Art Journal* praised *Woman Peeling a Lemon* for its "precision, . . . subtlety of hues, . . . [and its] scale of refined colour and tone which even his warmest admirers could hardly have anticipated from his brush," *Scribner's* found the colors to be "unpleasant." The reviewer in the *Evening Post* disliked all the watercolors and wrote in irritation, "Mr. Winslow Homer is fond of experiments, and is nothing if not Mr. Winslow Homer. [His] figures of young women . . . [have] hands and feet [that] are enormous and coarse, and . . . the faces display large, sickly, dirty, faint green patches. . . . We never saw the like to them either on canvas or on epidermis." The *Nation*'s critic, voicing the sentiments of many who found the color irreconcilable with reality, complained, "Mr. Homer was never more careless and capricious and trying."[40]

Such criticism undoubtedly both stung and angered Homer. The following year, he exhibited two oils at the National Academy of Design and sent five paintings to Paris for the Universal Exposition, but he showed no watercolors at the Society's exhibition. The snub was immediately noticed: "Perhaps no contributions have had quite so much *éclat* this year as the absence of certain contributions," wrote the *Nation*'s critic. "The

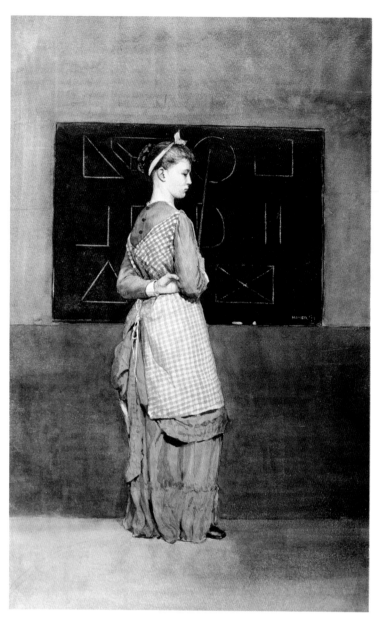

31 *Blackboard, 1877*

always-unexpected Mr. Homer, so certain to do something that nobody could have antic-
ipated and that no inferior artist could do, this season does nothing."[41]

As we have seen, one of the characteristics of Homer's watercolors is that they were
generally created in series or groups, with the themes selected according to the place the
artist was visiting. The major exception to this discrete time-place pattern is the subject of
women. Shown at leisure or at work, in groups or alone, with men or without them,
women appear in the watercolors (and paintings) throughout the 1870s more often than
any other subject. Perhaps these representations constituted both an emotional and an
artistic reaction to the many images of men he had created during the war years. In this
decade, when the early watercolor exhibitions were dominated by landscapes and still

32 *Woman Peeling a Lemon, 1876*

lifes, Homer was among the few American watercolorists to concentrate on the human figure.[42] *Girl Seated* (fig. 35) is one of the finest of a small group of watercolors permeated with a mood of reverie, executed in the late 1870s, showing a pensive young woman in a shadowy interior.

In focusing so often on the female image, Homer followed English models; we have only to look through the annual catalogues of British watercolor exhibitions to see the tremendous popularity of the subject, doubtless a reflection of the Victorians' "women worship," as it came to be called in the 1860s.[43] Homer's interest in the theme would become even more intense in England in the early 1880s, with his depictions of the anonymous Cullercoats fisherwomen. For a period of three or four years during the 1870s, however, his concern was focused on one woman. Beginning about 1874, the portrait of

the same red-haired young woman appears repeatedly, often in profile, her gaze always averted from direct contact with the viewer (figs. 30, 31, 32, 33, 34, and 36). The woman's identity remains unknown, but the lingering attention given to individual features and details of dress is, in a sense, an act of love. Homer clearly cared for her in some way.[44]

During the 1870s Homer most often portrayed women as creatures of leisure— playing croquet, promenading at resorts, riding in the mountains, reading novels, playing backgammon, or gathering flowers— and always in summer. In watercolors like *The Trysting Place* (fig. 36) and *Portrait of a Lady* (fig. 33), his conception paralleled that of many contemporary novelists who represented their delicate, young heroines in crinoline and innumerable flounces of white muslin, with knots of pale-colored ribbon, carrying fans or lace parasols to prevent freckles and tan, and standing in intimate garden settings.[45] Such heroines exude passive virtues. Brisk and efficient action on their part would appear unladylike and almost vulgar.[46] Many contemporary observers viewed this type of female negatively and strongly criticized the "vacuity of mind and flabbiness of muscle of the ornamental woman of the present epoch."[47] Some urged a return to the "noble office" of motherhood and the standards of the past;[48] others, reflecting the growing feminist movement, called for a new kind of woman.[49]

Later, at Cullercoats, England, Homer would find women like the "robust equals" Whitman dreamed of for America. During the 1870s, however, Homer's images of women are pervaded by passivity and a vague sense of dissociation. Even when he shows a young woman more actively engaged, as in *Fresh Eggs* (fig. 15) or *Blackboard* (fig. 31) or *The Morning Bell* (c. 1872; Yale University Art Gallery, New Haven) and even *The Cotton Pickers* (1876; Los Angeles County Museum of Art), she seems detached from her work, physically and psychologically remote.

The psychological reticence of women in Homer's work of the 1870s may be as much a reflection of the artist's mood as of the subject. Homer's ambivalent relationship to women is hinted at in the mysterious *Moonlight* (fig. 37). Of the two silhouetted figures on the beach, boldly drawn against the moonlit water, the man is slightly lower than the woman— and she turns her head from him. He is thus subtly presented as supplicant, the position that most often characterizes male-female relationships in Homer's works.[50] The man is almost lost in darkness; his face, in vanishing profile, reveals only the outline of a mustache much like the one Homer wore. By contrast, the top of the woman's head and her right shoulder and arm are caught and defined by the light. Both figures appear inviolate, two solitary beings lost in separate thought.

The space between the two figures holds the picture's energy. Here, painted in deepest black and darker than any other part of the brown-blue monochrome scheme, are the woman's open fan and the handle of the man's cane, objects with unmistakable sexual associations and surrogate references.[51] Here, too, the woman's skirt brushes against the man's knee. The figures' inner emotional landscape is echoed by their physical space. The setting is surreal, like that in a dream, both reinforcing and symbolizing the mood of its inhabitants. An eerie light locks the two figures together and leads the viewer, by

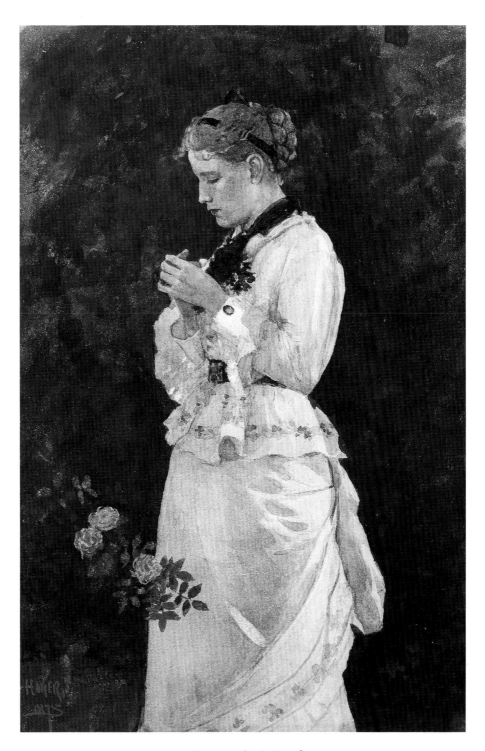

33 *Portrait of a Lady, 1875*

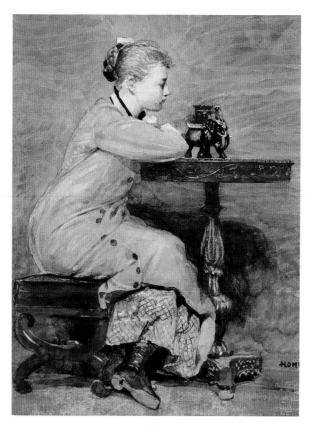

34

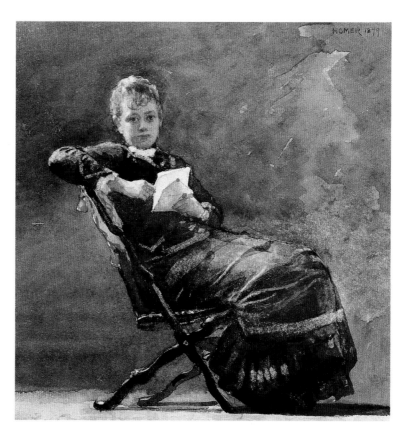

35

34
*Woman
and Elephant, c. 1877*

35
Girl Seated, 1879

36
*The Trysting
Place, 1875*

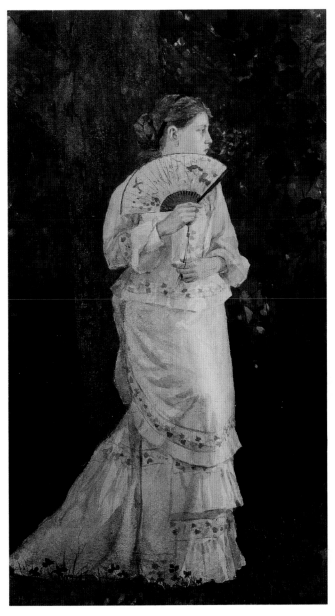

36

means of a directional path created by the moonlit clouds, across the quiet sea to the surf exploding against the edge of the shore, an image suggestive of underlying passions, perhaps allusive of the sexual act itself. As in a nightmare, the figures' ghostly shadows and the black, skeletonlike seaweed lying in the foreground seem to foretell the death of this relationship. Although Joseph E. Baker, a friend of Homer's from his Bufford apprentice days, said that the artist always spoke of women " 'in a remote tone,' as of a subject which did not closely or personally interest him,"[52] the evidence of these watercolors and oils would suggest that, until 1878, when she disappeared from his work, there was a woman who filled Homer's thoughts.

Notes

1 George H. Proctor, "An American Fishing Port," *Lippincott's Magazine* 1 (May 1868), 497. Homer had visited the town briefly in 1871; see his oil of that year, *Gloucester Ship Building* (Smith College Museum of Art, Northampton, Massachusetts).

2 It was also at this precise time, 1873, that Thomas Eakins took up watercolors with new purpose; Foster 1982, 204.

3 Henry James, "On Some Pictures Lately Exhibited," *Galaxy* 20 (July 1875), 94.

4 Theodore E. Stebbins, Jr., *American Master Drawings and Watercolors* (New York, 1976), 169. The first important study of Homer's watercolor technique is Hereward Lester Cooke, "The Development of Winslow Homer's Water-color Technique," *Art Quarterly* 24, no. 2 (Summer 1961), 169–194.

5 The colors referred to throughout the discussion are generally naked-eye colors. Homer used Winsor & Newton moist watercolors in pans. Two watercolor boxes are extant: Bowdoin College Museum of Art, Brunswick, Maine, and Portland Museum of Art, Maine. Both are Winsor & Newton 20-pan boxes and bear Homer's color notations. The Bowdoin box still contains nineteen pans of color, including three for his favorite vermilion. For the pigment names as well as their major elements and possible compounds, see R. Craigen Weston, "Pigment Analysis," Appendix B, in Cohn 1977, 68 and 70; also R. Newman, C. Weston, and E. Farrell, "Analysis of Watercolor Pigments in a Box Owned by Winslow Homer," *Journal of the American Institute for Conservation* 19, no. 2 (Spring 1980), 103–105.

6 See *Scribner's Monthly* 7 (April 1874), 761, for the remarks on the other participants; *New York Tribune*, 14 February 1874, 7, for the description of Homer.

7 For example, *Crossing the Pasture* (c. 1872; Amon Carter Museum, Fort Worth); and *The Nooning* (c. 1872; Wadsworth Atheneum, Hartford).

8 See Horace E. Scudder, *Children in Literature and Art* (Boston, 1894); also Lois Fink, "Children As Innocence from Cole to Cassatt," *Nineteenth Century* 3, no. 4 (Winter 1977), 71–75. Arthur Schopenhauer wrote, "Childhood is the time of innocence and happiness, the paradise of life, the lost Eden on which we look longingly back through the whole remaining course of our life"; from *The World As Will and Idea*, trans. R. B. Haldane and J. Kemp (London, 1907), 3:162.

9 On these urban social conditions, see William Peirce Randel, *Centennial: American Life in 1876* (Philadelphia, 1969), 311. In focusing on children in the Gloucester watercolors, Homer was ignoring a prevalent feature of life in the town: there is not the slightest hint of the dangerous and often tragic events that were part of daily existence in a fishing port; see also pp. 69-70 below.

10 For a discussion of this period in literature, see Robert Falk, *The Victorian Mode in American Fiction: 1865–1885* (Michigan State University Press, 1965).

11 Walt Whitman, "Democratic Vistas" (1871), in *Walt Whitman*, notes by Mark Van Doren, Viking Portable Library ed. (New York, 1973), 378 and 325.

12 For a general discussion of American culture in the post-Civil War years, see Alan Trachtenberg, ed., *Democratic Vistas, 1860–1880* (New York, 1970).

13 Augustus Kinsley Gardner, *Our Children* (Hartford, 1872), 8.

14 During this Adirondacks sojourn, Homer did a portrait in watercolor of Terry (Century Association, New York), which was probably the basis for the oil *Playing a Fish* (1874; Sterling and Francine Clark Art Institute, Williamstown, Massachusetts). From this visit also came Homer's first important Adirondacks oil, *Two Guides* (dated 1875 or 1876; Sterling and Francine Clark Art Institute).

15 Among others in the series are *Summer* and *Hunting for Eggs*, both in the Sterling and Francine Clark Art Institute.

16 Quoted in John W. Beatty, "Recollections of an Intimate Friendship," in Goodrich 1944, 222–223. Written in 1923–1924, this memoir was published as an appendix in Goodrich 1944. Homer's edition of Chevreul was *The Laws of Contrast of Color*, trans. John Spanton (London, 1859). His copy is in The Margaret Woodbury Strong Museum, Rochester, New York. For the other volumes owned by Homer in the Strong Collection, see David Tatham, "Winslow Homer's Library," *American Art Journal* 9, no. 1 (May 1977), 92–98.

17 The watercolors were priced from $30 to $75; at least ten were sold. As the decade progressed, Homer gradually raised his prices. Compared to the prices major figures such as Tiffany and Samuel Colman were asking for watercolors ($1,000–$1,500), Homer's prices were modest. Among the patrons for his watercolors during this period were his brother Charles, and Lawson and Henry Valentine, varnish manufacturers for whom Charles was chief chemist.

18 See for example, *Art Journal* (N.Y.) 1 (March 1875), 92: "With a few dashes of the brush, he

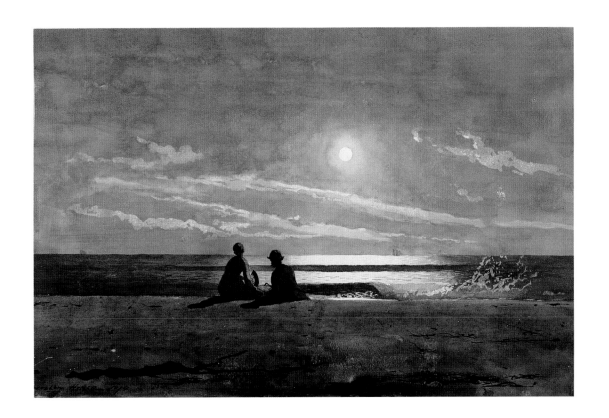

37 *Moonlight, 1874*

suggests a picture, but a mere suggestion only, and it is mistaken eccentricity which prevents its finish." *Nation* 20 (18 February 1875), 119, praised the evident "truth" of the watercolors, but regretted that Homer had not progressed to the point of painting "pictures, and not mere effects; at present his highest exercise is to lay silhouettes of pasteboard on a ground of pasteboard differently tinted." For additional reviews, see *Appleton's Journal* 13, no. 308 (13 February 1875), 216, and Clarence Cook, "Art," *Atlantic Monthly* 35 (April 1875), 508.

19 Samuel G. W. Benjamin, "American Water-Colour Society: Thirteenth Annual Exhibition," *Art Journal* (N.Y.) 6 (March 1880), 91–92.

20 James, "Some Pictures," 90, 93–94.

21 For the influence of Ruskin on American art, see Linda S. Ferber and William H. Gerdts, *The New Path: Ruskin and the American Pre-Raphaelites* (exh. cat., The Brooklyn Museum, New York, 1985).

22 Cook, "Art," 509.

23 John Ferguson Weir, "Plastic and Graphic Arts," in Francis A. Walker, ed., *Reports and Awards*, Group 27 (Washington: United States Centennial Commission International Exhibition, 1876), 4, 10.

24 Watercolors by these artists were shown at virtually every annual exhibition sponsored by the American Society of Painters in Water Colors and at important dealers such as M. Knoedler & Co. throughout the 1870s; see *Art Interchange* 6 (3 March 1881), 54.

25 *New York Daily Tribune*, 15 February 1872, 2.

26 *Nation* 16 (20 February 1873), 137.

27 How much scraping was allowable was a subject often discussed in reviews of watercolors; see n. 26.

28 Aaron Penley, in his widely known treatise, *A System of Water-Colour Painting* (London, 9th ed., 1852; London, 39th ed., 1878), 6, wrote: "The great charm of Water-Colour Painting lies in the beauty and truthfulness of its aerial tones. . . . [The effect] depends entirely upon the fact of the paper . . . being granulous; that is, upon its surface presenting so many little hollows and projections, which receive transparent washes of colour, whereby an alteration of light in the protuberances, and half-light in the cavities, is maintained."

29 For the best overview of Homer's drawings, see Stebbins, *American Master Drawings*, 200–204.

30 For a discussion of the different functions of graphite and wash, see Cohn 1977, 26–28.

31 To his friend John W. Beatty he defended his decision to leave, citing the poor quality of the reproduction of *Snap the Whip* in *Harper's Weekly*; Goodrich 1944, 45.

32 Later in 1876 Homer sent four watercolors to the Centennial Exhibition: *In the Garden* (fig. 16); *Taking a Sunflower to the Teacher* (fig. 22); *The Busy Bee* (fig. 21); and *The Trysting Place* (fig. 36).

33 Among the other watercolors in this series are *Contraband* (1875; Canajoharie Library and Art Gallery, Canajoharie, New York); *Blossom Time in Virginia* (fig. 18); and *Two Boys in a Cart* (1875; Philadelphia Museum of Art).

34 *New York Times*, "Watercolor Exhibition," 13 February 1876, 10. During this period, Thomas Eakins was enduring similar criticism for the "crude" color in his figure pieces. "Mr. Eakins enters the lists with Mr. Homer," wrote *Scribner's* 9 (April 1875), 764.

35 At the very brief moment when watercolor is half-dry or tacky, it is possible to lift the color from the paper with a dry brush or with the wooden end of the brush. Should the paint have dried, the highlight can be achieved by brushing the exact form of the intended light area in pure water, waiting a moment for the color to redissolve, and then blotting it up; see Cohn 1977, 44–46.

36 For a discussion of Homer's southern subjects, see Michael Quick, "Homer in Virginia," *Los Angeles County Museum of Art Bulletin* 24 (1978), 61–81; and Mary Ann Calo, "Winslow Homer's Visits to Virginia during Reconstruction," *American Art Journal* 12, no. 1 (Winter 1980), 5–27.

37 Homer's ambition for these watercolors was reflected in the higher (for him) prices he set for them: $125 for *Blackboard* (fig. 31) and $250 for *The New Novel* (fig. 30).

38 In several watercolors and paintings of this period, Homer portrayed young women reading. The motif was a popular one among Victorian artists and writers. The time between 1845 and 1875 was the great heyday of sentimental and domestic novels written largely by women for women. Commentators at the time noted that innumerable middle-class young women spent a great part of their girlhoods recumbent on chaise lounges with their heads buried in so-called worthless novels. These critics hinted that their grandmothers, by contrast, had spent their time studying the Bible and performing useful household tasks. The new kind of "light" reading was an occupation for the "unemployed" and "narcissistic" ones. Ann Douglas, *The Feminization of American Culture* (New York: Avon Books, 1977), 9.

39 Homer's focus on the schoolteacher in several oils and prints of this period coincides with the increased prominence of women in primary school education during the nineteenth century.

Women gradually came to constitute the majority of grade-school teachers, a situation unequaled in any other country, and one that was often remarked upon by contemporary observers of the culture. Douglas, *Feminization*, 89, and thereafter.

40 *Art Journal* (N.Y.) 3 (March 1877), 95; *Scribner's Monthly* 13 (April 1877), 866–867; *Evening Post*, 13 February 1877, 1; *Nation* 24 (15 February 1877), 108.

41 *Nation* 26 (14 February 1878), 120.

42 Thomas Eakins, Homer's contemporary, also focused on the figure in these years. Although their painting styles were vastly different— Eakins executing each sheet with an exacting, methodical draftsmanship, Homer working with apparent swiftness, fluency, and simplicity— both men followed remarkably similar paths in their thematic choices. In the same 1874 Society exhibition where Homer first showed his Gloucester watercolors, Eakins showed three rowing and sculling pictures. By the later 1870s, when Homer was portraying self-absorbed young women, Eakins' typical watercolor subjects were young women set in closed private interiors; for example, *Young Girl Meditating* (1877; The Metropolitan Museum of Art). For Eakins as a watercolorist, see Foster 1982, chap. 4.

43 A discussion of this complicated phenomenon is in Walter E. Houghton, *The Victorian Frame of Mind: 1830–1870* (New Haven, 1957), especially chap. 13.

44 According to Goodrich 1944, 56, Homer had one special love affair in his life, which ended unhappily because he did not have the income to marry. In conversation with the author in 1984, Goodrich suggested the woman may have been Helena de Kay, a respected flower painter. According to Goodrich, affectionate letters exist from Homer to Miss de Kay. Both Miss de Kay, one of the founding members of the Society of American Artists, and Homer had studios in the Tenth Street Studio Building. Homer's 1876 portrait of her (Thyssen-Bornemisza Collection, Lugano; Hendricks 1979, fig. 144), shows a strong resemblance to the woman in the watercolors. She later married Richard Watson Gilder, the influential editor of *Scribner's Monthly*. Several of the watercolors are discussed in Henry Adams, "Winslow Homer's Mystery Woman," *Art and Antiques*, November 1984, 38–45.

45 The garden was the natural setting in novels by Henry James, Nathaniel Hawthorne, Harriet Beecher Stowe, and William Dean Howells; see Paul John Eakin, *The New England Girl* (Athens, Georgia, 1976), 14. *Portrait of a Lady* (fig. 33) may be the work La Farge described in his obituary tribute to Homer as the one he saw "in the old studio building in Tenth Street. . . where [Homer] also kept rooms for many years. I met him on the stairs as I was going up, and . . . we went up to his room . . . and he pointed to a picture he had just painted. It was that of a girl who had hurt her hand, and the expression of the face was what in my Newport language I know as 'pitying herself.' This was as delicate [an] expression as it is possible to conceive"; quoted in Gustav Kobbé, "John La Farge and Winslow Homer," *New York Herald*, 4 December 1910, Magazine sec., 11.

46 A discussion of the timid, deferential female as a mainstay of Victorian American culture is in Douglas, *Feminization*. For this type of heroine in fiction, see Ernest Earnest, *The American Eve in Fact and Fiction: 1775–1914* (Urbana, Illinois, 1974), especially chap. 4, "Girls and Goddesses"; also Eakin, *New England Girl*, throughout.

47 Gardner, *Children*, 79–80.

48 See n. 47.

49 Whitman wrote: "Democracy . . . ponders its own ideals, not of men only, but of women. The idea of the women of America (extricated from this daze, this fossil and unhealthy air which hangs about the word, Lady), developed, raised to become the robust equals, workers . . . with the men— greater than man . . . capable of being so, soon as they realize it, and can bring themselves to give up toys and fictions, and launch forth, as men do, amid real, independent, stormy life"; "Democracy," *Galaxy* 4 (1867), 931.

50 See, for example, *Rustic Courtship* (fig. 17) and *Croquet Scene* (1867; The Art Institute of Chicago).

51 Homer created several oil paintings in this same year whose hidden theme is also the sexual undercurrents between a man and a woman; this group includes *Milking* (c. 1875; Webb Gallery of American Art, Shelburne Museum, Vermont), and *A Temperance Meeting* (c. 1874; Philadelphia Museum of Art).

52 Quoted in Downes 1911, 50.

Houghton Farm

1878

Never before has a collection of his works been so beautiful in sentiment and evinced such a feeling of truth.

—*Art Journal, 1879*

In the summer of 1878 Homer visited Houghton Farm, Mountainville, New York, the newly acquired upstate country home of Lawson Valentine, who was one of the artist's most devoted patrons. In this relaxed, family environment, he produced dozens of *plein-air* watercolors of young farm girls alone or in the company of a younger boy, tending sheep, picking apples, standing in hillside pastures, or resting in the shade— images of an agrarian past that was rapidly slipping away in the postwar rush toward urbanization.

In the late 1860s, Homer, like many American artists— among them, William Morris Hunt, Eastman Johnson, George Inness, and Homer Dodge Martin— came under the influence of the Barbizon School, an integral part of which was an interest in the relationship between man and nature.[1] His friend John La Farge recalled that Homer studied the work of Narcisse-Virgile Diaz, Constant Troyon, and others through prints: "Homer was a student of these things, and has, like myself, been largely made by them."[2] Homer certainly also knew the paintings of Jean-François Millet, which had been introduced to America in the 1850s by Hunt.[3] Homer's experience of Barbizon art and of Millet was further reinforced during his visit to Paris in 1866–1867, when Barbizon School paintings were creating a sensation, and where a virtual Millet retrospective had opened at the Universal Exposition. Indeed, several of the paintings Homer executed in France in 1867, such as *Return of the Gleaner* (The Margaret Woodbury Strong Museum, Rochester, New York) and *Girl with a Pitchfork* (The Phillips Collection, Washington), closely parallel Millet's in subject, placement of the horizon line, and concentration on dramatic outline.

Homer's exposure to rural subjects continued throughout the 1870s, when the genre enjoyed a widespread international popularity.[4] In America, paintings by Millet, Jules Breton (fig. 70), Rosa Bonheur, and Hague School painters led by Jozef Israels whose sympathetic treatment of fisherfolk was the Dutch equivalent of the Barbizon peasants (fig. 64), were eagerly sought by collectors at prices rivaling those for old masters.[5] It was the beginning of a heyday of books and articles on peasant art; images of stoic peasants and strong, statuesque fisherwomen appeared everywhere. Critics lauded

38 *Apple Picking, 1878*

39 *Feeding Time, 1878*

the "Sympathetic School," the simple, pleasing treatment of humble life; and examples were included in and commented upon at virtually every major exhibition of foreign paintings.[6] It is worth noting that the first important painting John Singer Sargent sent to New York in 1878, for the First Annual Exhibition of the Society of American Artists, was a scene of fisherfolk, *Oyster Gatherers of Cancale* (1878; Museum of Fine Arts, Boston). Painted in his Paris studio from *plein-air* sketches, it employed what was by then a well-known recipe for Salon success— the combination of a naturalistic setting and a subject strong in human appeal.[7]

Each country developed its own native school of the peasant genre. In America during the late 1860s and 1870s there was a marked increase in paintings of farm scenes, including those by Homer himself. At the heart of the peasant genre movement lay a nostalgia for the preindustrial past.[8] Rural subjects came to represent a sense of permanence and continuity within the disjunction of modern life. For Americans, having only recently emerged from the tragedy and chaos of the Civil War, the ostensibly simple and natural lives of peasants— like those of children— seemed to reaffirm lost fundamental values. "Now I see the secret of the making of the best persons," wrote Whitman, "It is to grow in the open air, and to eat and sleep with the earth."[9]

40 *The Flock of Sheep, Houghton Farm, 1878*

The Houghton Farm watercolors, rapidly executed and small in scale (most are approximately 9 x 12 inches), are less obviously contrived than the studio-finished watercolors of 1875–1877. They show greater ease in their compositional structure, freer brushwork, more simplified details, clearer color, and a more developed sense of atmosphere and light. Indeed, studio-finished watercolors no longer interested Homer. "I prefer every time a picture composed and painted outdoors," he told the critic George W. Sheldon. "This making studies and then taking them home to use them is only half right. You get composition, but you lose freshness; you miss the subtle and, to the artist, the finer characteristics of the scene itself."[10] Homer's commitment to the *plein-air* method and his interest in light as a subject parallels the luminist concerns during the 1870s of John F. Kensett and Sanford R. Gifford in oils, and Eakins, William Trost Richards, and Henry Farrer in watercolor.

In technique the watercolors of this summer fall into two distinct groups, both probably created at the same time: gouache, with some transparent washes over a graphite or chalk drawing, on light blue or tan paper; and transparent watercolors, with small touches of gouache, on white paper. The first group is backward-looking and derives from Homer's experience as an illustrator: the lights and darks are achieved through an economy of

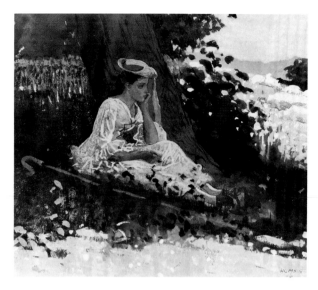

41 *Bo-Peep, 1878*

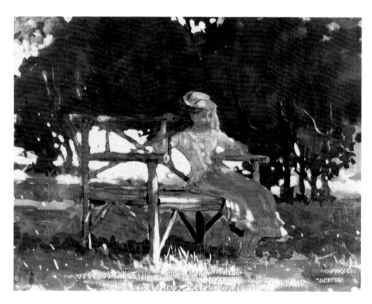

42 *Girl on a Garden Seat, 1878*

means and the design values are clearly articulated. Tinted paper (and therefore the need for the heavier medium of gouache for the lights) provided a quick, uncomplicated system for establishing the middle values and atmospheric unity.[11] In *Bo-Peep* (fig. 41), for example, he used a broad brush to lay bands of color onto the tan paper— yellow-green for the sunlit grass in the foreground, dark green in the middle ground, and light green in the distance. Thick, freely applied strokes of dark paint against light, and light paint on dark, weave the zones together, creating a sense of movement and life. The design is equally direct: the bright, triangular shape of the seated shepherdess placed within the strong diagonals of the shepherd's crook and the dark tree trunk and shrubs is balanced between the triangle of blue sky in the upper right corner and the bright strip of foreground grass flicked with white.

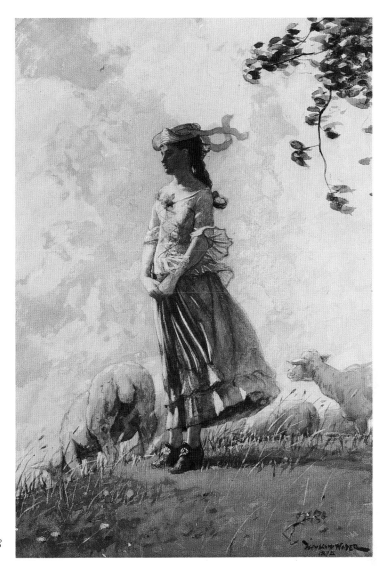

43 *Fresh Air, 1878*

In the second group, the works are essentially pure watercolor on white paper, and though frequently less successful in their technique, they look to the future. With more fluid and modulated washes than he had used before, these sheets reveal Homer's growing sureness of touch and of the special properties of his medium. In *Feeding Time* (fig. 39) he overlapped blue and yellow-green washes, controlling their flow and the density of the paint so that transparency is preserved and the natural luminosity of the white paper shines through. Opaque white is restricted to small details— highlights on the back of the girl's dress, on the boy's trousers, and on the cows. The pattern of sunlit, dappled leaves in the background has been achieved by more adept lifting out; to gain a similar effect in the foreground, he lightly scraped the paper. Homer was developing an ability to exploit accident and chance. In *The Flock of Sheep, Houghton Farm* (fig. 40),

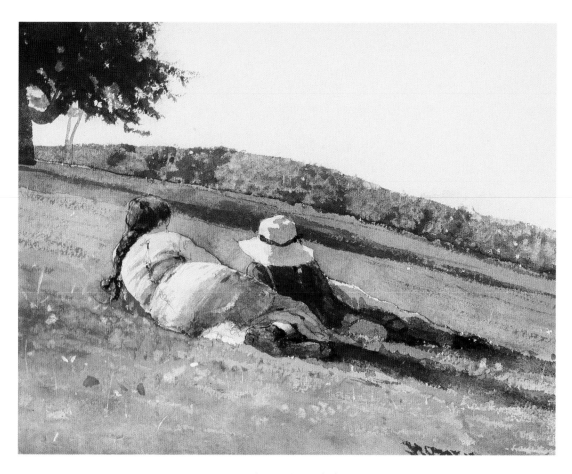

44 *On the Hill, 1878*

he allowed the rich green washes that had flooded in the foreground to settle unevenly, and then enlivened the surface with touches of ocher and yellow-orange.

Homer's masterly handling of pigment weight and consistency and his knowing use of the paper's texture give to even the simplest color harmonies a variety and delicacy that he had earlier attempted to achieve through spongings. In *Spring* (fig. 45), executed on heavier, grainier watercolor stock well-suited to sketchy, atmospheric effects, he plays the young girl's lilac-pink pinafore, with its blue and purple shadows, against the blue and yellow-greens of the landscape and the ocher tones of the fence rail and the boy's straw hat. The colors settled irregularly in places, trapping tiny pools of darker tint in the hollows of the paper; elsewhere, pinpricks of white glitter through, untouched by color, adding sparkle and depth to the washes.

One of the largest and most elaborate Houghton Farm watercolors is *Fresh Air* (fig. 43), painted on a smooth, medium-weight paper, best for subtle effects. Homer achieved the cloud-swept, silvery sky through loose washes of gray and palest pink, broadly brushed one over another and then blotted. The delicacy of his touch is evident in the girl's shadowed face and arm, modeled in warm rusts; in the peach tints which catch the effect

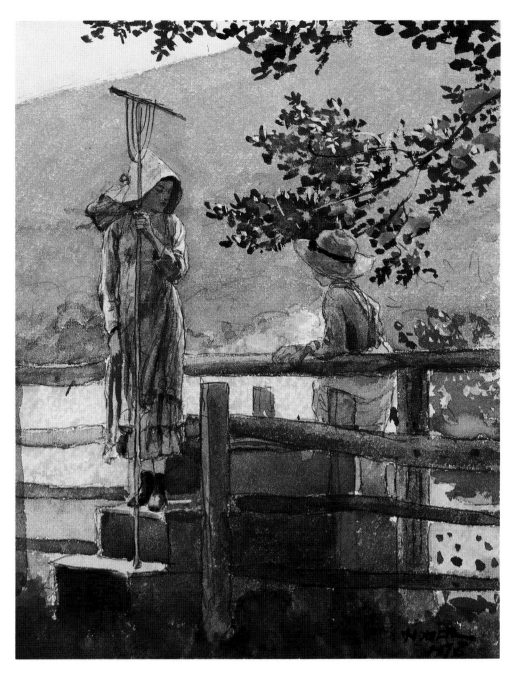

45 *Spring, 1878*

of sunlight on her profile and chest; and in the pale blue veins in her hands. Strokes of gouache articulate the folds on the bodice, the sheep, the wind-bent leaves of the tree, and the foreground grass and flowers.

If the watercolors of 1878 are often more assured in technique and composition, they also introduce an element of artifice into certain of the shepherdess images themselves. Perhaps the motif was inspired by the revived interest in anything "Early American" following the Centennial Exhibition in 1876. Yet Homer's shepherdesses are neither entirely American, nor unique. They are in fact conventional, in contrast to the usual sense of great originality in his work. *Fresh Air* has a distinctly French feeling. The figure's windblown vantage high on a hill, with the foreshortened sheep in the foreground, forces us to look up at the sky; the conception owes more to Barbizon art and such painters as Charles-Émile Jacque and, more distantly, Millet, than to American historical reality.

In costume, most of the farm girls are dressed like those in *Apple Picking* (fig. 38)— pinafores and sunbonnets, the contemporary dress for the countryside. Others, like the figure in *Fresh Air*, wear flounced skirts of flowing fabric, with tight cross-laced bodices, a bow or rosette at the breast, wide cuffs gathered at the elbows, and small hats with trailing ribbons— an American nineteenth-century fantasy of eighteenth-century "Bo-Peep" dress. Homer's interest in such a costume— its specificity of detail, as well as its repetition, even on obviously different models— suggests that he had access to a ready-made version. Indeed, "Arcadian" elements began to appear in women's fashion in the 1870s, and were swiftly adopted by American artists as subject matter.[12]

In Homer's work, archaically dressed shepherdesses made their first entrance in a number of tiles and related sketches executed during his brief membership in the Tile Club of New York. The club was founded in 1877 by Homer and a small group of young artists who wanted to meet regularly in an informal, convivial atmosphere. In response to the frenzy for decoration that swept the country following the Centennial Exhibition, they were drawn to the transparency and brilliance of ceramic colors and spent their evenings painting blank tiles. Homer may have bought the shepherdess costume in answer to the Tile Club's avowed intention of " 'doing something decorative, if we would not be behind the times.' "[13] In Homer's work, the historicism of his archaic shepherdesses is unique— and at odds with the particular brand of nostalgia in the Gloucester views. These earlier images, while thematically referential, remained realistic interpretations of what he had actually seen.

In the Houghton Farm series, as well as in such earlier works as *Dad's Coming* (fig. 27) and *The Cotton Pickers* (1876; Los Angeles County Museum of Art), Homer appropriated a European genre that had little or no reference in American life. In Europe, generations of peasants had tilled the fields or lived by the sea. But America had no peasants, few parts of its population were established long enough to have developed traditions, its farmers were not perceived as picturesque and downtrodden and, as Samuel Isham

noted, agrarian life was not primitive: "[The American farmer] was too independent, too sophisticated; his machinery, his reapers and threshers, lacked the epic note; they were new like his clothes, his house, and all his surroundings."[14]

Homer's shepherdesses differ in other ways from their French antecedents. The American artist cared little for Millet's biblical overtones, resolute prosaism, and heavy social themes. Moreover, although the peasantlike look of Homer's figures, whether in contemporary homespun or archaic costume, lends itself to a degree of picturesqueness, it is of a subtle variety compared to the cloying sentimentality found in the shepherdesses of some of Homer's contemporaries.[15] Homer's shepherdesses were not in fact Bo-Peep incarnations, and they were not received as such. The public saw them simply as "New England children . . . in spite of their Arcadian ribbons."[16] Homer suggests their contemporaneity partly by rendering even the archaically attired ones with the same fresh quality ("harsh" said the *Art Journal*[17]) with which he depicted more obviously contemporary girls dressed in homespun. Neither does he discriminate between the "real" and the archaic shepherdesses in his choice of postures and settings. Girls in either costume have an equally posed look, and the costumed shepherdesses have a particular air of "dress up."

A certain wistfulness also permeates these evocations of a preindustrial world. Regardless of costume, and whether seen alone or in the company of a younger boy, as in *On the Hill* (fig. 44), Homer's shepherdesses are usually caught in moments of adolescent reverie. Though their features are undifferentiated and often shadowed, like those in *Girl on a Garden Seat* (fig. 42),[18] his gentle portrayals draw us to them while their obliviousness and remoteness forbid contact. The pictures are permeated with a dreamy, meditative melancholy, a mood that colored much nineteenth-century figure painting and sculpture.[19] *Weary* (fig. 46) recalls images such as Millet's *Shepherdess Leaning against a Tree* (fig. 47) that concentrate on the pensive young female, idle in the very act of performing her task. Dreamily preoccupied with their own thoughts, Homer's shepherdesses often turn their backs to their charges or lean against a tree or on a staff. They are studies in chiaroscuro, in the emotional as well as in the formal sense. The little shepherdess in *Weary* stands beneath the dark green shade of the trees, in a deep, clear shadow juxtaposed to the brilliant dash of sunlight that throws her woody retreat into a poetic remoteness. The separateness of the figure from both the spectator and from her own larger surroundings also betrays the underlying unreality of the scene: the young "shepherdess" was in fact one of the Babcock children, a local girl in her early teens whom Homer hired to pose.[20]

In one small group of watercolors and oils, Homer portrayed the shepherdess as a mature young woman whose wasp waist and accentuated hips create a sensually curving, continuous line from bosom to thigh that was very much the fashion ideal of the time. The erotic potential of clinging fabric is seen in such overtly seductive poses as that in *Spring: Shepherdess of Houghton Farm* (fig. 48). But in more subtle ways even the costumes of the unselfconscious adolescents have erotic overtones. Although their skirts are

loosely cut, Homer hints at the bodies beneath them by fully exploiting the suggestiveness of the light, somewhat clinging fabric.

The shepherdesses appeared in Homer's art during the same period in which his "mystery lady" disappeared. If, as some have speculated, she was the object of an unsuccessful romance with the artist, the sudden and intense preoccupation with the shepherdess theme may have been a kind of escape into rustic lyricism and the innocence of uncomplicated youth (though, as in fig. 48, Homer did not always choose to emphasize the innocence). At the same time, with their historical overtones, day-dreaming youthfulness, and fancy-dress costume, Homer's shepherdesses were part of a popular— and marketable— fantasy.

In February 1879, Homer showed twenty-three Houghton Farm watercolors and gouaches at the American Water Color Society's exhibition; he was the largest single contributor.[21] The watercolors represented a turning point not only in Homer's development in the medium, but in his reputation. "Never before has a collection of his works been so beautiful in sentiment and evinced such a feeling of truth," stated the *Art Journal*. "It is thought by some that Mr. Homer's colour is harsh, and, to those who care for melting golden or purple tones, there may be something not altogether attractive in it. But, running one's eye along the line of pictures . . . the impression received from his colour is of its being the result of a robust and healthy eye and taste. . . . One may require time to relish it, but when once liked it is heartily enjoyed."[22] Sheldon went so far as to declare that these watercolors were Homer's artistic breakthrough: "Winslow Homer . . . never fully found himself until he found the American shepherdess."[23] *Scribner's* gave Homer "the palm" of the exhibition, and the *Art Interchange* placed him "in a distinct niche of honor."[24] *Appleton's* reviewer, worried whether such "charming studies" were "legitimate forms" of watercolor painting and thus really belonged in the Society's exhibition, believed that only other artists and connoisseurs rather than the wider public would find such work of interest; that the cognoscenti "set greater value on the bold and brilliant suggestion than on the perfected plan."[25]

Most telling, perhaps, was the *New York Times'* comment that: "Impressionists are here from Rome and Munich, but there is one Impressionist who is entirely homemade, and to American soil, indigenous. . . . His pictures have a vivid, fresh originality, . . . childlike directness and naivete. . . . He seems to be seldom or never bothered with the considerations of side issues, but hits straight at the mark and leaves the unimportant in a picture to take care of itself. This is being an Impressionist in the true and broad sense, not as limited by the exact forms of procedure used by certain artists in France. . . . Mr. Homer . . . must now take rank as one of the best of water-colorists."[26]

An important development in critical taste had clearly occurred. Homer's great success came from watercolors that were far from the more finished works he had shown in the previous exhibition. Although the charm of the shepherdess subjects may have contributed to their acceptance, in fact, the impressionist aesthetic was gaining critical approval.

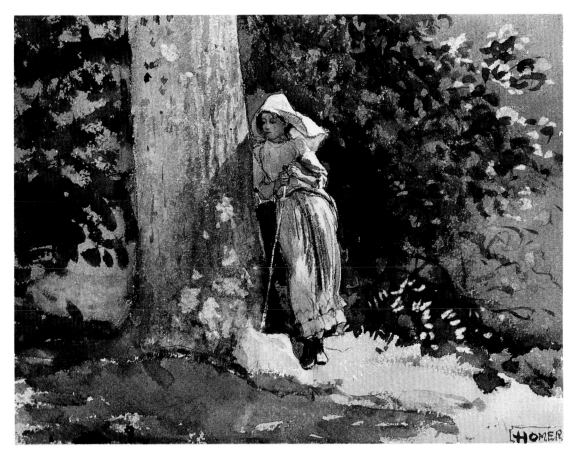

46 *Weary, 1878*

48
*Spring: Shepherdess
of Houghton Farm, probably 1878*

47
*Jean-François Millet.
Shepherdess, 1849*

The scale of the Houghton Farm watercolors, the lack of finish, the *plein-air* method, the sense of direct, unpremeditated execution, were considered the characteristics of Impressionism. "In the context of the Munich and Paris returnees, he could at least be categorized with the avant-garde . . . [and he] gained legitimacy— at last— through perceived connections to the international art world."[27] Whereas in 1875 Homer had been unacceptable as a watercolorist because his style was considered eccentric, in 1879 the sketchiness and unfinished quality could be explained and appreciated by the new concept of Impressionism.

Notes

1 For a discussion of the influence of the Barbizon School in America, see Peter Bermingham, *American Art in the Barbizon Mood* (exh. cat., National Collection of Fine Arts, Smithsonian Institution, Washington, 1975); Alexandra R. Murphy, "French Paintings in Boston: 1800–1900," in Anne L. Poulet and Alexandra R. Murphy, *Corot to Braque: French Paintings from the Museum of Fine Arts, Boston* (Boston, 1979), xvii–xxi.

2 Quoted in Royal Cortissoz, *John La Farge: A Memoir and a Study* (Boston, 1911), 70. See also Gustav Kobbé, "John La Farge and Winslow Homer," *New York Herald*, 4 December 1910, Magazine sec., 11, in which La Farge describes the early days when the two artists "fed" on engravings and lithographs of the French masters.

3 Important Millet paintings, such as *The Sower* and *The Harvesters Resting* (both now in the Museum of Fine Arts, Boston), were included in exhibitions beginning in the 1850s at the Boston Athenaeum and at the Allston Club, Boston, and were frequently illustrated in *Harper's* and *Every Saturday*. Homer's engraving *The Sower*, for *Scribner's Monthly*, August 1878, was clearly derived from Millet's famous painting, the principal version of which was in Hunt's collection. A suggestive case for the influence on Homer of Hunt's own work as the indirect source of Barbizon principles is made by Henry Adams, "The Contradictions of William Morris Hunt," in *William Morris Hunt: A Memorial Exhibition* (exh. cat., Museum of Fine Arts, Boston, 1979), 28–34.

4 This enormous popularity, which began following Millet's death in 1875, continued to the turn of the century; see Robert L. Herbert, "City vs. Country: The Rural Image in French Painting from Millet to Gauguin," *Artforum* 8 (February 1970), 50. In the 1880s a number of young American expatriate artists became specialists in peasant genre, among them George Henry Boughton, Charles Sprague Pearce, Daniel Ridgeway Knight, Elizabeth Nourse, Walter Gay, and Gari Melchers. Many of them worked in northern European coastal centers, where peasant traditions were thought to be untouched and particularly primitive.

5 In America, paintings by Bonheur, Israels, Breton, and Troyon brought up to $10,000; see Clara Erskine Clement (Waters) and Laurence Hutton, *Artists of the Nineteenth Century and Their Works* (Boston and New York, 1894; repr. New York: Arno Press, 1969), 73; and *Art Journal* (N.Y.) 3 (February 1877), 63. By 1880 the market for peasant genre was so bullish that Millet's *The Angelus* opened at auction in New York at $20,000, and a French dealer who came to America with $200,000 to buy Troyons, had to return home empty-handed; see Bermingham, *American Barbizon*, 73.

6 Breton was at this time perhaps the most admired painter of rural subjects and was considered the living exemplar of this school: "He is at once a painter of landscape and of human nature. The two are harmonized in all his works in such just proportion, and with such equal ability and care brought to the representation of each, that he occupies the rare position of excelling in two distinct branches of art. . . . [The] popular and artistic opinion is . . . united in favor of the merits of Jules Breton"; S.G.W. Benjamin, *Contemporary Art in Europe* (New York, 1877; facsimile, 1976), 92.

7 Richard Ormond, *John Singer Sargent: Paintings, Drawings, Watercolors* (New York, 1970), 17–18.

8 Herbert, "City," 50.

9 From "Leaves of Grass: Song of the Open Road," verse 6; *Walt Whitman*, Viking Portable Library ed. (New York, 1973), 159.

10 George W. Sheldon, *Hours with Art and Artists* (New York, 1882; facsimile, 1978), 138. The

interview was first published in "Sketches and Studies," *Art Journal* (N.Y.) 6 (April 1880), 105–109.

11 Many illustrators understood the atmospheric possibilities of this gouache-and-tinted paper system, and exotic colored papers were commonplace in the watercolor exhibitions; see Foster 1982, 84.

12 In the same way, "medieval" elements had punctuated fashion of the previous decade. Among the American artists who adopted the shepherdess motif were some of Homer's friends and fellow illustrators: Edwin Austin Abbey, Robert Blum, Frederic S. Church, and Thomas and Peter Moran. In the 1870s, Albert Pinkham Ryder produced a panel painting of a barefooted, seated shepherdess holding pan-pipes, surrounded by sheep in an idyllic natural setting (*The Shepherdess*, The Brooklyn Museum, New York).

13 Quoted in W. MacKay Laffin, "The Tile Club at Work," *Scribner's Monthly* 17 (January 1879), 401. Homer used the shepherdess costume on the figures in the twelve-tile fireplace set he made for his brother Charles (now in the collection of Arthur G. Altschul, New York; Hendricks 1979, figs. 128 and 192), and on a single tile (Lyman Allyn Museum, New London). For a discussion of the Tile Club's members and activities, see Mahonri Sharp Young, "The Tile Club Revisited," *American Art Journal* 2 (Fall 1970), 81–91.

14 Samuel Isham, *The History of American Painting* (New York, 1936), 494–495.

15 For example, Frederic S. Church's watercolor, *Little Bo-Peep*, exhibited at the Pennsylvania Academy in 1881; and the shepherdesses of James Archer and George D. Leslie who exhibited at the Royal Academy in 1876 and 1877, respectively, and whose works were illustrated in Henry Blackburn's *Academy Notes*, London.

16 *Scribner's Monthly* 18 (June 1879), 310–311.

17 *Art Journal* (N.Y.) 5 (March 1879), 94.

18 In *Girl on a Garden Seat* (fig. 42) and others in the Houghton Farm series, Homer shows Adirondacks rustic furniture that may be among the earliest examples of this decorative style shown in painting.

19 For a discussion of the theme of melancholy, see William Hauptman, "The Persistence of Melancholy in Nineteenth-Century Art: The Iconography of a Motif," Ph.D. diss., Pennsylvania State University, 1975.

20 The Babcocks were a family of squatters who lived on the northwest boundary of Houghton Farm; Hendricks 1979, 138.

21 Homer's watercolors were priced from $50 to $350.

22 See n. 17 above.

23 Sheldon, *Hours*, 140.

24 *Scribner's Monthly* 18 (June 1879), 310; *Art Interchange* 2, no. 4 (19 February 1879), 26.

25 *Appleton's Journal* 6 (March 1879), 281–282.

26 *New York Times*, 1 February 1879, 5. To many American critics and painters in the 1870s, impressionist painting meant looseness of handling and lack of traditional finish. The saturated hues, broken brushstrokes, and widespread use of complementary colors in French paintings of the same period were of little or no interest to the Americans.

27 Foster 1982, 90. Ironically, Homer's exposure to French impressionist painting was still in the future. Apart from Manet's *Shooting of Emperor Maximilian* (1867; Kunsthalle, Mannheim), which was exhibited briefly in New York and Boston in 1879 and had a short-lived celebrity, the first real opportunity to become acquainted with impressionist works in America was the show mounted by the Foreign Exhibition Association that opened in Boston in September 1883 and included works by Manet, Monet, Pissarro, Renoir, and Sisley. For a discussion of the exhibition, see Hans Huth, "Impressionism Comes to America," *Gazette des Beaux-Arts* 29 (1946), 225–252. For Impressionism in America, see William H. Gerdts, *American Impressionism* (New York, 1984), especially chap. 4, 48–53.

Gloucester

1880

No one could have guessed he might attempt such things.
—Mariana Griswold Van Rensselaer

Homer's critical success in the Society's 1879 exhibition encouraged him to try to sell his watercolors independently. The next year he sent nothing to the Society, but instead gave close to one hundred watercolors and drawings, chiefly of shepherdess subjects, to the Mathews auction rooms in New York.[1] *Scribner's* explained to its readers that Homer, "who is always surprising his admirers, chose to stay away from the [Society] exhibition. . . . Instead of hazarding again his reputation as a water colorist after the success of last year, he had the inspiration to doubt the fickle public and prefer a sale of his own."[2] This sale netted him $1,037.[3] Homer was convinced that he could now support himself through watercolors.

In July 1880, Homer returned to Gloucester for his second long stay. Unlike his earlier visit, when he lived in the midst of the port's activities, or his summers at Houghton Farm and West Townsend, when he lived with others, Homer now persuaded the lighthousekeeper's wife, Mrs. Merrill, to take him in as a boarder, and he moved out to Ten Pound Island, little bigger than a city lot, in the middle of Gloucester Harbor. He lived there for the summer, rowing over to the town only when he needed materials or different subjects.

It was not only a physical withdrawal but a social one. His old friend Joseph E. Baker recalled that Homer "knew plenty of nice people, but he associated with two fishermen, and preferred their company."[4] Although he was a reserved man, Homer had until then enjoyed going about in society. By 1879, however, people began to notice an antisocial tendency in him. Homer had begun to turn inward, and the change did not go unmentioned: "Of Mr. Winslow Homer's movements in summer time no person however intimate is ever supposed to have the secret."[5] Another observer criticized his work as that "of a hermit living in complete solitude."[6] Homer's growing need for such solitude often led him to behave brusquely. The critic for the *Art Interchange* complained that "Homer is posé in the extreme, and affects eccentricities of manner that border upon gross rudeness Mr. Homer's strength as an artist is only equalled by his roughness when he does not happen to be just in the humor of being approached."[7]

Clearly, Homer's need for privacy was very strong and the freedom from intrusion that he found on Ten Pound Island was precisely to his liking, for he produced over one hundred watercolors and drawings, more than at any other equivalent period in his life.

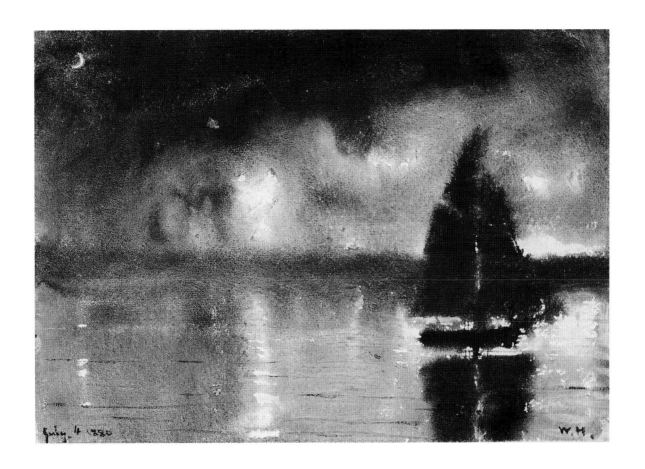

49 *Sailboat and Fourth of July Fireworks, 1880*

50 *Boys in a Dory, 1880*

51 *Sailing a Dory, Gloucester, 1880*

51 *Sailing a Dory, Gloucester, 1880* 52 *Boys Bathing, 1880*

The summer was one of artistic restlessness and experimentation. He broke his distinctive one-place-one-theme working pattern and instead touched on many subjects, and a variety of techniques and styles. In one group of watercolors he returned to the theme of young boys in boats, creating in an almost obsessive fashion dozens of watercolors of which *Boys in a Dory* (fig. 50) is typical. In another large series, of sailboats (fig. 51), he explored the shape and pattern of sails against the sky. There are also odd watercolors such as *Boys Bathing* (fig. 52), a somewhat disquieting work that may disclose an ambivalent attitude to the nude body: while he shows the boys in their unclothed freedom, he carefully shields their lower bodies from the viewer.

In at least seven watercolors, among them *Young Woman* (fig. 55) and *Woman with Flower* (fig. 54), Homer rehearses the image of a woman, not in close-up as in the watercolors of the mid-1870s, but in the middle ground. Dressed in black, her delicate features and slight form are less individualized and distinct. Unlike the earlier juxtaposition of a large, carefully described foreground figure against a more freely painted landscape (fig. 16), in these watercolors Homer grants the figure and landscape equal importance by rendering both with similar brushwork. As in some of the earlier figure pieces (figs. 31 and 32), he integrates color and subject; here, however, the result is less deliberate and intimate. The woman has simply become one with the setting: her muted mood and delicate color in *Woman with Flower* (fig. 54) are echoed in the hazy light and tones of the landscape.

In contrast to the delicacy of these watercolors is the vigorous *A Wreck near Gloucester* (fig. 53). In its subject, larger size (14 x 20 inches), and ambitious technique of layerings of wash and carefully stopped-out white areas, it foreshadows the watercolors Homer would produce in England the following year. *A Wreck near Gloucester* appears to be Homer's first representation in watercolor or oil of a marine disaster.[8] He shows not the disaster itself, however, but its aftermath, when the ship is being unloaded and its cargo salvaged. Gloucester was the largest fishing port in America and had a fleet of nearly five hundred sailing ships.[9] Its history, like that of other fishing ports, was written in tears. No other industry on sea or land sustained such a drain upon its physical and human resources: each year at Gloucester, at least three percent of the fishermen were swept

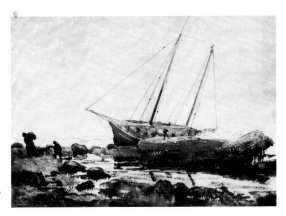

53 *A Wreck near Gloucester, 1880*

away by storms.[10] The summer before Homer's visit, a total of 29 vessels and 249 lives had been lost.[11] Yarns and legends were told at firesides, and the red granite shore was marked with the remains of memorable shipwrecks and storms. But with the exception of *A Wreck near Gloucester*, Homer's views in the 1873 and 1880 watercolors betray none of the fishing port's history of danger and tragedy. His watercolors tell instead of calm seas and childhood pleasures. Although the earlier painting *Dad's Coming* (fig. 27) has intimations of tragedy, *A Wreck near Gloucester* emerges as the first overt signal in Homer's paintings of a shift in his attitude toward the sea.

But the achievements of the summer of 1880 are found above all in watercolors distinguished by fluid, saturated washes, brilliant light, and reductiveness of composition. Light and color now fascinated Homer more than ever, and in sheet after sheet he experimented with washes of various intensities. The handling became bolder, and the compositions stronger and simpler than in his earlier *plein-air* sketches.

In one group of works the compositional structure becomes almost two-dimensional— reduced to parallel bars of land, sea, and sky, interrupted only by rowboats. Exploiting the freedom of liquid pigment, Homer concentrated on capturing reflections in the water. The children in *Two Figures in a Rowboat* (fig. 57) are expressed essentially in splashes of wash. Homer rendered their reflection in two broad, vertical strokes of blue-black paint that dominate the center foreground. In *Two Girls in a Rowboat* (fig. 56), he bled in additional washes of green and brown, bringing two or three more colors to the figures, the boat, and the reflection, thus giving greater subtlety to the range of values. In *Two Boys Rowing* (fig. 58), paint-charged strokes of dark red over green— in some passages wet paint over dry, in others wet-into-wet— create a reflection remarkable for its painterly freedom and more advanced than anything Homer had attempted to date. Whereas the tan-gray boat is a representation of the object, the broad strokes of the reflection below are vigorous assertions of materials and means. (In later years, whether in the Cullercoats works or in the Caribbean and Adirondacks watercolors, the watery surface continued to provide an opportunity for pure painting.) The extreme, almost oriental simplicity of technique and design in these watercolors in no way inhibits the naturalness of the scene. The *plein-air* vision has simply become more selective, the interest in landscape purer.

Homer was fascinated by light and the challenge of capturing its impression of movement and sparkle. "You must not paint everything you see," he once said, "you must wait, and wait patiently, until the exceptional, the wonderful effect or aspect comes."[12] To represent light on water in *Eastern Point Light* (fig. 59), he rapidly painted the sky with a single wash, mixing in a more opaque pigment for the darker areas to convey the sense of a low-lying cloud bank partially obscuring a vast and luminous sky. The quality of the sea was achieved by floating in two or three blue-gray washes applied with a relatively dry brush, allowing the texture of the paper to give the impression of silvery movement in the moon's path.

54 *Woman with Flower, 1880*

55 *Young Woman, 1880*

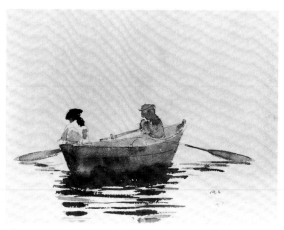

56
*Two Girls
in a Rowboat, probably 1880*

57
*Two Figures
in a Rowboat, probably 1880*

58
Two Boys Rowing, 1880

56

The most advanced of all the watercolors of this summer, and indeed for many years to come, was a group of marine studies in which Homer made color his chief concern and means of expression. They mark the second great high point in Homer's watercolor career. He had long owned a copy of Chevreul's treatise on color theory (see p. 28). By 1880 his good friend John La Farge was experimenting with color science in his flower paintings.[13] In his obituary tribute to Homer in 1910, La Farge recalled the early days of their shared interest in color: "I was just beginning to study in the direction of the future the question of colored light and the relations of the complementaries. Of course, a great deal had been done that way, but not as yet as far as we proposed to carry it. Homer was too great a man to be tied by the knowledges of art."[14] Given Homer's apparent early interest in color science, it is surprising that until 1880 he applied the theory sparingly, and then only in its simplest form of complementary colors.

In the summer of 1880, however, Homer's use of color took a great leap forward, and whole sheets became embodiments of a newfound coloristic energy. His unexpectedly intense interest may reflect the excitement caused in science and art circles several months earlier by the publication of Ogden N. Rood's *Modern Chromatics*.[15] Rood, Professor of Physics at Columbia University, derived many of his theories from Chevreul but treated the difficult subject of color and color mixing with greater lucidity and simplicity. His book was an immediate success with lay readers as well as with scientists and artists. Homer probably knew Rood, for both men belonged to the Century Association.[16] Rood was also an amateur watercolorist and a member, from its first exhibition in 1867, of the American Society of Painters in Water Colors, and his watercolors were frequently shown at the annual exhibitions. Under the stimulus of the interest in color theory generated by Rood, the theories of earlier scientists such as Herman von Helmholtz, Wilhelm von Bezold, and James Maxwell had lately attracted notice as well, and were being discussed for their possible influence on art.[17]

It was in this environment, where scientific knowledge met aesthetic sensibility, that Homer turned to a more serious exploration of color in his own work. Simplifying his

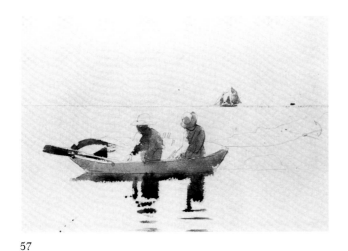

57

58

palette to Prussian blue, cobalt, vermilion, yellow ocher, and black, and selecting a heavily grained wove watercolor paper, Homer began each watercolor study over the barest graphite sketch, relying on color alone, blocking in the principal masses and tones, and accomplishing the overall structure of the composition in color rather than in line.

He chose as his subject wide views of the Gloucester sea at sunset, a simple uncluttered compositional and coloristic format that allowed him to focus entirely on experimenting with technique and on rendering within broader areas more saturated washes than ever before. *Sailboat and Fourth of July Fireworks* (fig. 49) is one of the greatest of these marine studies. First soaking the heavy paper with clear water— a new technique for him— he applied deep blue-black washes to the surface, soaking up portions for highlights with an almost dry brush, and bleeding in the orange-pink explosions of light. When this dried, he dragged the peach color through and, at the end, floated in the golden yellow. He adopted a trick popularized by Turner of mixing a very small amount of white gouache with the wash, not enough to make the color opaque but just enough to lighten it, and control its flow in the areas next to the sails; these he painted by floating a blue-black into the slightly wet sky and sea. The white reflections on the water at the left are executed in gouache, while precise scrapes or cuts in the paper form the moon and its glittering reflection in the water. Finally, using a relatively dry brush, he stroked in the black lines on the sea.

In *Schooner at Sunset* (fig. 61) and *Sunset Fires* (fig. 60), Homer reduced his palette to red and blue, relying on their power alone to express the mood of a stormy sunset. These two primaries were the colors that Chevreul, Rood, and the other theorists considered the most effective in producing the greatest contrast or force without sacrificing harmony; Homer's arrangement of them recalls the illustrations of effective contrast in color manuals of the period.[18]

Homer might also have been following exactly Rood's advice to artists:

In constructing a chromatic composition, it is . . . of the first importance to determine . . . what the leading elements are to be; after this has been done, it will be comparatively easy

59 *Eastern Point Light, 1880*

*to see what variations are allowable, and what are excluded. The most impressive and beau-
tiful compositions are by no means those that contain the most colours; far more can be
attained by the use of a very few colours, properly selected, varied, and repeated in differ-
ent shades, from the most luminous to the darkest.*[19]

In *Schooner at Sunset*, using a rough-textured paper, Homer divided the composition
into his favored thirds, suppressed all non-functional tones, and with few strokes brushed
in a set of pure, intense impressions. Spare graphite lines reinforce the mast, but the guide-
lines for the wash boundaries to the right and left of the schooner have been scratched in
with a dry pen nib. He had not tried this method before in watercolor, although some
years earlier he had executed scratch-board drawings;[20] in the watercolors, he was prob-
ably experimenting to see if he could achieve guidelines that would be less obtrusive than
those made by graphite. This scratch technique brought its own problems, however; the
scratched lines created tiny depressions in the paper that gathered and held the water
which, when dry, resulted in even darker lines than those made by graphite. Perhaps
this is why Homer apparently did not use the method again.

For *Gloucester Sunset* (fig. 62), Homer used three colors— red, yellow, and blue— the
triad considered by Chevreul to be the most powerful. In fact, Homer marked the pages
of his copy of Chevreul in which these color relationships are discussed. Placing the blue

60 *Sunset Fires, 1880*

next to the red-orange, the yellow next to the blue, interlacing and lashing them together with snaky lines of blackness, all resting on a white ground, Homer created the feeling of luminous, moving water at the moment of advancing night, an image of almost barbaric beauty.

With this unique series of watercolors Homer transformed scientific theory into personal statement, and in presenting these experiments as finished, saleable works— not as studies or private meditations (like Turner's color studies to which they bear some coincidental resemblance)— he pushed the commercial possibilities of the medium beyond its previously defined limits in America.

The following November, Homer exhibited forty-seven Gloucester watercolors at the Century Association; included were what one critic described as "vigorously washed effects of various aspects of nature," seven of which were sold.[21] In December he sent 112 watercolors and pencil sketches to Doll and Richards in Boston, selling forty of them for $1,400.[22] The next month he sent twenty-three watercolors to the Water Color Society's exhibition; because they were received late, they were badly hung— "skyed to the highest point, or floored," and installed "over doors and in corners."[23] The fact that they were also unmatted and badly framed apparently did not deter purchasers. "The knowing ones have found them out," said the *Tribune*, "and bought them nearly all."[24]

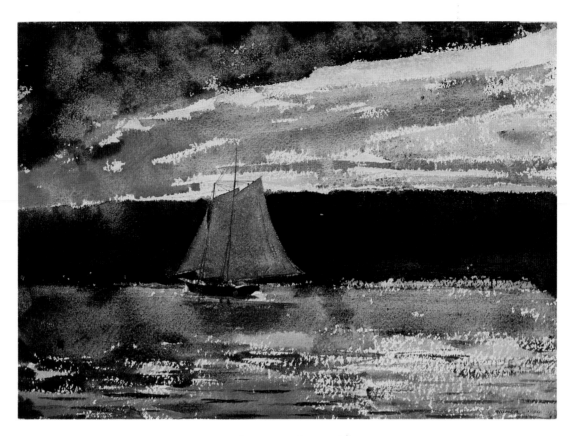

61 *Schooner at Sunset, 1880*

The critics, too, found the uncomfortable viewing worth the effort. Homer's search for a fresh kind of expression astonished many who thought they knew his work well and had gauged his talent. "No one could have guessed he might attempt such things," wrote the British-born critic Mrs. Van Rensselaer.[25] "What the 'impressionists' try to do and fail Winslow Homer [does] and succeed[s]," observed the *Independent*.[26] *Scribner's* wrote that the watercolors were "direct, simple, crude sometimes— never 'pretty'— they [have] the unmistakable look of nature. . . . Such drawings as these are a judgement upon the easily discerned tendencies of some other artists— toward the sentimental, the gorgeous, and the inanely pretty."[27] The critic Samuel G.W. Benjamin saw in these "eccentric and altogether original compositions . . . a vague yearning after an original form of art speech. . . . No artist has shown more versatility and inventiveness . . . and greater impatience with accepted methods. . . . He is evidently striving after the unknown."[28]

Despite, or perhaps because of, their extreme simplicity, these marine watercolors give the impression of intense conviction. In the context of Victorian culture, they have an artistic fierceness, an almost primitive affirmation of feelings. In a certain sense they coincide with the artist's choice of fishermen over "nice people" as friends. But the force-ful structure that characterized nearly all of his watercolors until 1880 is notably absent in this Gloucester series. This may explain why, when the summer was over, Homer

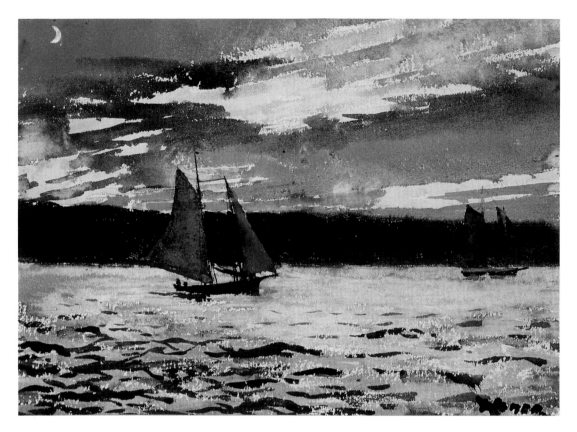

62 *Gloucester Sunset, 1880*

abandoned such loosely composed painting. Without the discipline of strong design the force of fully saturated color could easily become chaotic to an artist. Homer had tapped the source of an expressive power beyond anything he had attempted before but, as the years immediately following would make clear, he was not ready to go further, and so he withdrew. In watercolors like *Winding the Clock* (art market), painted only months after the end of the summer, he retreated to a muted, brown palette and the devitalizing effect of many spongings. Homer had discovered the language of color before he found the subject he wanted for it.

Gloucester pushed Homer across a critical threshold, but with this crossing came a loss of psychological and thematic "place." Images of childhood, of boys playing in boats under sunny skies and country girls daydreaming on grassy knolls— those wishful projections of adults— no longer served him, and he was not prepared to push atmospheric seascape themes further. He was poised for a new set of challenges.

During the 1870s, American art came increasingly to be seen and judged in an international context. The Hudson River School style and certain types of American subjects were gradually abandoned in favor of international art ideals. The press paid a great deal of attention to European art, and many collectors sought contemporary European rather than American art. This shift in patronage resulted in the importation of a large number

of works whose different styles and subjects introduced new expectations for the art public and exerted a powerful influence on the American artistic community.[29] As a result, American artists who felt attracted to the main current of painting began to seek their subjects in Europe.[30] Watercolorists were in the same position. *Scribner's Monthly* lamented the quality of American watercolors, and, in a rehearsal of Henry James' complaints about Homer's watercolors, praised the different attitude to the medium in America and in England:

There is no outlet [in America] *for the largest thoughts and the highest inspirations of the artist's mind and hand. . . . The recent exhibition of water colors . . . showed how far into pettiness the* [American] *artists . . . have gone. There was much that was bright and pretty and attractive, but how irredeemably petty it all was! It may be said that nothing can be expected of water colors beyond the representation of petty things . . . but we remember three large water color exhibitions in London, all open at the same time, where there were pictures so large and important and fine that thousands of dollars were demanded for them and commanded by them. The painters attempted and accomplished great things. They showed at least, that the desire and the motive to do great things were not absolutely extinguished within them. . . . Here . . . the topics* [are] *too trivial to engage any poet's attention, too petty to inspire any man's respect.*[31]

The call to American watercolorists to emulate English models in dignity of topic, larger size, and more elaborate execution coincided with the new ambitiousness of Homer's Gloucester watercolor explorations. Although these watercolors were clearly not in the English mold in theme, size, or execution, critics recognized that Homer had now outdistanced his contemporaries.

Mr. Winslow Homer goes as far as anyone has ever done in demonstrating the value of water-colors as a serious means of expressing dignified artistic impressions and does it wholly in his own way, [but] *it is what he will do hereafter, rather than what he has hitherto done, that one thinks of in connection with Mr. Homer's work.*[32]

Homer had reached a critical juncture in his development, and before the next stage could be reached, a severance of attitudes and attachments would be necessary. It would take time to absorb and integrate the discoveries of light and color at Gloucester. For the present, he needed to gain complete technical mastery of the medium and to find the stimulus for a more profound art. On 15 March, a few weeks after the close of the Water Color Society's exhibition, Homer sailed for England.[33]

Notes

1 "Winslow Homer Water-Colors," *New York Times*, 5 March 1880, 8.

2 *Scribner's Monthly* 20 (June 1880), 313.

3 The prices for individual sheets ranged from $5.50 for drawings to $50 for the watercolors; *American Art Review*, vol. 1, pt. 1 (Boston,

1880), 269. In December 1880 Homer sent some watercolors and drawings to auction in Chicago. Although the prices were very low, the sale was not a success. Nonetheless, there were in Chicago a number of early collectors of Homer watercolors, among them Lawrence C. Earle and Charles Hamill, who each acquired works in 1879.

4 Quoted in Downes 1911, 18.

5 "Summer Haunts of Artists," *Art Amateur* 1, no. 3 (August 1879), 50.

6 *Nation* 28 (6 March 1879), 171.

7 *Art Interchange* 5 (22 December 1880), 129.

8 Homer had depicted stormy seas in illustrations on at least three occasions before 1880: *Winter at Sea— Taking In Sail off the Coast*, in *Harper's Weekly* 13 (16 January 1869), 40; *At Sea— Signalling a Passing Steamer*, in *Every Saturday* 2 (8 April 1871), 321; *The Wreck of the "Atlantic" — Cast Up by the Sea*, in *Harper's Weekly* 17 (26 April 1873), 345. But as these were commissioned works they should not be considered in the same light as independent expressions.

9 Proctor Brothers, *The Fishermen's Own Book* (Gloucester, 1882), 57.

10 Proctor Brothers, *The Fisheries of Gloucester* (Gloucester, 1876), 71.

11 Frank L. Cox, *The Gloucester Book* (Gloucester, [1921]).

12 Homer to Beatty, quoted in Goodrich 1944, 224. Homer's interest in light and in capturing the moment were not, so far as we know, influenced by exposure to Impressionism. It was not until 1883 that he had any extensive experience of the style; see p. 65 nn. 26 and 27.

13 Kathleen A. Foster, "The Still-Life Paintings of John La Farge," *American Art Journal* 11, no. 3 ([July] Summer 1979), 10. La Farge, too, owned a copy of Chevreul's treatise. La Farge's studio in the Tenth Street Studio Building (where Homer moved in 1872) was a magnet for artists interested in color: "Those who knew him were drawn to his work shop as people go to see color and beauty in a conservatory in winter days.... He delighted in juggling with the magic colors; with lake and crimson overlaying blues and vermilions, and with the darks of all colors warmed and enriched by glazings of blue and green and purple"; Candace Wheeler, "The Painters of Yesteryear" (1900), 7–8; typescript in the Karolik Collection, Museum of Fine Arts, Boston. Quoted in Foster, "Still-Life Paintings," 10.

14 Quoted in Gustav Kobbé, "John La Farge and Winslow Homer," *New York Herald*, 4 December 1910, Magazine sec., 11.

15 Ogden N. Rood, *Modern Chromatics: Students' Text-Book of Color, with Application to Art and Industry* (New York, 1879).

16 Rood became a member of the Century Association in 1864; Homer was elected in 1865.

17 David L. MacAdam, ed., *Sources of Color Science* (Cambridge, Massachusetts, 1970), presents selected portions of Herman von Helmholtz, *Physiological Optics* (1866). Wilhelm von Bezold, *The Theory of Color in Its Relation to Art and Art-Industry*, trans. S.R. Koehler (Boston, 1876). "James Clerk Maxwell: The Beginning of Modern Methods," in Paul D. Sherman, *Colour Vision in the Nineteenth Century* (Bristol, England, 1981), 153–183. Among those who applied these theories to their own areas of interest were H. W. Herrick, *Water Color Painting: Description of Materials with Directions for Their Use in Elementary Practise: Sketching from Nature in Water Color* (New York, 1882), 91, who emphasized that a knowledge of color theory should precede any practical attempts with watercolor, and Owen Jones, *The Grammar of Ornament* (New York, 1880), 6–8, who used theories of simultaneous contrast for decorative colored ornament.

18 See, for example, J. Bacon, *The Theory of Colouring: Being an Analysis of the Principles of Contrast and Harmony, in the Arrangement of Colours, with Their Application to the Study of Nature*, 15th ed. (London, 1870), pl. 2.

19 Rood, *Modern Chromatics*, 301.

20 For example, *Pumpkins and Corn* (c. 1878; Museum of Art, Carnegie Institute, Pittsburgh); *Bob's Dilemma* (c. 1879; Yale University Art Gallery, New Haven).

21 *American Art Review*, vol. 2, pt. 1 (Boston, 1881), 84.

22 *American Art Review*, vol. 2, pt. 1 (Boston, 1881), 129.

23 *New York Daily Tribune*, 29 January 1881, 5; *Nation* 32 (3 February 1881), 80.

24 *New York Daily Tribune*, 29 January 1881, 5.

25 Mrs. Schuyler (Mariana Griswold) Van Rensselaer, "Winslow Homer" in *Six Portraits* (Boston, 1889), 244.

26 *Independent* 33 (3 February 1881), 8.

27 *Scribner's Monthly* 21 (April 1881), 955–956.

28 S.G.W. Benjamin, *Art in America* (New York, 1880), 117.

29 See Michael Quick, *American Expatriate Painters of the Late Nineteenth Century* (exh. cat., Dayton Art Institute, Ohio, 1976), 16.

30 Quick, *American Expatriate Painters*, 30.

31 *Scribner's Monthly* 20 (May 1880), 146.

32 *Nation* 32 (3 February 1881), 80.

33 *New York Times*, 17 March 1881, "Passengers Sailed."

London to Cullercoats

1881

On 25 March 1881, ten days after sailing from New York on board the Cunard liner *Parthia*, Homer landed at Liverpool.[1] In all likelihood, he went immediately to London. It was his second visit to Europe and the contrasts between the two stays are striking. Fifteen years earlier, in 1866, as a newly acclaimed young painter, he had come to Paris to see two of his paintings exhibited in the American section of the Universal Exposition.[2] His friends remembered him as a debonair and genial man who shared a studio in Montmartre with his painter-friend Albert Warren Kelsey. Homer had spent a year in France in the company of French and American artists, dividing his time between Paris and the countryside, producing paintings, drawings, and prints of fashionable society and rural life. But the effect of France and French art on his work does not appear to have been profound. Fifteen years later, forty-five years old and established as one of America's important genre artists, Homer's second (and last) journey abroad was characterized by a spirit of unwavering purpose, for which his stay in London laid the groundwork.

When Homer arrived in London in the spring of 1881, the exhibition season was in full sway. Art in London fell roughly into three groups: painters of the Hague School and their English followers; second generation Pre-Raphaelites; and Barbizon artists and earlier English masters making a smaller third group.[3]

A small colony of American artists was active in London in 1881, among them Homer's longtime acquaintance and fellow Tile Club founder, Edwin Austin Abbey. Plans were under way for an exhibition of a collection of representative American pictures,[4] but whether or not Homer joined in these plans remains a matter of speculation.

Never drawn to urban subjects, Homer produced only one watercolor of the city, *The Houses of Parliament* (fig. 63), a conventional tourist view taken from Westminster Bridge looking north toward Lambeth Bridge and showing Big Ben and the Houses of Parliament under a mid-afternoon sun. The technique, however, is subtle and refined, further developing the atmospheric qualities of such earlier watercolors as *Eastern Point Light* (fig. 59). Limiting his palette to shades of gray, and reserving some areas of the paper for the lighter clouds and the reflections in the water, he began by washing the whole sheet with a light gray tone, followed by darker pink-grays. Then, using still deeper tones, he laid in the buildings and the darker gray bridge, modeling them through

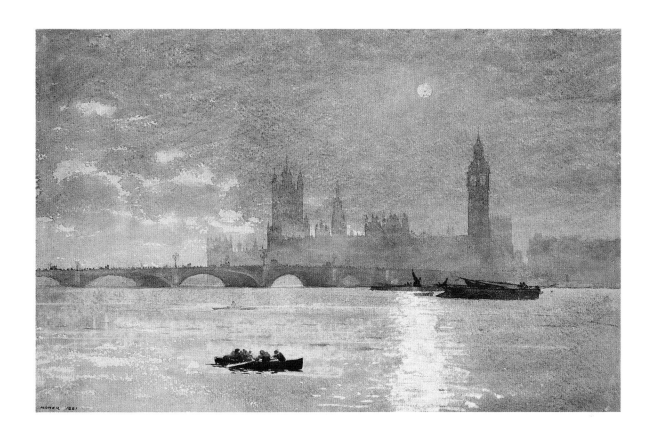

63 *The Houses of Parliament, 1881*

64 *Jozef Israels.*
Waiting for the Fishing Fleet,
c. 1875

blotting and defining their silhouettes with thin brush lines. Glancing strokes of blue-green suggest ripples in the water. The vermilion sun, its shape first drawn in graphite and its surrounding area rubbed to create a glowing aura, casts a shimmering orange-pink reflection in the water, an impression Homer achieved by scraping the paper, then brushing in pale pink washes, followed by short slashes of pure vermilion. In an artful touch, he uses the same red for the tiny flag on the boat at the right.

Although London held little interest for Homer as an artistic subject, his visit to the city exposed him to English marine painting and to a great number of works by Hague School artists. Of these latter, the paintings and watercolors of his contemporary Jozef Israels were widely exhibited and especially praised. Israels, like Millet (to whom he is often compared), saw in the life of the fisherman a vehicle for expressing social realism within settings that allowed for a sensitive recording of light and atmosphere. He produced a vast number of oils and watercolors that are full of deep feeling. Rendered in broad masses of light and shadow, which give prominence to the principal subject, works like *Waiting for the Fishing Fleet* (fig. 64) had a profound influence on British art. "Israels has enthralled England and the Continent by the power and truth with which he treats simple themes," commented one writer upon the highly successful opening that year of an Israels exhibition: "he has created a new school and so popular has it become that nearly all the . . . artists are now rushing to [these] subjects."[5]

Sea genre had come into prominence in the late 1850s. Although the English had practiced marine painting for some time, it was not until James Clarke Hook (fig. 65), followed by Colin Hunter, Stanhope Forbes, and others, that the picturesque aspects of the English seafaring population— rugged fishermen in jerseys and sou'westers, and sturdy

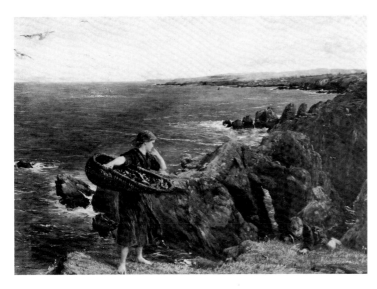

65 *James Clarke Hook.*
Two Children Picking Mushrooms
on the Cliff, 1879

barefooted fisherwomen with tucked-up skirts and ruddy faces— became the principal subjects of a picture.[6]

By the time Homer arrived in England in 1881, the subject was entrenched, appearing in watercolors and paintings at almost every exhibition of contemporary art. The popularity of such pictures lay in the opportunity fisherfolk themes afforded for escapism. Like the peasant scenes by the Barbizon painters in France, these apparently realistic images were in fact much idealized.[7] Coupled with the tremendous and widespread popularity of the Hague School, it was almost impossible to escape images of fisherfolk. Homer undoubtedly knew the work of many of these artists before he came to England; indeed, Hague School paintings had been included in nearly every major exhibition of foreign art in New York during the previous decade, but London gave him his first concentrated exposure to the genre.

Consistent with his long-standing practice of spending the summer months in the country or beside the sea, Homer probably left London in June or early July. Whether the fishing village of Cullercoats, 275 miles to the north, or Tynemouth, its large and famous neighbor, was his original destination can only be speculated, but given Homer's preference for non-urban locations it is likely that he chose the smaller center from the outset. How or from whom he learned about Cullercoats is not clear. Alan Adamson, a young Cullercoats native who became the artist's friend, recalled that Homer claimed he had learned of the village from a man he met on the voyage to England and that the reason he came was for "atmosphere and color," there being too much similarity about the people in America.[8] Four years after Homer's visit, the English journalist R.J. Charleton wrote that the artist

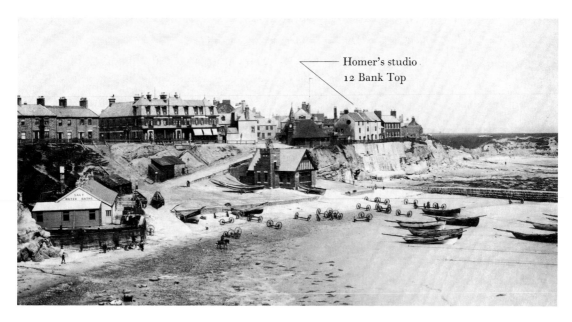

Homer's studio
12 Bank Top

66 *Matthew Auty. View of Cullercoats, c. 1900*

"happened by chance" upon the village "when on an art tour in Europe."[9] Cullercoats could also have come to Homer's attention while he was still in America, for the Gloucester fishermen constituted an international group that included a large number of English immigrants.[10] Or he might have learned of it from English magazines popular in America, which often featured articles on the English fisherfolk:

In secluded sea villages there are conserved the old methods and even the modes of speech; and to the visitor fresh from town the habits the language even of the fisher-folk is as markedly fresh as is the bracing air that blows across leagues of sea waves and foam. The great fishing waters of England are on the east coast from Yarmouth to Berwick, and probably the north-eastern portion preserves most fully the peculiarities of life and labour that have long marked the industry At Cullercoats . . . fishermen still form a distinct class of the population, with modes of thought and of action of their own.[11]

Even if Homer had never heard of Cullercoats before he came to England, once there he had only to ask about villages beside the sea where an artist might spend the summer to learn about the place. By 1881 Cullercoats was already long famous as an artists' colony, second in picturesque appeal only to the southwest coastal village of Clovelly.[12] To the New Englander, Cullercoats' northeast coastal location and climate, reminiscent of the fishing ports Homer knew along the coasts of Maine and Massachusetts, must have offered a special appeal.

In the seventeenth century, the village of Cullercoats, midway between Tynemouth to the south and Whitley Bay to the north, had been a place of some commercial importance — a shipping port for coal and a center for the manufacture of salt.[13] But the prosperity of

the village was short-lived. In the early eighteenth century, a violent storm demolished its pier and within a few years the Cullercoats colliery closed. The last of its salt pans were removed to Blyth, a town to the north, and the coal trade gradually shifted to Newcastle on the Tyne River. From that time on, the inhabitants depended almost entirely upon the so-called harvest of the sea for a livelihood, and Cullercoats became an important fishing station— by the mid-eighteenth century considered "the best fish market in the north of England."[14] The town also began to enjoy a reputation as a bathing place during the summer, and for a period in the eighteenth and early nineteenth centuries it was fashionable to take hot and cold salt water baths there.[15] By the later nineteenth century, the visitors were mostly miners and their families traveling out for a day to the coast, to the sands at Whitley, or to the health-giving breezes and baths at Cullercoats.[16] By 1881, the year of Homer's arrival, the population of the village was 1,365 (compared to 50,000 at Tynemouth, the popular seaside resort) but its character as a fishing village remained firm and relatively unspoiled.[17]

The village, which had a hotel and two or three public houses, was situated along a semicircle of sandstone cliffs (fig. 66). Fishermen's cottages crowded together in the old part of the village, and around this nucleus were new terraces and streets. The Life Brigade House, with its little steeple and flagstaff, overlooked the bay; below stood the square lifeboat-house.

It is not a place which strikes you at first sight as being eminently picturesque, and it is hard to account for the fact of its having been such a favourite with so many English artists, until you know it better. As you become acquainted with it, its good qualities and possibilities begin gradually to unfold themselves, and to present new features of interest day by day, until at length they appear to be practically inexhaustible, and the difficulty is to summon up resolution to leave such material behind.[18]

The "material" that captured the imagination of artists and made Cullercoats famous far beyond its fifteen acres was the beauty of its surroundings, the atmospheric grandeur, and the character of its inhabitants.

The ever shifting sands, both in form and colour, now pale yellow, now red gold— hard and firm to-day where yesterday was deep water— gave an ever varying foreground which served as protection to the small fishing fleet; the picturesque cliffs, the long graceful white and blue painted fishing boats and cobles, the fishing nets hanging like festoons of golden cobwebs from the cliffs or spread out to dry in glorious contrast to the green sward which crowns those gray and rugged cliffs; the ever changing sea and sky; the rolling sea fogs; the rosy cheeked fisher girls with their lithe graceful figures . . . the quaint serge petticoats of the women with their fanciful plenitude of tucks— all seemed . . . to make a natural school of art, instinct with life, sturdy independence, picturesque pathos and poetry.[19]

From the early part of the nineteenth century, so many artists had been drawn to the artistic possibilities of Cullercoats that one writer called it "a little Bohemia-by-the-Sea."[20]

67 *J. D. Liddell. Cullercoats, c. 1900*

68 *Fishergirls on the Beach,*
Cullercoats, 1881

The attractions of Cullercoats proved strong for Homer as well.[21] He rented a fisherman's cottage from a Mrs. Elliot, which consisted of a single large room behind what was called the Stonehouse, facing an inner garden surrounded by a high wall and reached through a tall locked gate on Front Street to which he had the key, assuring privacy. He lived alone and did his own cooking.[22] For a studio, he rented a room at 12 Bank Top on a cliff overlooking Cullercoats Harbor.[23] From there he could look south to the ruins of Tynemouth Castle and Priory, north to the tall sandstone cliffs, much admired for their rugged grandeur and rich natural colors, and down the banks to the pebbly beach and long-stretching sands where busy figures animated the view (fig. 67).

Homer was a reserved man who cherished his privacy— the *Art Interchange* of 21 July noted that "The latest bulletin from Winslow Homer [in England] described him as in Parthia," Homer's sly way of telling people back home to leave him alone.[24] Nevertheless, he soon made friends with the villagers and gave every indication of enjoying his life in Cullercoats. Indeed, he did not then, or ever, live as a total recluse. Adamson recalled his first meeting with Homer shortly after the artist arrived in the village: "Slightly unusual in appearance, wearing a rather short-tailed coat and a high silk hat, the latter a little worse for wear . . . [Homer] had not long been in the village before he discarded his tailed coat and tall hat and for the remainder of his stay usually went about the place in a fisherman's blue woolen jersey and nondescript felt hat." The rest of Adamson's description reveals Homer as a man at ease in the simple life of the village:

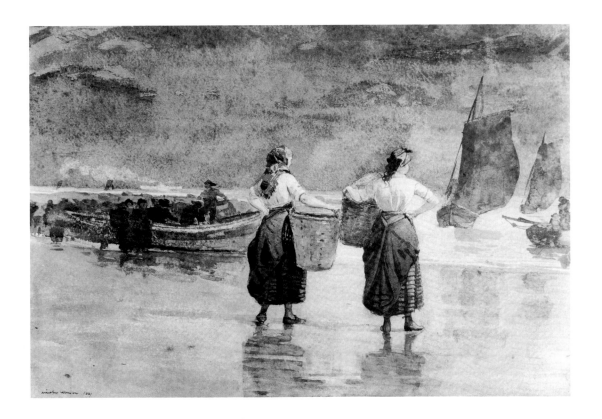

He was fond of walking and many a hike I have taken in his company along the shores of the
North Sea, scrambling over its cliffs and floundering about on its slippery, sea-weedy rocks.
He could play a good game of billiards, and frequently of an evening would be found in the
billiard room of the hotel . . . indulging with some of the villagers in that form of recreation.
On rare occasions, I have known him to join in the dance. . . . He had quite a fund of humor-
ous stories at his command and never displayed any hesitancy in their narration.[25]

Homer presented one of his earlier watercolors (*Daydreaming*, 1880; art market) "with
comp'ts of the artist" to Mrs. William Chapman, wife of the owner of the Huddleston
Arms Hotel. He also made contact with at least one local collector, William Cochrane, a
Newcastle coal mine owner, member of the Newcastle Art Association's sponsoring com-
mittee, and patron in a small way of local artists, who bought one watercolor.[26]

The earliest public notice of Homer's presence in Cullercoats is in the Newcastle Art
Association Exhibition, which opened on 26 August 1881. Homer sent in one watercolor
titled *Cullercoats*, offering it for sale at forty pounds. At the time the catalogue was printed
(delivery of artworks was required two weeks earlier, by 12 August), he gave two address-
es, Cullercoats and 449 Strand, London, a travel agency office,[27] suggesting he may have
been undecided about remaining in Cullercoats. By the time the exhibition was reviewed
on 26 August, however, he seems to have established himself in the village: "Winslow
Heron[*sic*], an American artist residing . . . at present at Cullercoats, contributes a charm-
ing sketch, containing a couple of wonderfully drawn figures."[28]

The Newcastle Art Association Exhibition was not simply a local show. Typical of the exhibitions held in many provincial cities— among them, Birmingham, Leeds, Bristol, and Liverpool— its purpose was to promote a taste for art as well as to encourage the development of local art. Well-established British and Continental painters often sent their work to these exhibitions, which became a veritable circuit for the artists as they moved from one show to another, bringing the so-called modern school to the attention of the local wealthy class who bought for their collections. Among the better-known French artists represented at the same Newcastle exhibition as Homer were James Tissot, Henri Fantin-Latour, and Léon-Augustin Lhermitte. British artists of note included a number who had at one time or another lived or worked in Cullercoats— John D. Watson, Arthur H. Marsh, and John Charlton— as well as artists who would shortly become known as part of the Glasgow School— E.A. Walton, Erskine Nicol, and Alfred East. Of the 775 pictures exhibited (225 watercolors and 500 oils), nearly 200 were by local artists and included works by Homer's Cullercoats neighbors, Henry H. Emmerson, Robert Jobling of neighboring Whitley Bay, Stephen Brownlow, George Horton, Thomas M. Hemy, and W. Cosens Way, all of whom were known for their fisherfolk themes.

Exactly which Homer watercolor was in the exhibition is difficult to determine: "Mr. Homer's study does not go very far, but his description of two Cullercoats fish girls is extremely natural," said one reviewer.[29] Another wrote:

[No.] 32 is a sketch of 'Two Cullercoats Fisher Girls,' by W. Homer, an American artist who is evidently influenced by the work of Jules Breton. There is an attempt to catch the noble forms and attitudes so frequently to be found in the toilers of the earth and sea, who are unfettered by modern unconventionalities of costume. The aim is an admirable one, for on our English coasts and fields are to be found types of simple and noble beauty equal to those which inspired the old Greek masters.[30]

Possibly, it was a watercolor like *Fishergirls on the Beach, Cullercoats* (fig. 68).

Apparently Homer originally intended to return to America at the end of the summer, for on 1 September the *Art Interchange* reported in its "Personal Items" column that "Among the artists who may shortly be expected home [is] . . . Winslow Homer."[31] At the last moment, he changed his plans. One villager recalled: "He came to Cullercoats and intended to stay three months [which was typical of his summer stays elsewhere] but he loved the village and the fisher-folk so much that he remained for three years."[32] Homer was working hard. In mid-September he wrote to his Boston dealer, J. Eastman Chase, "I have sent to you . . . thirty watercolors."[33] Three weeks later, on 7 October, he again wrote Chase, informing him that "By Dec. 1st I will send you some watercolors— large size and price."[34]

1 Hendricks 1979, 148. Two watercolors executed during the crossing record views of the ship: *Marine* (1881; Bowdoin College Museum of Art, Brunswick, Maine) and *Observations on Ship Board* (1881; Collection of Lois Homer Graham).

2 See p. 18.

3 Among the exhibitions during this 1881 season were the annual exhibitions at the Royal Academy, the Society of Painters in Water Colours, and the Institute of Painters in Water-Colours, the latter showing largely the work of contemporary British artists. The most important commercial galleries— Goupil and Company, French, Grosvenor, Thomas Agnew and Son, McLean's— focused on distinguished Continental painters and watercolorists. At the National Gallery there were early Turner oils on view in the Turner Room and in the basement the newly opened permanent exhibition of watercolors by Peter DeWint. The South Kensington Museum showed a collection of watercolors that included works by DeWint and Louis Francia, and paintings by John Constable on loan from his widow; "A Concise Epitome of All Matters Relating to the Arts of Paintings, Sculpture, Engraving and Architecture, Which Have Occurred during the Year 1881," in the *Year's Art* (London, 1882), vol. 3. English watercolors by such masters as Turner, Cox, DeWint, Müller, and Copley Fielding were easily seen at many of the dealers: Agnew's, for instance, had recently closed an exhibition that included works by each of these and other artists.

4 *Art Interchange* 7 (4 August 1881), 28. Among other American artists in London in 1881 were the portraitist Anna Lee Merritt, McLure Hamilton, Edward Gay, and Robert C. Minor. On his return to America later that summer, Minor reported that the British public generally was not excessively interested in American works of art "and, indeed, hardly cared to hear of things American; but regarded them with feeling somewhat akin to those with which they may be supposed to look on Irish matters"; "Personal Notes," *Art Interchange* 7 (18 August 1881), 30.

5 Thomas McLean Gallery, *Exhibition of the Most Important Works of Joseph Israels* (London, 1881), iii.

6 "Mr. Hook was . . . the first to show us what our own coasts could furnish in pictorial effect. . . . We hope . . . that this Sea-coast School of English art will . . . prove a long-lived one," stated the *Graphic* 3 (4 February 1871), 102; see also Denise B. Bethel, "James Clarke Hook, R.A. (1819–1907)," M.A. report, Courtauld Institute of Art, London, 1975. The theme of fisherfolk had been prominent for decades in French painting as well; when Millet began, he painted single figures (or sometimes two figures) against a stormy sea.

7 "Thousands of townsmen, jaded of eye, of heart, of spirit, have, like myself stood before [these] pictures and seemed to hear the far-off sea grow louder day by day," wrote the art critic Frederic George Stephens in 1882; quoted in Rosemary Treble, *Great Victorian Pictures* (exh. cat., London Arts Council, 1978), 45.

8 Alan B. Adamson, "The Homer That I Knew," memoir, c. 1922 (Private Collection). On 22 April 1882, Homer wrote a letter to his artist friend Albert Warren Kelsey in New York introducing the twenty-one year old Adamson, who was then immigrating to America. Adamson later became editor of the *Beloit Daily Call*, Kansas. I am indebted to Mrs. Linda Greenley, Cullercoats, for showing me copies of the Adamson memoir and Homer's letter to Kelsey.

9 R.J. Charleton, "Cullercoats," *Magazine of Art* 9 (1886), 458.

10 S.G.W. Benjamin, "Gloucester and Cape Ann," *Harper's New Monthly Magazine* 15 (September 1875), 469.

11 J.W.S. "Fisher-Life," *Graphic* 20 (25 October 1879), 410.

12 The painter John Linnell and his wife visited Cullercoats on their journey homeward after their marriage and honeymoon in Scotland in 1817 (*Coast Scene at Cullercoats*, 1817; Collection of Sir John and Lady Witt). Among those who lived in the village for a time and used it as subject matter was Thomas Miles Richardson, Sr., in about 1820, followed in the 1830s by his son, the watercolorist T.M. Richardson, Jr. Henry Perlee Parker, who was called "Smuggler" because of his paintings of smugglers on the Cullercoats coast (Laing Art Gallery, Newcastle), worked in the village from 1823 to 1842; the seascapist John Wilson Carmichael visited Cullercoats on and off for over a decade, and in 1845 painted a series of panels of Cullercoats subjects for the Duke of Devonshire at Chatsworth; Myles Birket Foster was a frequent visitor from the late 1840s on; the social realist Frank Holl began coming to Cullercoats in the summers after 1870 (see, for example, *Fisherman's Home*, 1881; Walker Art Gallery, Liverpool); Henry H. Emmerson, little known today, but one of the leading artists of the north of England in the 1870s and 1880s, visited Cullercoats from 1863 on and finally settled there in the early 1880s (he is recorded as a resident during the period of Homer's stay). The most famous of the locally born artists were the marine painter Charles Napier Hemy and the watercolorist George

Horton. But it was probably John Dawson Watson, through his illustrations for the *Graphic* and his paintings of fisherlife exhibited at the Royal Academy during the 1870s, who made Cullercoats famous beyond the limits of Northumberland. Later, the well-known and prolific watercolorist Arthur H. Marsh lived and worked for a time at Cullercoats, and local coastal and inland scenes were often the subjects of pictures he exhibited at the Royal Water Colour Society and elsewhere from the 1870s on. For the artists who worked at Cullercoats, see William Weaver Tomlinson, *Historical Notes on Cullercoats, Whitley, and Monkseaton* ([Monkseaton], 1893; repr. Newcastle-upon-Tyne, 1980); also, William George Larkins, "Reminiscences of Artistic Cullercoats," *Tyneside* 1 (January 1895), 36–43 and (February 1895), 86; Marshall Hall, *The Artists of Northumbria* (Newcastle, 1973); Dr. Ray Layton, "When Cullercoats Was an Artists' Colony," *North Magazine*, October 1974, 18–19.

13 The best general history of Cullercoats is Tomlinson, *Historical Notes on Cullercoats*.

14 *The History of Northumberland* (Newcastle-upon-Tyne, 1907), 8: 284. See also John Stanley Mitcalfe, *Guide to Tynemouth and Neighbourhood by a Native* (Newcastle-upon-Tyne, [1880]).

15 John Robinson, *Illustrated Handbook to the Rivers Tyne, Blyth, and Wansbeck* (Newcastle-upon-Tyne, 1894), 24–27. Robinson quotes Lady Astley, writing to her friends in 1751: "'My Lady Ravensworth and My Lady Clavering were a month at Cullercoats bathing. Tynemouth and Cullercoats were much in fashion, not a room empty'; in another letter, she writes: 'Cullercoats bathing, they tell me it is much the fashion this year.'" A less publicized but nevertheless important contribution to the village's economy was furnished through smuggling, with contraband kegs of spirits and tobacco from Holland run ashore regularly; see William S. Garson, *Historical Ramble in Cullercoats* (Newcastle-upon-Tyne, 1935), 79–80.

16 *Watering Places on the North Eastern Railway, Illustrated Guide to the Borough of Tynemouth* (Waterford [1899]), 75–79.

17 Herring fishing had once been the mainstay of Cullercoats but by 1881 it was beginning to lose out to the steam trawlers and steam tugs from Scotland which were able to reach the herring grounds earlier than the old-fashioned cobles, the special flat-bottomed northeast fishing boats that trusted to the wind. With the herring industry gone, the fishing activity was concentrated on haddock, whiting, cod, ling, and turbot from September to March; salmon during the summer to the end of August; and crab and lobster during the other months.

18 Charleton, "Cullercoats," 456–457.

19 Larkins, "Reminiscences," 36.

20 Tomlinson, *Historical Notes on Cullercoats*, 113.

21 The first concentrated discussion of Homer's Cullercoats period was undertaken by William H. Gerdts, "Winslow Homer in Cullercoats," *Yale University Art Gallery Bulletin* 36, no. 2 (Spring 1977), 18–35.

22 Downes 1911, 99, described Homer's dwelling as a cottage facing an inner garden and reached through a gate; see also Goodrich 1944, 76. In 1956, Ms. Kay Jenner, Monkseaton, England, interviewed some elderly residents of Cullercoats who either remembered Homer themselves or had heard of him from near relatives. She was able to identify the specific location of the cottage mentioned by Downes; "Winslow Homer," typescript for an intended broadcast, Monkseaton, 1956. Mr. John Boon, North Shields, identified the same dwelling by using contemporary ordinance survey maps of Cullercoats and local directories to isolate the only structure in the village that fit the original description given by Downes. "Stonehouse" and the cottage were destroyed during an air attack in 1941. I am greatly indebted to Mr. Boon for turning over to me the results of his painstaking research.

23 Tomlinson, *Historical Notes on Cullercoats*, 110; Layton, "Cullercoats," 19.

24 "Studio Notes," *Art Interchange* 7 (21 July 1881), 19. "Parthia," which was also the name of the ship on which Homer had sailed to England several months earlier, was an ancient kingdom of western Asia, often recalled for its horsemen who baffled the enemy by their rapid maneuvers and discharged their missiles backward while in real or pretended flight. By the nineteenth century, a "Parthian shot" had become an elegant and pointed expression for "having the last word" and casting back glances of scornful hostility (*OED*, 1971, 502).

25 Adamson, "Homer."

26 William and Sir Cecil Cochrane Archives, Local History Collection, Central Library, Newcastle-upon-Tyne. On 21 December 1881 Homer wrote to Cochrane, "I am very glad that you like it. I enclose the bill as you request." The watercolor *Fisherman's Family* (1881) and the above-quoted letter are in a private collection. The sale to Cochrane is the only one known to have occurred in Cullercoats.

27 See Newcastle-upon-Tyne, *Arts Association*, Autumn Exhibition, exh. cat., 1881. Homer's watercolor (#32) was one of the more expensive works, the range being £2 to £180, with most priced between £10 and £20. The Strand address was that of the American Exchange in Europe, Ltd., a firm that offered services similar to the present-day American Express.

28 *Newcastle Courant*, 26 August 1881, 6.

29 "The Arts Exhibition," *Newcastle Daily Chronicle*, 25 August 1881, 3. Although three of the five reviews of the exhibition mentioned Homer, other watercolorists such as Clara Montalba, known for her Venetian scenes, and the seascapist Arthur H. Marsh garnered the most praise.

30 "The Art Exhibition," *Tyneside Daily Echo*, 31 August 1881, 3.

31 *Art Interchange* 7 (1 September 1881), 38.

32 This slightly inaccurate recollection (Homer stayed for twenty months) is from Mrs. May Thorrington, a resident of Cullercoats, recalling the words of her mother, Margaret Jefferson Storey, who posed for Homer when she was a young fishergirl; "Model Memory," *Newcastle Evening Chronicle*, 26 June 1971, 4. For Maggie Storey as a model, see p. 121 n. 27.

33 14 September 1881, Archives of American Art, J. Eastman Chase papers. The letter is worth quoting for Homer's instructions about the disposition of the watercolors: "My dear Mr. Chase I have sent to you care of Mr. S.T. Preston, 89 Gold St. New York thirty watercolors. . . . I will pay for two weeks advertising in any two papers — and you will put them before the public in any way that you think best in way of mounts. When you have any returns to make, send the checks payable to S.T. Preston 89 Gold St., N.Y. You will receive the drawings about the first of January, I hope. Winslow Homer. 14th. Give my regards to Mr. Cole. Yours truly Winslow Homer. P.S. Understand, you can keep them in portfolio, or have an exhibition as you think best. W.H." Samuel Preston was the friend with whom Homer later shared an apartment in New York. He was also the nephew of the Mrs. Merrill who had rented rooms to Homer during the previous summer on Ten Pound Island. Cole was probably the painter J. Foxcroft Cole, a friend from Homer's apprenticeship days at Bufford's.

34 Ever concerned about money, Homer adds, "What is the value of a beautiful picture by Corot 9 x 12 inches painted about thirty years ago— not signed. Can you place such a picture? If you could sell this picture by Corot for 1,000— or near it and I should send it, how should I enter it for the Custom House, should I have to pay duty on its value or on the price I paid for it (five shillings)?"; Archives of American Art, J. Eastman Chase papers, cited n. 33 above.

Cullercoats

1881–1882

Homer stayed in Cullercoats for twenty months and, as his shipments to Chase suggest, it was a period of high productivity and single-minded intensity— he stayed longer with the fisherfolk of Cullercoats than with any previous subject, producing close to 150 watercolors and drawings and several oils.

These works disclose a shift in Homer's artistic approach. The formal device he now concentrated on was design rather than color, so that by 1882 he could— to a degree hitherto unknown in his work— express the profundity of themes through composition and structure. In this endeavor, he had quickly absorbed prevailing aesthetic models, adopting as well the more somber palette and elaborate techniques of traditional English watercolorists. In *Fishergirls on the Beach, Cullercoats* (fig. 68), for example, the subdued tones and compositional simplicity of large figures silhouetted against the broad horizontals of sea and sky recall such peasant scenes as Breton's *The Gleaner* (fig. 70). Thus, within months of arriving in England, finding himself in a culturally and artistically traditional environment, Homer turned away from the freer expression he had essayed at Gloucester, and was creating images that fit easily into the mainstream of the European peasant genre.

Although it could be argued that Homer was predisposed to the genre because of his ongoing involvement with rural themes and, further, that he saw an opportunity for success in the popularity fisherfolk scenes enjoyed in England, the very length of his sojourn in Cullercoats confirms that he found more in the subject than familiarity and fashion. Indeed, in the villagers of Cullercoats he discovered a vehicle for the profound level of expression he had been seeking since leaving Gloucester the previous summer. The inhabitants of the small fishing port, particularly the women at their daily tasks, gradually became archetypes for him, like ancient sculpture, imbued with a sober and noble simplicity. They seemed to Homer indivisible from nature and, hence, became his connection to nature's power.

The rhythm of life in Cullercoats was determined by the fishing boats setting out at dusk and returning in the early morning. From his studio, Homer could look down to the beach where this daily pattern was played out. It was the spectacle and anticipation of the boats' return, as they crossed the sandbar one after another and sailed into the little

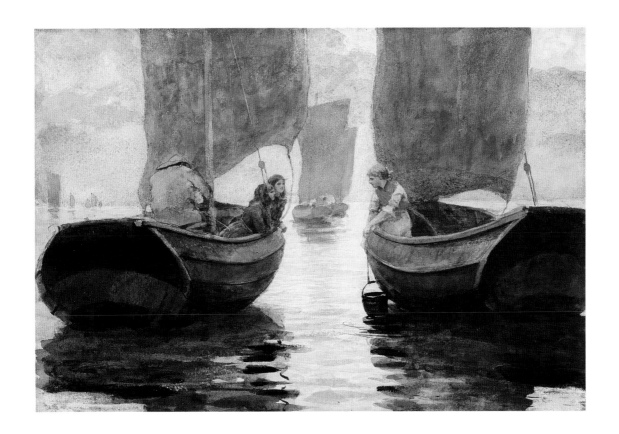

69 *Afterglow, 1883*

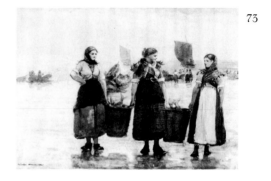

70 *Jules Adolph Breton. The Gleaner, 1875*

71 *Study for "Four Fisherwives," 1881*

72 *Fisherfolk on the Beach at Cullercoats, 1881*

73 *Fisherwomen, Cullercoats, 1881*

harbor to the waiting fisherwomen, that contemporary photographers and virtually every writer on Cullercoats singled out for its colorful and picturesque quality. Lillias Wasserman, who lived not far from Homer's cottage, wrote:

When the boats are coming in the crowd in the haven is one to delight an artist: the cobles nearing shore one after another, their brown sails flapping, lowering, furling, as they come to land; the men splashing about in the water with gaily-painted oilskins and huge sea-boots; the women in their blue flannel dresses, standing in groups, waiting and gossiping.[1]

When the boats came in, a division of labor was carefully observed: the men handed the fish over the side and then went home; the women divided the catch according to the share of the boat owned by their men.[2] Filling large wicker baskets or creels, which they strapped onto their shoulders (a load of from forty to fifty pounds), they walked through the streets of Newcastle and other Tyneside towns calling out their wares.

Homer's first watercolors in Cullercoats, executed during the summer of 1881, took for their subject these early morning scenes. In one series (figs. 71–74), the viewer can follow the progression of the women's activities, from the landing of the cobles to the distribution of the fish for market. The figures are set against a panoramic sky and rendered in thin, clear, often single washes in a palette predominantly gray-blue and brown,

74 *Four Fisherwives, 1881*

with accents of vermilion, over careful graphite lines for the details of face and dress.

Unlike his earlier watercolors, these Cullercoats sheets have a gravity and sense of timelessness that until then he had reserved for the oil paintings, as in *The Cotton Pickers* (1876; Los Angeles County Museum of Art). Even when depicting such modest activities as young women gracefully baiting lines and nets (figs. 76 and 77) he conveys, through the repetition of characteristic gestures and forms, the sense of skills virtually unchanged through generations.

Yet change was coming to the village. Modern life arrived in the form of steam trawlers, which had begun to replace the cobles as fishing craft.[3] The *Graphic* voiced the people's unease and sense of dislocation over the loss of the old ways: "The old industry is entering into new phases . . . and in consequence fishing society is losing picturesqueness and variety."[4] Homer, for his part, showed the trawler rarely, and then only in the background. He preferred to see Cullercoats as it had been; in dozens of watercolors and drawings he portrayed the more romantic coble, a vessel dating from the sixth century.

Homer's subjects also included the village's two most popular and picturesque buildings, the Life Brigade House and Sparrow Hall. The Life Brigade House, or Look-out House, as it was called, was the newest official structure in the village. Constructed in 1879 on a small headland on the site of a stone and wood bench around which village life

75 *Sparrow Hall, Cullercoats, 1882*

76 *Mending the Nets, 1882*

centered, it was distinguished by an open woodwork veranda with wooden seats, and a clock tower topped by a small steeple (see fig. 86). Fishermen gathered here to gossip and, through clouds of tobacco smoke, to contemplate the sea and sky.[5]

Sparrow Hall, also known as Dove Cottage, was the oldest house in Cullercoats. Built around 1682 and situated at the northeast corner of the village, it was a queer, dilapidated mansion— and a favorite subject with artists, photographers, and writers, who found its south view and its fisherfolk tenants especially picturesque.[6] For his version of Sparrow Hall, Homer turned to oil (fig. 75), creating a domestic scene of women and children.[7]

But Homer's engagement in the life of Cullercoats lay elsewhere. He never painted Sparrow Hall again, and except for a few watercolors in which he shows young women against the background of an unidentified structure and one unfinished oil showing fisherwomen in an interior, the women are invariably portrayed in open spaces beside the sea.

Similarly indicative of Homer's selectivity is the case of Tynemouth Priory and Castle, less than a mile south along the coast from Cullercoats. Virtually every painter of note in the northern counties, as well as those who only visited the area, made the ruins of this fourteenth-century gate house and presbytery and fifteenth-century chapel the subject

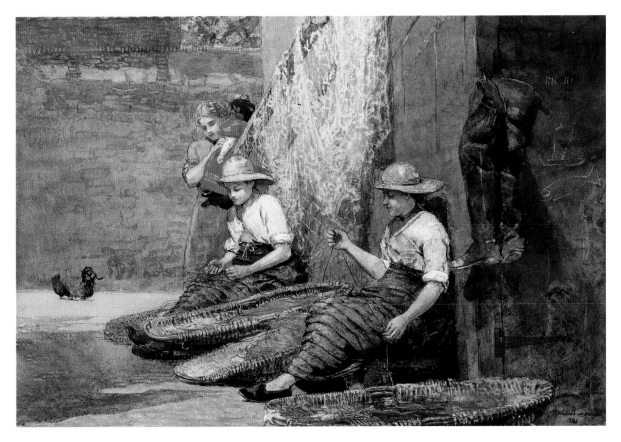

77 *Fishergirls, 1881*

of at least one painting. Although Homer could easily see the ruins from his studio, he included the famous landmark in only four watercolors and one drawing, and then only as part of the background— the major thematic statement is still made by the fisherfolk. In *The Breakwater, Cullercoats* (fig. 80), he shows the edges of the moss-covered north pier or breakwater from a low angle with the Priory in the far distance.[8] Constructed of stones, the breakwater began immediately below the Watch House and extended into the harbor. It is, in fact, not possible to see the Priory from the spot on the breakwater where the figures are standing.[9] Homer must therefore have decided that the Priory or, more likely, its shape, was an important design element in the compositional structure— indeed, it continues the alternating vertical rhythms that move across the sheet from the small fishermen at the far left to the large verticals of the sails at the right. Design thus took precedence over reality, as it did throughout Homer's career.

It was nature's grandeur as a background to the nobility of the Cullercoats fisherfolk that interested Homer. No man-made structure, no matter how picturesque or famous, could be as impressive. The Table Rocks, for example, were a particular attraction of the cliffs; situated a short distance north of his studio and reached via a promenade, this dramatic natural formation is the setting for several watercolors, among them, *Fisherman's*

Family (fig. 79) and *Looking over the Cliff* (fig. 78).[10] The famous, dramatic chalk cliffs of Flamborough Head, south of Cullercoats along the Yorkshire coast, also served as a background site.[11]

During the summer months, life in the little port took on a lively character. As one villager described it:

Village life consisted of the fisherpeople and artists with hefty pitmen on pay weekends from the outlying collieries. . . . There was also a smattering of Gentry and small tradesmen. . . . They all freely intermixed. We had the chapel and the public houses dividing their favours almost equally. In lovely, fine Summers it was a daily occurrence to see a detachment of soldiers from Tynemouth Castle— colourful in their bright scarlet tunics, going through the village.[12]

Among the most colorful summer visitors were the bands of exotic strolling players and musicians,

dancers . . . [in] open light shirts and cut-away blue waistcoat with trimmings of gold, . . . the Fiddler . . . dressed as a negro minstrel . . . German band of youths (two played while ten collected), a Russian with pole and dancing bear; Italian Zingarees dressed in rainbow colours like stage brigands, the women in short beribboned skirts, giving a native dance with tambourine; the men, in sombre brown, accompanying on flagatelle (flajolet), or Swiss pipe, with shrill bagpipe notes. Front Street was frequently the stage for their displays of music and dancing.[13]

Yet in the dozens of drawings and watercolors that Homer produced at Cullercoats, there is no sign of strangers or tourists. By concentrating on the sea and the most enduring and characteristic aspects of fisher life, Homer could return, in a sense, to an earlier, pre-tourist era.[14] He had reacted in a similar way in New York in the 1870s when he shut out the reality of urban street children with sunny images of rural childhood.

There is also a psychological parallel between the children of his earlier works and the Cullercoats people. The simplicity and naturalness that characterize children were also the perceived characteristics of the fisherpeople. Both groups had become symbols of life lived close to nature— serious, concise, and true— and free of the insincerities and complications of modern urban society. It was a form of cultural primitivism, the discontent of the civilized with civilization, the belief that simpler, less sophisticated lives were blessed with primal innocence.[15]

Homer's decision to remain in Cullercoats throughout the winter was an important one. For the first time since the early 1870s he did not return to the city at summer's end. Now, most of the artists and tourists were gone. He experienced the rawness of the sea in winter, its wildness and unpredictability— the forces of which man is part but which are beyond his control. The summer gardens and farms of his pre-Cullercoats watercolors implied

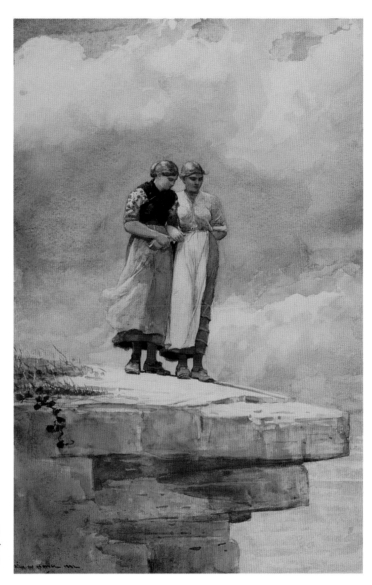

78
*Looking
over the Cliff, 1881*

79 *Fisherman's Family, 1881*

80 *The Breakwater, Cullercoats, 1882*

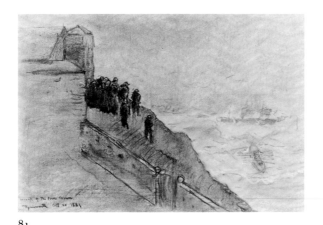

81

82

83

84

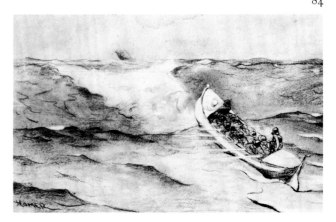

nature as a principle of order; in Cullercoats nature became a principle of creation, elemental and original.[16]

When the days grew shorter, the autumn and winter gales began to blow. A sudden freshening or slight shift of winds toward the east could quickly raise the short, viciously steep seas with heavy overfalls for which the shallow North Sea, with its swift tidal currents, was notorious. In easterly weather, the rockbound coast was hostile, with heavy breakers pounding the sandy shores. The weather the villagers feared most was the sudden squall, which could arise on the calmest of days, for it was most fatal to the fishing fleet. "As the storm begins to gather, the very air seems charged with possibilities of tragic disaster. The women, gathering bait amongst the rocks, look up with startled faces as the sky darkens, and the sharp blasts from the northeast, forerunners of the tempest, whistle past."[17] As the gale grew in intensity, the women ran to the beach "screaming and throwing their arms aloft," or gathered in groups upon the banks, watching as the lifeboat was run down and launched, and peering across the mass of white foam for the sight of a brown sail.[18]

One of the finest in Homer's series of drawings and watercolors that capture the drama

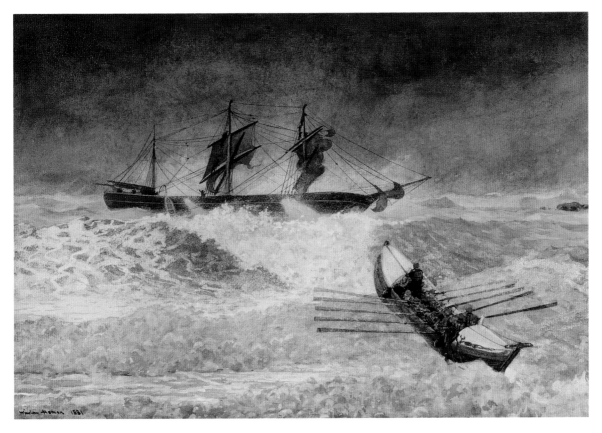

85 *Wreck of the Iron Crown, 1881*

81 *Study for "Wreck of the Iron Crown," 1881*

82 *Men and Women Looking out to Sea, 1881*

83 *Fishermen in Oilskins, Cullercoats, 1881*

84 *The Life Boat, 1881*

of these storms is *Watching the Tempest* (fig. 86). A group of fishermen and women, one with a child on her back, stand on the beach, watching a raging storm; above them on the hill is the Look-out. Although Homer had been in England for only a short time, in terms of fluency of brushwork, more subtle gradations of color, and knowledge and control of the medium, his watercolor technique was now advanced beyond anything he had done in America. The atmosphere of excitement and danger as the volunteer lifeboatmen prepare to launch their craft, is conveyed by palette, brushstroke, and design. Clouds of wind-swept spray, rendered through vigorous scraping, form the stormy background of the scene. Conceived as a series of agitated broken diagonals, the picture is executed essentially in four colors— indigo black, brown-red, yellow-green, and cadmium yellow— yet the range of values and hues is wide. The rich rust-red of the line of the boat, for example, is picked up in a higher key in the child's headcovering and in the woman's shawl, then deepened to a darker tone in the boat on the bank, and varied again in the fisherman's sou'wester at center.

The *Wreck of the Iron Crown* (fig. 85) depicts an actual disaster at sea, which Homer witnessed and first recorded in a series of drawings. In the early morning hours of Friday,

21 October 1881, the full-rigged ship *Iron Crown* ran aground during a violent storm and cast her anchor against Battery Rocks, south of Cullercoats, at the mouth of the Tyne. Many hours of anxious uncertainty followed. The life brigade launched a lifeboat and it was thought that all the crew had been brought ashore. But, when the roll was called, one of the men was still missing; somehow he had been left on board. The rescuers again launched the lifeboat, and by dint of great exertion, the crewman was brought safely ashore.[19] In his memoirs, Homer's neighbor, the English watercolorist George Horton, recalled the sight of Homer recording the event:

As I stood watching the rescue operations, a little cab turned up with an old Cullercoats fisherman on the dicky; out stepped a dapper medium-sized man with a watercolour sketching block and sat down on the ways. He made a powerful drawing with charcoal and some pastel. It was a brilliant drawing, the sea grey-green and the rest brown tone and in the middle distance sea he set the lifeboat.[20]

In a charcoal drawing inscribed *Oct. 21, 1881* (fig. 81), Homer shows a group of fishermen and women huddled together near the Life Brigade House at Tynemouth watching the coastguardsmen in the lifeboat rowing out to the stricken ship. In three other charcoal drawings (figs. 82, 83, and 84), he shows details of the fisherfolk on shore and of the lifeboat moving out. Finally, in the watercolor, the people and the land have been eliminated; only the lifeboat and the foundering ship remain, in a vast expanse of sea. The watercolor includes a detail, not seen in any of the studies, of one of the most suspenseful moments in this extraordinary drama: standing on the deck of the *Iron Crown* is the tiny figure of Carl Kopp, the forgotten seaman, waving frantically to the oncoming lifeboat.

The *Wreck of the Iron Crown* was the most ambitious watercolor Homer had yet attempted. Its large size (20¼ x 29⅜ inches) and elaborate technique suggest a studio production. He began with an extensive and adept use of a masking agent in the foam in the left middle ground, over which he brushed in washes of grays and ochers.[21] The surface was then soaked, sections of softened paint sponged up, and certain areas such as the swelling dark wave in the center foreground received subtle modeling through additional washes. Homer achieved the highlights in the foam spraying against the side of the ship by scraping, and used opaque white to outline the lifeboat covers and accent areas in the foam in the left foreground. Finally, with dark colors and decisive brushwork, he reinforced the oars, the rigging, and the figure waving from the deck.

Homer exhibited the watercolor in a Newcastle art dealer's window before sending it to Chase in February 1882.

My dear Chase, I sent yesterday by mail a watercolor of a wreck— "The Iron Crown" which I saw at Tynemouth October 28 [sic]. *It was taken from a high bluff and that makes the horizon high. If you like, you may cut off the life boat. . . . Price $250.*[22]

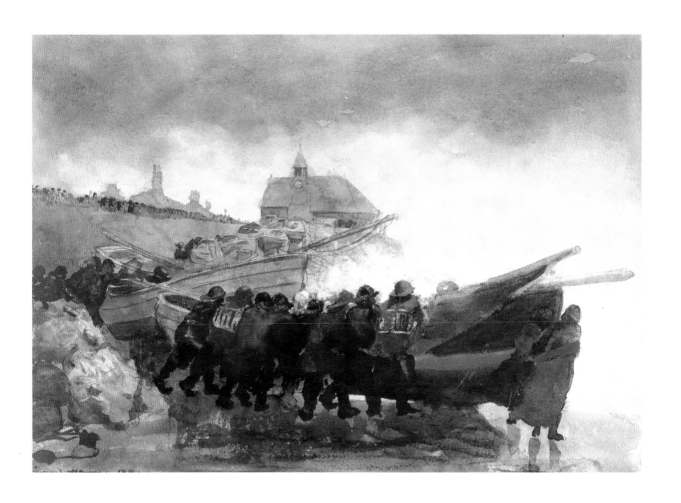

86 *Watching the Tempest, 1881*

87 *Mannikin*

88 *Head of a Woman, 1882*

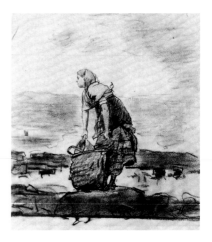

89 *After the Storm, 1882*

Homer's working habits made an impression on the villagers, and he was remembered with admiration:

His vitality, truly American, left the stolid, phlegmatic fishermen literally amazed. Then in the prime of life, erect and debonair, he would be seen going down the sloping bankside to the beach, carrying his easel and painting material and well within the hour he would be back again with the completed picture. The fishermen rated him "the fastest painter in the world."[23]

His friend John Beatty later wrote:

In England he . . . painted figures, posing them and working out every detail until he was satisfied he could do no more; then took his canvas and models to the seacoast, where, as he expressed it, "I would in a couple of hours, with the thing right before me, secure the truth of the whole impression."[24]

For Homer, the "truth" of a scene lay in the characteristic gesture of a figure, or in the fleeting moment when the colors of the atmosphere were exactly what he sought, so that he presented as spontaneous that which he had carefully selected.

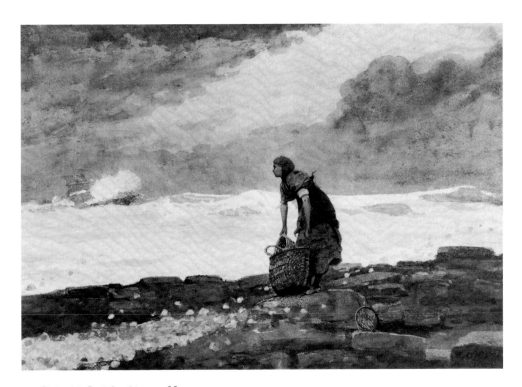

90 *Girl with Red Stockings, 1882*

Homer sometimes used as models three doll-sized wooden mannikins with movable limbs, purchased in England, which were dressed in replicas of the fisherwomen's clothes and could be arranged in a variety of poses (fig. 87). But more often he used some local residents. Horton recalled that Homer was well liked by the villagers, for he was "lavish" with his money; "he more than doubled the earnings of those who sat to him as models."[25] One of his models was Joe Robinson, the first captain of the Cullercoats Life Brigade, who had posed for John D. Watson a decade earlier and more recently for Henry H. Emmerson.[26]

Homer's most important model was probably Maggie Jefferson (later, Storey), a fifteen-year-old, red-haired girl who bears a resemblance to the mystery woman in the 1870s works. She lived in one of the cottages on Bank Top near Homer's studio. Homer paid her a shilling a sitting and often posed her in the field in Mast Lane, a green near the seafront, where curious villagers used to peep over the hedge to watch. "He was a real nice man," she said. "If you felt faint he didn't know what to do with you."[27] She is the subject of dozens of watercolors and drawings, among the most sensitive of which is a little portrait study in graphite (fig. 88). Mrs. Storey also reported that Homer took many photographs of her, although none has been found. The only surviving evidence that

91

91
First Sketch, 1881

92
*Figures in Lee of a Building
with Ocean Beyond, 1881 (recto)*

93
*Groups of Figures
and Two Small Framed Sketches,
1881 (verso)*

92 93

94
*House at a Railing
with Beached Dories, 1881*

95
*Three Women and a Child
Stand behind a Railing
Looking out to Sea, 1881 (recto)*

96
*Figures Landing
in a Dory, 1881 (verso)*

94

95 96

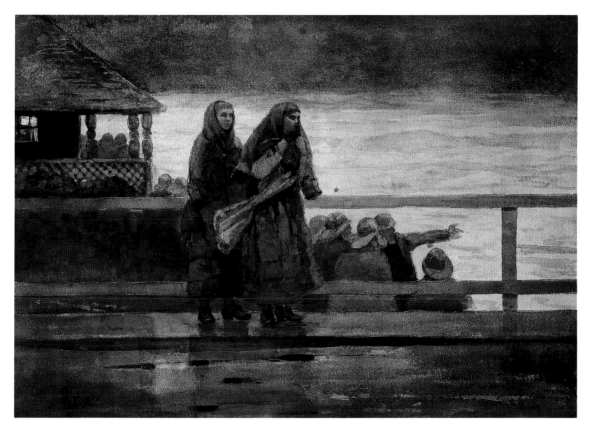

97 *Perils of the Sea, 1881*

98

99

100

98 *Two Women and a Child
at a Rail,
Overlooking the Beach
at Cullercoats, 1881*

99 *The Last Boat In, 1881*

100 *A Dark Hour, 1881–1882*

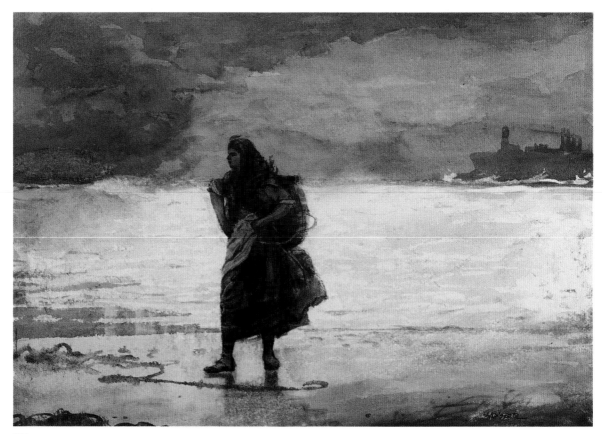

101

Homer had a camera in Cullercoats is a photograph, glued onto the endpaper of his copy of Chevreul, of a coble under sail, and below it, his inscription in ink, *Sept 1882 Cullercoats Newcastle-on-Tyne*.[28]

Homer's working method in Cullercoats involved a greater use of preparatory drawings than ever before. At no equivalent period in his life did he produce as many drawings (about seventy-five) as he did in Cullercoats. Until Cullercoats, he usually made brief graphite marks directly on the sheet to be washed. Although he was a prolific draftsman throughout the 1860s and 1870s, only rarely did drawings serve as studies for watercolors. At Cullercoats the drawings assumed the more traditional role as preliminary and exploratory works. He used graphite, charcoal, wash, and gouache to produce a variety of studies, ranging from spontaneous renderings to highly finished, carefully composed drawings. They are a painter's impressions of the daily life of the fisherpeople. Some sketches were translated line for line into watercolors (figs. 89, 90); others reveal a meticulous concern with figure placement and spatial relationships, as in the compositional study (fig. 71) for *Four Fisherwives* (fig. 74). The notations on the sketch— *180 Feet water line/36 Ft. Figures/60 Ft. man*— apparently record the distances Homer stood from each of the compositional elements.[29]

The Cullercoats drawings show Homer's draftsmanship at its best. They have a freshness and spontaneity that is sometimes lost in the carefully wrought watercolors. Unlike

102

103

101 *Fisherwoman, probably 1882*

102 *Two Figures by the Sea, 1882*

103 *Looking out to Sea, 1881*

104 *Fisherwives, 1883*

104

the watercolors, in which the mood and palette gradually became darker, Homer's drawing style remained constant during his twenty months in Cullercoats. The drawings are objective observations of site, gesture, and patterns of movement, while the watercolors are often developments of these observations. Seen together, the progression of sketches reveals Homer's ideas about nature and man's place.

Perils of the Sea (fig. 97) shows two fisherwomen bracing themselves against the wind, while below them on the beach a group of fishermen look anxiously toward the rolling foam. The series of preparatory sketches, in chalk and in pen and ink, illustrates the transformation of a specific moment into a timeless reality. Homer began with a black chalk drawing, inscribed *First Sketch* (fig. 91), which shows a group of men pulling boats onto the beach during a storm. The next sketch may be the one in which some figures are huddled together in front of the railing (fig. 92). Homer inscribed *pink* on the area of the road and the notation *sky the same value as road— but nothing as white as water*, instructions he followed in the final watercolor. On the verso, a number of women and fishermen in oilskins stand on the beach (fig. 93). At the lower left are two small studies, one of them showing for the first time the general layout of the future watercolor and some of the elements that would appear in it: a road, figures against a railing, and the Look-out House; in order to visualize the sketch as a discrete composition, Homer drew a line around it. Having established the general arrangement of the figures and

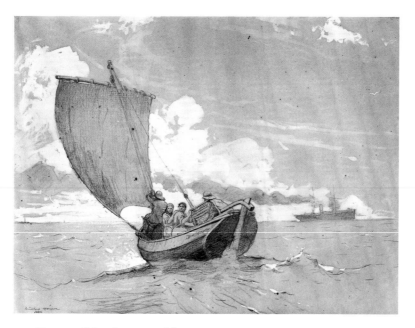

105 *Fishing off Scarborough, 1882*

106 *Returning Fishing Boats, 1883*

the location of Look-out House, he proceeded to work out the position and attitude of the figures.

One pen-and-ink sketch with color notations (for the cobles, *green inside and Blue*) presents the Look-out with some figures and boats, but with no figures against the railing (fig. 94); another has a group of fishermen and women leaning on the railing, looking out to sea (fig. 95). Concerned about finding the proper posture for the women, Homer devoted several studies to the problem, first sketching the women and a small child at the bottom of the sheet and, on the verso (fig. 96), giving the child more definition. In a series of charcoal studies, the forms have greater solidity. One shows two women and a kneeling child at the railing, looking down toward some fishermen at the foot of the Look-out House (fig. 98). Another sheet concentrates on the fishermen looking out to sea (fig. 99); this group of men would appear in the watercolor.

Probably the last sketch in the series is *A Dark Hour* (fig. 100) in which a fisherwoman, her face covered by her arm, turns from the sea, and hurries away in anguish. In the watercolor only two women appear and, for the first time, they face the viewer. Isolated from the men and held within a strict geometry of earth, sea, and sky— suggestive of their place in nature and role in life— they form an island of apprehension. Homer has synthesized the several descriptive studies into one suspended moment.

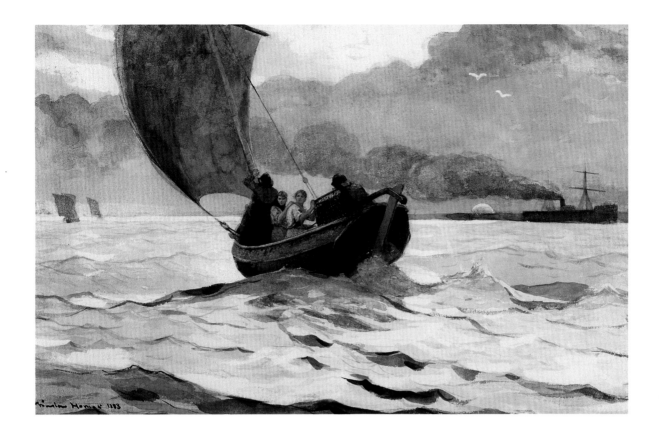

Homer seemingly never discarded compositional elements, but instead used figures and groups over and over, often combining features from different mediums into a single new composition. For example, the figures in the watercolor *Fisherwoman* (fig. 101) and the oil *Two Figures by the Sea* (fig. 102) were brought together for the watercolor *Fisher-wives* of 1883 (fig. 104), completed after the artist's return to America.[30]

Homer's watercolor technique in Cullercoats remained an old-fashioned one. Artistic taste in England in the 1870s and 1880s was governed by a dualism embracing both the elaborate statement and the flash of inspiration, of which the former was considered the more desirable. In watercolor, stippling in the manner of Myles Birket Foster (who was accused by one critic of "tickling a picture to death with small touches") and others was the so-called advanced method.[31] Despite his exposure to this style, Homer continued to represent nature by blotting in forms. Just as his subject matter was a kind of cultural primitivism, so did he reach back in time for his technical and stylistic models. He rejected minute detail, excessive control, and tight handling— techniques contrary to the natural properties of the medium, although used by many highly praised contemporary water-colorists. As it had from the beginning of his watercolor career, Homer's technique recalls that of watercolorists of an earlier generation— Turner, DeWint, Cox, and Müller—

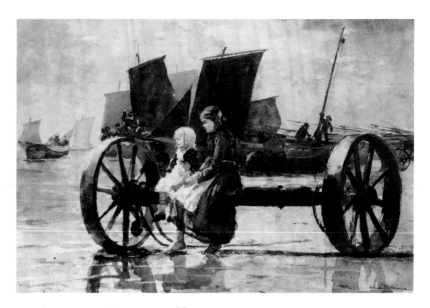

107 *On the Beach, Cullercoats, 1881*

painterly, with broad areas of transparent washes, long sweeps of wet paint over dry, the incorporation of accident, and the sacrifice of detail to general effect. Although he used elaborate watercolor techniques on some sheets, Homer never entirely gave up a more painterly freedom.

In the watercolors of his first months at Cullercoats, Homer's palette was still predominantly a light one of ochers, reds, and blues, orchestrated into various arrangements. In some watercolors, small passages of floodings of pure color recall the watercolors of the summer at Gloucester. In others, like *Afterglow* (fig. 69), the execution is dry, and the figures and boats are carefully painted within outlines. The intense light through the center and the hot palette of reds and golds evoke Turner, whose work Homer could easily have seen at the National Gallery in London. Set against a carmine sky (the color, once a more vivid pink-purple, has faded), the brown-sailed dark boats float on pale blue, red, and yellow water, the washes much worked over, while a strip of yellow light, reminiscent of the horizon in *Sailboat and Fourth of July Fireworks* (fig. 49), defines the horizon. Homer's favored vermilion resonates throughout this sheet— in the scarves of the three women, the two daubs of the figure in the distant center coble and its reflection, and in the reflection of the foreground coble. But with his increasing experience of the fisherpeople's harsh existence came the gradual suppression of brighter colors in favor of deeper and more muted tones, like those in *Fisherwoman* (fig. 101).

Homer's technical knowledge of watercolor was clearly growing. To produce highlights and lighter areas, he now used masking agents more often; for example, in the

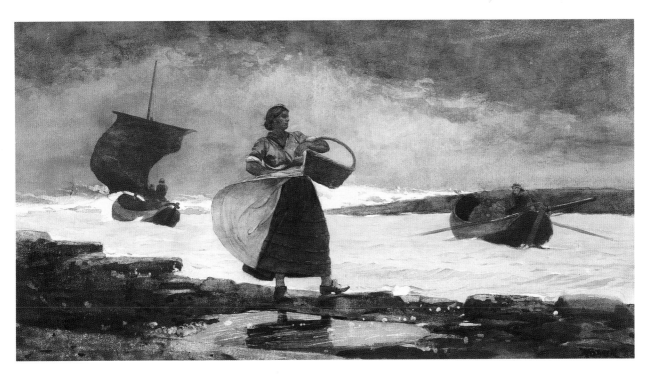

108 *Inside the Bar, 1883*

Wreck of the Iron Crown (fig. 85) or *Looking out to Sea* (fig. 103). In the latter, he created the light patches in the foreground rocks by extensive masking. It was not a technique Homer favored after he returned to America, and he used it only rarely in his later works.

Returning Fishing Boats (fig. 106), based on the graphite and gouache drawing *Fishing off Scarborough* (fig. 105), shows two young women and two fishermen returning to the harbor at sunset. With its carefully rendered figures, set against the layered and sponged washes that create the sky of pink clouds and drifting smoke-wreaths, and the waves freely drawn in brilliant blue brushed over with pale peach-pinks and yellow, the watercolor lacks stylistic cohesiveness. It is, nonetheless, a powerful work in which one senses the challenges of pure design as well as the artist's struggle between the need for realistic depiction and painterly freedom.

Homer obtained some of his greatest effects through composition. The importance of design became increasingly evident during his stay in Cullercoats. Many of the works manifest principles of compositional structure laid down in John Ruskin's *The Elements of Drawing,* a book that had a profound effect on American aesthetic thought in the 1870s.[32] Homer achieves unity in a composition of many elements such as *On the Beach, Cullercoats* (fig. 107) by employing methods similar to those advised by Ruskin: "The first mode in which [unity] can be effected is by determining that *one* feature shall be more important than all the rest, and that the others shall group with it in subordinate positions."[33] Although *On the Beach, Cullercoats* depicts an active shore scene, Homer's ultimate

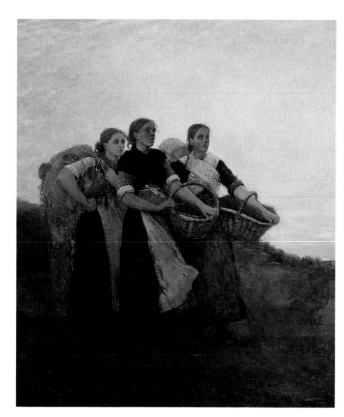

110 *Sketch
for "Hark! The Lark!,"
1881–1882*

109
Hark! The Lark!, 1882

interest was in the formal qualities of the picture. The focus of the composition is the design created by the cart's two large wheels, made to seem even larger by the small children sitting near them.

To achieve a sense of timelessness, Ruskin advised the use of reflection and repetition.[34] *Inside the Bar* (fig. 108), completed after Homer's return to America, resonates with repeating and echoing curved lines, the blowing apron affirmed in the curves of the sail, reiterated in the lines of the boats, and brought back in reverse in the line of the basket handle. Surrounded by these sweeping, duplicating curves, the magisterial woman seems an equal of the natural elements, like a solitary oak in a storm. Homer used gouache for the lightest areas at the horizon to create the effect of the brilliant, surreal light that flashes just before a storm, and a knife to scratch in the light streaks in the foreground pool and behind the woman. The interrelatedness of rocks, sea, and sky, of woman and man, basket, and boat, are underscored by the unifying, rich dark grays and glowing browns throughout the scene.

Homer's developing sense of composition was achieved through catching and isolating the autonomous and characteristic life of the subject. He restrained his so-called unfinished impressionist style in order to master traditional watercolor techniques within comprehensive pictorial schemes. And his earlier nostalgic sense of childhood and rural life turned to subjects (equally nostalgic in their own way) of timeless struggle.

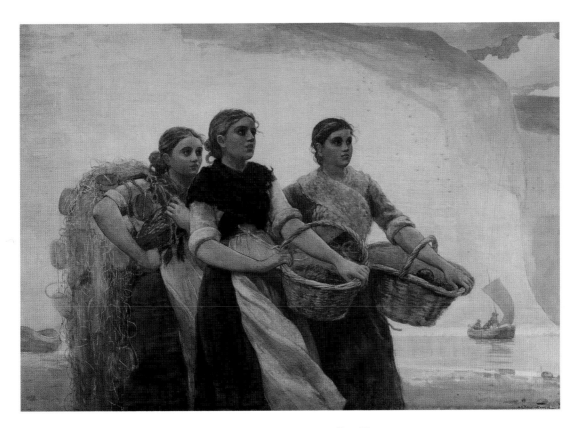

111 *A Voice from the Cliffs, 1883*

The gravity, sense of serious import, and the feeling that the action portrayed is one of great and permanent interest, not a trivial occupation of the moment, were accomplished through line rather than color.

In the first Cullercoats watercolors, the element of design is less evident and associative. In *A Voice from the Cliffs* (fig. 111), completed two years later, rigorous design predominates. The idea for *A Voice from the Cliffs*— women spellbound by the call of a lark — first appeared in 1881 in a small charcoal sketch with the relevant quotation from Shakespeare's *Cymbeline*,[35] as well as with precise color notations (fig. 110) that Homer scrupulously followed in executing the 1882 oil, *Hark! The Lark!* (fig. 109).[36] The watercolor was created after the oil. The sound of the skylark was a feature of Cullercoats and contemporary writers often commented on it: "High overhead the skylark sings, and his strain sounds congenial to our ear, so full is it of the joy of mere existence on such a morning."[37] Homer was not alone in finding attractive the idea of a fishergirl transfixed by the piercing sound of the lark; in the late nineteenth century the subject of a peasant girl lifting her head to listen to the ethereal call of the lark or warbler was a popular one.[38]

Although the oil and the watercolor are executed in similar colors and the women are virtually identical, the psychological impact of each is different— not because of the different media but because of the compositional structure. Set within a vertical format, the oil shows three young women standing on a hillside at some distance from the viewer,

silhouetted against a windblown sky that covers half the composition. Only a small strip of sea is visible at the right. The watercolor is a horizontal composition, and the three women stand at the water's edge; behind them a coble sails toward shore and, in the distance above the horizon, a puff of white cloud drifts across a small patch of sky. The women fill most of the sheet and because Homer has cut it at a point just below their knees, there is no foreground. The viewer is thus brought close up, to share both their ground and the suspended moment. Held in place by the commanding cliffs in the background, by the beached coble at left, and by the coble under sail at right— to which all lines in the composition lead— the women are bound by and dependent on both nature and their relationship to the men in the fishing boats. Each woman moves within her own psychological space, yet is tied to the others in a master scheme whose rules are not evident but unconsciously perceived and accepted. The dialogue of advancing and retreating lines, of reiteration and repetition, conspires simultaneously to suggest a real image as well as the durable, unchanging nature of the fisherwomen's work and lives.

No one could spend any time in the village without becoming aware of the special qualities of the fishermen and women. Ruggedly independent, they needed both endurance and courage, for they had to bear with and battle the elements for sustenance. However, Homer did not view both sexes equally. While on a few occasions he made the men the central subject, most often he relegated them to the background. Like almost everyone else who visited Cullercoats, Homer was drawn to the fisherwomen. "Fair complexioned, sun-tanned, ruddy cheeks, with strong-built but supple forms," they were famous for their beauty. They were, as one writer put it, "the great feature of the place."[39]

In Homer's first Cullercoats watercolors, executed in the summer of 1881, the women appear slim and young, in groups, and often accompanied by children. But as the months passed, and the village revealed itself to him, his image of the fisherwomen gradually changed. Children appeared less often and finally not at all, and the compositions became dominated by larger, stronger women (fig. 101).

In winter the Cullercoats landscape seems to abstract itself into the basic elements of sea, sky, and land, making the figures who move across its unrelenting terrain seem heroic. For such wintry works as *Fisherwoman* (fig. 101), Homer divided each sheet into more emphatic horizontal bands and used more somber colors than before. He eliminated many of the anecdotal features as well as the brighter palette and lighter mood of the summer watercolors. Deep red-brown washes over ocher for the foreground, layerings of dark gray for the threatening sky, and a cold gray-blue wash, with lashings of white achieved by scraping or gouache for the foaming sea, create compositions of fundamental simplicity. The young woman is the single element that joins land, sea, and sky, a device Homer had often used before, especially in his Millet-inspired oils of the 1860s, to suggest the figure's integrated relationship with every part of nature.

Unlike Jozef Israel's fisherwomen (fig. 64), Homer's figures were not conceived as examples of social realism; nor was he interested in the individuality of his subjects;

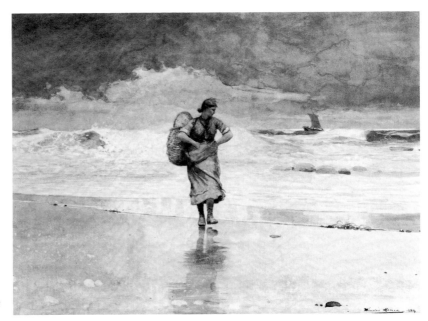

112 *Incoming Tide, 1883*

rather, his women are generalized and larger than life. Unbroken by their environment, they stand against the turbulent sea, their postures embodying strength, pride, and endurance; only their clothes are moved by the wind.

This subtle change in Homer's conception of the Cullercoats women— from slender, young figures to idealized stalwarts— also suggests his heightened awareness of the pivotal role women played in the life of the community. Not only did the complete care of the family fall to them, but its prosperity was largely dependent on their ability to sell the fish the men caught. As the men slept, the fisherwomen worked throughout the day. They searched for bait, dug for sand worms, or gathered mussels, limpets, and dogcrabs from the rocks. They assisted in the baiting of hooks, helped to push the boats into the often icy waters at sunset, and pulled them in again at five or six in the morning when they returned laden with fish. The fisherwoman was described as healthy and powerful; her ways, modest and restrained.[40] In her bracing vigor and native dignity, she bears a kinship to the kind of new woman Whitman had called for in America a decade earlier. Just as Whitman's woman of the future would be the opposite of the languishing females he saw about him, Homer's statuesque and powerful fisherwomen are the opposite of his earlier delicate young ladies of leisure, the socially confined women of his own class and even of his decorative young shepherdesses and farm girls.

Literary and social critics have observed the general impulse toward the end of the nineteenth century to deify women.[41] Homer's representations fall well within this contemporary expression. His larger-than-life fisherwomen, sisters to Breton's peasants, are undoubtedly a conflation from several visual sources, including American neoclassical marble sculpture. Homer's females are classic figures, but with life and breath.[42]

The stately woman set against an exploding sea, such as the figure in *Incoming Tide* (fig. 112), embodies, more than anything Homer had done before, the timeless values of womanhood. Her great, determined shape suggests a kind of earth mother and protector. The conception of nature as the maternal source of new life also suggests another familiar belief— that a return to nature could restore lost energies.[43] During this period in Homer's life, the Cullercoats fisherwoman became the source of new inspiration. Vigorous and glowing, she appeared to possess a sense of inner life and strength. Bound to the sea and dependent on it, she seemed almost to live the life of the sea itself. Inevitably, she must have come slowly to symbolize the sea and therefore its treacherous power.[44]

In changing from scenes primarily of rural life, or, as at Gloucester, of calm water, to images of primitive life beside the sea, Homer moved from a view of nature as essentially benevolent, predictable, and life-supporting to an experience of it as inherently dangerous and uncertain. As others have noted, there is something noble and hopeful in the tilling of the earth, done in simple faith in the regularity of the seasons, of seed time and harvest. Yet farming, at its noblest and best, lacks the element of danger that characterizes the lives of those who seek their living by the sea.

The shift from country subjects to images of the sea also meant a change in the nature of the landscapes. Until Cullercoats, Homer's women were most often set in cultivated landscapes or in closed spaces, under clumps of trees, in gardens or sheltered fields, all of which offered opportunity, both real and implied, to withdraw, to hide, to be safe, and to see without hazard. Even when he showed them more exposed to the elements, as in *Long Branch, New Jersey* (1869; Museum of Fine Arts, Boston), their stance is cautious, they carry parasols to protect their complexions, and they are safely in the company of dozens of other figures. At Cullercoats, the women are often alone or in smaller groups of two or three, confronting the elements full face— standing on cliffs, walking on beaches, climbing on rocks, and sailing in boats on the open sea, situations that offer little opportunity for shelter. Silhouetted against the broad sky, they are at risk in a nature that is uncontrollable and inscrutable. In their contemplation of the horizon, they direct the viewer to speculate about what lies beyond it.[45] This shift in thematic and psychological perspective suggests Homer's growing willingness to confront the primitive elements in nature, and perhaps in himself, more directly.

Homer's last known letter from England, written on 4 November 1882 to his friend William B. Long in New York City, reported that he intended to sail "next Saturday" for New York by the Cunard liner *Catalonia*.[46] On 11 November, Homer sailed from Liverpool, arriving in New York thirteen days later. He moved into 80 Washington Square East and began completing about twenty watercolors that he had either started in England or that were based on his English sketches, dating them *1883*.[47]

The effect of Cullercoats on Homer's art is nowhere more evident than in the four watercolors he sent to the American Water Color Society exhibition that opened on

1 February 1883: *Returning Fishing Boats* (fig. 106), *Inside the Bar* (fig. 108), *A Voice from the Cliffs* (fig. 111), and *Incoming Tide* (fig. 112). These studio works are almost twice the usual size of his previous watercolors, and display a wide range of watercolor techniques. He may have been influenced by the large scale and technical ambition of English exhibition watercolors. Despite Homer's reputation as a bold and unconventional artist, the Cullercoats watercolors surprised the picture-viewing public. Although well within a traditional European mode, to most Americans these fisherfolk scenes were unique.[48] The critic Mariana Griswold Van Rensselaer wrote:

The most complete and beautiful things he has yet produced, [and] *among the most interesting American art has yet created. They are, to begin with,* pictures *in the truest sense, and not mere studies or sketches, like most of his earlier aquarelles. . . . The dignity of these landscapes and the statuesque impressiveness and sturdy vigor of these figures, translated by the strong sincerity of his brush, prove an originality of mood, a vigor of conception, and a sort of stern poetry of feeling to which he had never reached before.*[49]

Although some reviewers criticized the palette as having "a slightly unpleasant tendency to purplish hues . . . [with] too great prevalence of brown and black," and a hardness and lack of mystery in the execution— "everything, flesh, drapery . . . sky, and water, being done in the same way"[50]— to most of Homer's audience the largeness of conception and veracity of feeling made these watercolors the finest works he had yet shown in any medium. The critics were in agreement that the most interesting and valuable feature about the Cullercoats watercolors was the beauty of line, a quality not previously attributed to Homer's work. "A master designer" was what Kenyon Cox called him.[51] The *Nation* wrote, "These works evince a power of design . . . which is very admirable, and in modern art uncommon; . . . He has a true painter's powers and true designer's instincts."[52]

Later that year, in December 1883, Homer sent fifty-one watercolors to Doll and Richards, his new dealers in Boston who had replaced Chase. The *Boston Evening Transcript* praised the watercolors in lavish terms:

Homer is both the historian and poet of the sea and sea-coast life. . . . The whole gamut of watercolor power, from the richness of elemental life depth and vividness to the density of storm darkness and human woe, and thence again to life light, joyousness, delicacy and subtle glow, is here run with a strength and accuracy that few not seeing will believe it capable of. Indeed it seems to proclaim its capacity to be perhaps the most artistic of all art mediums when adequately handled.[53]

Close to half the watercolors were sold almost immediately. Thus by 1883, whatever confusing qualities the public had found in Homer's earlier watercolors (the Gloucester works of 1880 had been appreciated primarily by connoisseurs) were replaced by easily understood and warmly accepted images. Henceforth, this acceptance would serve him well, for although his future watercolors bore little resemblance to the Cullercoats sheets, his reputation as a watercolorist was now securely established.

1 Lillias Wasserman, "Some Fisher Folk," *Art Journal* (London) 49 (January 1867), 60. Mrs. Wasserman, the wife of the sometime painter J. C. Wasserman was well known in Northumberland as a writer of short stories. One of these, "A Cullercoats Artist," *Northern Weekly Reader*, 15 January 1887, described an artist who became disillusioned with his life in London and returned to his native Cullercoats where he was "free to live and to paint, untrammelled by the necessity of following meretricious fashions or the conventionality of schools." Mrs. Wasserman's story reflects perfectly the issues of civilized versus primitive and city versus country that troubled so many late nineteenth-century artists— among them, Gauguin, Van Gogh, and the Hague School painters, all of whom believed that in nonurban and nontechnological societies life was uncorrupted.

2 Aaron Watson, "After the Herring," *Magazine of Art* 5 (September 1882), 455.

3 Some fishermen favored trawlers because they reached the fishing grounds earlier, but the majority disliked them, alleging that the wake caused by the trawl beam was harmful to the breeding beds and fishing places, and the trawl-net destructive of spawn and immature fish; see William Weaver Tomlinson, *Historical Notes on Cullercoats, Whitley, and Monkseaton* ([Monkseaton], 1893; repr. Newcastle-upon-Tyne, 1980), 84.

4 J.W. S., "Fisher-Life," *Graphic* 20 (25 October 1879), 410.

5 G.W. Lisle, "Memoirs of a Boyhood, Old Cullercoats Recalled," [1880s], North Shields Library, North Shields, Tyne and Wear, England. Lisle was the son of a fisherman. The memoir is undated, but the events Lisle describes can be dated to the early 1880s.

6 "Its charm lay in its quaintness, its colouring and its old world flavour of fisherpeople. Its pantile roof showed diversity of red colouring with patches of blue slate. . . . The yellow sandstone was stained with patches of mossy green. . . . Here the artists were often to be seen painting the fisherpeople . . . sitting on low stools, or crackits, baiting their lines. . . . To add further interest and colour to the picture, wickerwork creels and baskets . . . would be littered around"; Lisle, "Memoirs." See also Wasserman, "Some Fisher Folk," 60. The building was demolished in 1979.

7 The convention of a young peasant woman standing in a doorway and knitting was well-established; see, for example, Stanhope Forbes, *Street in Brittany* (1881; Walker Art Gallery, Liverpool).

8 Other watercolors that include the Priory are *Fisherwoman* (fig. 101); *Under the Cliff, Cullercoats* (1883; Addison Gallery of American Art, Phillips Academy, Andover, Massachusetts); and *Tynemouth Priory, England* (1881; The Art Institute of Chicago.)

9 I am indebted to Kenneth McConkey, Fine Art Department, Newcastle-upon-Tyne Polytechnic, for pointing this out to me.

10 The studio is not shown in any watercolors but is in the background of several drawings, one of which is *Men Beaching a Boat* (1881; Harvard University Art Museums, Fogg Art Museum, Cambridge). See, for example, *Flamborough Head* (1882; The Art Institute of Chicago).

11 According to interviews published after he returned to America, Homer traveled to Wales and to Scotland, although no watercolors or drawings survive whose subject matter would specifically identify these places. "Mr. Homer . . . was in Wales and England for a year or so, making sketches and finished pictures"; Augustus Stonehouse, "Winslow Homer," *Art Review* no. 4 (February 1887), 14. Following the opening in 1883 of the Sixteenth American Water Color Society Exhibition, in which his Cullercoats watercolors were highly praised, Homer was interviewed by a reporter for the *Art Interchange*: "Being curious . . . about Mr. Homer's pictures, I called on him, and . . . I found him . . . not too busy . . . to take a few minutes to tell me something of his last summer's work on the English coast. He was enthusiastic over the grandeur of the cliffs and the fine character studies to be had among the fisher people. In the course of his stay he travelled along the coast of Yorkshire and Northumberland, and as far north as Scotland"; "Ego Notes," *Art Interchange* 10, no. 4 (15 February 1883), 40.

12 G.W. Lisle, "Memoirs."

13 G.W. Lisle, "Memoirs." The painter Henry H. Emmerson, Homer's Cullercoats neighbor, portrayed this lively street scene in *A Foreign Invasion* (c. 1881; Laing Art Gallery, Newcastle-upon-Tyne).

14 Several years later Monet would respond in a similar fashion to the throngs of tourists in the village of Etretat by concentrating on the cliffs; see Robert L. Herbert, "Method and Meaning in Monet," *Art in America*, September 1979, 105.

15 Arthur O. Lovejoy, Gilbert Chinard, and George Boas, *A Documentary History of Primitivism and Related Ideas* (Baltimore, 1935). See also Robert Goldwater, *Primitivism in Modern Art* (New York, 1938; Vintage Books, rev. ed., 1967), 251: "It is the assumption that the further one goes back— historically, psychologically, or esthetically— the simpler things become; and that because they are simpler they are more profound, more important and more valuable."

16 The idea of two principles of nature is discussed in Raymond Williams, *The Country and the City* (London: Paladin, 1973), 158.

17 R. J. Charleton, "Cullercoats," *Magazine of Art* 9 (1886), 458.

18 Wasserman, "Some Fisher Folk," 60.

19 "The Wreck of the Iron Crown at Tynemouth," *Newcastle Daily Journal*, 22 October 1881, 3.

20 "The Life Story of George Horton," *Sunday Sun*, Newcastle-upon-Tyne, 5 March 1939. The drawing he speaks of may be fig. 84.

21 The masking material probably had a gum resin or rubber base and was soluble in turpentine or alcohol. For a discussion of masking agents, see Cohn 1977, 48.

22 Undated letter; Archives of American Art, J. Eastman Chase papers. Homer's suggestion that the picture could be cut down seems extraordinary. Perhaps he realized that the presence of the lifeboat made for a somewhat awkward, reportorial composition.

23 Kay Jenner, "Winslow Homer," typescript for an intended broadcast, Monkseaton, England, 1956.

24 Quoted in Goodrich 1944, 223.

25 "George Horton," *Sunday Sun*.

26 Joe Robinson, described as "keen-eyed, resolute and imperturbable," was the model for Watson's *The Life Brigade Man*, which appeared in the *Graphic* 1 (19 February 1870), 274. See also Tomlinson, *Historical Notes on Cullercoats*, 110.

27 Quoted in Jenner, "Winslow Homer," cited on p. 90 n. 22. In 1956, when Ms. Jenner interviewed Mrs. Storey, the fisherwoman was eighty-nine years old and was still living in Cullercoats. She recalled that when he was at Cullercoats, "Homer took a fancy to collecting old-fashioned upright, eight-day grandfather clocks, which nearly all fishermen's homes then possessed as treasured heirlooms. He bought two of them and then had them securely packed for shipment to America." George Horton also noted Homer's fascination with clocks: "He must have bought almost a dozen grandfather clocks at the regular figure of ten pounds apiece, no matter how poor the clock might be; then he had cases made for each of them, which meant more money"; "George Horton," *Sunday Sun*. Ms. Jenner also included the following information: "Of one fact she [Maggie Storey] is certain— that one of his brothers (Charles, she thinks) visited him when he was at Cullercoats." There is, however, no evidence that such a visit did take place.

28 Homer apparently acquired a camera, made by Marion and Co., London, and introduced in 1882, while he was in England (Worcester Art Museum); Hendricks 1979, 157, fig. 250. But this was not the camera used for the Cullercoats coble photo because the plates are of a different size. Maggie Storey told Ms. Jenner that Homer gave her the photographs he had taken of her, but she could not recall what had happened to them.

29 The identical central group of the four women appears in a smaller watercolor, *Four Fishergirls on the Beach* (1881; Collection of Mr. and Mrs. Paul Mellon).

30 *Scotch Mist* (1883; McNay Art Institute, San Antonio), is made up of four works: *Perils of the Sea* (fig. 97); *Storm on the English Coast* (1882; Collection of Mrs. Roger S. Warner); *Fishermen in Oilskins* (fig. 83); and *Blyth Sands* (1882; Amon Carter Museum, Fort Worth). Homer's use of the same figure in different compositions was an early characteristic of his work. For example, the figure at the right in *A Game of Croquet* (1866; Yale University Art Gallery, New Haven) reappears as the windblown figure at the left in *Long Branch* (1869; Museum of Fine Arts, Boston); as the standing figure in the

print *The Coolest Spot in New England— Summit of Mount Washington*, published in *Harper's Bazar* 3 (23 July 1870), 473; and, a decade later, as the shepherdess in the Houghton Farm watercolor, *Fresh Air* (fig. 43). See David Park Curry, *Winslow Homer: The Croquet Game* (exh. cat., Yale University Art Gallery, New Haven, 1984).

31 Wyke Bayliss, "Dualism in Art," *Magazine of Art* 2 (1879), 79.

32 John Ruskin, *The Elements of Drawing* (New York: Dover Publications, 1971; orig. ed. London: Smith, Elder & Co., 1857). For Ruskin's influence in America, see Roger B. Stein, *John Ruskin and Aesthetic Thought in America, 1840–1900* (Cambridge, Massachusetts, 1967). It is more than likely that Homer knew of the Ruskin treatise, as it was an immensely popular book that went through many American editions even during the years when Ruskin withdrew it from circulation in England; Stein, *Ruskin*, 280 n. 15. Among its fans were Henry David Thoreau and Charles H. Moore; Moore used it from 1871 to the end of the century in his watercolor and drawing classes at Harvard; Stein, *Ruskin*, 92 n. 353. In addition, Ruskin's own drawings were shown in exhibitions in Boston and New York in 1879, accompanied by a pamphlet he wrote on useful points in drawing. For these exhibitions, see *Art Journal* (N.Y.) 5 (December 1879), 380, and *New York Daily Tribune*, 8 December 1879, 5.

33 Ruskin, *The Elements of Drawing*, 164.

34 Ruskin, *Elements*, 168. The influence on Homer of Ruskin's principles of design can be seen as well in certain pre-Cullercoats works; in *The Cotton Pickers* (1876; Los Angeles County Museum of Art), a sense of timelessness, of repetition, and of the quiet succession of tasks is evoked by reiteration and symmetry.

35 Act 2, sc. 3, line 22.

36 According to Beam 1966, 56, Homer considered the oil version of *Hark! The Lark!* to be the best picture to come out of his visit to England. Homer's opinion notwithstanding, the painting received no critical notice whatsoever when it was exhibited at the Royal Academy in the spring of 1882.

37 Charleton, "Cullercoats," 458.

38 See Kenneth McConkey, "'Pauvre Fauvette' or 'Petite Folle': A Study of Jules Bastien-Lepage's 'Pauvre Fauvette,'" *Arts Magazine* 55, no. 5 (January 1981), 140.

39 J.W. S., "Fisher-Life," *Graphic* 20 (25 October 1879), 410. John Stanley Mitcalfe, *Guide to Tynemouth and Neighbourhood by a Native* (Newcastle-upon-Tyne, [1880]), 27.

40 James Runciman, *The Romance of the Coast* (London, 1883), 27.

41 Among the many sources, see Page Smith, *Daughters of the Promised Land* (Boston, 1970), especially "From Woman's Rights to Feminism"; also Martha Banta, "They Shall Have Faces, Minds, and (One Day) Flesh: Women in Late Nineteenth-century and Early Twentieth-century American Literature," in Marlene Springer, ed., *What Manner of Woman* (New York, 1977).

42 Some previous writers on Homer's English period have suggested that Pre-Raphaelite painting, particularly the work of Edward Burne-Jones, was the source for these idealized figures; Albert Ten Eyck Gardner, *Winslow Homer, American Artist: His World and His Work* (New York, 1961), 80–81. Others proposed that Homer's English style was influenced by the Elgin Marbles in the British Museum which he could have visited during his stay in London; John Wilmerding, *Winslow Homer* (New York, 1972), 133. Indeed, the seated figures in *Mending the Nets* (fig. 76) recall in a general way East Pediment figures such as Persephone and Demeter.

43 G. J. Barker-Benfield, *The Horrors of the Half-Known Life: Male Attitudes toward Women and Sexuality in Nineteenth-Century America* (New York, 1976), 220.

44 A similar theme is found in Henrik Ibsen, *The Lady from the Sea* of 1888, acts 3 and 4, where, in their magnified power, both the woman and the sea equal death.

45 For a discussion of the theory of refuge-dominant and prospect-dominant landscape, see Jay Appleton, *The Experience of Landscape* (London, 1975), 157.

46 Goodrich 1944, 231–232. Long was connected with Valentine and Co. of which Charles Homer was by then vice-president, and he became a friend of the artist. According to Long's daughter, he visited Homer "in Cullercoats in the early 80s" (personal communication from Lloyd Goodrich to author, 1979). The Cullercoats watercolor *Above the Sea, Cullercoats* (probably 1882; Canajoharie Library and Art Gallery, Canajoharie, New York) is inscribed *To Mr. Long/with Comp'ts of/ Winslow Homer*.

47 Similarly, several English drawings shown at Doll and Richards the following year were dated *1884*.

48 *A Voice from the Cliffs* and one or two others sold, priced between $300 and $500. In May, Homer sent twenty-seven watercolors to the Century Association; twenty-one were sold, for a total of approximately $3,500.

49 Mrs. Schuyler (Mariana Griswold) Van Rensselaer, "An American Artist in England," *Century Magazine* 27 (November 1883), 17, 19.

50 *Nation* 36 (15 February 1883), 156.

51 Kenyon Cox, "The Art of Winslow Homer," *Scribner's Magazine* 56 (September 1914), 386.

52 See n. 50.

53 *Boston Evening Transcript*, 6 December 1883, 6. In February 1882 a group of Homer's English watercolors had been exhibited in Boston at the gallery of his dealer at the time, J. Eastman Chase (see above, p. 88). This first showing of Cullercoats works in America generated high critical praise:

> The collection . . . is positively exhilarating. . . . We have rarely seen the local color of a scene more accurately and sympathetically caught . . . the women being especially excellent. . . . His women are women all over, in the way they stand, sit, hold their hands, use their back and shoulders in carrying heavy weights, such as baskets of fish and the like. There is a charming feminine grace in these sturdy Christie Johnstones, a grace not only of posture and bearing, but a look and expression.
>
> But what makes these sketches peculiarly valuable in our eyes is a certain unstrained poetic treatment . . . which . . . is delightfully suggestive. . . . Many of the sketches strongly stimulate the imagination, without confining it to any particular direction.
>
> "The Fine Arts," *Boston Evening Transcript*, 9 February 1882.

Prout's Neck

1883–1884

The need for isolation that had led Homer to spend over a year and a half in Cullercoats remained with him in America. He found an appropriate environment in Prout's Neck, a rocky peninsula on the coast of Maine, ten miles south of Portland. Jutting into the Atlantic, it stands fully exposed to easterly storms. With its gray cliffs rising out of the water and surf breaking spectacularly against huge rocks, its gnarled juniper bushes underfoot and wind-bent trees silhouetted darkly against the sky, Prout's Neck has a wild, weatherbeaten beauty and a tough, dramatic character hardly matched anywhere on the Atlantic coast.

The Homer family had come to the area as early as 1875 and the artist had spent part of several summers in Prout's Neck. In the early 1880s only a few fishermen and farmers lived there. The city people who came in summertime lived in one or two primitive boarding houses— there were no summer residences. In 1882 Winslow's brother Arthur built a cottage, and his older brother, Charles, bought a big house that had been started near the shore, and completed it as a summer home for his father and mother.[1]

Homer lived in the big house during the summer of 1883, using a room on the top floor as his studio. The rocks and sea at Prout's Neck would become inseparably identified with his art. One of the first works to describe the drama of this locale is *The Ship's Boat* (fig. 114). It shows four men clinging to the hull of a capsized boat that is being lifted by a huge wave and carried toward the rocks. Rapid brushstrokes suggest the flickering movement of the sea, while contrasts of light and dark convey the size and strength of the rollers. In its large format, ambitious technique, and restrained color, *The Ship's Boat* carries on the watercolor style Homer had perfected in Cullercoats. Although the subject also recalls his English work, the rocky shore was inspired by the ledges near Eastern Point at Prout's Neck.[2]

At Prout's Neck, Homer began to concentrate on nature itself. He no longer seemed to need the mediating and symbolic presence of monumental female figures. The human presence was now implied, the artist and viewer together experiencing directly the forces of nature. The finest Prout's Neck watercolors are characterized by less labored execution, a freer use of the white paper, and clearer, lighter colors, as in *Maine Cliffs* (fig. 113). Here the tipped-up horizon recalls Japanese prints, and Homer conveys through direct, bright washes, calligraphic brushwork, and reserved paper the fresh atmosphere of a

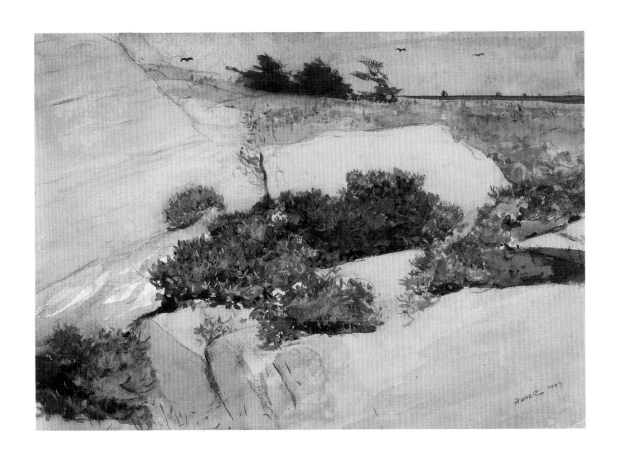

113 *Maine Cliffs, 1883*

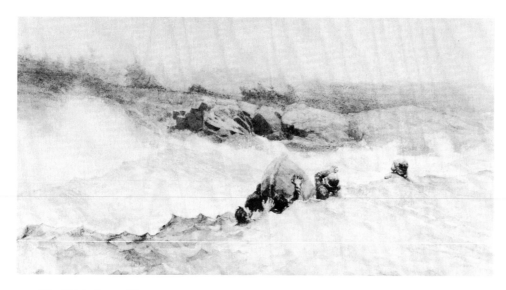

114 *The Ship's Boat, 1883*

clear day. Less successful are watercolors like *The Incoming Tide, Scarboro, Maine* (fig. 116) where Homer tried to capture the massive power of the waves swirling in, the speed and spray of the breakers, and the impact of tons of solid water crashing against the great rocks. He brought to these sheets many of the technical skills he had perfected in England— sponging, scraping the paper, layering the washes, and lift-out. But these seascapes are not successful.[3] Despite the somber gray-greens of the water and sky, the palette lacks depth; the rocks do not seem massive and unyielding, nor the waves relentless. Although he would again essay the subject in a few watercolors in 1887, 1894, and 1895, ultimately the great breakers defied his efforts in the watercolor medium. He had to turn to the heavier medium of oil to evoke the grandeur and elemental force of the granite coast.

The first of the great oils was *The Life Line* (fig. 115), a painting Homer had begun after visiting Atlantic City the previous summer, where he first saw a breeches buoy (a canvas apparatus used for rescuing victims of shipwrecks) in operation. The painting was completed in his New York studio during the winter of 1883–1884. It shows a woman, perhaps unconscious, supported by a seaman who struggles above huge waves to pull her to shore.[4] The sweeping brushwork, somber palette, concentration on essentials within a strong design structure, and rendering of atmospheric effects are all clearly derived from the Cullercoats watercolors. In its evocation of the power of the sea and sense

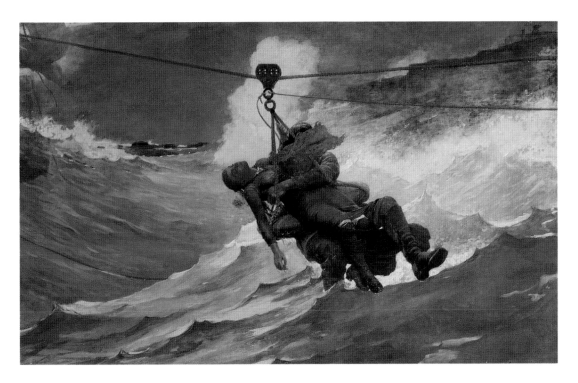

115 *The Life Line, 1884*

of drama, *The Life Line*, exhibited at the National Academy that spring to almost unanimous acclaim, was a landmark in Homer's career.

In April 1884, Homer's mother died in Brooklyn. That summer at Prout's Neck he was restless, perhaps unsettled by her loss. He sailed for a short time with the herring fleet to the Grand Banks, off the coast of Newfoundland, producing a number of large drawings in charcoal and an occasional watercolor of fishermen at sea. Possibly because he was now uncomfortable at the thought of working in the big house, Homer moved the stable, a small mansard-roofed building that had been near the house, to the southwest corner of the promontory, and altered it to make it habitable. He built a covered porch on the second floor that commanded a superb view of the sea. His brothers recalled that he used to spend hours walking up and down this porch,[5] where, directly overlooking some of the most interesting rocks of the entire Neck, he could look eastward toward Scarboro Beach, west to the grand sweeping curve of Saco Bay and the large and popular seaside resort of Old Orchard Beach, and southward out over the water to Stratton and Bluff Islands.

From this time on Homer spent most of the year at Prout's Neck, and he considered the plain wood-frame studio, heated only by a stove, as his permanent dwelling. Despite the spartan surroundings, he found pleasure in keeping a fine home. He had his provisions sent from the best Boston markets and took considerable pride in his culinary skills. He loved flowers and kept a well-tended plot beside the studio. "My home here is *very pleas-*

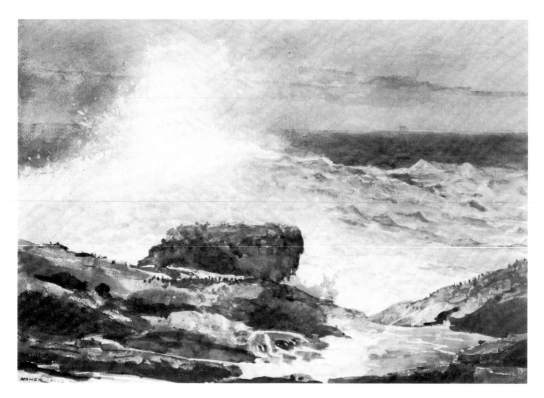

116 *The Incoming Tide, Scarboro, Maine, 1883*

ant, I do not wish a better place," he wrote to Charles.[6] After his father and brother left in the late fall, he was alone; his nearest neighbors, a few fishermen and farmers. He was content. "I like my home more than ever as people thin out," he wrote to Charles in September 1884.[7] Although he cherished his privacy, he was not a misanthrope. "I deny that I am a recluse as is generally understood by that term," he wrote to his friend Louis Prang on the occasion of some proposed visit; "neither am I an unsociable hog."[8] His custom was to work at Prout's Neck until December, sometimes into January or February, and, on occasion, all winter. He visited Boston regularly to see his father, and in the early spring, when many of the art exhibitions were open, he usually spent some time in New York. Almost every year he took a fishing trip— Florida in the winter, and either the Adirondacks or Quebec in the summer. Whereas he worked on his oil paintings in the studio, he turned to watercolor on these working vacations.

Moving to Prout's Neck represented a major shift in Homer's life pattern and it affected the nature of his art. For the most part, the oils focus on the sea and the rocky coast outside his studio. They were created over long periods of time, in an unhurried manner, which allowed elaboration of details, refinement of tones, and clarification of ideas. The watercolors encompass a wider range of thematic material. Swiftly executed, they were more immediate responses to place and moment, each series having a character of its own. Indeed, the evidence of the watercolors suggests that, aside from the obvious fishing attractions of his vacation sites, Homer chose particular places to find his artistic subjects.

Unwavering in purpose, and feeling assured of a reasonably steady patronage following the critical and financial successes of the Cullercoats watercolors and *The Life Line*, Homer believed he could move forward on his own terms. Prout's Neck offered him the solitude he needed and direct contact with that aspect of nature which he cared for the most— the wild, the elemental, and the least touched by man. Years later he would write: "The life that I have chosen gives me my full hours of enjoyment for the balance of my life. The Sun will not rise, or set, without my notice, and thanks."[9]

Notes

1 In 1883 Charles Homer, Sr., with money supplied by Charles, Jr., bought almost all of Prout's Neck and subdivided the land into cottage lots.

2 The watercolor may have been the basis for *Kissing the Moon* (1904; Addison Gallery of American Art, Phillips Academy, Andover, Massachusetts). The composition of the watercolor recalls John La Farge's illustration for *Shipwreck* in the volume of Tennyson's *Enoch Arden* published by Ticknor and Fields (Boston, 1865), facing p. 35. I am indebted to Henry Adams for this reference.

3 Some of these 1883 watercolors may have served as studies for later oils; for example, *Prout's Neck Breakers* (The Art Institute of Chicago) was used twenty years later for the oil *Early Morning after a Storm at Sea* (1903; Cleveland Museum of Art).

4 *The Life Line* bears a startling resemblance to the Currier and Ives print *They're Saved! They're Saved*, published sometime between 1857 and 1872.

5 Goodrich 1944, 84.

6 28 February 1898; Bowdoin.

7 Bowdoin.

8 30 December 1983; Archives of American Art, Homer papers (Prang correspondence).

9 21 February 1895, to Charles Homer; Bowdoin.

Bahamas and Cuba

1884–1885

Bahamas

In 1884 *Century Magazine*, perhaps in response to the popularity of a series of reports on Nassau and Cuba recently published in the *New York Times*, commissioned Homer to illustrate an article it was planning on Nassau.[1]

Nassau was becoming a popular tourist resort, much praised for its beautiful setting and temperate climate.[2] Travel guides to the Bahamas were published in London and New York throughout the 1870s and 1880s, and popular periodicals such as *Frank Leslie's Illustrated Newspaper* and *Harper's Monthly* regularly carried articles extolling the virtues of the so-called Isles of Eden. The Bahamas offered trees that were ever green, flowers always in bloom, tropical fruit in abundance, and, for Americans, a common language.

In New York, on 4 December 1884, Homer and his father boarded the luxurious Ward Line steamship *Cienfuegos*, bound for the Bahamas.[3] Upon their arrival in Nassau, the Homers took up residence at the elegant Royal Victoria Hotel, located on a hill, the largest building in the Bahamas. Standing on its broad front veranda, they could look over most of the city and far out to sea.[4]

By 1884 Nassau was a sizable, flourishing city of ten to twelve thousand inhabitants.[5] "Everything . . . was either dazzlingly white or rich cream-color," wrote one visitor, "streets, houses, stone walls, even the soil in such gardens."[6] The main part of the city lay between the summit and the water. Behind the hill were the suburbs, inhabited almost entirely by the blacks who made up four-fifths of the island's population.[7]

For many visitors to Nassau, the gridlike, narrow city streets, bustling with activity, provided some of their most interesting experiences on the island. A typical street in Nassau, on a busy day, presented a "veritable treasure trove to the appreciative artist,"

the natives in their quaint costumes, the open bazaars, the delicious tone-poems in color; the houses of every hue of the rainbow . . . the curiously shaped vehicles, the strangely constructed buildings, the tropical vegetation, the neat, yet clumsy attempt at the recent and the modern.[8]

Grant's Town, which consisted of one principal street, was the major town closest to Nassau and the most popular one with tourists, partly because they believed its population

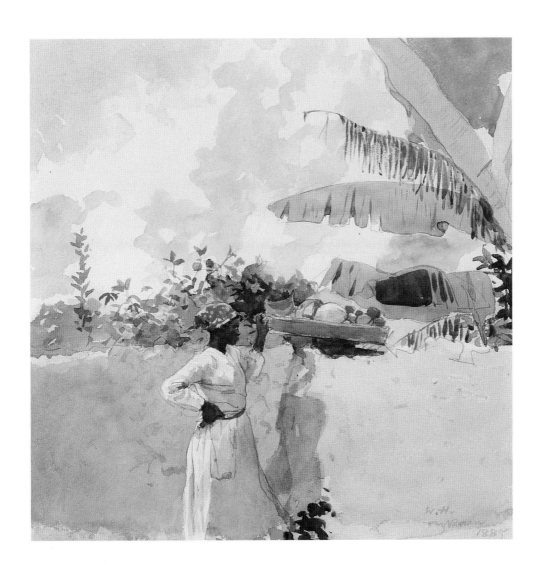

117 *Rest, 1885*

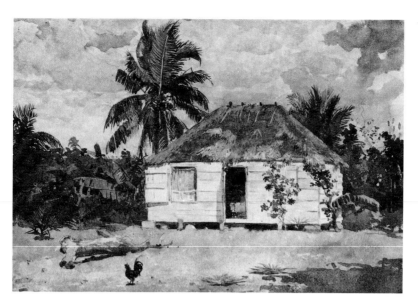

118 *Native Huts, Nassau, 1885*

119 *Cabins, Nassau, 1885*

dwelt in conditions nearly approximating those of Africans.[9] In the 1880s, many of the Africans who were originally brought to Nassau as slaves were still alive and they and their descendants often retained distinct tribal rituals, languages, and mores. The most noted of their customs was the use of thatch for the roofs of the houses.[10] *Native Huts, Nassau* (fig. 118) represents such a roofing style as well as the typical raised construction, clapboard walls, and wood-shuttered windows derived from European tradition. Despite their picturesque character, however, such man-made objects did not hold Homer's attention for long. Even when he shows the average Bahamian planter's home with its steeply sloped roof, wide, open veranda, and adjoining shed, all bounded by the characteristic coral walls, as in *Cabins, Nassau* (fig. 119), it is the light and atmosphere of the scene that draws him.

Sponge was the colony's major export and most important industry during the nineteenth century.[11] Collecting sponge was an arduous task; it was taken from the ocean bottom with long iron hooks, usually by black men who shipped out on specially built wooden schooners with attached dinghies for the five-to-eight-week expedition. Bred to the sea, the sponge fishermen endured dreadful living and working conditions under a pitiless sun. When the boats came in, the women sorted, cleaned, clipped, and packed the sponge in the long sponge exchange building located along the Nassau wharf.[12]

This division of labor— the men going out to sea, the women collecting and processing the catch— was not unlike that which Homer had found in Cullercoats. Again, as in

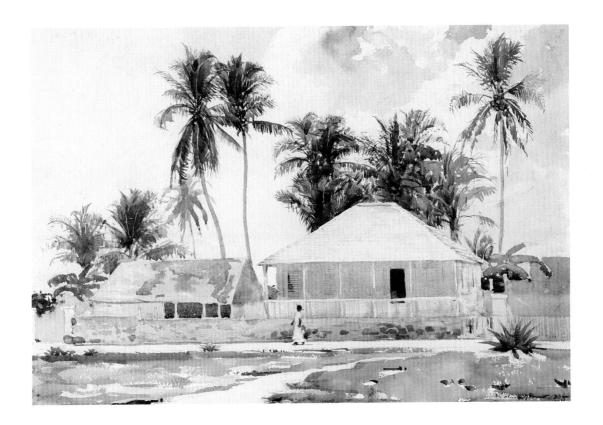

Cullercoats, he preferred to paint views of daily life and tasks, ignoring the tourists and the more picturesque aspects of the local scene. Of the thirty-three known watercolors he produced during this two-month stay, most portray the black population. And these men and women appear within the context of their own environment— not in relation to white visitors.

Two important features, however, distinguish these Bahamas watercolors from the Cullercoats works. While both series focus on the local population, the Bahamas scenes are essentially benign in subject. Perhaps because the mild, tropical weather in December posed little threat to the inhabitants' lives (if there were any hurricanes on this visit, Homer clearly chose to ignore them), small concern is shown here for the theme that preoccupied Homer at Cullercoats— man in relation to the all-powerful, potentially destructive forces of nature. Indeed, such concerns appear in the Bahamas watercolors only as a minor theme. The visit to the Bahamas was Homer's first vacation away from Prout's Neck since returning from Cullercoats and settling in Maine in 1883. During the intervening two years, he had completed the oil *The Life Line* (fig. 115) and had begun studies for *Undertow* (1886; Sterling and Francine Clark Art Institute, Williamstown), highly ambitious paintings distinguished by their evocation of nature's terrible power. From this time forward, Homer would use the heavier medium of oil primarily to express the elemental force of the sea; watercolor became a vehicle for describing what was spontaneous, poetic, and sensual in nature.

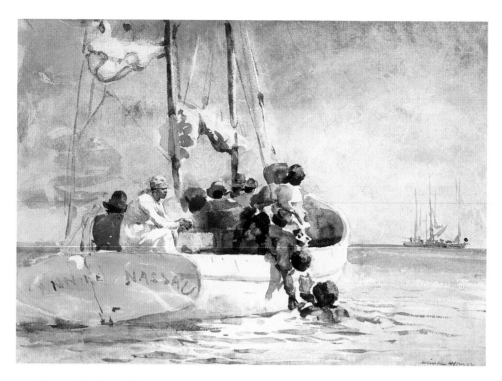

120 *Sponge Fishing, 1885*

Formally, the Caribbean light had a liberating— and lasting— effect on Homer's watercolor style. The Bahamas sheets are painted with free and gestural strokes in transparent washes often of brilliant colors, leaving large areas of white paper exposed. Their style was undoubtedly affected by the conditions of their creation: painted outdoors, and quickly, before the watery pigment could dry under the hot sun. With fewer spongings, scrapings, and lift-outs, they have a direct, seemingly unpremeditated execution. Homer was able suddenly to say things with ease that had before been communicated only with effort.

In both subject and technique, Homer's scenes of the local sponge industry define his Bahamas works. The palettes of *Sponge Fishing, Nassau* (fig. 121) and *Sponge Fishing* (fig. 120) are brighter, the washes purer and more transparent. One also sees a greater exploitation of accidental effects, and an increased suggestiveness, fluidity, and freedom of brushwork. In *Sponge Fishing, Nassau*, Homer shows a view of the wharf from the water, looking toward the shore with the buildings of Nassau in the hazy distance. A small fishing boat, loaded with brown-gold sponges, pulls up to the wharf. As white men in black hats and jackets (presumably the buyers) look on, the straw-hatted black fishermen unload their cargo onto the dock. Within a composition of parallel horizontal elements, which he further emphasized by trimming the paper to a more emphatic lateral format, Homer used a paint-loaded brush to drop pools of color— black, brown, red, blue, and green— over brief graphite outlines to suggest the bustling activity on the wharf.

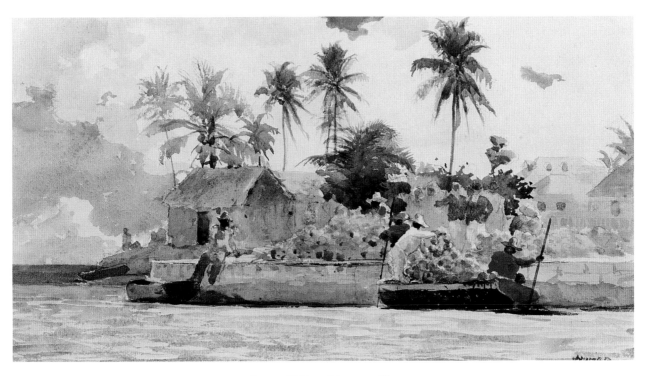

121 *Sponge Fishing, Nassau, 1885*

Against a blue sky almost completely obscured by pale gray and white clouds, watery strokes of gray and green form the palm trees, while the blinding white light of a Caribbean morning reflecting off the glittering sea is achieved through reserved paper.

In *Sponge Fishing*, a crowded schooner, *Annie Nassau*, dominates the foreground. The title for the work is misleading: the boat is not a sponging boat but is probably one of the vessels that conveyed people to and from the islands. In the stern, a young woman sits quietly watching a black boy in the water as he brings up a sea treasure of coral, sponge, or shell. In contrast to her carefully defined and delicately painted face and body, the rest of the figures in the boat are rendered in loose, runny washes that create a blurred effect, as if seen in a passing moment. Reserved paper for the white of the boat and in some of the figures, and scraping for the masts and rigging, give sparkle and texture to the sheet.

Homer also found the market life of Nassau an intriguing subject. The island's rich soil provided a profusion of vegetables and fruit, which were carried on the heads of the women to the market in the central city early every morning. These women walking along the coral roads toward Nassau, with large trays piled high with layers of bananas, oranges, melons, vegetables, and eggs, became the subject of at least six watercolors, among them, *Rest* (fig. 117) and *Hemp* (fig. 126). Although Homer portrayed the women with a quiet dignity, he never endowed them with the heroic presence of *The Cotton Pickers* or the Cullercoats fisherwomen. Such monumental types no longer represented a primary subject for him. Shown at some distance from the foreground and consequently

122 *Oranges on a Branch, 1885*

small in scale, the Bahamian women are but one element in a scene whose real subject is light and color.

Like most visitors to the islands, Homer delighted in the sight of the abundant fruit. Until the early twentieth century, when much of the crop was devastated by a blight, citrus fruit flourished on New Providence. To a northerner, the experience of picking oranges, bananas, lemons, sugar apples, and tamarinds in the middle of winter was both exotic and memorable.[13] In *Orange Tree, Nassau* (fig. 123), the branches are weighed down by ripe fruit, the bright color of the oranges juxtaposed against the characteristic Bahamian white coral walls with their distinctive lattice gates and pyramid-shaped capitals. "It seems, indeed, as if the rock itself must possess some fertilizing qualities, for one sees whole orchards of fruit-trees, and bearing upon what looks like a solid bed of limestone," wrote one visitor.[14]

Oranges on a Branch (fig. 122) is a close-up, cropped view of a laden branch. In format, it recalls the images of fruit-bearing branches characteristic of Pre-Raphaelite and Ruskinian compositions. In Homer's oeuvre, however, such a foreground focus on a very small part of nature is rare. In coloristic terms, it displays more brilliant color than Homer had ever used before. Over brief graphite guidelines, he began by washing in the pale gray-blue sky, reserving the white paper for the house and tree trunk. Broad strokes of saturated tones of orange form the fruit; opaque and transparent greens create the

123 *Orange Tree, Nassau, 1885*

thick, glossy leaves; and lift-out and some form of masking make the white blossoms.

One series of watercolors depicts statuesque palm trees and sisal plants, the only vertical elements in the horizontal Caribbean landscape. The sight of these trees punctuating the wide expanse of beach and sky, giving scale and visual rhythm to the scene, presented Homer with the opportunity to render forms almost solely through calligraphic brush-work. The watercolors range in style from the detailed *Boy Climbing a Coconut Tree* (fig. 125), showing the palm trees' leathery ringed trunks and nut-brown coconuts nestled under crowns of feathery leaves, to the more loosely rendered *Hemp* (fig. 126), in which the tall poles of the elegant sisal trees are suggested by washes from almost black to silver.

Homer's increasingly free use of the medium is evident in watercolors like *Spanish Bayonets* (fig. 124), where he used only a small amount of graphite, relying instead on gestural brushstrokes and washes of ultramarine, green, red, brown-yellow, and yellow of varying degrees of transparency for the plants; Prussian blue (a color he began to use in the Bahamas) for the sea; and tiny strokes of vermilion to articulate the rust-orange distant shoreline, all set beneath a gray-blue sky.

Nature's architecture became a subject for Homer as well: *Glass Windows, Bahamas* (fig. 127) captures the monumental quality of the famous limestone arch that stands eighty-five feet above the sea on the neighboring island of Abaco. He shunned more

124

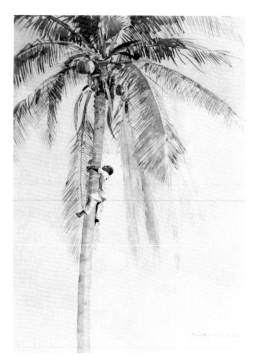

125

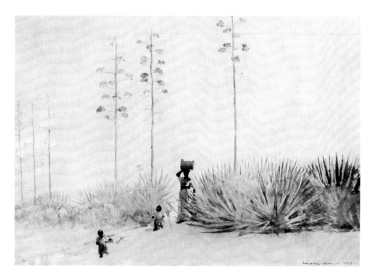

126

124
Spanish Bayonets, 1885

125
*Boy Climbing
a Coconut Tree, 1885*

126
Hemp, 1885

127
*Glass Windows,
Bahamas, 1885*

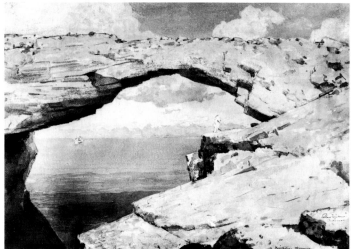

127

dramatic views of the scene when "the setting sun, seen through this opening, looks like a globe of fire in a framework of coral rock," or during a storm, when the Atlantic rises suddenly without warning and washes under the arch and entirely over the island.[15] Instead, Homer portrayed the gray calcareous rock on a calm day, using it as a framing device to enclose the sky, the ocean, and a small ship on the horizon. This juxtaposition of huge, natural arch and tiny ship presages variations on the same theme that he would later execute in Bermuda when he placed tiny, uniformed soldiers on rocks to give a sense of relative scale to the compositions. Despite its arresting composition, however, the rendering of the light striking the rock in *Glass Windows, Bahamas* seems to have presented Homer with some problems, for there is a considerable amount of sponging and reworking throughout, and the attempts at transparent washes are not entirely successful.

Like many watercolorists, Homer occasionally redesigned a painting by cropping the finished work. *Sea Garden* (fig. 130)— the title refers to the much-visited gardens on the eastern end of Hog Island, where the exceptionally clear water makes the bottom distinctly visible— shows a young black man standing in the water, offering a branch of coral to a young woman on a schooner. The focus of the composition is the interaction between the two figures. Originally, however, the sheet was significantly larger, and the scene therefore less insistently narrative. Two fragments exist, one about four inches wide, cut from the left side of the original sheet, and the other about three inches high, cut from the bottom. The vertical section has two palm trees and a sailboat at sea; the horizontal section depicts the lower half of the man's body. The reconstructed composition (fig. 131) reveals a wider view of the water and a more distant, detached conception of the young couple. Homer may have considered the cropped, relatively anecdotal depiction (which was close to contemporary illustrations of Sea Garden) more saleable.[16]

Sponge diving and coral and conch fishing also became pictorial subjects. *The Sponge Diver* (fig. 132) is dated 1889, but as there is no evidence he visited the Bahamas that year, it was probably begun in 1885, its broader, more fluid washes reflecting Homer's increased facility in the intervening four years. This sheet and *The Coral Divers* (fig. 128) represent a bronzelike figure bearing his trophy as he emerges lustrous from the waves. Homer gives these scenes vivid clarity by juxtaposing colors: the stretch of brilliant blue water shot with pale pink reflections from the submerged reefs, the white boat achieved through reserving the paper, and the dusky color of the figures.

The Conch Divers (fig. 129) portrays three half-naked young men leaning over the side of the sloop to meet the diver coming up with a conch shell. The flesh of the conch was a staple of the local diet, and its shell was sold as a marine curiosity in tourist shops, or used for the manufacture of ornaments. Whereas most of the Bahamas watercolors are executed in a free style with fluid pigments and broad brushstrokes, *The Conch Divers* is a relatively finished, tighter work. It is among the most carefully drawn and constructed of the Bahamas watercolors, recalling the Cullercoats compositions in its effective grouping of figures and the rhythmic arrangement of lines. A brown and blue palette (now much faded) predominates, the brownish tan of the boat becoming a darker, richer tone in the

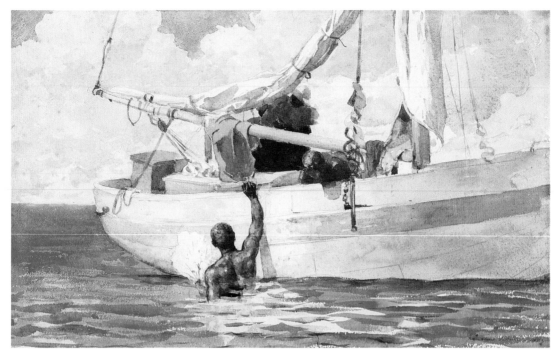

128 *The Coral Divers, 1885*

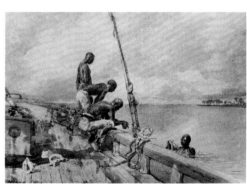

129 *The Conch Divers, 1885*

130 *Sea Garden, 1885*

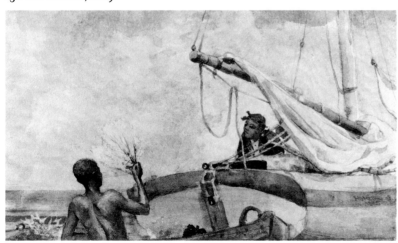

131
*Sea Garden
(reconstructed), 1885*

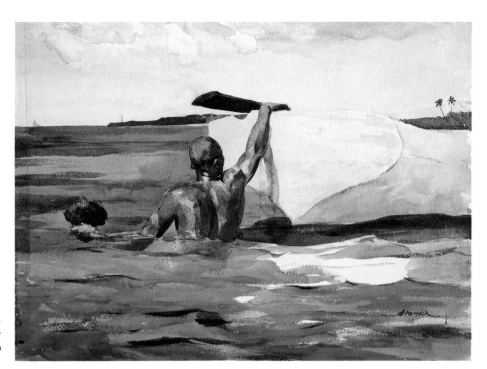

132
*The Sponge
Diver, 1889*

bodies of the men, the bright blue sky a more intense turquoise in the water. The figures
have a sculptural clarity enhanced by the play of warm sunlight on their dark skin. The
pose of the youth in the water apparently presented some problems; pentimenti reveal
that originally his arm was raised, but then Homer scraped it out and placed it in
the water instead. Like Eakins' *The Swimming Hole* (1883; The Fort Worth Art Muse-
um) and contemporary stopped-motion photographs, each of the figures on the deck
appears to embody the movements a single figure might make in rising from a crouching
to a standing pose.

An exception to Homer's usual benign Bahamas subjects is *Shark Fishing* (fig. 137),
which recalls the man-against-nature themes of Cullercoats. Shark hunting was one of
the favorite sports of the local men and the more adventurous visitors. Although tour-
ists were reassured that "along the bathing beaches, where the water is shallow, there
is no more danger from sharks than there is at Coney Island,"[17] shark fishing was none-
theless considered a dangerous activity, and the unexpected sight of a fin gleaming
above the water sent a shiver of terror through the hunter. In *Shark Fishing*, Homer
pitted nature, in the form of a killer shark, against man, and gave both equal weight.
Executed mainly in washes of blue-grays and browns, the watercolor shows two young,
black men in a rowboat holding a line on a huge white shark. The figures' large size and
central placement within the composition, and the flat, stable position of their boat,
suggest a sense of confidence and skill in the face of this treacherous task. As in the most
elaborate of the Cullercoats watercolors, where the figures of the women reiterate the
forms of the boats and sails to create images of power and strength, so in *Shark Fishing*
vigorous design underscores the theme. The shape of the open boat is reiterated in the

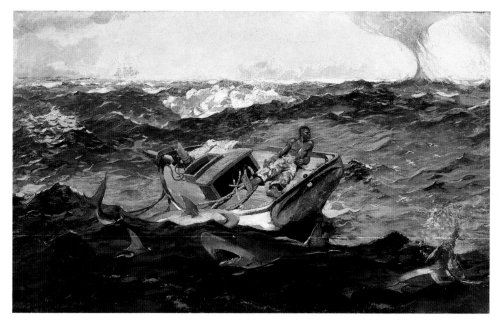

133

134

133
The Gulf Stream, 1889

134
The Gulf Stream, 1889

135
The Derelict, 1885

136
*Study for "The Gulf Stream,"
probably 1885*

137
Shark Fishing, 1885

135 136

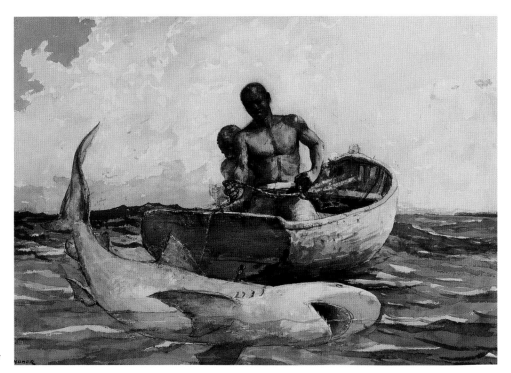

137

body of the open-mouthed shark; the triangle formed by the carefully painted, dark bodies of the men silhouetted against the broad gray sky is balanced by the shape of the shark's high-tipped tail against the horizon. It is a struggle of equals, in formal as well as thematic terms.

Homer varied his interpretation of man in a dangerous natural environment in *The Derelict* (fig. 135). A school of blue-white sharks hovers hungrily around an empty dismasted schooner rocking sharply on its side. The implications seem clear: those once on board are now lost, either drowned or devoured by the sharks, in either case having lost in their struggle against natural forces. In *The Gulf Stream* (fig. 134), dated 1889 but probably begun during his 1885 visit, Homer combined parts of *The Derelict* and *Shark Fishing*, adding the figure of a black man to the deck of the former and borrowing the foreground shark from the latter. This watercolor, and the sketch *Study for "The Gulf Stream"* (fig. 136), served as the basis for the 1899 oil, *The Gulf Stream* (fig. 133).

The inspiration for the watercolors, and ultimately for the painting, may have been the well-known Bahamian tale of "McCabe's Curse," an account of which Homer had clipped from a local newspaper and pasted inside his copy of *Guide to the Bahamas*. The clipping recounts the story of Captain McCabe, commander of the British troops stationed in Nassau in 1814. McCabe was robbed by powerful local thieves, who stripped him of all his possessions. In desperation, he hired a small sailing vessel and set out for one of the neighboring islands, hoping there to hail a passing ship. But his boat was caught in a storm and wrecked, and he was cast shivering upon the island of Abaco. Subsequently he returned to Nassau, where he later died of yellow fever.[18]

Cuba

By mid-February, Homer seems to have felt the need for change. On 17 February 1885, leaving his father in Nassau, he boarded the Ward Line steamer S.S. *Santiago* bound for Santiago de Cuba.[19]

Santiago was the second oldest town in Cuba, a major port for exporting coffee, sugar, tobacco, cotton, rum, copper, nickel, and other goods. Second only to Havana in municipal and financial importance, it had once been a grand city, but by 1885 it had fallen into disrepair following a series of earthquakes and torrential rains. Access to Santiago was either from Havana via ship around the coast, or overland by horse.[20] The difficulty of reaching Santiago, together with its reputation for an unpleasantly humid climate, made Havana the preferred resort of businessmen and tourists. Nonetheless, Santiago charmed visitors with its open-hearted atmosphere and hospitable population, exceptionally picturesque situation, and quaint buildings of Spanish-Moorish character.

Shortly after arriving in Santiago, Homer wrote to his brother Charles from the Hotel Lassus:

Here I am fixed for a month having taken tickets for N.Y. on 8th, leaving 27th of March— this is a red hot place full of soldiers. They have just condemned six men to by [sic] shot for landing with arms, and from all accounts they deserve it— The first day sketching I was ordered to move on until the crowd dispersed— Now I have a pass from the Mayor "forbidding all agents to interfere with me when following my profession." I expect some fine things— it is certainly the richest field for an Artist that I have seen.

At the same time, he complained, "No breakfast until 11, very bad smells, no drains, brick tiles and scorpions for floor and so hot that you must change your clothes every afternoon. I will be very glad to get home."[21]

During the five weeks Homer spent in Cuba, he executed at least eighteen watercolors and a small number of drawings. Perhaps the foreign language and customs, together with the unpleasant living conditions and the heat, made him listless, for unlike the Bahamas watercolors, where every brushstroke seems infused with color and light, the Cuba watercolors, with a few exceptions, seem to lack commitment. The sheets have little of the brilliant light and sense of unpremeditated expression that characterize the best of the Bahamas watercolors, which he had created only weeks earlier. Despite his enthusiastic claims at the outset of his visit that Santiago was "the richest field for an Artist," the series is among the least satisfying Homer made.

What is unusual in these watercolors is Homer's focus on man-made sites, a subject that had never before interested him: views of the characteristic Spanish architecture, the skyline of Santiago against the mountains, and Morro Castle. There are also several watercolors of women in Spanish dress and scenes of cockfights. Generally, the figures are small, conceived as little more than picturesque details. Architecture was indeed the great feature of Santiago. "In few places will the artist or the lover of the odd in architecture

138 *View of Santiago de Cuba, 1885*

139 *Morro Castle, 1885*

find more to interest him." With jutting casement windows and upper balconies held by elaborate wood or iron supports, the small, flanking, polychromatic houses— pink, lavender, salmon, green— were the "delight of sketchers."[22] In at least seven watercolors Homer took views of the streets and colorful buildings. Whereas most guidebooks showed the characteristic long vistas stretching down to Santiago harbor, Homer chose less conventional vantages such as the close-up in *Street Corner, Santiago de Cuba* (fig. 140). His interest in design is evident in the compositional structure of repeated vertical forms and the careful description of the characteristic ornamental ironwork. Despite the warm palette of orange-golds, reds, and blues, his restrained style, minimal exploitation of the white paper, multiple spongings and reworkings, and thin washes laid onto dry

ones, rather than flooded wet-into-wet, robbed the colors of much of their richness and transparency.

Like most tourists to Santiago, Homer visited Morro Castle. Situated on the western edge of the entrance to the harbor, it was reached either by a one-hour ride on a launch, or by traveling on the Old Spanish Road. With its thick walls and sentry walks along the top, parapets, scarps, long flights of worn steps, and dungeons, it is a unique and impressive structure. In *Morro Castle* (fig. 139), the single watercolor he executed of the site, Homer disregarded the usual dramatic view from below and the panoramic view from the harbor, and focused on a small cannon and sentry lookout.[23]

Although the city seemed to constrict Homer's artistic style, a somewhat freer technique is evident in a small series of watercolors made outside the town. *View of Santiago de Cuba* (fig. 138), a vantage probably taken from one of the grassy hills on either side of the city, shows the dome and two towers of Santiago Cathedral, the largest church on the island, silhouetted against the mountains. Homer applied flat, pale washes of gray blue, mustard yellow, and brown-red over a considerable amount of detailed graphite drawing, with short strokes of more saturated color to define the houses and tile roofs. The watercolor reveals Homer's attempts to join, in one work, the needs of architectural description with those of atmosphere and color. This was the principal problem he faced in the Cuba watercolors, and he never successfully resolved it.

If Homer kept to the plan he had outlined in his letter to Charles of "leaving 27th of March," he probably boarded a Ward Line steamer at Santiago on that date, bound for the city of Cienfuegos, the next stop in the circle around Cuba. Here, he may have been reunited with his father who had remained in Nassau until 29 March.[24] The two men arrived in New York on 8 April.

Homer returned to Maine. He worked throughout the summer and fall to complete three oils: *The Herring Net* (1885; The Art Institute of Chicago), *Lost on the Grand Banks* (1885; Collection of Mr. and Mrs. John S. Broom), and *The Fog Warning* (1885; Museum of Fine Arts, Boston). On 5 December 1885, the Century Association opened an exhibition of thirty-six of the Nassau and Cuba watercolors. Four days later, these watercolors and six additional ones were shown at Reichard and Company, Homer's new dealer in New York. The watercolors were exhibited again two months later, in February 1886, at Doll and Richards in Boston.

Grouping the watercolors together as West Indies works, the critics made no distinction in quality between the Bahamas watercolors and those of Cuba, though the only watercolors they singled out for discussion were the Bahamas sheets. The radiant color, fluid handling, and suggestive brushwork of these works came as a shock to an audience that had, little more than a year earlier, hailed the artist for his powers to express the grave and earnest dignity of the Cullercoats fisherfolk through beauty of line, composition, and arrangement. Although most reviewers were disappointed that the Bahamas watercolors were not "complete pictures" like those in the English series but only "memoranda of

140 *Street Corner, Santiago de Cuba, 1885*

travel— mere rapid studies and sketches,"[25] they recognized that Homer's talent was being revealed in a new way. "These brilliant watercolor sketches, flashing with sunlight, strike the attention . . . by their newness," wrote the reviewer for the *Boston Evening Transcript*. "There is immense movement here. . . . Life, vigor, fire— all are here, and the sketch is masterly. . . . In no respect are they pictures, only sketches, and as such they are unusually notable."[26]

But the critics saved their most extravagant praise for the two oils also exhibited, *The Herring Net* and *The Fog Warning*. Whereas the Bahamas sheets, with their greater spontaneity, brighter color, and interest in light, signaled a new departure in Homer's watercolors, the heroic themes, vigorous brushwork, and somber palette of these oils continued the style of the Cullercoats watercolors. Not until the great seascapes of the 1890s would the advances he made in watercolor appear in oil.

Unlike the previous shows of his Gloucester and Cullercoats watercolors, the exhibitions of the Bahamas and Cuba watercolors resulted in only moderate sales. The New York and Boston shows together sold about twelve to fifteen works, at prices around $75; the yield to Homer was about $1,000.[27]

Although these modest sales indicate that the public was less than enthusiastic about the novel subject matter, loose brushwork, and the new colorism in the tropical water-

colors, the critics were more sympathetic: "Only sketches . . . [but] unusually notable."[28] Homer was again reaping the benefits of the positive critical response to Impressionism in America. While clearly not impressionist in the French sense, his watercolors had been labeled as such by American reviewers after suggestiveness and pure color had become desired hallmarks of modern art. The shift in critical taste meant that although his watercolors might occasionally be dismissed as unimportant art, they would rarely again be censured for their unfinished or sketchy character.

While the Bahamas and Cuba watercolors were on exhibition, Homer was already in Florida, working on his second set of tropical watercolors.

Notes

1 The article was published more than two years later: William C. Church, "A Midwinter Resort," *Century Magazine* 33 (February 1887), 499–506. Nine illustrations by Homer are included. The articles in the *New York Times* were written by William Drysdale (as "'W. D.' Letter") and were published regularly from 22 June to 23 November 1884.

2 See, for instance, Charles Ives, *The Isles of Summer or Nassau and the Bahamas* (New Haven, 1880); and William Drysdale, "In Sunny Lands: Out-Door Life in Nassau and Cuba," *Harper's Franklin Square Library*, no. 490 (18 September 1885), 16. The latter was based on his articles for the *New York Times* (see n. 1, above).

3 Ward's steamships bound direct for Nassau left New York every Thursday. The *Nassau Guardian*, Wednesday, 10 December 1884, announced that the Homers had arrived in Nassau on Monday, 8 December.

4 Homer was not the first American artist to visit the Bahamas. Thomas Moran visited in the late 1870s, and during the 1870s and 1880s Albert Bierstadt periodically visited Nassau where his wife, who suffered from chronic consumption, regularly wintered. During these stays, he executed a number of oil paintings and sketches of the islands. Mrs. Bierstadt was listed as a guest at the Royal Victoria Hotel the same winter as the Homers and probably knew both men. Several of Bierstadt's Bahamas sketches were exhibited in Nassau in December 1885, a year after Homer's visit. These were included in the first loan exhibition of art held in the West Indies. "To the lover of art, the exquisite sketches of Mr. Bierstadt, so kindly lent by Mrs. Bierstadt whom we welcome back to our shore, are an education in themselves"; *Nassau Guardian*, 9 December 1885.

5 Established in 1695 under a provisional English government, Nassau was the capital of the Bahamas and the center of all exports from the islands. During the American Civil War, Nassau had served as a center for gunrunning and other clandestine confederate activities; see S.G.W. Benjamin, "The Bahamas," *Harper's New Monthly Magazine* 49, no. 294 (November 1874), 762. Southern families fled to the islands, bringing their slaves and building large plantations (which many of them later abandoned). It was during these prosperous years that substantial buildings like Government House and the Royal Victoria Hotel were erected. As guests at the hotel, Homer and his father were automatically considered part of the island's fashionable circle and would have been invited to most social occasions. The *Nassau Guardian*, 3 January 1885, noted that among the guests who were honored with invitations to the annual Children's Fancy Dress Ball at Government House was "Mr. Homer."

6 Drysdale, "In Sunny Lands," 6.

7 During the eighteenth and early nineteenth centuries, a number of Spanish slave ships had been captured and brought to Nassau by the English. As recently as the middle of the nineteenth century, a cargo of three hundred African slaves arrived in New Providence, where they were granted freedom and given individual plots of land in black "settlements" adjacent to the city. The relationship between the races on New Providence, although not as controversial an issue as in America, was nonetheless, a complex one. As one observer noted, it was "neither . . . that of Southern states, nor . . . quite that of the

West Indies. It lacked the exclusiveness of the former, and the equality of the latter"; see George J.H. Northcroft, *Sketches of Summerland* (Nassau, 1900), 64.

8 Mrs. Frank Leslie, *Frank Leslie's Illustrated Newspaper*, 25 May 1878, 204.

9 Leslie, *Illustrated Newspaper*, 6 July 1878, 307.

10 Drysdale, "In Sunny Lands," 24, was so taken with this form of roofing that during one of his extended visits to the islands he built himself an "African hut" and recommended the experience to his readers: "It is really the most sensible house-covering for this climate. No rain, nor wind, nor cold, nor moisture nor anything else can go through it. It keeps off the sun, and makes as healthy and comfortable a house as anybody could want."

11 Almost every article on the Bahamas written in the nineteenth century discusses the sponging industry; see also, *The Sponging Industry*, booklet of the Exhibition of Historical Documents, Nassau, February 1974.

12 The sponge was sold in Nassau to buyers from London, Paris, and New York who would assemble every Monday morning on the Nassau wharf in order to bid on the week's catch.

13 See Drysdale, "In Sunny Lands," 30.

14 Leslie, *Illustrated Newspaper*, 1 June 1878, 220.

15 For the passage quoted, see Louis Diston Powles, *The Land of the Pink Pearl* (London, 1888), 73. In 1872 an extraordinary tidal wave rose at the Glass Windows, carrying away several young people.

16 *Sea Garden* was acquired by the great Boston collector Grenville L. Winthrop from Knoedler's in February 1911, and given to the Fogg in 1943. The fragments were given to Samuel A. Chapin in May 1911 as a memento of the artist, by Charles Homer, who took them down from a wall of Homer's bedroom in the studio at Prout's Neck; information in a note written by Chapin, dated 21

August 1911; Collection of the Yale University Art Gallery. The fragments were later acquired by Allen Evarts Foster who bequeathed them to Yale in 1965. The fragments were identified by the author.

17 Drysdale, "In Sunny Lands," 17.

18 The clipping is pasted into *An Almanack for 1884 (Leap Year), with a Guide to the Bahamas, Nassau Directory, etc.* (New Providence, Nassau); Bowdoin. Homer not only changed the character but— at least verbally— the ending as well. When pressed for information regarding the fate of the black man in *The Gulf Stream*, Homer asked his dealer to reassure viewers that the man "will be rescued & returned to his friends and home, & ever after live happily." Letter of 19 February 1902; Knoedler Archive.

19 *Nassau Guardian*, 18 February 1885. Homer's father remained in Nassau for another month.

20 The first railroad line between Havana and Santiago de Cuba (eighty-five miles) was begun in 1900.

21 Undated letter, Bowdoin. Among other American artists who visited Cuba in the early 1880s was Thomas Moran, who came in 1883 but concentrated on views of Havana.

22 *Terry's Guide to Cuba* (Havana, 1929), 393.

23 The monumental oil *Searchlight, Harbor Entrance, Santiago de Cuba* (1901; The Metropolitan Museum of Art) was based on drawings made in 1885. Homer began working on the composition in 1899 when the Spanish-American War brought Santiago Harbor to wide public attention; Beam 1966, 220.

24 *Nassau Guardian*, 1 April 1885.

25 Mrs. Schuyler (Mariana Griswold) Van Rensselaer, *American Architect and Building News* 19, no. 530 (20 February 1886), 89.

26 *Boston Evening Transcript*, 25 February 1886, 6.

27 Goodrich 1944, 101.

28 *Boston Evening Transcript*, 25 February 1886, 6.

Florida and Prout's Neck

1885–1890

Florida 1885–1886

In the mid-1880s, Florida was becoming a winter mecca, in part the result of Henry Flagler's railroads into the area. Beginning in December, streams of northern tourists eager to escape the bitter cold descended on the "Land of Flowers," many remaining until the end of April. "In Florida," wrote one enchanted visitor, "the rest of the country has found its Persian gardens."[1]

Between 1885 and 1909, Homer made seven winter visits to Florida, primarily to fish. On only three of these trips (1885–1886, 1890, and 1903) did he work in watercolor, and each group presents a different vision of the state. In the 1885 watercolors, executed in Tampa and Key West, Homer focused on tourist scenes; in 1890, we catch a glimpse of the fisherman's Florida, at Enterprise and along the St. Johns River; the 1903 works offer a prolonged look at the boats in Key West Harbor, as well as a more emotionally charged and penetrating study of fishing.[2]

Arrival and departure dates as well as the exact itinerary of Homer's first trip are uncertain. In 1885 travel to Florida was either by rail or steamship. Given Homer's preference for the sea, it seems likely that he would have chosen the ocean route, probably taking the Mallory Steam Ship Line from New York, the line recommended by almost every late nineteenth-century guidebook to the state.[3]

The evidence of the dated watercolors of the 1885–1886 visit suggests that Homer traveled as far as Jacksonville, the main terminus of the line and the place where most visitors began their stay in Florida, and then crossed to Tampa by railway before descending southward to Key West by one of the several different steamship lines. The earliest dated watercolor from this trip, *At Tampa* (fig. 143) is inscribed *Tampa Fla/1885*. A second Tampa watercolor, *Spanish Moss at Tampa* (fig. 142), is inscribed *Tampa, Fla/W.H. '86*. Of the Key West watercolors, none is dated 1885, one is dated *January 1886*, and the others *1886*, which suggests that Homer traveled first to Tampa and then to Key West. Arriving in Tampa in December 1885, he could have remained there for a few weeks, until sometime in January 1886, when he sailed for Key West.[4] He probably remained in Key West until late February, and then returned to Jacksonville either overland via Tampa or by sailing directly back along the coast.[5] On 24 February 1886, Homer's fiftieth birthday, the *Florida Times Union* listed the Homers and Lawson Valentine as among

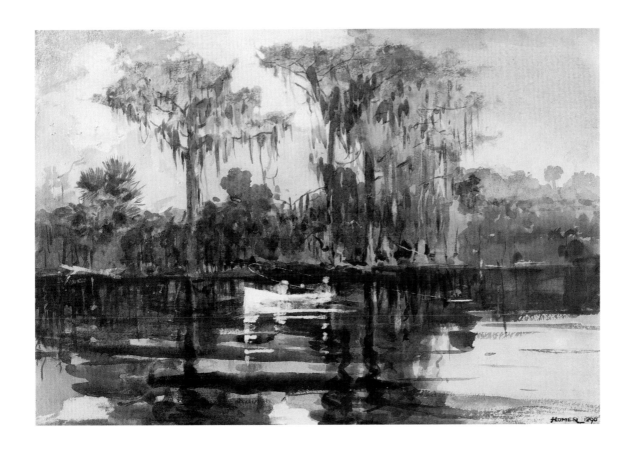

141 *St. Johns River, Florida, 1890*

142 *Spanish Moss at Tampa, 1886*

143 *At Tampa, 1886*

the arrivals at the elegant St. James Hotel in Jacksonville. Sometime after, the Homers returned to New York.

Each of the places Homer visited on his first trip had a distinctive character. Jacksonville, located on the St. Johns River, was the largest city in the state and its commercial and social center. During the winter it became a haven for an international group of visitors, with 85,000 seasonal guests arriving in 1884. Described variously as the "American Nice," the "southern Newport," or the wintertime alternative to Long Branch, Jacksonville was a handsome and prosperous city of wide streets shaded by long rows of live oaks, forming arcades of green. In the winter, when all the hotels were filled with guests, it offered an animated and picturesque environment.[6]

By contrast, Tampa was a small, somewhat remote community of about 1,500 inhabitants, and held little attraction for wealthy tourists. Quaint and old-fashioned in appearance, its attractions seemed to consist of "history, scenery, oranges, fish, and [Indian] mounds."[7] Many of the visitors to Tampa were sportsmen drawn by the excellent hunting and fishing often guaranteed by contemporary guidebooks. Although it was probably Homer's fondness for angling that led him to visit Tampa, none of the six or seven watercolors he produced there shows a fishing subject.

Key West, like Tampa, was famed for fishing; its waters held nearly every variety of fish found in Florida.[8] Situated in Monroe County, on Key West Island, it was a large and wealthy city with an economy based on cigar manufacturing, boat salvaging, sponging, fishing, and turtling. The population consisted mainly of Cubans and Bahamians, but

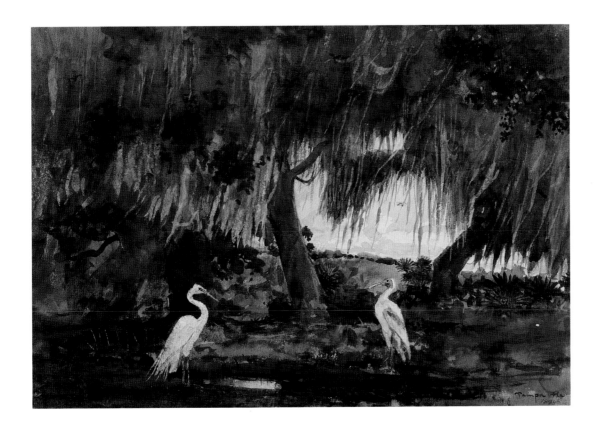

there were also English, French, Germans, Spaniards, and Italians. At the time Homer visited the island, it was linked more closely, both economically and culturally, to Europe, Cuba, New York, and New Orleans than to the Florida mainland. These connections lent the city a cosmopolitan flavor. "Everything in and about Key West is strange, foreign, and interesting. The business houses and public buildings, the dwellings, the gardens, lawns, flowers, trees, soil, and vegetation, the appearance of the people, their costumes, and even their names, all are so un-American and suggestive of a foreign clime, that it is difficult indeed to realize it as one of the busy, enterprising cities of our United States."[9]

The twelve or so watercolors Homer made on his first Florida trip are as diverse as the places he visited. Most of his subjects were also treated by guidebook illustrators, yet there were other subjects popular with the illustrators that he completely ignored. He eschewed famous tourist sights such as Jacksonville's Sub-Tropical Exposition and Harriet Beecher Stowe's house. And despite the picturesque character of many Florida buildings, little architecture of any sort appears in these 1885–1886 watercolors. The commercial activities so common in the guides— farming, turtling, and sponging— are not represented at all, even though Homer had essayed the latter two themes in the Bahamas series. And, as usual, despite the fact that he was staying at the most elegant hotels, fashionable people and their activities are absent from the watercolors. Homer did, however, share with the guidebook authors a fascination for coconut palms, alligators, exotic birds, live oaks, hurricane-swept palms, palmetto jungles thickly hung with Spanish moss, distant vistas of Key West, women under palms, and Indians in the swamps. Rare was the guidebook

144 *Coconut Palms,
Key West, 1886*

that did not offer florid descriptions of roseate spoonbills, scaly alligators, or still rivers bordered by dense growths of pine and palmetto. It is, in fact, relatively easy to find prose equivalents for most of Homer's 1885–1886 Florida images.

But though Homer chose to depict similar subjects, he took a different vantage. Where-as guidebook illustrators usually provided the spectator with a safe spot from which to view the scene, Homer often placed him in a perilous natural environment— suspended above a body of water, plunged into brackish water beside an alligator, or lifted into the fronds of a coconut palm. The manipulation of the viewpoint was one of Homer's most powerful devices for subtly heightening the emotional impact of a scene.

Coconut Palms, Key West (fig. 144) presents not a grove seen from a distance, but a single tree from the topmost fronds and coconuts. Even in this dramatically cropped, obviously artful composition, however, Homer does not deprive the viewer of any impor-tant information: the shapes of the trunk and fronds are given in the two more distant trees that fill the right half of the composition. Executed with calligraphic brushwork in a

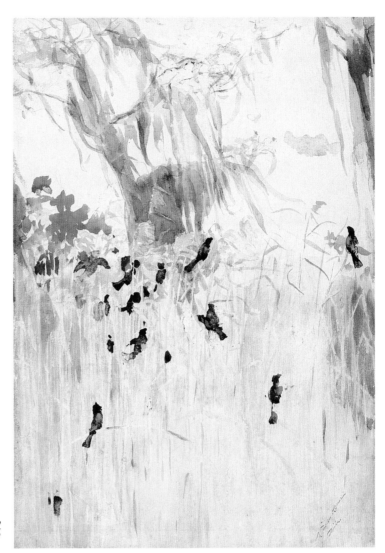

145 *Redwing Blackbirds,*
1886

range of rich green washes, with some of the fronds achieved by lift-out, and in brown-red and mustard yellow washes for the coconuts, the watercolor successfully conveys the dense luxuriance of the jungle.

In a Florida Jungle (fig. 146) represents an early instance of Homer's preoccupation with mortality in nature. In the foreground an alligator juts its snout out of the still, brackish water. Its eyes seem to be fixed on the roseate spoonbill that stands on the bank, unaware of any danger. Originally the alligator too was on the beach; traces of his raised snout are visible in the foliage at the shoreline. Similarly, a faint silhouette of the bird appears to the left of its present position. But Homer's final arrangement of the two natural enemies is more compelling. By cropping the sheet across the bottom, he places the viewer immediately next to the alligator that stares at its prey. We are thus forced to contemplate the last moments in the life of the innocent bird. In the following years, Homer would repeatedly make the viewer confront a living creature that is about to die.

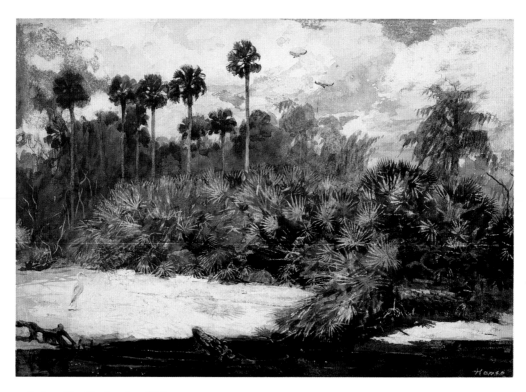

146 *In a Florida Jungle, 1886*

The Florida watercolors encompass a range of techniques from the complex layerings and subtractive methods of *In A Florida Jungle* (fig. 146), to such delicate works as *Redwing Blackbirds* (fig. 145), which was rapidly painted with transparent washes of the palest colors. The loose and increasingly expressive style in the Bahamas watercolors is further developed in certain of the Florida works. In *Spanish Moss at Tampa* (fig. 142), narrow strokes of ever darker gray against a medium gray sky for the dripping moss on the trees, broader strokes of pink-grays for the silvery sea, and watery sienna grays for the foreground evoke the haunting moisture-laden quality of the scenery. *A Norther—Key West* (fig. 147) captures the effect of a gale force wind in the tropics through its directness and calligraphic brushwork. With a limited palette of gray-green washes— as if the artist had had no time for more colors— the composition conveys a sense of unpremeditated execution and authenticity.

In *At Tampa* (fig. 143), luxuriant gray-green moss sweeps low from the live oak branches. The focus is on the two birds standing watchfully in shallow pools of salt water. The yellow bill, long neck, and snow-white feathers of the common egret at the left, and the light and darker pinks of the roseate spoonbill at right, provide flashes of color in the shaded grove. The birds' plumage is a brilliant contrast to the rich, muted tones of the foliage. *At Tampa* is an ambitious watercolor: layered washes in a narrow range of tones; the exploitation of accidental effects as in the floodings of wash in the lower left; the description of the dripping moss through positive and negative forms and through rewetting and lifting existing layers of paint; and the interest and variety of the whites on the

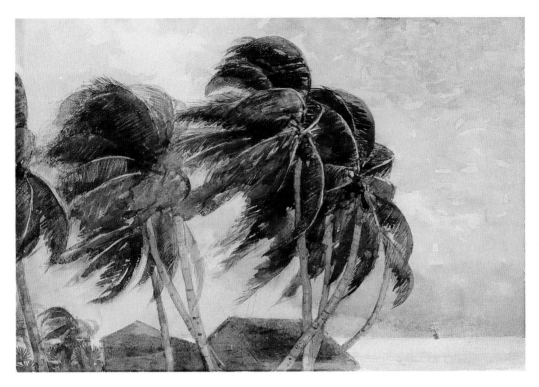

147 *A Norther— Key West, 1886*

sheet— scraping for the body of the egret and reserving the paper for the spoonbill and the clouds.

Prout's Neck 1887

Homer returned to New York in late February or early March 1886, in time to read the mixed reviews of the exhibitions of the Bahamas and Cuba watercolors and to learn the somewhat disappointing news about the shows' modest sales. In Maine he began work on two major oils, *Undertow* (1886; Sterling and Francine Clark Art Institute, Williamstown) and *Eight Bells* (1886; Addison Gallery of American Art, Phillips Academy, Andover, Massachusetts). Somewhat discouraged about sales in general, he wrote to his sister-in-law in December 1886 from Prout's Neck, lamenting the "standing on one leg, one day, and another leg, some other day, and looking in vain for profits."[10] To the American Water Color Society exhibition in January 1887 he sent two Florida watercolors, both listed as in the collection of C.S. Homer, one of which was *Thornhill Bar* (1886; Museum of Fine Arts, Boston). Except for the reviewer in the *Critic*, who called them "striking impressions," most critics found the watercolors "unimportant and not particularly attractive."[11] The response to the Florida works was much less sympathetic than the more cautious praise given to the Bahamas watercolors in 1885. By contrast, the major oil *Undertow*, exhibited a few months later at the National Academy, was lavishly praised.[12] Nevertheless, like almost all his oils, it was not quickly sold.

In Prout's Neck, Homer turned again to watercolor as an easier way to earn money.

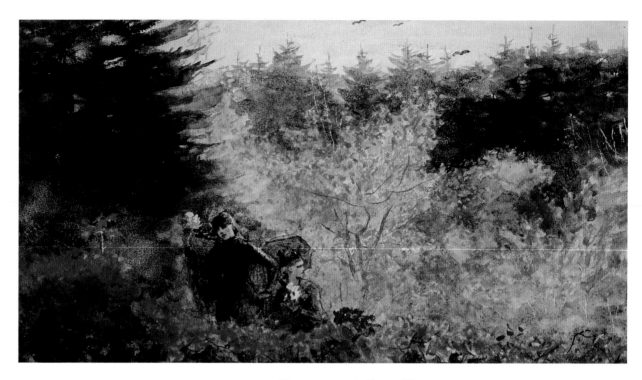

148 *Woods at Prout's Neck, 1887*

In September 1887 he wrote Charles: "I am very busy painting in watercolor which means something that I can sell for what people will give," but lest Charles should worry, he added, "I have money in plenty."[13] The watercolors he was working on included scenes of rocks and breaking surf, Prout's Neck fishermen at sea and on land, women on the shore and in the woods, and farm boys in fields.

The seascape watercolors reveal both the limitations and the freedom of Homer's use of the medium. Although he had, with seeming ease, caught the dazzling light and sparkle of Caribbean waters, he continued to be less successful in rendering the power of the northern Atlantic with its violent bursts of spray and long rhythm of the breakers. Much of the force of Homer's great oil seascapes of the 1890s comes from the vigorous brushwork for which the weight and density of oil paint are appropriate. The delicacy and transparency of watercolor, by contrast, are better suited to express suggested rather than raw power.

Perhaps for this reason, the most effective of the 1887 watercolors are views that do not take in the sea or coastline. In *Woods at Prout's Neck* (fig. 148) and *Among the Vegetables* (fig. 149) Homer's pleasure in pure color is evident. The surface is alive with a range of saturated hues in orange, red, yellow, dark green, blue, violet, and brown, all applied with robust, spirited brushstrokes.

During this period Homer resumed illustrating for a time, redoing fifteen of his wartime sketches for the *Century Magazine*, which was publishing a series of articles on the

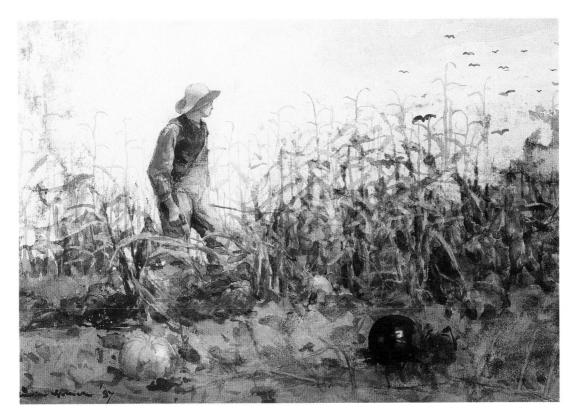

149 *Among the Vegetables, 1887*

Civil War. Possibly due to the current etching craze in America, and to his wish to reach a wider audience, he also began work on several large etchings taken from his recent oils and the English watercolors.[14] In February 1888, he sent six watercolors to the American Water Color Society exhibition— three from his 1885 visit to Florida, and three executed at Prout's Neck in 1887. Perhaps because his Florida subjects now seemed more familiar, the critics were generally more enthusiastic than they had been the previous year: "Homer's Florida subjects and his farm-lad gathering pumpkins are in his best manner— at once impressionistic in feeling and decorative in quality," stated the *Critic*.[15] The *Nation's* reviewer considered Homer the "most original of all the painters represented . . . not so much in mere choice of subject as in his manner of presenting it artistically."[16]

In April, Homer sent *Eight Bells* to the Academy, where it was much praised and bought by the collector Thomas B. Clarke, who would become one of his foremost patrons. From this time on, Homer stopped showing regularly at the Academy and the Water Color Society, relying instead on his dealers.

Florida 1890

In early February of 1890, Homer left the bitter Maine winter for a vacation in Florida. He had not visited the state for four years. This time he went to Enterprise, a resort

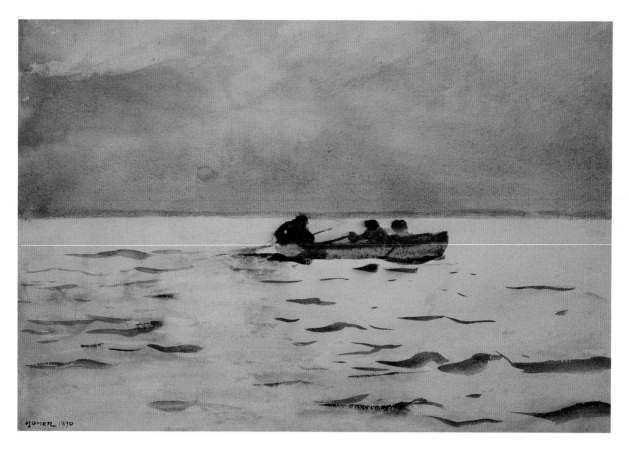

150 *Rowing Home, 1890*

renowned for fishing on the St. Johns River. Writing to Thomas B. Clarke from the Brock House Hotel on 16 February, Homer described Enterprise as "the most beautiful place in Florida."[17]

The watercolors Homer produced during his stay in Enterprise (at least eleven are known) show a vision of the St. Johns River as seen through the eyes of an angler. Painted in tonal harmonies of gray, green, and blue, or in the muted pinks and yellows of sunset, full of delicate nuances as well as resonant tones, they are quiet pictures, more suffused with atmosphere than almost any watercolors he had executed to date, their restful formats emphasized by the wide, horizontal expanses of calm water in the foregrounds. Action is kept to a minimum; only the slightly bent back of a fisherman or the taut arching of a fishing rod hint at physical exertion. With a single exception, the watercolors depict men fishing from rowboats, or from stands of tall green palmettos seen from the water.

St. Johns River, Florida (fig. 141), showing two fishermen in a boat, catches the character of the narrow channel at the beginning of the lower St. Johns, where the water is darker and the shores covered with live oaks, cypresses, and other vegetation, all interlaced with huge vines and draped with Spanish moss. Homer laid multiple, transparent

layers of greens and blues onto deep violet-browns to suggest the tropical foliage and its reflection in the dark water, while decisive brushwork enhanced accidental effects like those formed by the touches of fluid color in the dripping moss. He used scraping boldly (the whole boat has been gouged out) to create texture, catching the light in a more aggressive manner than if he had merely reserved the paper from paint.

Compared to the varied palette and complex technique in *St. Johns River, Florida, Rowing Home* (fig. 150) has an almost oriental simplicity. Fluid washes of subtly orchestrated values and loose brushwork evoke a scene of transcendent beauty. The flame of the setting sun coloring the clouds is reflected in the water, iridescent and luminous, casting tones of russet and gold, vermilion and violet, silver and blue. The three figures in the boat, darkly silhouetted against the water and placed below the horizon line, seem one with the shining stillness.

Notes

1 George Canning Hill, "Florida for the Winter," *New England Magazine* 6 (March 1888), 215–216.

2 Homer was not the first important American artist to visit Florida. John James Audubon traveled to Key West in 1832; Martin Johnson Heade settled in St. Augustine in 1884, and remained until his death in 1904; R. Swain Gifford completed a series of Florida pictures for articles published in *Harper's New Monthly Magazine* in 1884 and 1885; Frederic Remington went there to illustrate the article "Cracker Cowboys in Florida" for an 1895 issue of *Harper's*; and in the early 1890s, George Inness spent a considerable part of each year in Tarpon Springs where he had a house and studio.

3 See for example, George M. Barbour, *Florida for Tourists, Invalids, and Settlers*, rev. ed. (New York, 1884), 303–304.

4 For different versions of Homer's itinerary in Florida in 1885–1886, see Hendricks 1979, 184–185; Patti Hannaway, *Winslow Homer in the Tropics* (Richmond, Virginia, [1973]), 88–90; and *Winslow Homer's Florida, 1886–1909* (exh. cat., Cummer Gallery of Art, Jacksonville, Florida, 1977), 17.

5 In addition to the Tampa and Key West subjects, several watercolors indicate that Homer took side trips, although when or how he reached the sites is not certain. *Thornhill Bar* (1886; Museum of Fine Arts, Boston) may represent the fishing camp of that name near Tampa. Guidebooks and Florida itineraries, outlined in sporting magazines, regularly recommended visiting the St. Johns River on the journey between Jacksonville and Tampa. *Indian Hunter in the Everglades* (probably 1886; Museum of Fine Arts, Boston) suggests another trip. Homer could have made the excursion from a number of points: sailing over to the swampy mainland from Key West (the route recommended by a number of guidebooks); sailing into the region on his way from Tampa to Key West; or traveling the inland route by ascending the St. Johns River to its headwaters and then traveling farther south into the Everglades.

6 Barbour, *Florida*, 92.

7 James Wood Davidson, *The Florida of To-Day: A Guide for Tourists and Settlers* (New York, 1889), 97.

8 Charles Stillman, "Angling in Florida," *Forest and Stream* 70 (1908), 540.

9 Barbour, *Florida*, 152.

10 Bowdoin.

11 *Critic* 7, no. 162 (5 February 1887), 69. For the other responses, see Mrs. Schuyler (Mariana Griswold) Van Rensselaer, *American Architect and Building News* 21, no. 587 (26 March 1887), 148; *Nation* 44 (10 February 1887), 128; *New York Daily Tribune*, 29 January 1887, 4.

12 Typical was the review in the *Nation* 44 (14 April 1887), 327: "*Undertow*, by its virility, its truth, its sincerity of intention, outranks every picture in the . . . exhibition."

13 Bowdoin.

14 The etchings are *Eight Bells* (1887); *Perils of the Sea*, *Mending the Tears*, and *A Voice from the Cliffs* (all 1888); *Saved* and *Fly Fishing, Saranac Lake* (both 1889). In 1884 Homer had published an etching after *The Life Line*; and in 1886, one after *Undertow*.

15 *Critic* 9 (4 February 1888), 58.

16 *Nation* 46 (23 February 1888), 163.

17 Archives of American Art.

Adirondacks

1889–1900

Homer's preference for fishing vacations also took him in the summer and fall to private preserves in the northern wilderness— first in the Adirondacks and later in Quebec. In these environments, he was part of that group of affluent gentlemen at the end of the nineteenth century who supported their passion for shooting and angling with the earnest and persistent claim that such vacations were essential for a man's well-being.[1] Charles Hallock, called the dean of American sportsmen, summarized the sportsman's value to society: "We will esteem him for his aesthetic tastes, and his selection of a pastime which invigorates, humanizes, educates, and ennobles— which hardens the muscles and stimulates the brain."[2] Such passages did not address the humble man of rural America. They were directed at businessmen whose interest in sporting was more than a matter of physical recreation. Thus, when former President Cleveland referred again and again to "the fishing fraternity," in only one sense did he mean a group of men who liked to fish. More accurately, this fraternity described the power network of the United States: bankers, industrialists, attorneys, and judges.[3] Cleveland adamantly defined the constituency of the group: "We certainly have nothing in common with those who fish for a livelihood, unless it be a desire to catch fish."[4] He carefully pointed out that the term angler applied only to "those of us who fish in a fair, well-bred and reasonable way, for the purpose of recreation and as a means of increasing the table pleasures of ourselves or our friends."[5]

It was among these anglers that Homer sought recreation, and it was their playgrounds which formed the settings of his Adirondacks and Quebec watercolors. These men, too, were among the most enthusiastic collectors of his watercolors. Homer's greatest patron, Thomas B. Clarke, perfectly fits this pattern. He was a prominent member of numerous New York social clubs and a strong Republican. His first art purchase was probably Wakeman Holberton's *Brook Trout*, which is said to have appealed to Clarke's sportsman's sensibility.[6] In large measure, Homer shared the outlook of his patrons. He was, wrote one of his admirers, "a Bostonian by birth and a Cosmopolite by habit." "[He] was the essence of gentlemanly elegance. . . . He might have been taken for a successful stock broker," said another.[7] Yet the Adirondacks Homer most often painted was from the vantage of the solitary, rugged woodsman and guide.

By the time Homer first visited the Adirondacks in 1870 the area had become familiar to the gallery-going public through the paintings of Arthur F. Tait, Alexander H. Wyant,

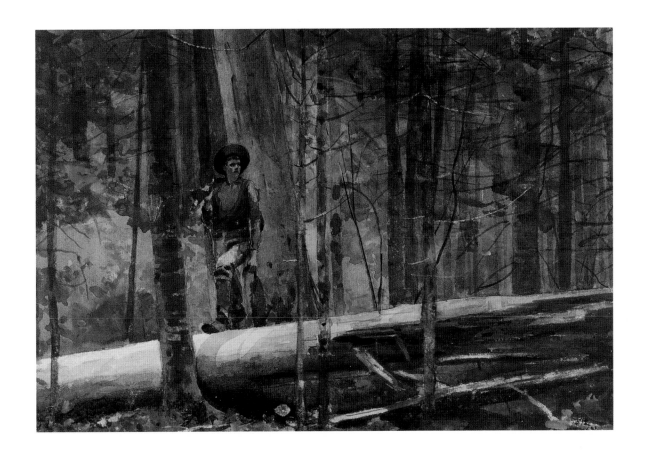

151 *Hunter in the Adirondacks, 1892*

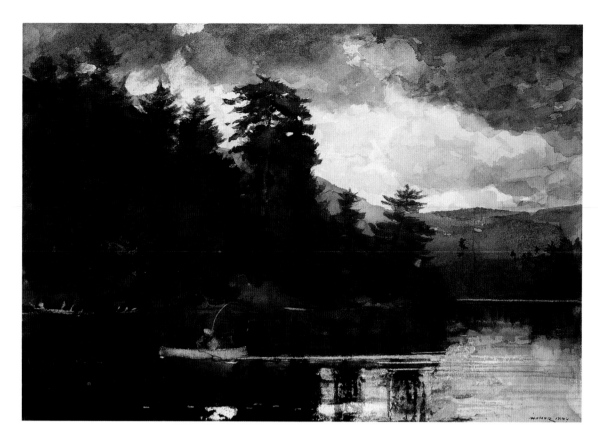

152 *Adirondack Lake, 1889*

Robert C. Minor, Roswell M. Shurtleff, and others. In 1863 Currier and Ives further popularized the area with the publication of a series of hunting scenes based on paintings by Tait. The Adirondacks Wilderness, as it was called, had opened in earnest as a recreational site in 1849, with the publication and huge success of Joel T. Headley's *Life in the Woods*.[8] After the construction of short railroad lines into the region, thousands of people flocked there, having read of the seemingly infinite stock of fish and game. Others came because Headley reported that life in the woods cured a variety of diseases.

By the early 1850s, hotels had begun to appear, usually operated by backwoods families, who also found work as guides. The richness of the wilds also stimulated the development of lumbering as an industry. With its forests, mountains, lakes, and streams, the region was a wealthy storehouse of iron and timber, and fortunes were made.

Isolated cries for conservation began to be heard as writers and editors urged caution and the replacement of the resources being rapidly exhausted.[9] Best-selling books with exciting tales of hunting and fishing continued to appear, however, filled with campfire philosophy and arguments for the necessity of shooting deer.

During the 1870s, the most influential book about the area was *Adventures in the Wilderness*, by the Reverend William Murray ("Adirondack Murray").[10] Following Joel Headley's approach, Murray told the simple story of a city man who went into the woods

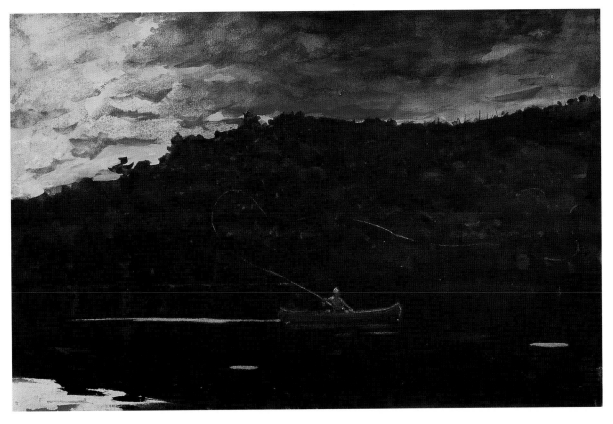

153 *Sunrise, Fishing in the Adirondacks, 1892*

to fish and hunt, met with an extraordinary guide, then advised other city people to do the same to gain new health and strength. Murray's book had a phenomenal effect and the periodical *Every Saturday* published excerpts, with illustrations by Homer Dodge Martin.

By 1873, the railroad— probably the major factor in opening the wilderness to tourism,[11] had penetrated deep into Adirondacks country, and the woods had become so popular that, as one writer to the *New York Times* lamented, "[the Adirondacks has] fallen from that estate of fish and solitude for which it was originally celebrated. . . . The desert has blossomed with parasols and the waste places are filled with picnic parties, reveling in lemonade and *sardines.*"[12] Even so, there remained enough relatively unspoiled rivers, lakes, mountains, and forests, to attract anyone who loved outdoor life.

In 1886 Homer and his brother Charles were among the twenty charter members of the North Woods Club, a private hunting and fishing preserve established on a newly purchased clearing known as Baker's Farm and on the surrounding land on the shores of Mink Pond, a few miles from Minerva, New York. Over the next two decades Homer visited the club at least eleven times, his stays lasting anywhere from one week to more than two months.[13] These visits combined sport and art. Of the approximately eighty-seven watercolors he executed of Adirondacks subjects, most were painted or at least

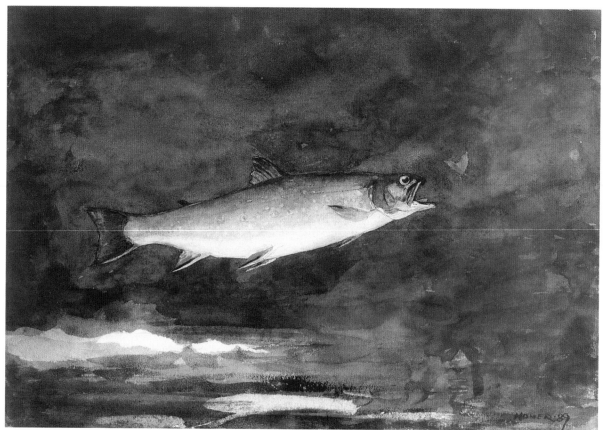

154

155

154 *Leaping Trout, 1889*

155 *Leaping Trout, 1889*

156 *Boy Fishing, 1892*

157 *Adirondack Catch, 1889*

begun at the North Woods Club between 1889 and 1900, with the period of greatest activity from 1889 to 1894.

Homer's Adirondacks watercolors are among the masterworks of his career. Beginning with the large series of 1889, they mark a new stage in his artistic development. In the context of his own work, these watercolors reveal a new brilliance and technical complexity. Rapturous and wonderful color betray his intense response to nature, every movement of the brush not only a record but a self-revealing gesture. Taking an already

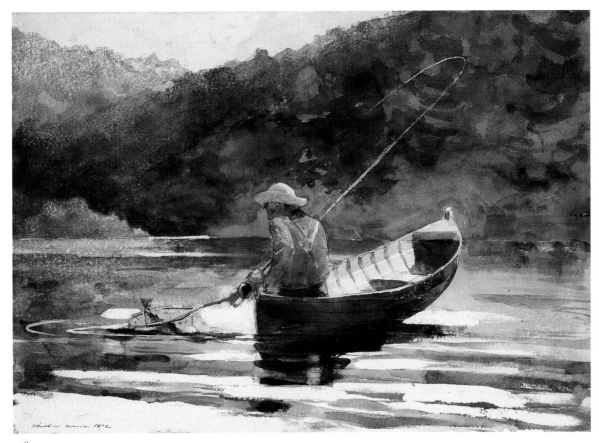

156

157

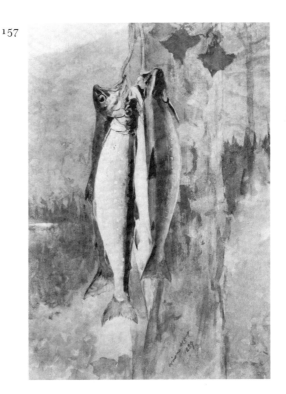

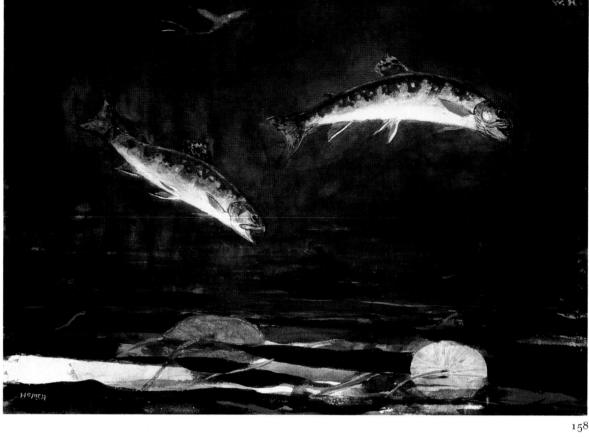

158

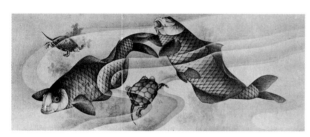

159

158 *Leaping Trout, 1889*
159 *Hokusai. Carp, 1813*
160 *Mink Pond, 1891*

popularized environment, Homer rearranged and synthesized the elements into a personal expression. In the end, he painted not so much the thing but the effect it produced.

At the same time, Homer brought to the watercolor medium itself an extraordinary freedom and bravura. With a heavily loaded brush, he laid in areas of color that were remarkably broad compared, for example, to those in the work of the Englishman David Cox, who confined heavily loaded strokes to small areas, or to that of John La Farge, who painted in patches rather than using layers of transparent washes. With sensuous color and decorative patterns, Homer evoked an astonishing sense of physical immediacy and self-forgetfulness.

Watercolor was perfectly suited to these moods. Layers of transparent color could create a sense of mystery; suggestive and allusive, the medium allowed the general to

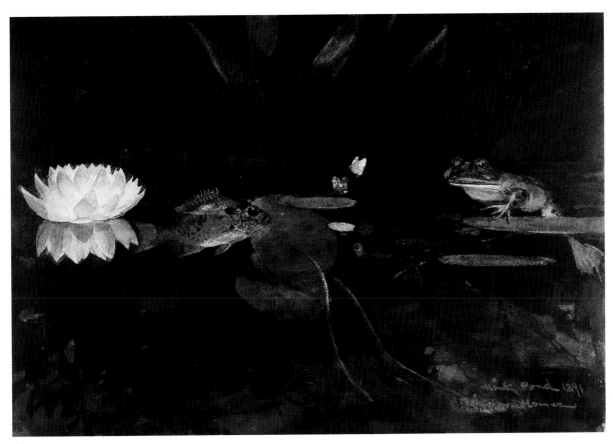

160

emerge from the particular. It encouraged him to exploit fully the play of reflected and refracted light, developed in combinations of opaque and transparent colors. In *Hunter in the Adirondacks* (fig. 151), for example, he manipulates the pigments to evoke the complex light of deep shade in the autumn woods. Opaque cadmium yellow represents sunlight glittering through gaps in the green canopy and reflecting off young undergrowth, while subtracted lights and thin washes of yellow-greens, which permit the paper to shine through, achieve the effect of light filtered through the leaves and pine branches.

The Adirondacks watercolors portray a broad range of sporting figures and local scenery— fish and fishermen, hunters and lumbermen, lakes and forests, deer and dogs— all set against a nature envisioned as unspoiled. Fish and deer hunting themes predominate.

And these share certain concerns, principally Homer's profound admiration for the nervous, shy vitality of the creatures, and the poignancy of their deaths at the hand of man. Also running throughout the watercolors, as a subtheme, is the relationship between old and young woodsmen.

Homer's fishing scenes record his response to the invasion of tourists, encouraged by the large number of publications and periodicals devoted to sport fishing.[14] Before the middle of the century, sport fishing in the United States was largely an activity of the well-to-do, who acquired techniques and equipment in Britain. But with the new railroad lines, wilderness regions became accessible to a wider audience. And British technical improvements spread quickly to American enthusiasts of all classes. With the introduction in the 1860s of stiffer rods made of split bamboo cane or greenheart, and in the 1870s of eyed hooks, gaudy flies, and silk line (heavy enough to cast into the wind but light enough to float on the water's surface), the average middle-class tourist had the means to become a skilled trout fisherman. Such tourists made the Adirondacks, with its abundant fish, their first destination.

More than one-third of Homer's Adirondacks watercolors are of fishing themes and they present a purified ideal of the angling life. He ignored the tourists— as he had done in Cullercoats and the Bahamas— and again altered reality to serve his personal vision. Moreover, even in the relatively few depictions he made of private hunting and fishing preserves, he denied the club spirit and the sense of camaraderie of the sportsmen. Unlike the conventional anecdotal sport fishing paintings by Tait or Junius Brutus Stearns, who showed the fishermen close-up, as appropriately attired recreational sportsmen, Homer presented a solitary fisherman, aloof, dedicated, and completely at home in the wilderness.

Homer began fishing as a child and was an experienced and enthusiastic fisherman.[15] In watercolors like *Adirondack Lake* (fig. 152) and *Sunrise, Fishing in the Adirondacks* (fig. 153), his ability to convey the action and atmosphere of the sport rather than to render detail earned him the admiration of fishermen. With broad, layered washes of subtly differentiated tones of transparent grays for the sky and water, and strokes of opaque red and yellow to give accent and focus, Homer describes the luminous solitude and the companionable noise of the water, with the guideboat in profile across a misty lake and the fisherman in a characteristic attitude, his curving rod gleaming like a line of silver.

In some sheets the object of the fisherman's cast is merely hinted at; in others the prey itself— a great rosy, speckled trout— leaps through the air at the seductive fly. Executed in suites, the watercolors can be organized to form narrative sequences that repeat the progression from life to death. One group follows the activity of trout fishing from the moment the lone fisherman, sitting quietly in a dark-colored, slender guideboat, makes a long cast toward a white spot that marks the rise of a fish. In these watercolors, Homer shows the fisherman at a remove from the viewer. Then, changing the viewpoint so that the fisherman's presence is implied by the flash of a line or a gaudy fly, he studies the fish

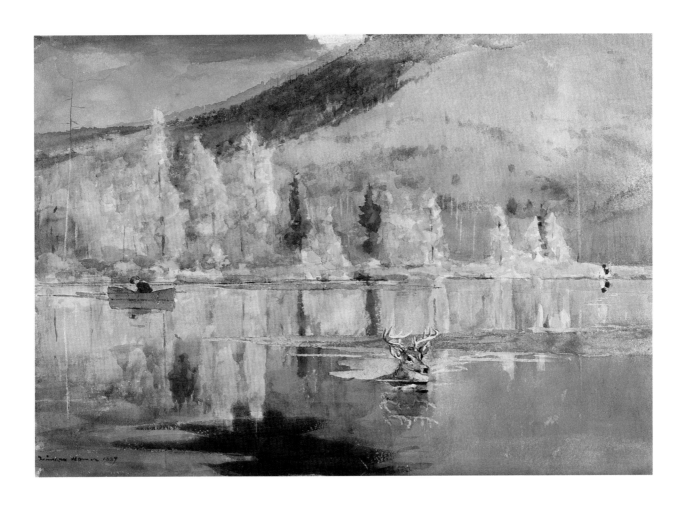

161 *An October Day, 1889*

162 *Guide Carrying a Deer, 1891*

close-up— jumping at the fly as in *Leaping Trout* (fig. 154), and in a desperate death leap, caught on the hook (fig. 155). In *Boy Fishing* (fig. 156) we see the fisherman coaxing the hooked fish toward the net. Finally in *Adirondack Catch* (fig. 157) the trout hang from a branch, like trophies.

But only one other such trophy composition, *Two Trout* (1889; IBM Corporation) is known in Homer's oeuvre. And only once did he attempt a composition, popular among artists such as Tait, that showed a catch lying on the ground, artfully arranged with rod and creel. The dead trophy, for Homer, neither served the interests of accuracy, since most fish rapidly lose their brilliant color on exposure to air, nor evoked the excitement the catch.

Given these goals, it is not surprising that among the most arresting of Homer's fishing images are those portraying trout leaping, the majority of them produced in 1889. In Homer's vision, the trout appear to be caught in perfect focus for only an instant, their silver bodies and vermilion fins flashing against the dark water, often with butterflies and moths circling about. In these close-up, almost life-sized images, Homer struck a balance between incident, naturalistic illustration, and personal expression. Yet the compositional arrangement— an oversized fish dominating the foreground— was found in illustrations in sporting publications. From about 1886, such compositions became so common as to be virtual clichés; *Outing*, *Field and Stream*, and the *American Angler* contained dozens of similar images.[16]

Homer's images, however, convey a thorough grasp of the physical and nervous nature of the subject combined with an approach that is sympathetic yet unsentimental. But above all, there is in these portrayals an almost ecstatic sense of wonder and mystery. In

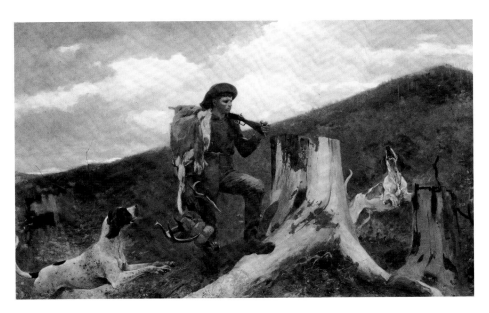

163 *Huntsman and Dogs, 1891*

Leaping Trout (fig. 158), he depicts a brace of speckled trout jumping out of the dark waters of a pool, stirring the pink lily pads.[17] Iridescent tones of rose madder and magenta — two colors that began to appear in his watercolors at this time— and carmine, vermilion, ocher, streaks of bright blue and dull olive green, set against an almost black gray-blue background, create a fluid mysterious world, one that seems closer to dreams and visions than to reality. Images like these, close-up and rich with atmosphere and life, recall the orchid and hummingbird paintings of Homer's older contemporary, Martin Johnson Heade. Starting with nature, Homer (like Heade, and before them both, Frederic E. Church) moved on to a memory of nature, and finally to an intense glorification of it.

Homer's isolation of these leaping trout from their larger world, and their decorative beauty, also recall La Farge's watercolors of a decade earlier, especially subjects such as *Waterlily and Moth* (c. 1879; Wadsworth Atheneum, Hartford). Homer's exposure to his friend's work in stained glass may have influenced him as well. The richness, depth, and glow of color, the play of light flashing through the scene, and the interest in texture, all of which La Farge achieved through the use of opalescent stained glass, and had accomplished earlier in watercolor, are also characteristics of *Leaping Trout*.[18] We know from La Farge that Homer experimented in glass and that he consulted La Farge about the subject.[19] It is worth noting that around 1890, at the very time La Farge was completing his decorative glass panels of fish and butterflies, Homer's leaping trout series appeared. The influence of Japanese art, again by way of La Farge, may be seen in works like *Leaping Trout*, whose mystical compositional balance and slightly fantastic subject recall such Hokusai images as *Carp* (fig. 159). But as much as anything else, it is the fluid, trans-

parent, phantasmal nature of watercolor that allows Homer to capture the quicksilver movement of these creatures.

In *Mink Pond* (fig. 160), the visual reality is ambiguous and playful. A yellow-green frog sitting on a lily pad and an orange-bellied sunfish each brightly eye the pink butterflies suspended between them. It is a "world elsewhere," everything floating among water lilies and pickerelweed in a dark crystal-clear pool, as if separated from the viewer by a sheet of glass. Homer denies the natural refraction of the half-submerged fish and frog, while he represents correctly the reflection of the white water lily on the water. The glowing color, complex washes and delicate graphite lines, the mysterious light source, artful asymmetry of the composition, and contrasting densities of opaque and transparent pigments all combine to create a work of surpassing brilliance.

The fish watercolors have exceptional delicacy and refinement— on a certain level they are almost tremulously aesthetic. But these aspects were disguised by a distinctly masculine choice of subject, by an often intentional rawness and bravura, and by a sense of impending death.

Another series in Homer's Adirondacks subjects deals with the life and death of the deer. Although each watercolor is a complete work, each is also a partial expression of a subtle narrative. From the watercolors executed in 1889, which focus primarily on the deer in nature and the practice of hounding, to the dying and dead deer of the early 1890s, the works can be organized to describe the progress of the hunt.

Hounding and still-hunting were the two main methods employed in hunting deer. Hounding involved using trained dogs to chase the deer, which would instinctively take to water, where dogs cannot follow the scent. Hunters waited silently in fast rowing boats on nearby lakes, listening for the sound of the hounds, which signaled the approach of the deer. It was then a simple matter for the closest boaters to overtake the deer once it had entered the water, and club or shoot the exhausted creature to death. It was a common, and controversial, form of hunting, considered by many to be unsportsmanlike.[20] *An October Day* (fig. 161) is a dazzling autumn scene showing a stag swimming hard across a broad lake before a boat carrying a young man with a rifle. On the far shore to the right, an excited black and white dog is alertly poised, about to enter the water. The ripples suggest that the hunter had followed the shoreline before heading directly toward the deer, and that the deer made an abrupt turn. In the water, yellow-orange washes, flooded into vivid blues that mirror the brilliant autumn sky, create reflections of the magnificent red, gold, and russet foliage at the shore, while on the low hillsides daubs of watery vermilion bleed into the pale gray-green trees. In contrast, the deer's features are clearly defined by delicate brushwork and point-of-brush drawing, its antlers formed by scraping to expose white paper, which was then retinted. Similarly, Homer scraped and recolored the rippled water in the center. The high key and strong color are in stunning juxtaposition to the ominously dark foreground. Color becomes a vehicle for prefiguring the stag's imminent death.

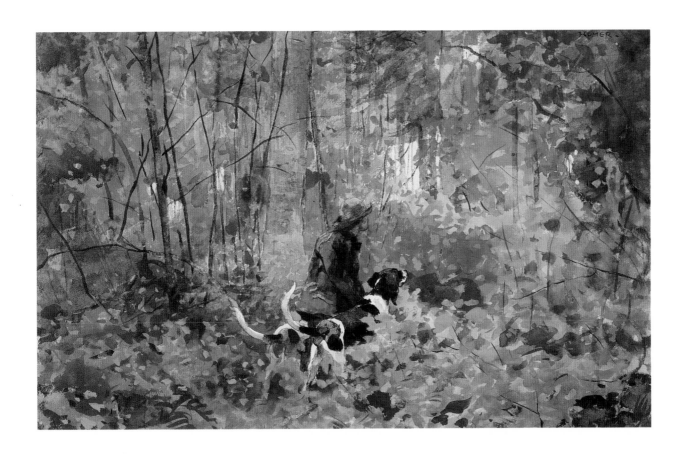

164 *On the Trail, 1892*

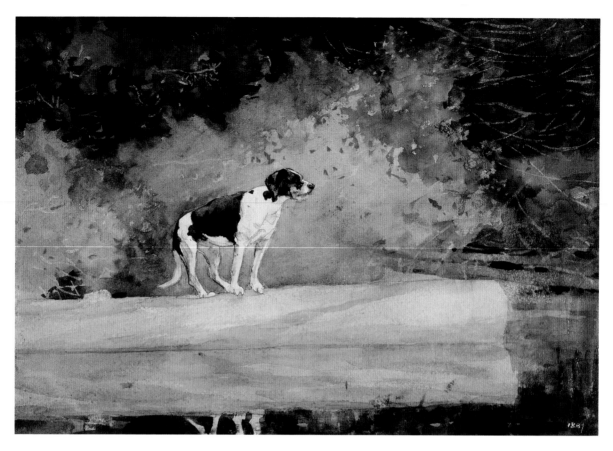

165 *Dog on a Log, 1889*

In *Guide Carrying a Deer* (fig. 162), the young hunter has been successful. This water-color was the basis for the 1891 oil *Huntsman and Dogs* (fig. 163). On the few occasions when Homer translated a watercolor into the heavier medium, numerous little changes clarified and strengthened the design, transforming spontaneity into permanence. In *Huntsman and Dogs*, the vision has also become harder and more ruthless: the blazing autumn landscape is now colder and more forbidding; the reduction of the just-killed animal to a pelt and antlers suggests that the youth is not merely a hunter, but probably a market or pot-hunter who will sell the pelt and antlers as trophies. Finally, the addition of the hounds seems to symbolize the savage aspect of the whole scene.

Dogs were a necessity for hunting, but they were expensive to buy and keep, and hence a constant cause of anxiety if they did not return after a hunt. The usual practice was for the guide or hunter to enter the forest with a leash of hounds attached to his belt, and to release one dog at a time, allowing it to run in ever-widening circles in search of a deer trail.

Homer's portrayal of dogs alone must be seen in the context of the deer pictures, for they constitute an essential part of a sequence on hounding. *Dogs in a Boat* (fig. 166), described by one critic as "a quiet, comparatively low-toned and very beautiful sympho-

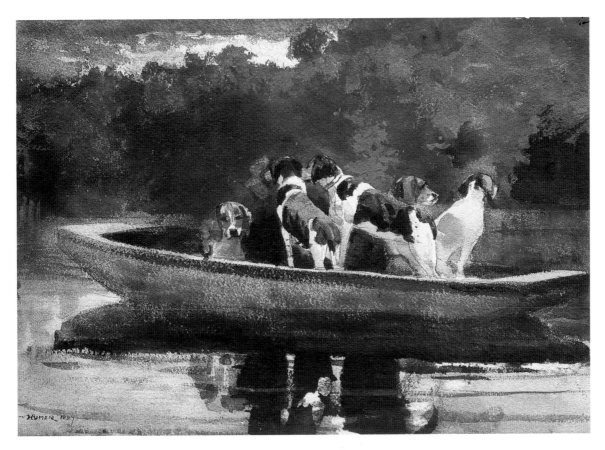

166 *Dogs in a Boat, 1889*

ny,"[21] shows five dark brown and white-spotted hounds (a sixth dog was sponged out) alertly waiting in a scow; how they will get to land is not clear. In *On the Trail* (fig. 164), a young woodsman holds two lively dogs, their tails twitching in anticipation of being set free. Finally, in *Dog on a Log* (fig. 165), the dog is poised on a half-submerged log at the water's edge, presumably having just chased a deer into the lake. The dog then becomes part of the wider narrative, as in *An October Day* (fig. 161).

As in his fishing scenes, Homer's vision of a wilderness uncontaminated by commercial concerns is reflected in his representations of hounding. Unlike contemporaneous portrayals of deer hunting, where nattily attired sportsmen hound with guides, Homer depicts hounding as a rural occupation, practiced by local hunters for whom the deer would in most cases be food rather than trophy. *The End of the Hunt* (fig. 167) presents an old hunter with a boy at the oars of the skiff. Two dogs, having hounded the deer into the water, are about to be lifted into the boat by the old man. The blood-red streaked sky suggests the violence implicit in the death of the stag. Both the sky and the gray-green hillside are rendered with a direct execution, the accidental patterns formed by the drying washes in striking contrast to the paint-charged, deliberate strokes of darker color and scraped reflections in the water. *After the Hunt* (fig. 168) brings the scene to the fore-

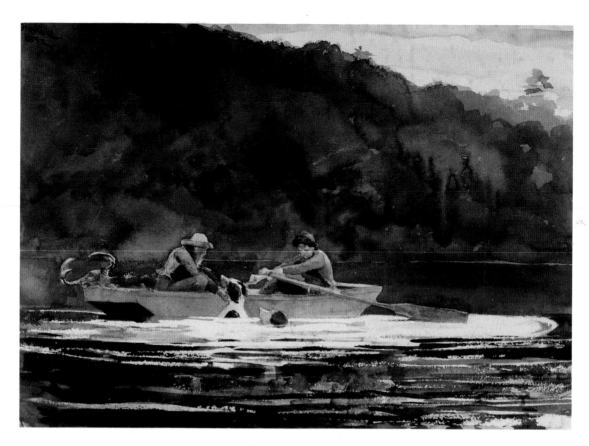

167 *The End of the Hunt, 1892*

ground, with only a single dog in evidence. The palette is the familiar one of opaque cadmium yellow, ochers, and siennas set against fluid green washes that capture the effect of light sparkling through the dense woods.

Homer juxtaposes the old man with the boy, the latter smaller and in a subordinate position, with his face in shadow as he hunches forward to watch. The old man's size and presence dominate the composition; his rough dress contrasts to his refined features, which communicate intelligence and concern for the task at hand. His knowing grasp of the thick fur around the dog's neck not only bespeaks a tender relationship with the animal and a respect for nature, but also serves as a model for the boy. This sense of teacher and student, of skills passed on from one generation to the next, pervades many of the sheets that show both the old and the young woodsmen.

In the Adirondacks watercolors, Homer repeatedly portrays these two guides, both separately and together: the first, a young, supple man, the second an older man with a full beard. Homer is said to have modeled the young man on the Adirondacks woodsman Michael "Farmer" Flynn or on Wiley Gatchell, Homer's Prout's Neck neighbor. The old mountaineer was based on Orson Phelps, Rufus Wallace, or Harvey Holt, well-known hunters and guides in the Keene Valley, all three of whom were interchangeable

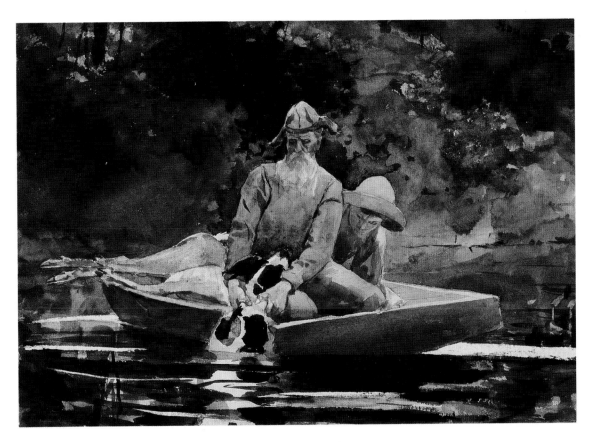

168 *After the Hunt, 1892*

as "types."[22] With the opening of the wilderness to tourism, the occupation of guide had assumed increased importance, real as well as mythic. In particular, the wise old Adirondacks woodsman, dressed simply in rough, colorless clothes that, like himself, had withstood the elements, became a favorite subject for writers and artists. Charles Dudley Warner immortalized Phelps as "Old Mountain Phelps":

He was a true citizen of the wilderness. . . . His clothes seemed to have been put on him once for all, like the bark of a tree, a long time ago. . . . This woodsman, this trapper, this hunter, this fisherman, this sitter on a log, and philosopher, was the real proprietor of the region over which he was willing to guide the stranger. . . . In all that country, he alone had noticed the sunsets, and observed the . . . season, taken pleasure in the woods for themselves, and climbed mountains solely for the sake of the prospect.[23]

In *The Blue Boat* (fig. 170), the old man in a red shirt and his younger companion set out in their bright blue guideboat on a brilliant Adirondacks day. The only clue to their purpose is the rifle on the seat between them. Gestural brushwork and intense color give the watercolor the impression of spontaneity, disguising its careful construction and execution. Parts of the sky have been left white; elsewhere, as in the tip of the paddle and

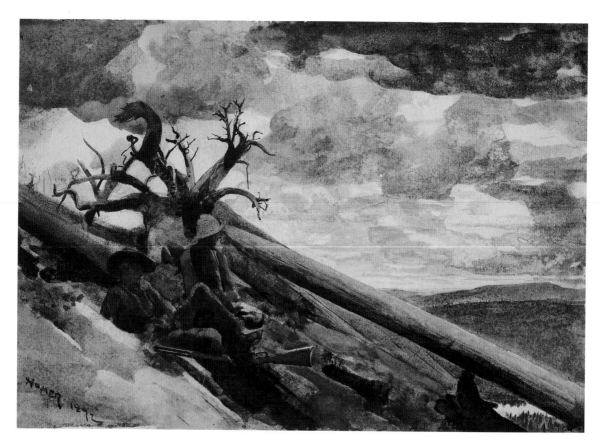

169 *Burnt Mountain, 1892*

its reflections in the water, Homer gouged out the paper and created the ripples through scraping and then lightly painting the absorbent surface. To give body and translucence to some of the greens and browns in the middle and far distance, he added a binder, probably gum arabic, to the colors. His economical drawing style is evident in the rendering of the pine trees, where he used the paint-charged tip of the brush to lay the briefest of strokes over graphite lines, giving these forms an abstract reality rather than a descriptive one.

Burnt Mountain (fig. 169) again shows the two hunters, this time resting on a barren, desolate mountain ledge. Below them is a section of Mink Lake. The young man lounges casually, his rifle at his side; the old man, although more alertly posed, is also relaxed. Both postures suggest that the hunt is over. Palette and composition convey the impression of the land's inevitable destruction. The smoky blacks and grays that constitute the primary tonality are relieved only by the tiny patch of green beside the old man and the bright blue water below; moreover, the aggressive diagonal formed by the rocks culminates in the exposed roots of the dead tree— like sharp claws against the darkening sky.

In the watercolors that show the grizzled old mountaineer alone, the landscape resonates with the sense of a long life near its end, of the shadows closing in. There is a coinci-

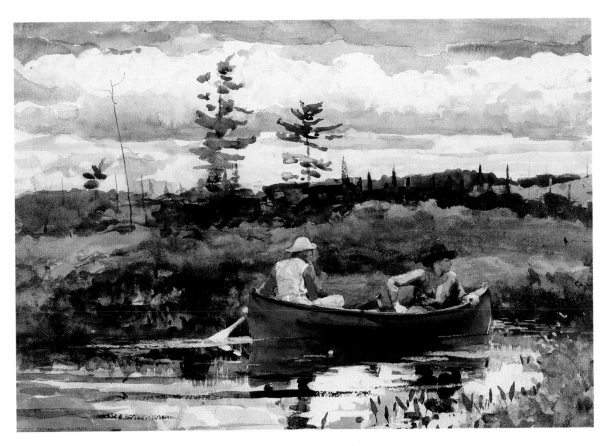

170 *The Blue Boat, 1892*

dence of outward stillness and intense inner emotion, of simultaneous impressions. In *Camp Fire, Adirondacks* (fig. 172), he sits against a tangled mass of gray-black roots whose gnarled forms and somber colors suggest great age. In *The Guide* (fig. 171), he paddles his boat under the great stretching branches of a hemlock through a deep recess near the edge of a lake. Homer catches the mood of wilderness solitude through washes of black, green, and gray, over which a brush charged with deeper pigment renders the branches and the shadows in the silvery water.

Homer's use of color to express emotional tone and content is particularly evident in *The Adirondack Guide* (fig. 2). Here he heightened the effect of light on the actual colors in the landscape with such authority that a known environment is transformed into an essentially imagined one. Within a classically stable, pyramidal structure, each form relates intimately to and partakes of the other's qualities. Thus the faint blue cast of the tree trunk intensifies in the overhanging branches brushing the ground and in the reflections in the dark water; ultimately, it becomes the ethereal blue of an infinite clear sky, a color of exaltation. Vehement slashes of burning orange-red on the shore and water, and, in the background, layers and floodings of green, amber, and gold, all speak of a nature warm and ripe. The bearded guide, his fine features touched with the same bright blue as the tree, turns his head as if in response to some sound or sight, stopping his oars in

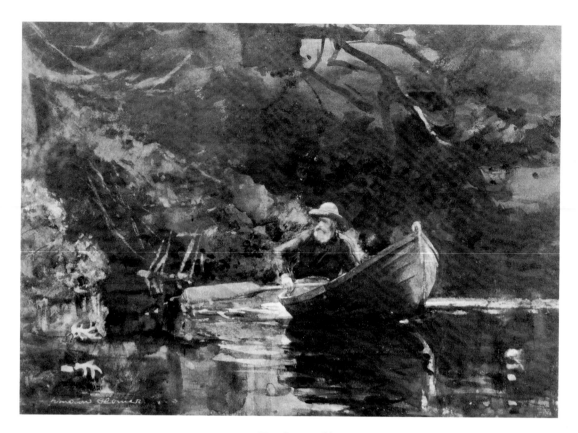

171 *The Guide, 1889*

mid-stroke. There is here the sense not only of a passage in space but of a passage in time, of the cycle of nature, of a life now coming to a close. In the face of death, the old man betrays neither fear nor anger nor resignation; a true man of nature, death for him is the inevitable condition of life. Only in the emotion-charged colors of the landscape do we perceive his (and the artist's) passionate response to the beauty of nature, most acute at its moment of loss.[24]

In contrast to the quiet confidence and balance implicit in the watercolors depicting the old guide alone, there is often rawness and instability when the young man is without his mentor. In *Sketch for "Hound and Hunter"* (fig. 173), he lies in a guideboat, tightly holding a noose in one hand and a dead deer by the antlers in the other; his attention centers on the dog swimming toward him. The tension abides in the youth's anxious concern about the hound. Having shot the deer, the boy's first task is to secure it, and then either haul it into the boat or tow it ashore. At the same time, however, the dog will have to be lifted into the boat. In *The End of the Hunt* (fig. 167) and *After the Hunt* (fig. 168), the hunting was done from a skiff, and, perhaps most important, the old man was present. The self-assurance of man in relation to nature that characterized the double portrayals is notably absent from *Sketch for "Hound and Hunter."* In this dark place, in an unstable craft suggestive of the precariousness of the situation and, in a sense, of the condition of

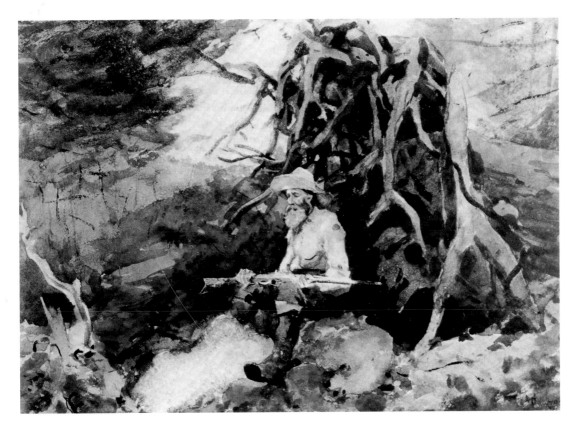

172 *Camp Fire, Adirondacks, 1894*

those who have little knowledge or respect for nature, the outcome of the boy's efforts is far from certain.

The watercolor was the basis for the oil, *Hound and Hunter* (fig. 174). The oil presents a more sinister vision, in part because Homer has added the butt of a rifle and a dead tree in the right rear. In the oil, the rifle, presumably just used to kill the deer, rests across the central thwart of the boat; in the watercolor, the brown pentimento across the boat indicates that a rifle had been scraped out and painted over. The most obvious difference is in the deer's head, now submerged, with only the nostrils and part of one eye above the water. This, however, was a later change, made sometime before 1900; early photographs of the oil show that Homer originally placed the deer's head above the water as in the watercolor. Perhaps the change was occasioned by the public's response when the oil was first exhibited in 1892. Upon learning that some people believed it showed the deer being drowned, Homer was indignant and wrote to his friend Thomas B. Clarke: "I can shut the deer's eyes, & put pennies on them if that will make it better understood. . . . Anyone thinks this deer alive *is wrong*."[25]

Just as Homer produced watercolors with leaping trout as the visual focus, so he made deer the subject of individual portraits. But whereas the fish are brilliantly vital, with the

presence of death implied, the deer are shown in the anguished moment between life and death. Homer's theme becomes nothing less than the sensation of dying.[26] The image of a traditionally noble beast at the point of death was a well-established Romantic subject. In America it even found its way into popular art: Currier and Ives published *The Death Shot* (fig. 175), which became one of their more popular prints. Like Courbet's *Stag at Bay* (fig. 176), there is within these images the paradox of the sportsman's activities: that it is chiefly through the instinct to kill that man achieves intimacy with nature and life.

Still-hunting, in which the deer was tracked through the woods, with or without dogs, while the hunter stood still to shoot, was considered more sportsmanlike than killing deer from a boat. In *A Good Shot* (fig. 177), we are in the presence of death. Cut off spatially and emotionally from the hunter, we identify with the victim. The only watercolor to show a deer being killed, it represents the moment a stag is shot as he climbs in desperation to the top of a rock in a river of rushing water. On the right are the silhouettes of two hounds running in the direction of the deer. To the left is a puff of white, presumably from the hunter's just-fired rifle. This inclusion of the animal's killer as a distant element, with the exhausted and terrified creature thrown up boldly against the foreground, anticipates the artist's late masterpiece *Right and Left* (1909; National Gallery of Art, Washington). Fluid brushwork and saturated washes of Prussian blue, yellow-green, sienna, and purple-gray create a densely wooded river landscape. The soft, furry texture of the animal's white underbelly, tail, and ears are accented through reserve paper and light scraping, while black lines reinforce and articulate the body and especially the head, with its wide eyes and dilated nostrils. Light falls dramatically on the stag, ennobling its elevated stance on the rock, but at the same time isolating and strengthening the illusion of the creature's terrible plight.

Perhaps the most poignant of the deer pictures is a small series ending with the death of a doe. In the contemporary press the killing of doe was a subject of concern.[27] Since doe usually give birth to pairs of deer, killing the mother meant that in all likelihood two young fawns would also die.

Deer Drinking (fig. 178) portrays a doe feeding by the water. Deer normally feed at water courses from June to September, wading out to find lily pads and other bottom grasses in shallow water. Homer shows the animal close-up, drinking from a shimmering pool of water in a leafy glade. Judging by the lighter, silvery color of her coat, it is late September or early October (during the summer the coat is red, but as the animal prepares for winter it gradually sheds its red fur and blue-gray hairs come through). Unaware of any other presence, intent on drinking, the creature seems also to be mesmerized by her own reflection. Her awkward but characteristic position— belly on a log, forelegs straddling one side and hind legs the other— precludes quick movement, thereby exposing her to mortal danger. Homer suggests the animal's extreme vulnerability by emphasizing and reinforcing the downward curve of her neck and back and the soft whiteness of her underbelly, furry tail, and ears (the latter parts by gouging out the paper to give texture). He evokes mood and atmosphere through the tender color and

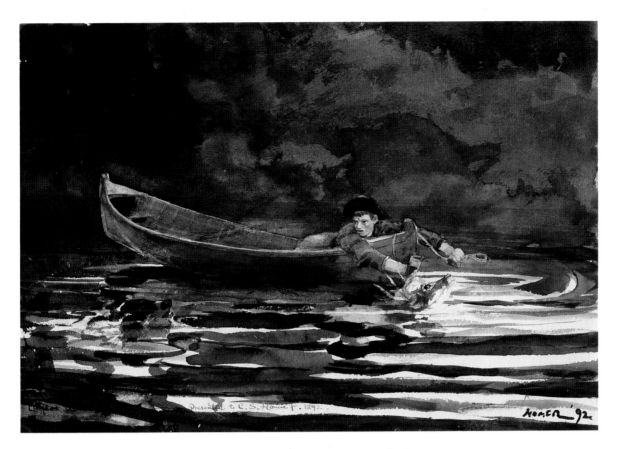

173 *Sketch for "Hound and Hunter," 1892*

174 *Hound and Hunter, 1892*

175
Currier & Ives.
The Death Shot

176
Gustave Courbet.
Stag Taking to the Water, 1861

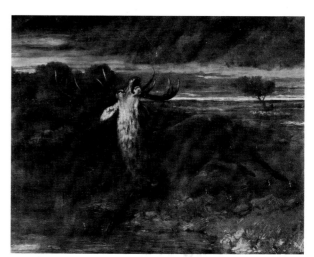

lively brushwork in the background shrubbery and water. The intimate view, capturing all the nervous tension of this shy animal, involves the spectator vicariously in the mysterious life of the forest.

In *Fallen Deer* (fig. 178), the doe is dead. The landscape itself seems to mourn. Instead of the warm, transparent greens and siennas of the trees and the gold-flecked dancing surface of the water in *Deer Drinking*, there are dark grays and blue-blacks in the background, and in the now still water long, demanding strokes of black catch the truth of the moment. In one of the few instances when he recorded his feelings about a subject he had painted, Homer inscribed the verso of the sheet: *just shot* and *A miserable* [illegible] *Pot hunter*. The intensity of Homer's response suggests he actually saw such a dead doe in the woods. It also suggests that *Deer Drinking* and *Fallen Deer* can be read as pendants:

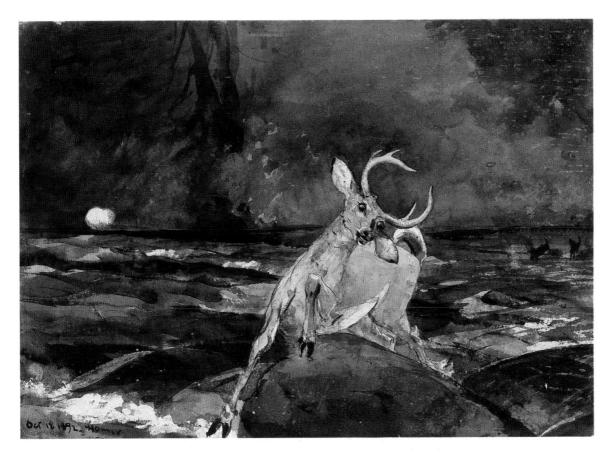

177 *A Good Shot, 1892*

through the contrast of the living and dead deer, they express more dramatically the impact of the hunter's flagrant disregard for life.

If in his deer hunting pictures, Homer called attention to the cruelty of the hunter's sport, he was no less concerned with the callous rape of the land. After the Civil War, as the lumbering industry penetrated the Adirondacks wilderness, whole forests of large trees, particularly conifers, became depleted. The cutting began in the autumn, and the felled trees— many of the white pines were 150 feet high, some as high as 200 feet with 6½-foot diameters— were peeled of their bark and drawn to the nearest tributary stream, and then on to the Hudson. They were stored during the winter in banking grounds (frozen surfaces of a headwater) until spring, when the ice melted and they could be

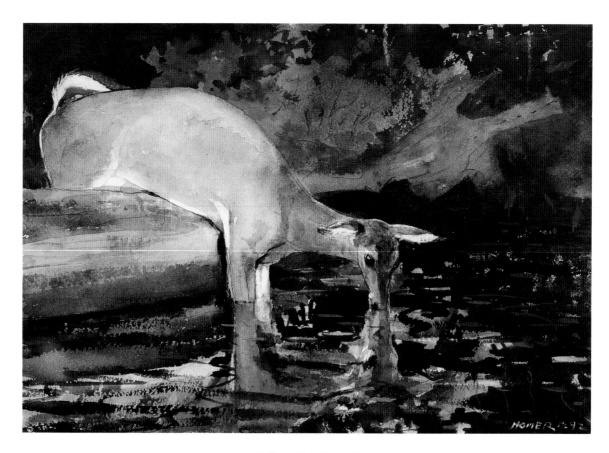

178 *Deer Drinking, 1892*

released and driven downstream on the flood currents to the mills in Glens Falls.[28] The great number of floating logs often caused logjams further downstream. It was the log-driver's task to prevent such jams, a dangerous job that required skill and strength.

A group of Homer's watercolors, executed over almost a decade, record the encroachment of the lumbering industry into the wilderness— the death of the great woods. In these works, the old mountaineer and the huge trees seem inseparably linked, both of them elements of a rapidly vanishing past. Taking their place as Homer's pictorial subjects (as well as in real life) are vigorous young men engaged in logging, to many mountain men the occupation that represented the future.

An elegiac quality pervades *Old Friends* (fig. 181). The old woodsman looks up reverently and gently touches the stately tree high above him. The gesture betrays an emotional kinship with the magnificent trees. It is also a personal gesture of farewell and, with the loss of the wilderness, a farewell to a way of life. Mellow harmonies set a mood of autumnal melancholy: amber, brown, green, and gold, with streaks of vermilion in the deep gash in the bark and dotted on the ground, as if the great tree itself were bleeding.

In *The Woodcutter* (fig. 180), a strong young lumberjack holding an ax stands confidently on the deforested summit of a mountain. In the shadowless light of midday, his lean body is silhouetted against a bright blue sky full of scudding, gray clouds. Rendered

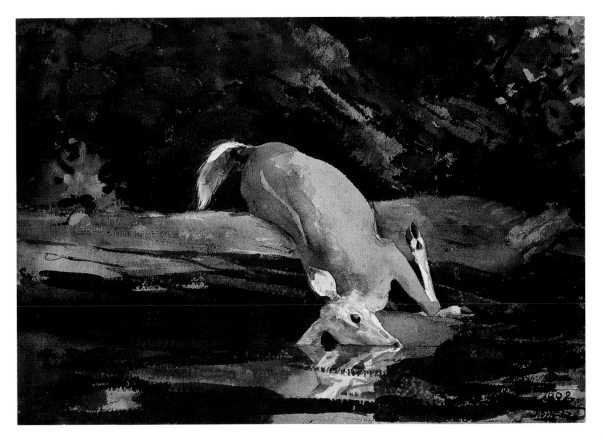

179 *Fallen Deer, 1892*

with decisive brushstrokes of saturated color over light graphite, the composition's low horizon line emphasizes the woodcutter's dominating position, taller and grander than anything in view. The strength and clarity of the figure itself, recalling in part the pose of Michelangelo's *David,* give the work a timeless quality and a sense of inevitability.

Hudson River (fig. 183) shows the riverman pushing logs from the shore into the rushing stream. On the far side of the river a young ram chases a doe. A bright palette of ultramarine, yellow-green, and red-brown, with accents of opaque red and yellow, creates a sparkling surface, capturing the cold freshness of early spring after the thaw. In *Hudson River, Logging* (fig. 182), Homer represents two log riders, the standing figure armed with a pike pole. It is an invigorating scene, full of bright color, fluid brushwork, and a sure sense of design. Homer's ability to exploit spontaneous effects and the precariousness of the medium are especially evident in the sky. We can see just where he touched the watery brush to the freshly washed paper, then allowed the blue paint to gather its own darker edges as it bled into the wash beneath, giving the impression of a cloud edge. Similarly, he allowed the edges of the yellow-green wash in the trees at right to remain so that they suggest the form. Homer had full control over these so-called accidents; he knew exactly how much pressure to apply to the brush and the precise moment to lift it from the sheet.

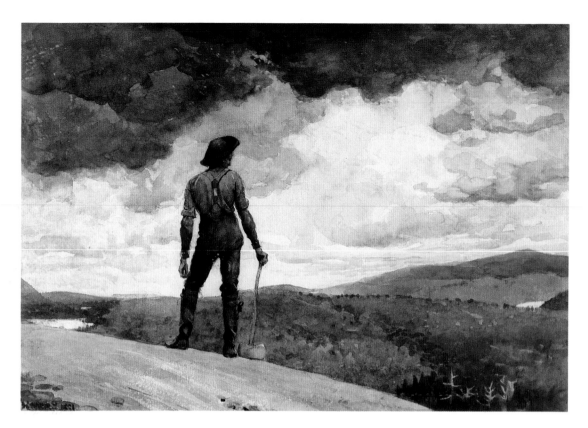

180 *The Woodcutter, 1891*

The final image in the sequence that began with the old mountaineer is *The Pioneer* (fig. 184). A solitary lumberjack, seen from the rear, shoulders an ax as he strides purposefully toward one of the few remaining— and poignantly vulnerable— trees in the stump-littered clearing. Unlike the paintings of a decade earlier, where a lumberjack stood triumphantly on a mountain top, the figure here is diminished by the hillside. In color and form he echoes the remaining trees, his size midway between the still-standing trees and the crude stumps; pictorially and in actuality he is the link between the two groups. Powerful contrasts of light and shadow underscore the violence of a wilderness nearly destroyed by the ax. The paint is laid on with gestural strokes of thick color— greens and yellow in the clearing, layerings of alizarin crimson and brown in the foreground, and purple-brown, green, and teal over light blue for the tender, grassy outcroppings. Thin, quick brushstrokes articulate the trees and shrubbery, while graphite lines turn the daubs of green on the tree into leaf shapes.

The Pioneer was Homer's last Adirondacks work. Painted in 1900, the watercolor has a sense of finality, a requiem not only for the artist's beloved wilderness, but in a sense for his own vigorous manhood and the most artistically passionate period of his career. The Adirondacks had called forth from him his greatest watercolors. The intensity of his response to the north woods exceeded his response to any other environment. After 1900,

181 *Old Friends, 1894*

182 *Hudson River, Logging, 1897*

183 *Hudson River, 1892*

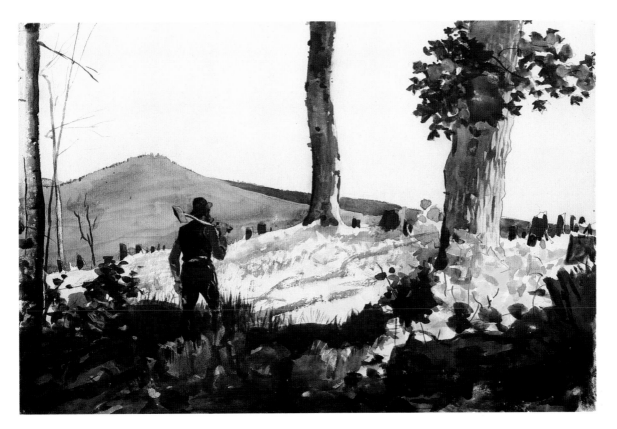

184 *The Pioneer, 1900*

Homer's artistic focus turned primarily to the tropics— to beautiful but neutral subjects. Although he returned to the North Woods Club in 1902, 1904, and 1908— the last time to recover from a paralytic stroke— Homer never again made the Adirondacks the subject of a picture.

From the beginning, Homer's Adirondacks watercolors found a responsive audience. In addition to Thomas B. Clarke, such important patrons as William Thomas Evans of New York and Edward C. Hooper of Boston were enthusiastic collectors. Of the thirty-two Adirondacks scenes Homer sent to Reichard's in February 1890, twenty-seven sold. "So it would seem that this admirable painter is actually becoming popular," wrote the *Art Amateur*.[29] By now not only artists and connoisseurs took an interest in his work. The critics and the public were learning to appreciate fully Homer's watercolor style, approving of "those bold effects of color, extreme breadth and facility of treatment and that science of abstraction on which this artist has based his powerful style."[30] "These paintings . . . are marked . . . by the artist's best qualities," wrote the *Art Interchange*, "[the] summary renderings of woodlands and water are admirable examples of painting the essentials and omitting the incidents."[31] The *New York Sun* spoke for many viewers when it wrote that in the Adirondacks watercolors, "the simplicity and force of [Homer's] brush were never better."[32]

1 Grover Cleveland argued that outdoor sport encouraged patriotism: "The fishing habit, by promoting close association with Nature, by teaching patience, and by generating or stimulating useful contemplation, tends directly to the increase of the intellectual power of its votaries, and, through them, to the improvement of our national character; "The Mission of Fishing and Fishermen," in Grover Cleveland, *Fishing and Shooting Sketches* (New York, 1906), 96–97.

2 Charles Hallock, *The Fishing Tourist* (New York, 1873), 53–54.

3 Consideration was shown to these sportsmen by hotel proprietors and transportation lines all over the country. Many railroad companies furnished excursion cars expressly fitted up for sportsmen, with sleeping bunks, kitchen apparatus, rod racks, and other conveniences. One line deferred so particularly to this class of patronage that it dubbed itself "The Fishing Line"; Charles Hallock, *An Angler's Reminiscences* (Cincinnati, 1913), 112.

4 Cleveland, "A Word to Fishermen," in *Fishing and Shooting Sketches*, 165–166.

5 Cleveland, "A Word to Fishermen," 165–166.

6 H. Barbara Weinberg, "Thomas B. Clarke: Foremost Patron of American Art from 1872 to 1899," *American Art Journal* 8, no. 1 (May 1976), 69.

7 G.M. Fairchild, Jr., *From My Quebec Scrapbook* (Quebec, 1907), 150; Harrison S. Morris, *Confessions in Art* (New York, 1930), 62.

8 Joel Tyler Headley, *The Adirondack or, Life in the Woods* (New York, 1849). It is worth recalling that James Fenimore Cooper's *The Leather-Stocking Tales*, dealing with life in the wilderness, had appeared in parts beginning in 1823.

9 One of the most important publications was George P. Marsh, *Man and Nature* (New York, 1864). Marsh was among the first to realize the basic importance of conservation. He urged that Reconstruction, in addition to being a period of political readjustment, must also be one of re-orienting and re-evaluating the potential of natural resources.

10 William Henry Harrison Murray, *Adventures in the Wilderness or, Camp Life in the Adirondacks* (Boston, 1869).

11 From the end of the Civil War until the beginning of the First World War, the railroad was the most significant force in the political, economic, and social development of the United States. See Gabriel Kolko, *Railroads and Regulation 1877–1916* (Princeton, 1965); Alfred D. Chandler, Jr., ed. and comp., *The Railroads: The Nation's First Big Business* (New York, 1965).

12 Quoted in William Chapman White, *Adirondack Country* (New York and Boston, 1954), 99–100.

13 The North Woods Club House Register records two visits in 1889 and in 1891; and one each in 1892, 1894, 1899, 1900, 1902, 1904, and 1908.

14 See Charles Eliot Goodspeed, *Angling in America: Its Early History and Literature* (Boston, 1939); note also the initiation of popular sports periodicals such as *Forest and Stream* in 1873 and *Outing* in 1882.

15 One of Homer's earliest drawings is a sketch of a man fishing, rendered, appropriately enough, on the end-paper of his copy of *Boys' Treasury of Sports, Pastimes, and Recreations*, sometime between 1847 and 1854 (The Margaret Woodbury Strong Museum, Rochester). Fishing was also the subject of at least two of Homer's early illustrations: *The Fishing Party*, in *Appleton's Journal*, 2 October 1869, and *Waiting for a Bite*, in *Harper's Weekly* 18 (22 August 1874).

16 As early as 1874 Currier and Ives published a sporting print called *Hooked*, with the same type of composition.

17 *Leaping Trout* has hitherto been dated 1892—the date given in the 1899 sale of Thomas B. Clarke's Homer collection. However, the watercolor was exhibited at Reichard's in February 1890 and reviewed in the press. For example, see the *New York Times*, 26 February 1890, 6.

18 For a discussion of La Farge's watercolors see Kathleen A. Foster, "The Still-Life Paintings of John La Farge" *American Art Journal* 11, no. 3 ([July] Summer 1979), 4–37. For La Farge's achievements in stained glass, see Henry B. Adams, "The Stained Glass of John La Farge," *American Art Review* 2, no. 4 (July–August 1975), 41–63.

19 Gustav Kobbé, *New York Herald*, 4 December 1910, Magazine sec., 11.

20 In 1885 New York State passed the Curtis Bill which prohibited hounding, but two years later the pro-hounding lobby managed to get a new hunting law passed which made it legal once again.

21 "Mr. Homer's Water Colors: An Artist in the Adirondacks," *New York Tribune*, 26 February 1890, 6.

22 Beam 1966, 102–103. For a further discussion of the identities of the models, see *Winslow Homer in the Adirondacks* (exh. cat., Adirondack Museum, Blue Mountain Lake, New York, 1959), 19; Ashton Sanborn, "Winslow Homer's 'Adirondack Guide,'" *Bulletin of the Museum of Fine Arts, Boston* 46, no. 264 (June 1948), 48–51.

23 Charles Dudley Warner, *In the Wilderness* (Boston, 1878), 86–92.

24 For an informative discussion on the connection between color and feeling, see Ernest G. Schachtel, "On Color and Affect," *Psychiatry* 6 (November 1943), 393–409.

25 Homer to Thomas B. Clarke, 11 December 1892. Archives of American Art.

26 For a discussion of the moment of death as the subject of a work of art, see Linda Nochlin, *Realism* (Harmondsworth, England, 1971), especially 72–73.

27 See, for example, *Forest and Stream* 26 (8 April 1886), 205–206; 31 (8 November 1888), 301; and 31 (29 November 1888), 368.

28 Harold K. Hochschild, *Lumberjacks and Rivermen in the Central Adirondacks, 1850–1950* (Blue Mountain Lake, New York: Adirondack Museum, 1962), 8.

29 *Art Amateur* (22 April 1890), 93.

30 See n. 29.

31 *Art Interchange* 24, no. 5 (1 March 1890), 66.

32 *New York Sun*, 3 March 1890, 4. The watercolors in the exhibition were moderately priced at about $125 each. The *Sun's* reviewer believed Homer ought to have set higher prices for the watercolors: "It is also a pity that he rates himself below his proper worth. Not only for his own sake, but for the sake of art and American artists in general." After the success of this exhibition Homer raised his prices to between $200 and $300, and began to send a few watercolors at a time to Reichard's and to Doll and Richards; Goodrich 1944, 118.

Quebec

1893–1902

The place suits me as if it was made for me by a kind of providence.

By the 1890s, as the wilderness territories in New York State were claimed by tourists and developers, serious sportsmen began to look elsewhere for fish and game. They turned northward to Canada, whose woodlands, only recently made accessible, constituted a vast and fertile realm, hiding myriad lakes and sheltering varied forms of bird and animal life. Moreover, the region had been left virtually untouched since it was first discovered by French explorers in the seventeenth century.

Homer visited Quebec for the first time in the spring of 1893, and over the next decade he vacationed in the province numerous times. Accompanied by his brother Charles, he chose the region about a hundred miles north of Quebec City along the Saguenay River, near its headwaters at Lake St. John, an area that had become popular only in the 1880s. The train journey from New York (thirty-three hours) and Boston (twenty-nine hours) to Roberval, a fishing center and principal settlement on Lake St. John, was advertised in sportsmen's manuals and magazines as a trip through "the Canadian Adirondacks" to "the most attractive fishing ground in North America."

Winslow and Charles became members of the exclusive Tourilli Fish and Game Club, some 355 square miles of wilderness on Lake Tourilli near the village of St. Raymond, but on the main line of the railroad. The largely Canadian membership was limited to seventy, but included socially prominent Americans from New York, Boston, and Cleveland.[1] Although by the 1890s colonization and lumbering were already advancing at a rapid pace, the area was still one of unbroken forests. The Homers first stayed in the clubhouse but, perhaps finding life there too civilized, they built a log cabin on the extreme edge of the lakeside property. This structure became the subject of at least two monochrome gouache and watercolor studies that Homer executed in 1895 during his second visit.

Log Cabin, Tourilli Club (fig. 186) depicts a typical French-Canadian farmhouse built of squared logs caulked with the beaten bark of white cedar or white oak, its outer walls and curved-eave roof often sheathed with large pieces of birchbark held in place by hand-split strips of cedar. Homer's accurate description of the brittle sheets of birchbark included the narrow laths of cedar that anchored the sheets, which were carelessly affixed like so many pieces of tape. Two rifles leaning against the side wall allude to the cabin's occupants.

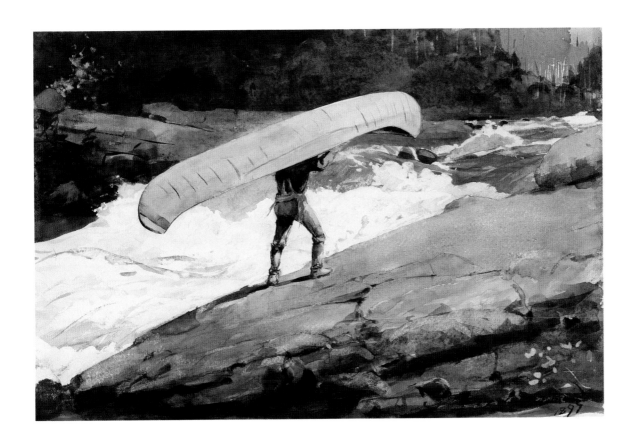

185 *The Portage, 1897*

186
Log Cabin,
Tourilli Club, 1895

187 *Wolfe's Cove, 1895*

Homer apparently made no watercolors during his first visit, but forty-eight survive from visits in 1895, 1897, and 1902. As in the Adirondacks, these visits combined sport and art. Homer kept a specially built, twelve-foot, flat-bottomed boat on Lake Tourilli, which he used for both fishing and painting. He loved Quebec: "The place suits me as if it was made for me by a kind of providence."[2]

In the earlier Adirondacks watercolors Homer portrays a nature that is essentially rich and life-enhancing, the only destructive forces being those introduced by man. The Quebec watercolors, by contrast, reveal a nature that is inherently violent, with man no longer the aggressor but the creature at risk. Homer concentrated on three sites along the fearsome Saguenay River, the most famous of the northern waterways, which the traveler and poet Bayard Taylor dubbed the "River of Death": at its tidewaters, Lake St. John, with its deceptively peaceful, shining surface; the savage, rocky gorges of the Saguenay itself; and the spectacular rapids at Grand Discharge, where the lake discharges into the river, "boiling, surging and leaping with an indescribable roar and confusion," its dark purple- and orange- brown colors the result of the iron-rich waters "unlike those of any other river known."[3] The Quebec watercolors forcefully record this vigorous setting through their rhythmic running strokes, energetic scraping, and predominantly gray and

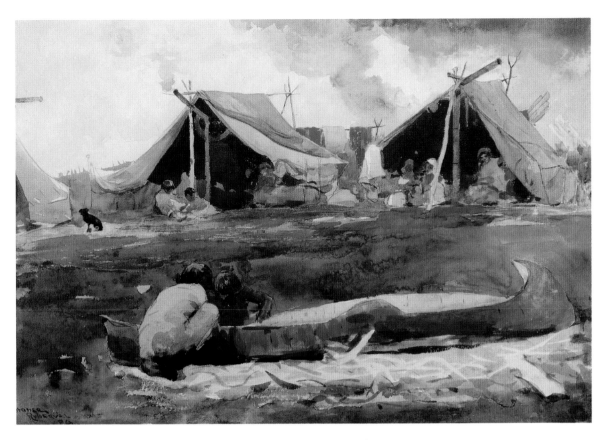

188 *Montagnais Indians, 1895*

orange palette— all in contrast to the shorter strokes and luminous, layered colors of the Adirondacks works.

Homer never depicted the caribou and moose that were among the great attractions of the area, perhaps because his visits took place when game hunting was out of season. Staying at the Island House Hotel, a hostelry built on an island near Roberval on the west side of the lake and a base for fishing expeditions, he concentrated instead on scenes of fishing. But unlike the Adirondacks watercolors where the local guide had pride of place, Homer here focused on his fellow anglers on Lake St. John as they attempted to land the legendary ouananiche, that feisty and cunning land-locked salmon much sought by sportsmen. A second group of watercolors portrays French-Canadian and Indian woodsmen, usually in the company of the sportsmen, shooting the rapids or guiding their canoes through the treacherous currents of the river. Finally, a smaller series depicts the Montagnais Indians in their camp at Pointe Bleue, north of Roberval.

The Montagnais watercolors, like the 1885 Bahamas works, depict characteristic aspects of the life of the indigenous people. The Montagnais tribe, believed to belong to the Cree family (American Plains Indians), was unfailingly mentioned in the Lake St. John guide-books as of great interest to the visiting sportsman; certainly the presence of these dark-

189 *A Good Pool, Saguenay River, 1895*

skinned Canadian Indians added to the visitor's sense of being in a remote, untrammeled territory. The Montagnais people lived on the shore of Lake St. John during the summer, earning money as guides and canoeists for sportsmen. When the hunting season began in September the families scattered to the far north, to base camps for winter trapping. A domestic and industrious group, they are portrayed in Homer's watercolors working on their canoes amid their simple tents, with furs hanging on poles.

The Montagnais spent considerable time building the long slender birchbark canoes, or sheemauns, that were critical both to their way of life and to the tourist trade. In *Montagnais Indians* (fig. 188) Homer represents the final stage of construction of a canoe, when the seams were sealed with the resin of the fir tree. Here Homer included the Montagnais' unique shelters; unlike the teepees of the Plains Indians, these were built by draping the covering over thin sticks arranged to create a long rectangular space. Rendered with free brushwork in clear greens, red-browns, and yellows, the emphasis on general atmosphere rather than trivializing detail lifts these works beyond the illustrations that often accompanied the descriptions of the Montagnais in contemporary magazines.

As if rejecting the brilliant color he used in the Adirondacks and tropics watercolors, Homer set himself the challenge of expressing, through graded black washes, the form, light, and atmosphere of a scene. The degree of dark or light became the substitute for color. Among the watercolors of 1895 are at least eleven monochromes executed on smooth gray paper in subtle washes ranging from light gray to black with highlights of white gouache. Several show the city of Quebec and panoramic views of famous sites

190 *Three Men in a Canoe, 1895*

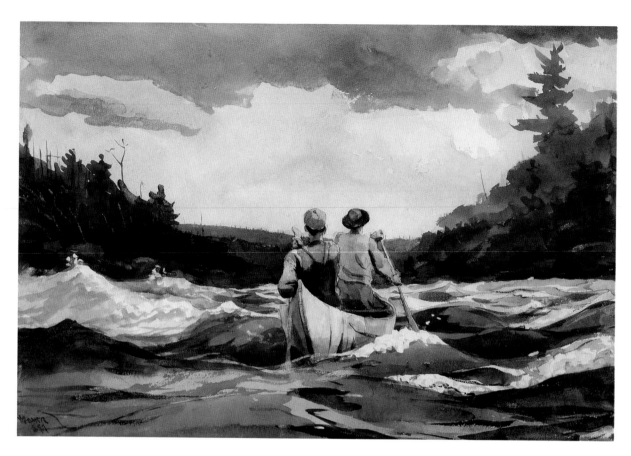

191 *Canoe in the Rapids, 1897*

along the St. Lawrence, among them *Wolfe's Cove* (fig. 187). Although they capture through broad, vigorous handling the bleakness of these northern outposts, most are summary descriptions, more reflective of the attitude of a tourist who took care to inscribe the name of each site on the sheet.

Homer realized the pictorial possibilities of monochrome in a small series of Lake St. John subjects which are unlike any watercolors he had done before. *Two Men in a Canoe* (fig. 1) and *Three Men in a Canoe* (fig. 190) evoke through a wealth of black and white tones the silent and almost mystical effect of the lake at sundown. In one of the few statements Homer ever made about art, he dwelt on the importance of finding the precise relationship of values of dark and light as well as of colors. "It is wonderful how much depends upon the relationship of black and white," he said; "if properly balanced, [it] suggests color . . . the question is the truth of the values."[4]

The Lake St. John monochromes reveal Homer's extraordinary power in chiaroscuro—his exploration of negative and positive image, of opaque and reflected light, and of the tangible and intangible. All of these features Homer had rendered with color in the Adirondacks works. But the Quebec watercolors cast the same spell of place and generate the same pictorial excitement in pure monochrome. Their delicate, silvery beauty,

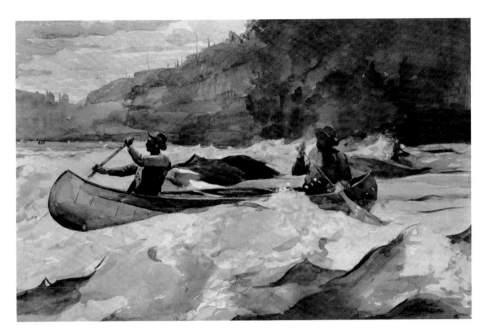

192 *Shooting the Rapids, 1902*

unique in the genre of sporting pictures, is one of the most poetic achievements of Homer's career.

The crystalline quality and stillness, the use of allusion over definition, of suggestion over specifics, give these works a kinship to Chinese landscape painting. They also exhibit characteristics that had not appeared so clearly in Homer's work before: the head-on point of view; the structural division of the composition into horizontal fields that stretch completely from left edge to right; the sky-wide expanse of tranquil lake water in the foreground; the strip of background hills— the staccato, vertical counterpoint of thin, dark trees reaching upward and their reflections in the polished water; and particularly, the effect of shading and contrast, achieved through subtle modulations of tone.

Just as the visiting sportsmen constituted an elite, so did their catch. The ouananiche, particular to the Lake St. John region, and the "grandest game fish that has yet fallen to the fisherman's lure," was considered a worthy competitor for his much-prized skills.[5] *A Good Pool, Saguenay River* (fig. 189) focuses on the magnificent silver-gray fish with its almost black back beginning to turn bright blue as it leaps high out of the water, its mouth hooked by a gaudy red fly. Homer had used a similar composition, with a large fish in the foreground in some of the Adirondacks watercolors (fig. 155). Even though the

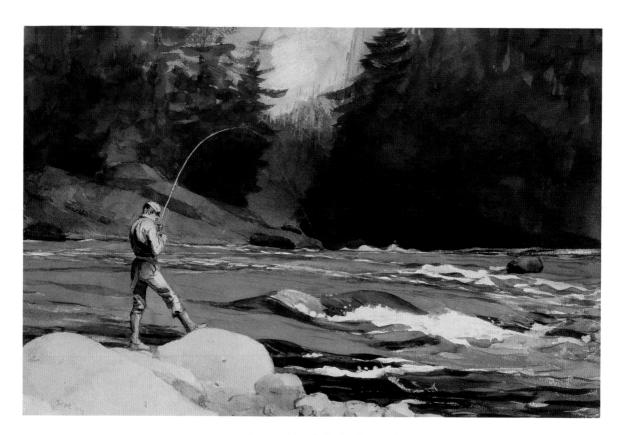

193 *Ouananiche, Lake St. John, 1897*

composition in both series recalls sporting illustrations, Homer rethought his models, rendering through ambiguity and resonant color a sense of the sublime grandeur of nature. Against a dark green and blue background which has the look of stained glass (a shiny effect achieved through the glazelike use of gum arabic), the majestic ouananiche commands the composition and confronts the viewer. The three tiny men in the canoe are in dramatic juxtaposition— at left, a French-Canadian guide; in the middle, the fisherman in his deerstalker cap; and, at right, an Indian wearing a feather headdress and a red sash. The precarious position of the fishermen in the turbulent water adds to the tension of their struggle to land the fish. The elegant sweep of the casting line declares the experience and discipline of the angler, while the vigorous, rapid watercolor technique— scraped paper at the right to suggest foam, and bold sweeps of orange and bright blue washes for the waves— underscores the movement, challenge, and unpredictability of the contest.

On subsequent visits to Quebec and Lake St. John in 1897 and 1902, Homer concentrated primarily on images of fishing in the rapids, evoking through forceful brushwork the swift currents of the Saguenay. Descending the river, the terrifying trip through the

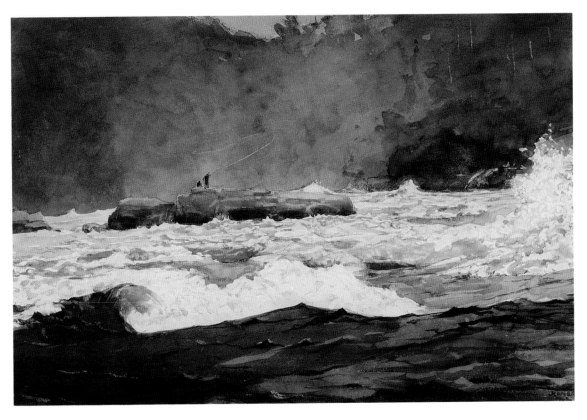

194 *Fishing the Rapids, Saguenay, 1902*

rapids was safely made only with the expert aid of an Indian guide. Watercolors like *Shooting the Rapids* (fig. 192) and *Canoe in the Rapids* (fig. 191) catch the breathtaking sense of peril and excitement of a whitewater passage. In the former, Homer so identified with the scene that he signed his name within one of the waves. In the latter, the swirling rapids in the foreground and the surge of the slate blue and ocher river are emphasized by calligraphic brushwork and the way the birchbark canoe cuts the seething billows at an angle almost perpendicular to the picture plane. As in the Adirondacks watercolors, the overlapping and layered colors do not depend on the presence of the white sheet for coherence (as they would in the later Key West works); rather, the white paper serves primarily for accent and highlight.

A sense of nature's power also permeates the watercolors of portage scenes. In *The Portage* (fig. 185), conceived as a series of diagonal, almost parallel lines, the guide carries his canoe to a point above the foaming rapids. In *End of the Portage* (fig. 195), the challenge that confronts the guide and the sportsman carrying the canoe is not the perilous water; it is the enormous trunk of a pine tree. While the dead tree does not possess the energy of churning water, Homer suggests its power by richly describing its twisted form and weather-beaten bark so that it becomes a potential foe for the approaching men.

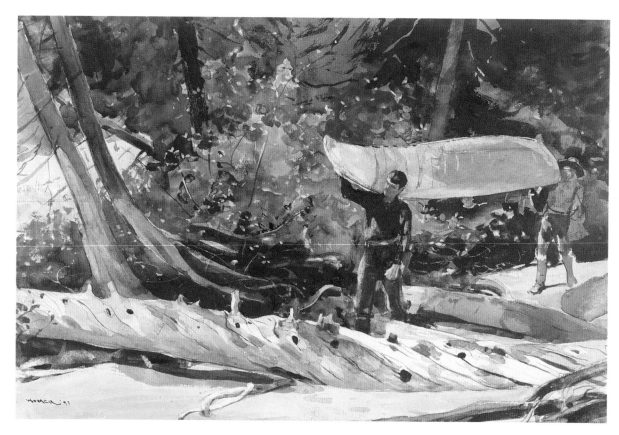

195 *End of the Portage, 1897*

Ouananiche, Lake St. John (fig. 193) is one of a small group of watercolors where man and nature appear in harmonious relationship. A lone fisherman casts his line from a rocky ledge. Saturated blues, apricots, and ochers laid down in broad strokes of transparent color set against reserves of white paper call forth the freshness and solitude of a northern wilderness morning. The gleaming arc of the fisherman's cast line, which Homer created by scratching the wet paper with the pointed end of his brush, unites foreground and middleground, while the angler's graceful stance— the red scarf at his waist a brief refrain of Homer's favorite color— suggests the sportsman's easy, knowing intimacy with the landscape around him.

In *Fishing the Rapids, Saguenay* (fig. 194), Homer placed the fisherman casting his line on a rock in the middle distance, thereby giving full play to the splendid foreground swirl of icy waters and the rush of foaming rapids. Here, as in his greatest watercolors, Homer does not describe the specific details of the activity, but swiftly and authoritatively, in colors true and pure, brings to life the whole experience.

"Something of the vigor and vitality of the cold air of these northern latitudes has entered into the artist's brush," wrote one critic on seeing the Quebec watercolors. "Mr. Homer's water colors are permeated with outdoor feeling and with the atmosphere

of the region."[6] Homer himself considered the Quebec watercolors to be exceptionally fine, and he hoped a significant number of them could be kept together. "My idea is to keep them in one collection for some Institution to buy the lot."[7] He priced them at $100 and up, with the highest being $400— the most he had asked for his watercolors since the large Cullercoats sheets, and an indication of what he thought of them. Although the critical response was uniformly favorable, his hope was not immediately realized. He sold only three Quebec watercolors out of ten during an exhibition at the St. Botolph's Club, Boston, in 1895, and none from the Knoedler show in 1898.[8] In March 1899, however, fourteen of the Quebec watercolors were sold from Doll and Richards. But his hope that they would be kept together was not realized. Except for three which were acquired by the Museum of Fine Arts, Boston, the Quebec watercolors were sold individually.

Notes

1 The club's amenities included rooms for twenty guests and sixteen guides, "sixty canoes and boats, . . . and kennels of spaniels kept for the fall partridge shooting. . . . Five- and six-course meals, with coffee on the clubhouse veranda, were served by Mme. Lessard, the steward's wife, a cook whose reputation reached far beyond the wilderness"; Frank Sleeper and Robert Cantwell, "Odyssey of an Angler," *Sports Illustrated* 25 (December 1972), 71.

2 Letter to Charles Homer, 23 February [perhaps 1895]; Bowdoin.

3 Eugene McCarthy, *The Leaping Ouananiche* (New York, 1894), 21; William Henry Harrison Murray, *The Doom of Mamelons* (Philadelphia, 1888), 112. Homer owned a copy of the McCarthy book. See David Tatham, "Winslow Homer's Library," *American Art Journal* 9, no. 1 (May 1977), 92–98.

4 Homer to John Beatty; Goodrich 1944, 220.

5 J.M. Le Moine, *Historical and Sporting Notes on Quebec and Its Environs* (Quebec, 1889), 114.

6 *New York Times*, 9 April 1898, 242.

7 Homer to Thomas B. Clarke, 15 December 1897; Goodrich/Whitney Museum Record.

8 Twenty-seven of the Quebec works were shown in April 1898 at M. Knoedler & Co. which had replaced Reichard's as Homer's New York dealer.

Bahamas

1898–1899

I think Bahamas the best place I have ever found.[1]

On 12 December 1898, Homer returned to the Bahamas, sailing from New York on board the steamship *Seneca*.[2] So far as is known, he had not visited the Bahamas since the winter of 1884–1885.[3] On that trip he had been accompanied by his father; this time he came alone, his father having died the previous August.

During the more than two months Homer spent in Nassau, he executed at least twenty-five watercolors. They include many of the same subjects that had interested him during his first stay: young black men in the water and along the shore; seaside vistas; sailboats under billowing clouds; and tropical vegetation. Some of the sheets again reveal Homer's delight in the colorful and decorative aspects of his subjects. But others, especially the scenes of black men, show a new, epic quality.

Homer brought to the late Bahamas watercolors the skills he had developed in the Adirondacks and Quebec— achieving maximum effect through simple composition and bold, uncluttered combinations of color. The Bahamas watercolors convey an intensely physical and unmediated response to the almost barbaric beauty he saw all around him: the brilliant colors of the lush landscape under the high sun of midday, and the gleaming, sculptural figures of young black men at one with nature. The sensual content of these sheets is given full expression in their form. Saturated colors— ultramarine and Prussian blues, turquoise and bright green, siennas, ochers, scarlet and pink— laid down with liquid strokes, over little or no graphite lines, build compositions of extraordinary strength and clarity.

Homer's refined understanding of color theory and of the interaction of color is evident in these watercolors, as it is throughout the mature works. Now, rather than place simple complementary colors *next* to one another as he had done in the watercolors of the mid-1870s, in the later watercolors he laid washes of complementary or related colors *over* one another, like fragments of different colored glass. For instance, in *Deer Drinking* (fig. 178), he used dark blue washes of varying saturations over cadmium yellow to render the shimmering green foreground water. The amount of light he allowed through, by virtue of the density of the paint applied, creates luminous tones ranging from black-green to olive, that are far fresher than if he had mixed the colors on his palette. Even when he uses layers of closely related hues, as in the deepening blues in the palm

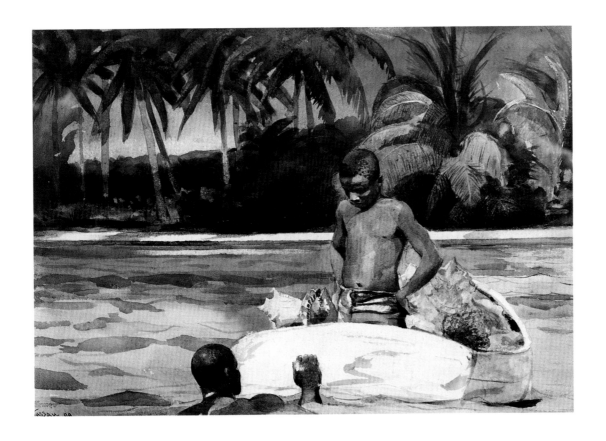

196 *West India Divers, 1899*

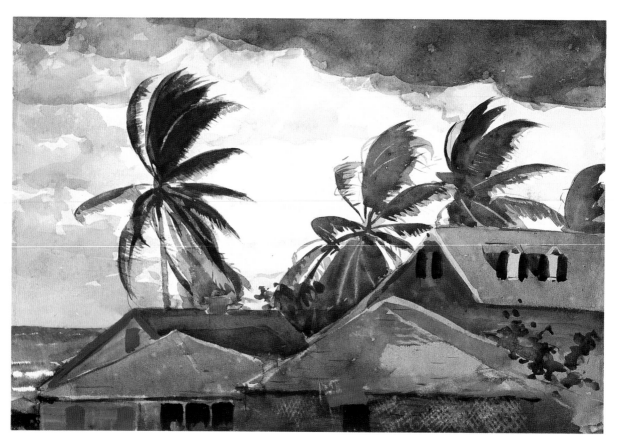

197 *Hurricane, Bahamas, 1898/1899*

fronds of *Under the Coco Palm* (fig. 201), he creates more tones than the actual number
of colors applied. The result is a painted surface that is tremulous with changing tints.

The vitality of such painted surfaces animates the subject matter itself, as in *Hurri-
cane, Bahamas* (fig. 197). Although no figures are present, the theme of man in a threat-
ening natural environment is implied. The low-lying buildings— surrogates for the men
who constructed them— seem as living things, huddled together and tenaciously cling-
ing to the earth lest they be swept away in the fury of the storm. By contrast, the palms
stand erect, despite their apparent fragility, defying through their very flexibility the
power of the hurricane. A limited palette and gestural brushwork convey the charged
atmosphere. Homer applies washes of gray-blues and greens with accents of rust-red
directly and swiftly, thereby strengthening the impression of a spontaneous response to
the windswept scene. Even the cross-hatching of the latticed veranda in the foreground,
rendered by using the wooden end of the brush to lift off the wet paint, gives the impres-
sion of spontaneity.

One group of watercolors reveals the pleasure Homer took in the colors and textures of
the landscape. *A Wall, Nassau* (fig. 198), inscribed *Dec. 31, 1898/Nassau*, is a study of
contrasts. The rough texture of the characteristic Bahamian coral limestone wall with the

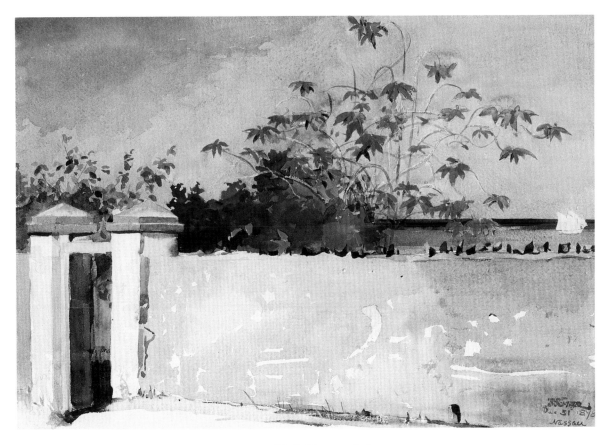

198 *A Wall, Nassau, 1898*

broken bits of dark glass cemented onto the top to keep out intruders, washed in gray-pink shadows, is a foil for the velvety smoothness of the poinsettias exploding against the ultra-marine sky and sea, while the wall's implied enclosure of space contrasts with the freedom suggested by the sailboat on the open water. *Nassau, January 1st, 1899* (fig. 199) represents three ancient, rusted cannons on the white sand, probably relics from English or Spanish men-of-war. Immediately evident is the visual delight Homer took in the transparent turquoise waters, the white hulls of the sailboats, the splashes of vermilion shirts against dark bodies, all under an azure sky. That Homer was able to execute this watercolor and *A Wall, Nassau* on two successive days is eloquent testimony to his extraordinary facility in the medium.

The same sense of physical pleasure and well-being is conveyed in *Sloop, Nassau* (fig. 200), where Homer laid down lapidary tones of sapphire, turquoise, and emerald in liquid strokes. The sweeping, furled white sail— the lines of its repeating arched forms reinforced with graphite and point-of-brush and its whiteness reaffirmed in the brighter white reflections— asserts itself as a grand gesture against the pink-tinged sky. In *Nassau* (fig. 203) Homer shows a wide view of the low-lying shoreline looking north toward Hog Island with its lighthouse. Near the white sand beach, shaded by palm trees, stands a

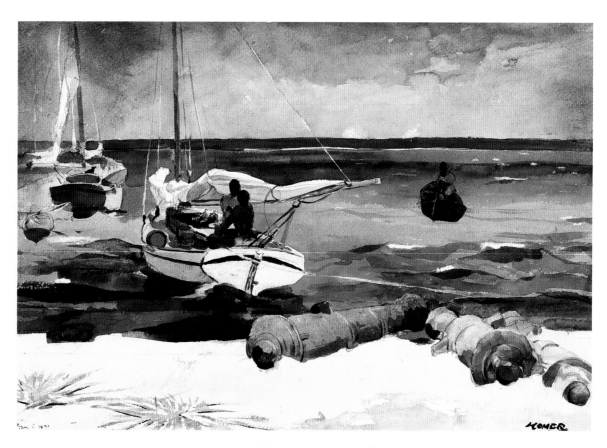

199 *Nassau, January 1st, 1899*

wooden cottage, perhaps the home of the woman and child walking along the smooth road. Composed entirely in shifting tones of greens, ochers, iridescent blues, and deep reds, *Nassau* evokes perfectly the seductive Bahamian atmosphere of flower-scented breezes and easy living under the sun.

On this Bahamas visit, Homer looked anew at the black men and found in them a vehicle for expressing man in harmony with nature. His vision of them was in direct contrast to his portrayal of the young Adirondacks woodsmen, whom he most often showed as exploiters and destroyers of nature. Sheets like *West India Divers* (fig. 196), full of color and warm light, portray the divers in unity with nature and with each other. Although visitors to the Bahamas praised the young girls for their charm and beauty almost as often as they did the young boys, in these late works Homer rarely shows a woman, and then only at a distance. Almost two decades earlier, the Cullercoats fisherwoman had become for the artist a larger-than-life figure symbolizing the sea and its terrible power. In the Bahamas works it was the man who came to assume a monumental physicality; he, however, inhabited an Edenic world.

The Bahamas watercolors have a persistent and overt sensuality. *Under the Coco Palm*

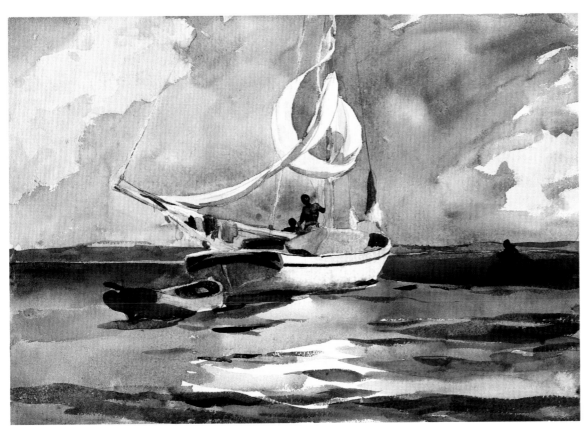

200 *Sloop, Nassau, 1899*

(fig. 201) shows a black boy seated beneath a young palm tree in the midst of a moist, junglelike grove of foliage and fallen fronds. Enveloped, sheltered and protected, he contentedly drinks from a coconut. The color scheme, primarily greens, ochers, reds, and white, is opulent and expressive, and the rhythmic movement of quick, vivid strokes of varying intensities drawn over broad washes is remarkably free, creating a double primitivism of poetic image and style. Only the boy's features and hands lovingly cradling the coconut are carefully delineated. With his head thrown back like a suckling infant, his body bespeaks sensual gratification and refreshment.[4] The sense of a life that enjoys extraordinary communion with nature suffuses the sheet, no less so through the unity of color between boy and tree. Moreover, the finlike appendage formed by the piece of fallen palm stem near the boy's legs marks him as a creature also at home in the watery landscape.

The Turtle Pound (fig. 202) also expresses the close affinity between the black man and nature. Under an azure sky, a magnificently proportioned man stands chest deep in the green and turquoise water, straining to hand over a struggling turtle to his darker-skinned companion. Young turtles such as this one were stored and fattened in seawater pens or krawls before being taken to market. The twin arcs of the turtle's limbs reiterate

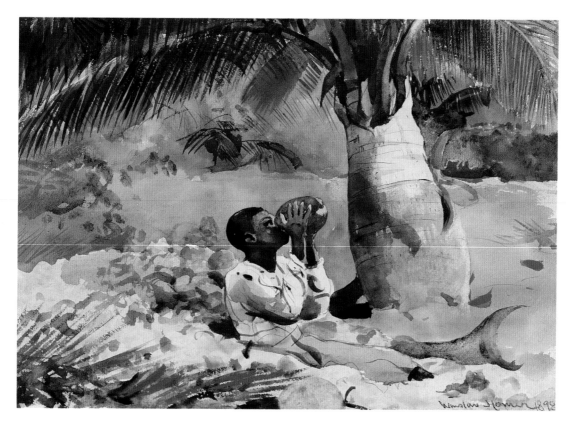

201 *Under the Coco Palm, 1898*

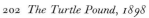

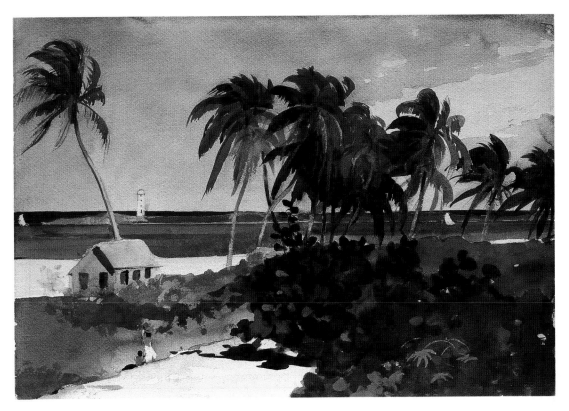

203 *Nassau, 1898/1899*

in color and form the wings of the gull soaring above, sounding a poignant contrast between the captive reptile and the unfettered bird. More striking is the analogy Homer draws between the stubby, weblike fingers of the man looking over the top of the pound and the turtle's limbs. The artist's own identification with the scene being enacted is subtly suggested by his half-submerged signature on the side of the pound.

After the Hurricane (fig. 204) can be seen as the final image in a narrative sequence about the power of nature and man's ineffective struggle against it. Fourteen years earlier, a shark hunting scene had been exceptional among Homer's otherwise benign Bahamas subjects. *Shark Fishing* (fig. 137) presented two black men in a dinghy, in control of a huge shark. When the idea evolved into the 1889 watercolor *The Gulf Stream* (fig. 134), Homer rendered a single figure lying helpless on a dismasted schooner, almost engulfed by the rough sea, with the shark hovering dangerously close. In *After the Hurricane*, painted a decade later, the ship has been wrecked, the seas are again calm, and the figure has been washed ashore.

A haunting work, *After the Hurricane* is characterized by pure color, animated draftsmanship, and expressive design. Under a liquid gray sky beginning to clear, the young black man lies curled on his side on the white beach, his head cradled on his arm. His

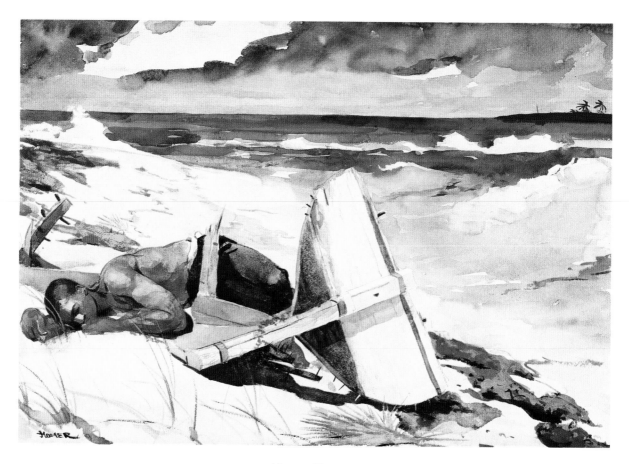

204 *After the Hurricane, 1899*

relaxed position suggests he is still alive. Too exhausted to move upon reaching land, he has fallen into a deep sleep on the warm sand just where the waves deposited him, next to the wreckage of his boat. Muscled and gleaming, he is like a magnificent animal, who, unresisting, accepts nature's power over his life. His legs are concealed by the remains of the stern and rudder, which Homer arranged to suggest an enormous tail or fin, thereby giving the overall contour of man and wrecked boat the form of a huge aquatic creature.

Sometime shortly after 6 February 1899 (the last dated Nassau watercolor), Homer left Nassau for Enterprise, Florida, where he planned to remain until the northern weather became warmer. As on his previous visit in 1890, he stayed at the Brock House Hotel. This time, however, he did no work.

In mid-February the great auction of Thomas B. Clarke's American collection took place in New York. Included in the sale were thirty-one works by Homer, of which sixteen were watercolors.[5] Upon learning that five of the highest bids received were for his oils (the watercolors brought only moderate prices— the highest being $370 for *Watching the Tempest*, fig. 86), Homer was elated. He wrote to Clarke from Enterprise: "I owe it to you to express to you my sincere thanks for the great benefit that I have received

from your encouragement of my work & to congratulate you. . . . Only think of my being *alive* with a reputation (that you have made for me)." He added: "I have had a most successful winter at Nassau. I found what I wanted & have many things to work up into *two paintings* that I have in mind."[6]

One of these paintings was *The Gulf Stream* (fig. 133), which Homer completed within months after returning to Prout's Neck in early spring. It was Homer's last variation on the theme of the perilous sea. Ten years had passed since he had executed the watercolor of the subject (fig. 134). In the final translation of the image into oil, the vision has become harder: the figure is half-naked; the foreground is infested with sharks; and in the seemingly limitless ocean, streaks of blood-red hint of a terrible occurrence. Partly through enigma and ambiguity, partly through explicit detail, Homer suggests a nature infinitely indifferent to the fate of man, with man himself resigned to his lot.

Notes

1 Homer to Louis Prang, 18 October 1905; Goodrich/Whitney Museum Record.

2 *Nassau Guardian*, 14 December 1898.

3 The two watercolors of Bahamas subjects dated *1889*, *The Gulf Stream* (fig. 134) and *The Sponge Diver* (fig. 132) were probably begun during that visit.

4 I am indebted to Madalena Velasquez for this interpretation. Leslie A. Fiedler has written of the black man in American literature: "In dreams of white men, psychologists tell us, the forbidden erotic object tends to be represented by a colored man . . . [a] 'grand sculptured bull' . . . [a symbol] for the primitive world which lies beyond the margins of cities and beneath the lintel of consciousness"; *Love and Death in the American Novel* (New York, 1960; rev. ed., 1975), 365–366.

5 H. Barbara Weinberg, "Thomas B. Clarke: Foremost Patron of American Art from 1872 to 1899," *American Art Journal* 8, no. 1 (May 1976), 75–76. Clarke's admiration for Homer's work was so strong that in 1892 he had established a private one-room Homer gallery in his residence. Upon learning of this, Homer had written to him: "I never for a moment have forgotten you in connection with what success I have had in Art. I am under the greatest obligations to you and will never loose [*sic*] an opportunity of showing it"; letter of 28 March 1892; Goodrich/Whitney Museum Record.

6 Letter of 25 February 1898; Goodrich/Whitney Museum Record.

Bermuda

1899–1901

In the winter of 1899–1900, Homer visited the crown colony of Bermuda for the first time. Sailing on board the *Trinidad*, he arrived in Hamilton, the principal city, on 8 December 1899.[1] He may have stayed at Mrs. Rebecca Swan's Country Boarding House, a tourist hotel at Scaur Hill, Somerset.[2] In any case, he remained in Bermuda until 22 January 1900.[3] The special beauty of this coral island— actually an island cluster forming a ring of coral reefs around a lagoon— apparently captivated the New Englander, for he returned in 1901.[4] At least nineteen watercolors are known from these two visits. In them, Homer focuses on the qualities that give Bermuda much of its charm: dazzling light, brilliant color, and beautiful vistas, which he renders in saturated jewel-like colors thrown in broad washes against the pure white sheet.

At the turn of the century, Bermuda was still a relatively unfamiliar place to Americans, but its reputation as a desirable warm-weather resort was rapidly growing. Periodic reports in the press and such magazines as *Harper's*, *Century Magazine*, and *Metropolitan* described the pleasures of Bermuda's climate and the peace of mind attainable in a beautiful, largely unspoiled setting. After a voyage of less than three days, the journals promised, the visitor would have protection from "the disturbances of modern life."[5]

In the watercolors of the Bahamas, Homer had made the blacks the central subject, their so-called primitive lifestyle suggesting a certain pagan, and to the visitor perhaps unsettling, abandonment. Conversely, the discreteness of the human presence in the magnificent Bermuda settings underscores the sense of refined repose and serenity that were the perceived attractions of the island.

Homer shows Bermudans in only a few of the watercolors, perhaps because the character of their work was not inherently dramatic: the average Bermudan worked as a mason, day laborer, farmer, or servant. There seemed to be few opportunities for profound encounters between man and nature such as he had found in the Bahamas. Consequently, the Bermuda sheets show no close-up views of the human figure at work or at rest. Instead, the landscape became Homer's chief pictorial interest, with human beings relegated to small and incidental places. The figures that do appear in the Bermuda watercolors are not only remote, but often puzzling. *Flower Garden and Bungalow, Bermuda* (fig. 207) includes a little girl who appears to chase two domestic birds or animals behind the house. We cannot read her face, and we understand her action only through

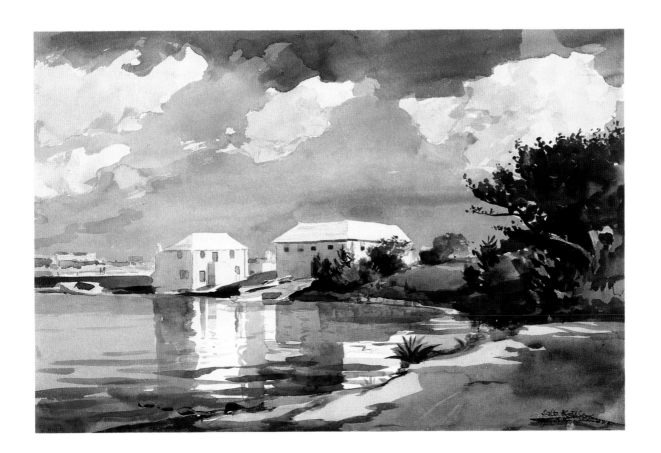

205 *Salt Kettle, Bermuda, 1899*

her outflung arm and upraised left leg. Despite the allure of lush foliage, sea, and sky, we are drawn back to this tiny note of red and black in the center of the composition. This powerful hint of energy amid the enchanted stillness creates a vague sense of disquiet.

Most mystifying, perhaps, is the portrayal of Bermudans in *House and Trees in Bermuda* (fig. 206). Behind a white shorefront house, a young boy and girl crouch on a hill of the island's distinctive red earth; the girl peers at the boy, while he tensely looks out toward the sea. Possibly Homer himself did not know what to make of these figures, for after laying in the first wash, he left them unfinished.

Equally perplexing are the representations of soldiers in *Coral Formation* (fig. 208), one of at least three watercolors showing red-coated military figures on the extraordinary rock formations found on the westernmost part of the island opposite the Royal Bermuda Dockyard, at the time a British naval garrison and close to Homer's boarding quarters.[6] The presence of the military was strong: the island was considered by some to be one of England's prize possessions, joining Gibraltar and Malta to form "an equatorial belt of British supremacy."[7] In particular, Bermuda's location made it a strategic center for the storage of arms and ammunition. At the time of Homer's second visit soldiers were more prominent in Bermuda than usual. From July 1900 to September 1902, the British government used Bermuda as a detention area for Boer prisoners captured during the South African War (1899–1902). The special guards entrusted with the prisoners added to the already large number of military men who staffed the island in peacetime.

Yet Homer did not paint the organized ceremonial activities of military officers. He shows instead ordinary soldiers in isolated and unexplained situations, often placing them along the stratified, fantastically shaped geological formations typical of the Bermuda coastline.

As much as the rocks, these soldiers seem an intrinsic element of the island's local color. Indeed, William Dean Howells described the vision of the flaming scarlet and gold uniforms against the black skin of the soldiers (the garrison of the island being a regiment of Jamaicans) as "gorgeous."[8] The result in the watercolors, however, is more than

206
House and Trees
in Bermuda, probably 1899

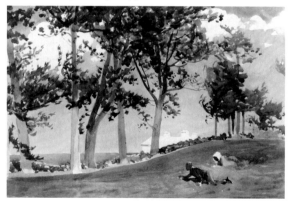

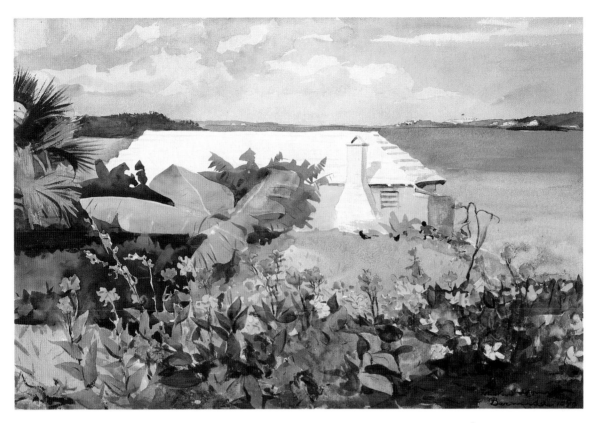

207 *Flower Garden and Bungalow, Bermuda, 1899*

208 *Coral Formation, 1901*

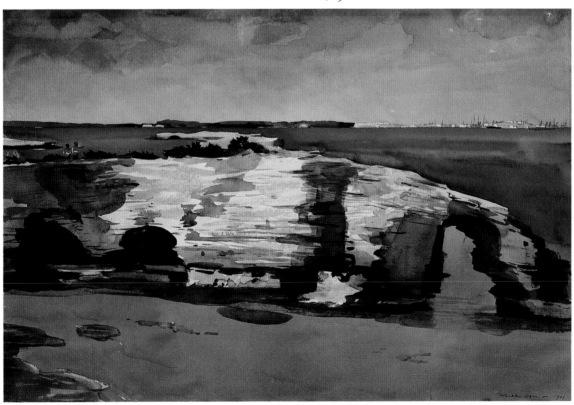

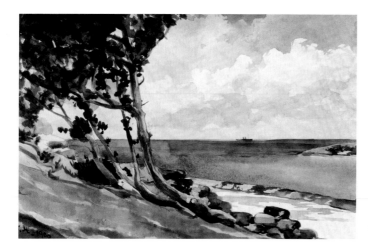

209 *North Road, Bermuda, 1900*

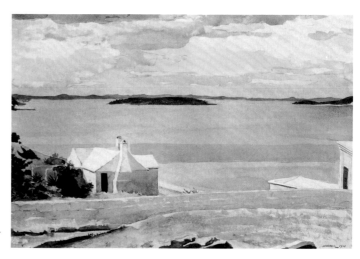

210 *Inland Water, Bermuda, 1901*

merely colorful. The human presence purposefully, and in a disquieting way, interrupts the landscape's untamed grandeur.

Homer's physical remove from these military figures may in part have been the result of recent legislation in Bermuda that strictly forbade the sketching or photographing of fortified posts within close distances.[9] Seen in the context of all his Bermuda works, however, these soldiers are as small and subsidiary as Homer's other figures. Indeed, the Bermuda watercolors as a group are characterized by a puzzling neutrality, even conventionality, as if the artist were suddenly tired of more vital themes and found solace in Bermuda's serene beauty.

In Homer's day, as today, Bermuda was an island whose hills and roadsides were dotted with stately palms, palmettos, and bamboo, and banana, orange and lemon trees. A seemingly endless array of exotic flowers— wild oleander, scarlet hibiscus, poinsettia, morning glory and lilies— enlivened the evergreen landscape with brilliant color. The coral-bottomed, crystalline sea and a deep blue sky engendered rapturous descriptions of

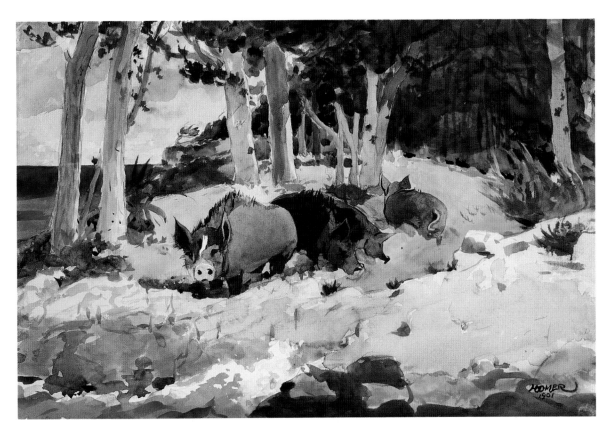

211 *Bermuda Settlers, 1901*

Bermuda as an earthly paradise. Homer captures this sense of primeval innocence in *Bermuda Settlers* (fig. 211); it is as if the viewer simply happened upon these five wild razorback pigs in a cedar grove.[10]

The most striking feature of the landscape, remarked by countless visitors, was the curious mixture of northern and tropical vegetation. The prevailing foliage is a tough, dark green cedar, almost disappointing to northerners in its familiarity. William Dean Howells characterized the trees as seeming transplants from Maine; others described the hilly terrain as reminiscent of the Adirondacks.[11] Both locales, were, of course, well known to Homer, and his explorations of the Bermuda foliage, and the play of light upon smooth, rocky, or aquatic surfaces are informed, at least in part, by that knowledge. Earlier watercolors such as *Maine Cliffs* (fig. 113) forecast the kind of terrain he found in Bermuda: bright, sheer rock interrupted by tufts of scraggy verdure.

Among Bermuda's semitropical vegetation and animal life were a number of much acclaimed natural phenomena, including the sea-gardens, full of exotic fish and plants, which served as public aquaria, and large caverns with stalactites and stalagmites. Yet

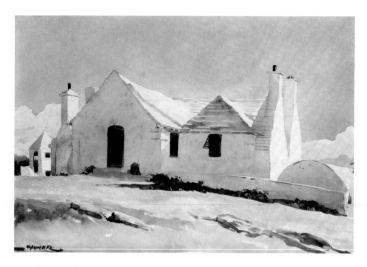

212 *Bermuda, 1901*

Homer depicted none of these attractions. His Bermuda is closer to the one described by Mark Twain twenty years earlier:

The country roads curve and wind hither and thither in the delightfulest way, unfolding pretty surprises at every turn: billowy masses of oleander that seem to float out from behind distant projections like the pink cloud banks of sunset; sudden plunges among cottages and gardens, life and activity, followed by as sudden plunges into the sombre twilight and stillness of the woods; flitting visions of white fortresses and beacon towers pictured against the sky on remote hill-tops; glimpses of shining green sea caught for a moment through opening headlands, then lost again; more woods and solitude; and by-and-by another turn lays bare, without warning, the full sweep of the inland ocean, enriched with its bars of soft colour, and graced with wandering sails.[12]

Watercolors like *North Road, Bermuda* (fig. 209) and *Inland Water, Bermuda* (fig. 210) share this personal, almost intimate encounter with the island, reflected in the insistent immediacy of the foreground space, the sense of a series of dissolving views, the absence (or quiet) of human activity, and the stillness of sea and sky.

In contrast, *Salt Kettle, Bermuda* (fig. 205) represents a specific site. Located across the harbor, southwest of Hamilton, the area was once the home of the salt industry so important to Bermuda in the eighteenth century. A hundred years later Salt Kettle had no

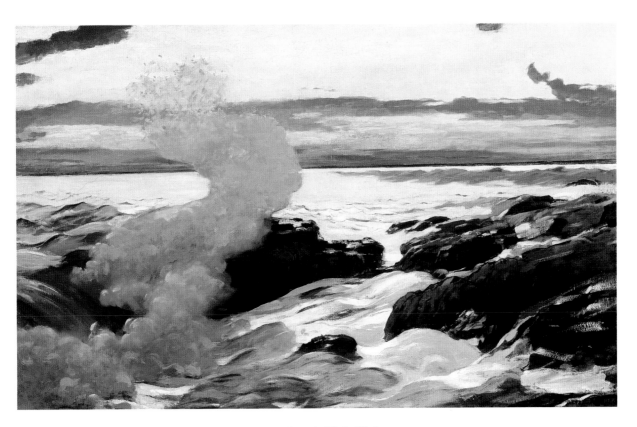

213 *West Point, Prout's Neck, Maine, 1900*

commercial importance, but its sparkling inlet continued to attract visitors.[13] Homer portrays the site in a state of undisturbed rest, its only activity the moving clouds and shimmering reflections in the water. The vigorous clarity of the reserved white paper, the purity and ease of the brushwork in the fluid overlaid washes of resonant color— gray-blue over pink, indigo over rust-red, rich greens, with notes of vermilion sounded across the sheet to bring the whole together— create a work of striking luminosity.

One aspect of the Bermuda environment that fascinated virtually every commentator was its unique vernacular architecture. Every building — private and public, grand and humble— was constructed of the indigenous soft, white coral sandstone that was both durable and easy to work. Even more striking were the roofs, made of broad, inch-thick slabs of the same material. The stone, obtained from quarries all over the island, was sawed into huge blocks about two feet long, a foot wide, and six inches thick. Upon completion, a waterproof coating was applied and then the whole building was encased with a thick coat of whitewash, making it look as if it had been carved from a single block of stone. These houses, rising from their emerald surroundings, gleamed in the sunlight. Drysdale dubbed Hamilton the "Whitest City in the World" and Twain marveled that it was whiter than marble, and could describe it only as "exactly the white of the icing of a cake."[14]

Homer made such a house the subject of *Bermuda* (fig. 212). The soft clouds that form

its backdrop emphasize, in their abundance, his fascination with the pure white of the houses. The planes of the house are set solidly into the earth, while the sharp angles point toward the sky. The twin chimneys that enframe the full breadth of the shining facades receive particular emphasis.[15]

Most of Homer's views depict the houses nestled upon hills along the shore. In *House and Trees in Bermuda* (fig. 206), however, the viewer is situated further inland, looking down upon the houses, a vantage point that accentuates the meeting of earth, sky, and water. *Flower Garden and Bungalow, Bermuda* (fig. 207) is set along the shore, but here the viewer is among an array of red hibiscus, red and yellow cannas, and palm fronds and leaves in an extraordinary range of greens. The house has the familiar, wide roof and prominent snow-white chimney, but the walls, usually white, are brushed with a coat of soft yellow. At the time, colored walls were rare among Bermuda houses, and Homer was probably intrigued by the individuality of such a cottage.[16] Illustrated in guidebooks as "old-time" and "ancient" homesteads, cottages of this size and architectural style usually belonged to the islanders. Here, as in the other Bermuda watercolors, Homer has abandoned narrative priorities to indulge his mastery of the medium and pleasure in the island's luminous beauty.

Homer considered his Nassau and Bermuda watercolors to be "as good work . . . as I ever did."[17] At the Pan-American Exposition in Buffalo in 1901 he chose to be represented by the watercolors only, sending twenty-one scenes from the Bahamas and the first Bermuda trip, which he priced at $4,000 for the group. The watercolors received a gold medal. Perhaps piqued because they did not sell as a group, he had them returned, explaining to Knoedler: "That makes my winter's work of 1898 & 1899 *complete*. I shall leave them boxed as they are until such a time as I see fit to put them out. The price will be $400 *each*!! for choice if I ever put them out again."[18] He changed his mind, however, and in June and July of 1902 he sent Knoedler fourteen watercolors, some new works and some older ones, including *The Turtle Pound* (fig. 202) and *After the Hurricane* (fig. 204). He confided to his Day Book: "Murder comes now. To net me $200 each & all, good or bad, large or small."[19]

Homer was growing increasingly frail, in part the result of chronic stomach problems.[20] He still visited the Adirondacks almost every summer, but after 1900 his visits were for fishing only. The cold weather and spartan living conditions at Prout's Neck were becoming harder to bear. Yet he managed to complete some of his greatest marine paintings, among them *On a Lee Shore* (1900; Museum of Art, Rhode Island School of Design, Providence); *Eastern Point Light* (1900; Sterling and Francine Clark Art Institute, Williamstown), and *West Point, Prout's Neck, Maine* (fig. 213). The influence of the mature watercolors is evident, in the expressive color— brilliant turquoise, surreal iridescent greens, silvery grays, and characteristic slashes of vermilion, in the direct application of paint with gestural brushwork, and in the intense glorification of nature.

Homer himself realized the importance of his watercolors. Although he tended to speak only of their monetary worth— that they "paid expenses"[21]— he worried about their eventual disposition. He kept a number of the Nassau and Bermuda works in his studio, resisting all offers for them in the hope they would be acquired as a group by some institution.

Notes

1 *Royal Gazette*, Bermuda, 12 December 1899.
2 Homer had inscribed Mrs. Swan's name and hotel in his copy of the *Bermuda Pocket Almanack* [1899]; see David Tatham, "Winslow Homer's Library," *American Art Journal* 9, no. 1 (May 1977), 96.
3 *Royal Gazette*, Bermuda, 23 January 1900.
4 In a letter of 18 October 1905 to his friend Louis Prang, Homer states that he had "passed the last two winters [1904 and 1903] in Florida, the year before in Bermuda, & before that in Nassau"; Goodrich/Whitney Museum Record. Homer's recollection of these trips is not precise. For instance, he seems to have forgotten his trip to Bermuda in the winter of 1899–1900. There is no record or any other mention of any trip to Bermuda in 1902, nor are there any Bermuda watercolors known with this date. It is possible that the trip in question began in 1901, the date on at least six watercolors, in December (as did almost all his visits to the south) and continued into the new year.
5 William Dean Howells, "Editor's Study," *Harper's New Monthly Magazine* 89 (June 1894), 150. Much of the island was too hilly and rocky to be organized for cultivation and certain restrictions upon land development helped to slow the pace of growth; see James H. Stark, *Stark's Illustrated Bermuda Guide* (Boston, 1902), 62.
6 Soldiers are also included in *Rocky Shore, Bermuda* (1900; Museum of Fine Arts, Boston) and *Natural Bridge* (probably 1901; The Metropolitan Museum of Art).
7 *Bermuda Pocket Almanack*, 84.
8 [William Dean Howells], "Editor's Easy Chair," *Harper's New Monthly Magazine* 103 (June 1901), 149.
9 *Bermuda Pocket Almanack*, 85.
10 In his Day Book entry for 5 July 1902, Bowdoin, Homer titled his sketch of this watercolor, *Bermuda Pigs*.

11 [Howells], "Easy Chair," 146; and *New York Times*, 11 February 1883, 9.
12 Mark Twain, "Some Rambling Notes of an Idle Excursion," in *The Stolen White Elephant, etc.* (London, 1927; orig. ed. Boston, 1882), 63. If Homer's watercolors are an indication, the artist seems to have shared Twain's opinion that "There are several 'sights' in the Bermudas, of course, but they are easily avoided"; 83.
13 In 1912 Woodrow Wilson chose the site for his vacation villa.
14 *New York Times*, 28 January 1883, 10; Twain, "Some Rambling Notes," 60.
15 Twain found the Bermuda chimneys "too pure and white for this world; [I know] of no other country that has chimneys worthy to be gazed at and gloated over"; "Some Rambling Notes," 61. The artist Charles Demuth appears to have been equally fascinated by Bermuda's architecture; see, for example, his *Bermuda, no. 4* (1917; The Metropolitan Museum of Art).
16 Guide books and essays on Bermuda published about the time of Homer's visits to the island described only the whiteness of the houses. It is not until a quarter of a century later that there is mention of the occasional home with walls coated in yellow or pink; see for example, John J. Bushnell, *Bushnell's Bermuda Handbook* (Hamilton, 1926).
17 Homer to the dealers O'Brien and Son, Chicago, 1902; Goodrich/Whitney Museum Record.
18 Knoedler Archive.
19 Bowdoin.
20 In a letter of 30 March 1903, he humorously explained his illness: "The trouble was I thought that I would give up drinking— & it was a great mistake & although I reduced the size of my nose & improved my beauty my stomach suffered"; Knoedler Archive.
21 Homer to Col. George G. Briggs, August 1900; Goodrich/Whitney Museum Record.

Florida

1903–1905

In early December 1903 Homer returned to Florida. He had done no painting at all for more than a year. On the eve of sailing from New York for Key West, he wrote to his brother Arthur of his projected second visit to the island city:

I know the place quite well & its [sic] *near the points in Florida that I wish to visit— I have an idea at present of doing some work but do not know how long that will last.*[1]

The watercolors Homer executed on this trip would turn out to be the last series he ever did.

Homer remained in Key West until the first of the year, then traveled, most likely by steamer, up the Gulf Coast to Homosassa, where he spent more than a month before returning to Prout's Neck in March. He produced two separate series of watercolors on this vacation. The Key West works focus exclusively on the schooners in the harbor; the Homosassa watercolors depict fishing along the palmetto-lined Homosassa River.

Homer's nine known watercolors from this Key West trip have, like those made in 1886, more in common with certain of the Bahamas watercolors than with those of the Florida mainland. The white-hulled boats floating on pellucid blue waters (figs. 215 and 218) carry on a theme begun in such Bahamas watercolors as *Sloop, Nassau* (fig. 200).

Within a firm compositional structure, Homer ignored all but the essentials and concentrated on capturing large effects of light and color. His brush flowed effortlessly, carried by a fresh surge of creative energy. As a result, these watercolors are among the artist's most luminous and vibrant works. They also mark the final highpoint of Homer's watercolor career. He conceived these sheets with animated drawing, the colors in sequences of broad washes of grays, blue-greens and blues of the utmost transparency, with accents of vermilion, red-brown, and black, leaving large areas of white paper untouched for the boats and sails. Throughout, subject and style are inseparable.

In *Key West, Hauling Anchor* (fig. 218) the thrusting, furled sail cut off by the right edge of the sheet, and the masts and rigging cut off by the top edge, create in the mind's eye a sense of continued movement, while the simplified color scheme of white hull and sails, red-shirted crew, and gray-blue sea and sky produce a scene of sunlit clarity. By contrast, *Fishing Boats, Key West* (fig. 216) is suffused with the atmosphere of a brooding storm. Flooding in pale washes of gray-blues for the sky and the sea, Homer gave subtle

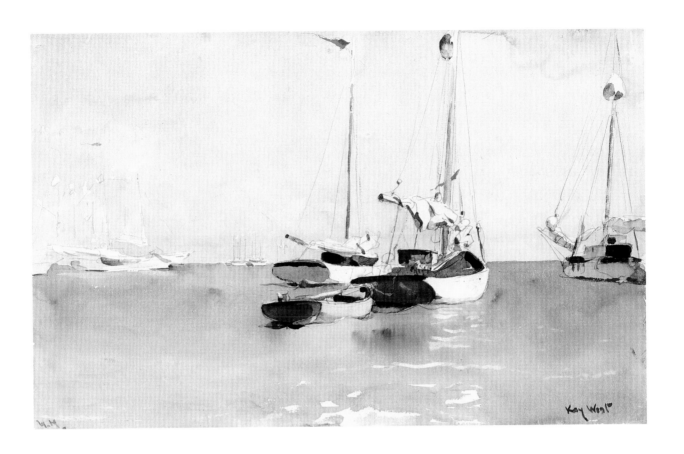

214 *Key West, 1903*

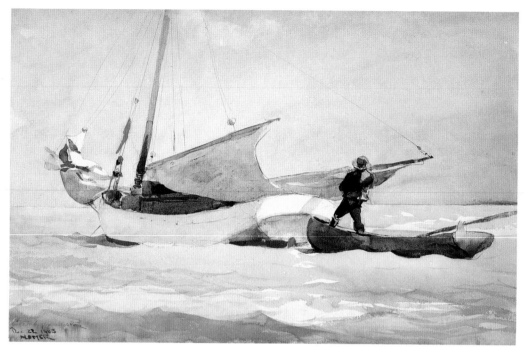

215

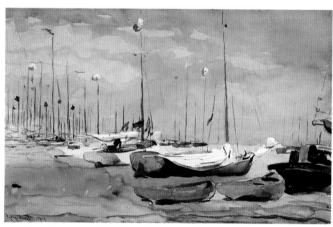

215
*Stowing the Sail,
probably 1903*

216
*Fishing Boats,
Key West, 1904*

217
*Fishing Boats,
Key West, 1903*

216

217

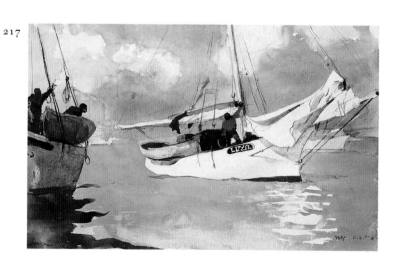

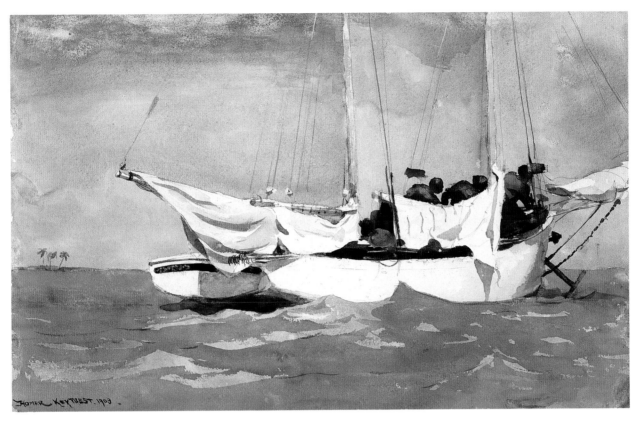

218 *Key West, Hauling Anchor, 1903*

variation to the sky at the upper right by dropping small pools of water onto the drying wash, and suggested the effect of a breeze moving across the water at the bottom left by backwashing the area. Reserved white paper for the furled sails forms a diagonal pattern through the center of the composition, as if the boats had been struck by the flash of light that precedes a storm. Graphite and point-of-brush drawing create the masts, a forest of vertical lines independent of the wash.

In his ability to use accidental effects, Homer had few rivals. In *Key West* (fig. 214), the wet-into-wet blending of a darker splash of blue into the pale wash captures the effect of the shimmering, rayed, refracted shadows that hang under sloops bobbing on a tropical sea. The artist's use of graphite line is equally masterful. In *Fishing Boats, Key West* (fig. 217) the three-dimensional volume of the topsails is defined by wash surrounding

219 *In the Jungle, Florida, 1904*

220 *Life-size Black Bass, 1904*

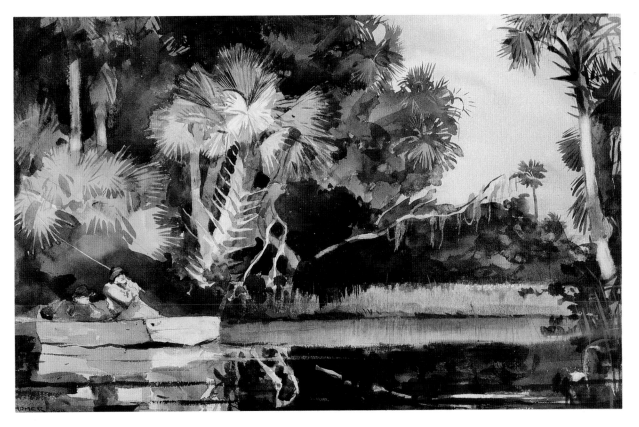

221 *Homosassa Jungle, 1904*

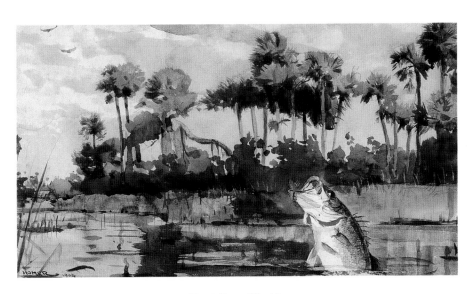

222 *Black Bass, Florida, 1904*

reserves of white, while the two-dimensional masts and rigging are drawn in graphite.[2] Homer's technical virtuosity is evident in even the smallest passages, as in the way he handles the differences between wet and dry-brushed pigments. In *Key West* (fig. 214) bold scratches in the paper make white reflections in the damp washes. Apparently deciding that some of the scraped reflections intruded upon the effect of the wet-into-wet darker blue shadow, Homer touched their leftmost edges with a blue paint, dry enough not to be fully absorbed into the roughened paper but which perfectly matched the watery blues of the sea.

Homer left Key West in early January, and moved on to Homosassa, about four miles from the Gulf of Mexico. He probably took the steamer from Key West north to Cedar Keys on the Gulf Coast and then made a forty-mile trip to Homosassa by train. On 7 January 1904, he registered at the Homosassa Inn, one of the few hotels in the town (increasing numbers of gentleman-anglers who regularly visited the area were now building cottages along the river). While Key West was one of the most fashionable vacation spots in Florida, Homosassa was rarely mentioned in the average guidebook. It was, however, often described in fishing magazines as a fisherman's paradise. "It is one of the few places where an angler will not be disappointed," wrote one visitor.[3] Black bass, sea trout, sheephead, red fish, and channel bass were to be found in abundance. With its waters so crystal clear that "tarpon may be seen disporting sixty feet below the surface," Homosassa offered excellent fishing. "As many as thirteen different species of salt-water fishes have been taken with artificial flies by one rod in a morning's outing," reported another enthusiast.[4]

Homer developed a fondness for Homosassa, returning there the following year, and again in 1908 and in 1909, but he produced watercolors only during his first visit. In a letter to his brother Arthur, he said of Homosassa,

Delightful climate here about as cool as our September— Fishing the best in America as far as I can find. . . . I shall fish until the 20th then my guide has another engagement & I shall take my own boat & work half the time & fish on my own hook. . . . I shall only paint to see if I am in up [sic] it — & with a chance of paying expenses.[5]

The eleven known Homosassa watercolors, like the series he had produced at Enterprise more than a decade earlier, most often focus on fishermen, their activities, and the surrounding landscape. And, as in the earlier sheets, the scenes are presented from the vantage point of a fisherman on the river. There are, however, significant differences between the two series. In the Homosassa works, the colors are darker and richer, the light more brilliant, and the shadows more complex. The objects are described in greater detail, and the mood of quiet attention so prevalent in the Enterprise series is often replaced by a heightened level of activity and drama. Whereas the Enterprise watercolors give only the merest hint of physical exertion, in the Homosassa series a puma screams in a tree, bass thrash in the water, nearly every rod is bent by the weight of a fish,

223 *Diamond Shoal, 1905*

and the bodies of the fishermen strain backward as they attempt to land their catches. Indeed, the animation of the Homosassa watercolors more closely allies them to the Adirondacks works than to the Enterprise ones.

In terms of execution, the Homosassa watercolors are among the most complex. *In the Jungle, Florida* (fig. 219) conveys the luxuriant and savage character of a tropical forest. Serpentine forms predominate in the dense undergrowth broken only by pools of dark water, in the broad, glossy foliage set side by side with rotting and dead trees, and in the sleek puma, tensely poised in mid-climb, its head sharply turned as if in response to a sudden sound. A range of yellow and green washes, splashed here and there with streaks of red, blended wet-into-wet or superimposed in myriad shades and multilayerings, seems to repeat the dense layers of growth in the jungle itself.

In *Homosassa Jungle* (fig. 221), we can follow Homer's working procedure. He began by putting down the ground for the main color areas: pale blue for the sky, yellow for the palmetto areas and along the shore line, and pale red (probably carmine, a beautiful and fugitive red) for some of the tree trunks, mixing it with gray for the foreground. Next he laid down the tones of the boat and its reflection, bleeding the red and blue together. Along the shoreline he brushed dark green pigment over the yellow, followed by a brownish-red wash, all of which was then lightly blotted. For the palmettos, he super-imposed dark green washes over the yellow, the brushwork in the final washes describing the forms of the foliage. In certain passages, as in the palmetto at left, Homer put down a watery touch of color rather than a stroke, allowing the accidental shape formed by the fluid green paint to serve as the edges of a tree. In some places, he bled a brighter orange-yellow into the wet green, while in others he laid it on top of the dry yellow. To keep the fronds from appearing to leap forward, he touched dots of black at their tips. Some of the branches are formed through reserved paper while others are rendered in gray wash or, as in the tree trunk, through light scraping. Short strokes of yellow and ocher suggest the grasses, and in the foreground, characteristic flicks of vermilion give the final touches.

As in the Adirondacks and Quebec works, Homer here presented close-up views of lo-cal fish, in this case, bass. *Black Bass, Florida* (fig. 222) and *Life-size Black Bass* (fig. 220) express something of his admiration for these creatures struggling to rid their jaws of the fly. In contrast to the earlier watercolors, which convey the experience of fishing, the bass images seem more explicitly to be about dying. The Homosassa bass has taken the bait and Homer heightens the sense of its vulnerability by turning its soft, pale belly and bloody, punctured throat toward us. These scenes of the last tortured moments of the fish, hanging suspended between the hook and the water, recall the same moment between life and death that Homer had depicted a decade earlier in *A Good Shot* (fig. 177).

In early December 1904, Homer returned again to Florida, his fifth trip to the state. He went directly to Homosassa but spent all his time fishing. As he explained in a letter to Knoedler, "I am very well but have not worked any it being too cold here— ."[6] It was probably on the trip northward at the end of January that he conceived the idea for, or

may have even begun, *Diamond Shoal* (fig. 223), which shows the Diamond Shoal lightship, fifteen miles southeast of Cape Hatteras, wallowing in rough seas during a storm. The only watercolor dated 1905, it is also Homer's last known watercolor. The theme is once again man in a treacherous nature. Compared to the radiant but benign watercolors of Key West sloops, *Diamond Shoal* is an aggressive image whose dramatic, cropped view gives it a distinctly twentieth-century attitude. The energetic draftsmanship, adept handling, and clear color betray no weakening in the powers of the aging artist as he joins, perhaps for the last time, his passion for the sea with his beloved medium of watercolor.

Notes

1 5 December 1903; Bowdoin.
2 For a discussion of the different functions of line and wash in Homer's watercolors, see Cohn 1977, 32.
3 Henry C. Ford, "Homosassa River, Florida," *American Angler* 9 (1886), 196.
4 William C. Harris, "Southern Angling: Where to Go and What to Catch," *Outing* 39 (1902), 620.
5 Bowdoin.
6 Letter of 23 January 1905; Knoedler Archive.

Final Years

By his seventieth year, Homer was increasingly preoccupied with money and unsold pictures. Much of his anger was directed at Knoedler: "It would not be a bad idea for you to notify me if any of the watercolors sell as I could replace them with a *higher class goods* if I had any encouragement to do so."[1] Acknowledging a check for two watercolors, he wrote, "I receive with pleasure this unexpected sum of money. It's not a bad idea this looking at a little money now & then— who knows but I may paint something some-day."[2] At the same time, however, he told Louis Prang: "You will be glad to know that I am comfortably fixed for life in regard to cash as I only desire enough for my support and a reasonable help to others— and I am having a happy life, *free from care.*"[3]

But the sense of ease and contentment evident in his letter to an old friend was tempo-rary. The remaining five years of Homer's life were characterized by illness, a with-drawal from art, and a further withdrawal from society. The frustrations of old age and the results of a prolonged gastrointestinal disorder often made him edgy and querulous. To this was added his recurrent concern about money, and his discouragement at what he saw as the public's lack of interest in his work. He showed three watercolors from his Florida visit of 1903–1904 at the American Water Color Society exhibition in early 1906. In July 1907 he wrote to Leila Mechlin, who was planning an article on him for the *Inter-national Studio:* "I care nothing for art. I no longer paint." To J. Eastman Chase he said: "What's the use of my painting any more? The public don't want my pictures."[4] In December 1907 he gave the Chicago dealer James W. Young ten watercolors, including some late ones. "I will not bother giving you different prices for these, some being very good and others quite bad. They must each net me one hundred dollars."[5] Much of his time was spent in repainting old canvases.

Homer's perception of the public's disinterest in his work was undoubtedly colored by his overall melancholy and lack of creative energy. In fact, he was famous, and his paint-ings were being acquired by major museums and important collectors. In the spring of 1908, the Carnegie Institute honored him with a major loan exhibition of twenty-two oil paintings, half of which came from museums; probably no other living American artist of the period was represented by so many major works in public collections.[6]

In mid-May 1908, Homer suffered a mild stroke that temporarily impaired his speech and muscle control. He spent about a month at the North Woods Club, recovering slowly.

By mid-summer he had sufficiently improved to write to Charles that the only thing he could still not do was "tie my neck tie in the way that I have done for the past 20 years. It is impossible for me to make the sailors knot. Every four or five days I try to do it but . . . it has been of no use."[7] Homer never regained his full strength. Yet, as if in compensation for the debilitating effects of the stroke, his interest in painting suddenly returned. The result was *Right and Left* (1909; National Gallery of Art, Washington), which he completed in January 1909 and which was promptly sold. He went again to Homosassa and, on his return, began what would be his last painting, *Driftwood* (1909; Collection of Emlen Stokes), which he completed in November and sent to Knoedler's. He spent part of the next few months visiting doctors and getting his affairs in order.

In the summer of 1910, his health began to fail rapidly. His stomach disorder grew worse, and he was in considerable pain. In the late summer he had an internal hemorrhage which was followed by blindness. But gradually his strength seemed to return, and he was optimistic that his sight would also be restored. However, in the early afternoon of 29 September he took a turn for the worse and died that same day, at the age of seventy-four. His brothers were at his side. Following a simple funeral service in Mount Auburn Cemetery, Cambridge, on 5 October, his body was cremated in accordance with his wishes, and the ashes placed in the family plot beside the remains of his mother and father.

In Homer's studio at his death were some north woods subjects, and a large number of his late Nassau and Bermuda watercolors, some unframed, others framed and on the walls.[8] He had never had any difficulty in parting with his oils, but he considered this group of watercolors to be among the finest he had ever done, and he had refused all offers for them. It had been his hope that they could be kept together as a record of his accomplishment in the medium. Knowing his brother's wishes, Charles Homer allowed the Metropolitan Museum to purchase twelve, and others went to the Worcester Art Museum and The Brooklyn Museum.[9]

Homer's watercolors spanned a period of more than three decades. He had lived to see the critical response to them shift from initial disparagement as raw and unfinished works to high praise as supreme achievements in American art. Late in his life he himself came to realize their importance. "You will see," he said to a friend, "in the future I will live by my watercolors."[10]

In watercolor he had first captured new scenes and subjects, experimented technically, and most readily voiced his interests in light, spontaneity, design, and color. From the time he took it up as a separate means of serious artistic expression in 1873, he had used it naturally and with ease. Working through the known watercolor conventions, he had transformed accepted techniques into a personal style characterized by a modern directness.

Throughout his watercolor career, style and subject, method and meaning, had been bound together, in response to places visited and seasons experienced. Created primarily during working vacations in places he loved— the New England seaside, the Adirondacks,

Quebec, Bahamas, Bermuda, and Florida— the watercolors treated a wider range of subjects than did the oils. With the years, his watercolor technique became more suggestive and complex, full of the discovered qualities of the scene.

Thus, the clear colors laid down in single washes in the 1873 watercolors of children at Gloucester had reflected not only the works' early date, but the simplicity and innocence of the subject. The graded washes and chiaroscuro in the *plein-air* studies of shepherdesses at Houghton Farm of 1878 had underscored the poetic remoteness of the motifs. In the gouache and watercolor studio pieces of the 1870s, he had joined imaginative and expressive color to the image of a beautiful young woman, creating a group of exquisite portraits. When, in the Gloucester summer of 1880, atmosphere and light became the subject, his instinct for generalization was exercised in broad washes of intense color thrown across a sheet.

His long stay in the English fishing village of Cullercoats had marked a turning point in his life and his art. Using sober colors and a wide range of watercolor techniques, he expressed profound themes through design and structure. Upon his return to America, the impact of Cullercoats on his watercolors was evident in a more confident use of the medium— in the freer brushwork, more saturated hues, and suggested rather than delineated forms.

In the watercolors of the northern woods and the tropics, during the 1890s and early 1900s, luminous color and eloquent brushwork became inseparable elements of expression. Layerings of shimmering, transparent hues flowed easily and limpidly from his brush, disguising the extraordinary control he had over the liquid pigment.

Whereas his oils were carefully planned and completely worked statements, with a sense of solidity and permanence, the watercolors were a more immediate utterance. To view a series of them is to follow closely the direction and formation of his ideas and feelings. Watercolor called forth in him a brilliance and economy of means that were never translated into oil. In watercolor as in no other place in his art, the reserved, intensely private man expressed a more intimate and sensual self.

Notes

1 April 1905; Knoedler Archive.

2 25 May 1905; Knoedler Archive.

3 18 October 1905; Goodrich/Whitney Museum Record.

4 Quoted in Goodrich 1944, 188; and *Harper's Weekly* 54 (22 October 1910), 13.

5 Goodrich/Whitney Museum Record.

6 For a list of Homer's works in public collections during his lifetime, see Goodrich 1944, 233–234 n. 189: 15–17.

7 18 July 1908; Bowdoin.

8 William Macbeth, *Art Notes*, December 1910, 646.

9 Figs. 184, 197–200, 207, and 217, went to The Metropolitan Museum; figs. 146, 208, and 216, to the Worcester Art Museum; and figs. 127, 206, and 219, to The Brooklyn Museum.

10 Quoted in Goodrich 1944, 159.

Lenders to the Exhibition

Addison Gallery of American Art,
Phillips Academy, Andover, Massachusetts

Albright-Knox Art Gallery,
Buffalo, New York

Mr. and Mrs. Arthur G. Altschul

The Art Institute of Chicago

The Art Museum, Princeton University

Bowdoin College Museum of Art,
Brunswick, Maine

The Brooklyn Museum

Canajoharie Library and Art Gallery,
Canajoharie, New York

Sterling and Francine Clark Art Institute,
Williamstown, Massachusetts

The Cleveland Museum of Art

The Corcoran Gallery of Art, Washington

The Fine Arts Museums of San Francisco,
Achenbach Foundation for Graphic Arts

Collection of Daniel and Rita Fraad

Mr. and Mrs. Morton Funger

Collection of Jo Ann and Julian Ganz, Jr.

Harvard University Art Museums
(Fogg Art Museum),
Cambridge, Massachusetts

Collection of Mrs. Wellington Henderson

Hirshhorn Museum and Sculpture Garden,
Smithsonian Institution, Washington

The Henry E. Huntington Library
and Art Gallery, San Marino, California

The Hyde Collection, Glens Falls, New York

IBM Corporation, Armonk, New York

Mr. and Mrs. George M. Kaufman

Mr. and Mrs. William S. Kilroy

Dr. Anthony Ladd

Lano Corporation, Washington

Collection of Thelma and Melvin Lenkin

Collection of Cornelia and Meredith Long

Los Angeles County Museum of Art

Mr. Richard Manoogian

Mr. and Mrs. Alastair Bradley Martin

Mr. and Mrs. Brooks McCormick

Collection of Mr. and Mrs. Paul Mellon,
 Upperville, Virginia

The Metropolitan Museum of Art, New York

Mr. Carleton Mitchell

Murjani Collection

Museum of Fine Arts, Boston

Museum of Fine Arts,
 Springfield, Massachusetts

National Gallery of Art, Washington

Mr. and Mrs. Roy Nutt

Mr. and Mrs. Arturo Peralta-Ramos

The Phillips Collection, Washington

Mr. Ogden Phipps

Ogden Mills Phipps

Plainfield Public Library,
 Plainfield, New Jersey

The Harold T. Pulsifer Memorial Collection,
 on loan to Colby College Museum of Art,
 Waterville, Maine

Museum of Art, Rhode Island School of Design,
 Providence

Scripps College, Claremont, California

Helen F. Spencer Museum of Art,
 (The William Bridges Thayer Memorial)
 University of Kansas, Lawrence

G. Frederick Stork

Mr. and Mrs. Edward F. Swenson

Terra Museum of American Art,
 Evanston, Illinois

Timken Art Gallery, San Diego

The Westmoreland County Museum of Art,
 Greensburg, Pennsylvania

Mr. and Mrs. Brayton Wilbur

Mr. and Mrs. W. Bryant Williams

Erving and Joyce Wolf

Worcester Art Museum

Yale University Art Gallery, New Haven

Private Collections

Illustrations

Unless otherwise stated, all works are by Winslow Homer. Titles in parentheses are alternate titles by which the work has been known. Height precedes width. The watercolors shown in the exhibition "Winslow Homer Watercolors" are indicated by an asterisk ().*

1 *Two Men in a Canoe*, 1895
watercolor
13 x 19¼ in (33.0 x 48.9 cm) (sight)
Portland Museum of Art, Portland, Maine.
 Gift of Charles Shipman Payson, 1980

*2 *The Adirondack Guide*, 1894
watercolor over graphite on cream wove paper
15⅛ x 21½ in (38.4 x 54.6 cm)
Museum of Fine Arts, Boston.
 Bequest of Mrs. Alma H. Wadleigh
Shown in Washington only

HENRIETTA BENSON HOMER
 (United States, 1809–1884)
3 *Wildflowers*
watercolor
13 x 9 in (33.0 x 22.9 cm)
Collection of Susan E. Stebbins

*4 *The Farmyard Wall*, 1873
watercolor and gouache
7⅝ x 13½ in (19.4 x 34.3 cm)
G. Frederick Stork

*5 *A Basket of Clams*, 1873
watercolor
11½ x 9¾ in (29.2 x 24.8 cm)
Mr. and Mrs. Arthur G. Altschul

6 *Boy in a Boatyard*, 1873
watercolor and gouache over graphite
7⅜ x 13¾ in (18.7 x 34.9 cm)
Portland Museum of Art, Portland, Maine.
 Gift of Charles Shipman Payson, 1980

*7 *The Berry Pickers*, 1873
watercolor and gouache over graphite
9⅜ x 13⅝ in (23.9 x 34.6 cm)
The Harold T. Pulsifer Memorial Collection,
 on loan to Colby College Museum of Art,
 Waterville, Maine

*8 *How Many Eggs*, 1873
watercolor
12½ x 9½ in (31.8 x 24.1 cm)
Collection of Mr. and Mrs. W. Bryant Williams

*9 *Three Boys on the Shore*, 1873
gouache and watercolor on paper mounted
 on board
8¼ x 14 in (21.0 x 35.6 cm)
Daniel J. Terra Collection, Terra Museum of
 American Art, Evanston, Illinois

*10 *Watching the Harbor*, 1873
watercolor and gouache over graphite
8¼ x 13¼ in (21.0 x 33.7 cm)
Private Collection

*11 *Waiting for the Boats*, 1873
watercolor and gouache over graphite
8½ x 13½ in (21.6 x 34.3 cm)
Private Collection

12 *Schooners in Gloucester Harbor*, 1873
gouache and graphite on tan paper
9½ x 13½ in (24.1 x 34.3 cm) (sight)
Photograph courtesy of M. Knoedler & Co.,
 New York

13 *Man in a Boat Fishing*, 1874
watercolor over graphite
9½ x 13⅛ in (24.1 x 33.3 cm) (sight)
Collection of Mr. and Mrs. Norman I. Shafler

14 *Trappers Resting*, 1874
watercolor
16⅛ x 19½ in (41.0 x 49.5 cm)
Portland Museum of Art, Portland, Maine.
 Gift of Charles Shipman Payson, 1980

*15 *Fresh Eggs*, 1874
watercolor and gouache over graphite
9¼ x 7½ in (23.5 x 19.1 cm) (sight)
Collection of Mr. and Mrs. Paul Mellon,
 Upperville, Virginia

*16 *In the Garden*, 1874
watercolor
9⅟₁₆ x 6¹¹⁄₁₆ in (24.4 x 17.0 cm)
Mr. and Mrs. Arthur G. Altschul

*17 *Rustic Courtship (In the Garden)*, 1874
watercolor and gouache
8⅝ x 12¼ in (22.0 x 31.1 cm) (sight)
Collection of Mr. and Mrs. Paul Mellon,
Upperville, Virginia

18 *Blossom Time in Virginia*, probably 1875
watercolor and black chalk
14 x 20 in (35.6 x 50.8 cm)
The Detroit Institute of Arts.
Bequest of Robert H. Tannahill

19 *Boy Seated on a Plow*, 1879
graphite
6⁹⁄₁₆ x 10⅝ in (16.0 x 27.0 cm) (sight)
Private Collection

*20 *Harrowing*, 1879
watercolor
12 x 19 in (30.5 x 48.3 cm)
Private Collection

*21 *The Busy Bee*, 1875
watercolor
10 x 9¼ in (25.4 x 23.5 cm)
Putnam Collection, Timken Art Gallery,
San Diego, California

22 *Taking a Sunflower to the Teacher*, 1875
(exhibited American Water Color Society,
1876, as *A Flower for the Teacher*)
watercolor
7 x 5⅞ in (17.8 x 14.9 cm) (sight)
Georgia Museum of Art, The University of
Georgia, Athens. Eva Underhill Holbrook
Memorial Collection of American Art,
Gift of Alfred H. Holbrook

23 *Four Boys on a Beach*, c. 1873
watercolor over graphite
5⁹⁄₁₆ x 13⅜ in (14.1 x 34.0 cm)
National Gallery of Art, Washington.
John Davis Hatch Collection, Andrew W.
Mellon Fund

*24 *Gloucester Harbor*, 1873
watercolor and gouache
9½ x 13½ in (24.1 x 34.3 cm)
Collection of Cornelia and Meredith Long

25 *Gloucester Harbor*, 1873
oil on canvas
15½ x 22½ in (39.4 x 57.2 cm)
The Nelson-Atkins Museum of Art,
Kansas City, Missouri. Acquired through
the Enid and Crosby Kemper Foundation

26 *Longing (Waiting for Dad)*, 1873
watercolor and gouache
9¾ x 13⅝ in (24.8 x 34.6 cm)
Mills College Collection, Oakland.
Gift of Jane C. Tolman

27 *Dad's Coming*, 1873
oil on panel
9 x 13¾ in (22.9 x 34.9 cm)
Collection of Mr. and Mrs. Paul Mellon,
Upperville, Virginia

*28 *Sailing the Catboat*, probably 1875
watercolor and gouache over graphite
7½ x 13¾ in (19.1 x 34.9 cm)
Private Collection

29 *Breezing Up (A Fair Wind)*, 1876
(exhibited National Academy of Design,
1876, as *A Fair Wind*)
oil on canvas
24⅛ x 38⅛ in (61.3 x 97.0 cm)
National Gallery of Art, Washington. Gift of
the W. L. and May T. Mellon Foundation

*30 *The New Novel*, 1877
(exhibited American Water Color Society,
1877, as *Book*)
watercolor
9½ x 20½ in (24.1 x 52.1 cm)
Museum of Fine Arts, Springfield,
Massachusetts.
The Horace P. Wright Collection

*31 *Blackboard*, 1877
watercolor
19⁷⁄₁₆ x 12³⁄₁₆ in (49.4 x 32.6 cm) (sight)
Collection of Jo Ann and Julian Ganz, Jr.

32 *Woman Peeling a Lemon*, 1876
(exhibited American Water Color Society,
1877, as *Lemon*)
watercolor over black chalk
18⅞ x 12 in (48.0 x 30.5 cm)
Sterling and Francine Clark Art Institute,
Williamstown, Massachusetts

*33 *Portrait of a Lady*, 1875
watercolor over graphite
11¼ x 7½ in (28.6 x 19.1 cm)
Mr. Ogden Phipps
Shown in Washington only

*34 *Woman and Elephant*, c. 1877
watercolor and gouache
11¾ x 8¾ in (29.9 x 22.2 cm)
Albright-Knox Art Gallery, Buffalo, New York.
 Gift of Mrs. John W. Ames, 1959

*35 *Girl Seated*, 1879
watercolor
8½ x 8½ in (21.6 x 21.6 cm)
Private Collection

*36 *The Trysting Place*, 1875
watercolor
13½ x 9⅞ in (34.3 x 25.1 cm)
Princeton University Library,
 Princeton, New Jersey.
 Bequest of Lawrence Hutton
Shown in Fort Worth and New Haven only

*37 *Moonlight*, 1874
watercolor and gouache
14 x 20 in (35.6 x 50.8 cm)
Canajoharie Library and Art Gallery,
 Canajoharie, New York

*38 *Apple Picking (Two Girls in Sunbonnets)*, 1878
watercolor and gouache
6¾ x 8⅛ in (17.1 x 20.7 cm) (sight)
Private Collection

39 *Feeding Time*, 1878
watercolor and gouache, over graphite
8¾ x 11¼ in (22.2 x 28.6 cm)
Sterling and Francine Clark Art Institute,
 Williamstown, Massachusetts

*40 *The Flock of Sheep, Houghton Farm*, 1878
watercolor
8⅝ x 11³⁄₁₆ in (21.9 x 28.4 cm)
Private Collection

41 *Bo-Peep (Girl with Shepherd's Crook Seated by
 a Tree)*, 1878
gouache and black chalk on buff paper
7 x 8¼ in (17.8 x 21.0 cm)
Museum of Fine Arts, Boston.
 Bequest of John T. Spaulding, 1948

42 *Girl on a Garden Seat (Woman Seated on a
 Bench)*, 1878
watercolor and gouache
6⅜ x 8¼ in (16.2 x 21.0 cm) (sight)
Marion Koogler McNay Art Museum,
 San Antonio, Texas

*43 *Fresh Air*, 1878
watercolor and gouache over graphite
20¹⁄₁₆ x 14¹⁄₁₆ in (52.3 x 37.0 cm)
The Brooklyn Museum. Dick S. Ramsay Fund

*44 *On the Hill*, 1878
watercolor
8½ x 11 in (21.6 x 27.9 cm)
Mr. and Mrs. Alastair Bradley Martin

*45 *Spring*, 1878
watercolor
11⅛ x 8⅝ in (28.3 x 21.9 cm)
Collection of Daniel and Rita Fraad

*46 *Weary*, 1878
(exhibited American Water Color Society,
 1879, as *Watching Sheep*)
watercolor and graphite
8⅝ x 11¼ in (22.0 x 28.6 cm)
Daniel J. Terra Collection, Terra Museum
 of American Art, Evanston, Illinois

JEAN-FRANÇOIS MILLET (France, 1814–1875)
47 *Shepherdess Leaning against a Tree (Une
 Bergère au repos)*, 1849
black crayon on tan paper
11¾ x 7⁹⁄₁₆ in (29.8 x 19.2 cm)
Fitzwilliam Museum, Cambridge, England

48 *Spring: Shepherdess of Houghton Farm*,
 probably 1878
oil on canvas
24½ x 28⅛ in (62.2 x 71.5 cm)
Private Collection

49 *Sailboat and Fourth of July Fireworks*, 1880
watercolor and gouache
9⅝ x 13¹¹⁄₁₆ in (24.5 x 34.8 cm)
Harvard University Art Museums (Fogg Art
 Museum), Cambridge, Massachusetts.
 Bequest of Grenville L. Winthrop

*50 *Boys in a Dory*, 1880
watercolor
13¾ x 19½ in (34.9 x 49.5 cm)
Addison Gallery of American Art, Phillips
 Academy, Andover, Massachusetts

51 *Sailing a Dory, Gloucester*, 1880
watercolor
9 x 13¼ in (22.9 x 33.7 cm)
Philadelphia Museum of Art.
 Gift of Dr. and Mrs. George Woodward

52 *Boys Bathing*, 1880
watercolor
9½ x 13⁹⁄₁₆ in (24.1 x 34.4 cm)
Williams College Museum of Art,
 Williamstown, Massachusetts.
 Gift of Mrs. William C. Brownell, 1958

53 *A Wreck near Gloucester*, 1880
graphite and watercolor
14¹³⁄₁₆ x 19⅝ in (37.6 x 49.9 cm)
Museum of Art, Carnegie Institute, Pittsburgh.
 Purchase

*54 *Woman with Flower*, 1880
watercolor over graphite
8⅞ x 11¼ in (22.6 x 28.6 cm)
Mr. and Mrs. Arthur G. Altschul

55 *Young Woman*, 1880
watercolor over graphite
9⁷⁄₁₆ x 13⅜ in (24.0 x 34.0 cm) (sight)
The Margaret Woodbury Strong Museum,
 Rochester, New York

56 *Two Girls in a Rowboat*, probably 1880
watercolor over graphite
9⁹⁄₁₆ x 13 in (24.3 x 33.0 cm)
Cooper-Hewitt Museum, The Smithsonian
 Institution's National Museum of Design,
 New York. Gift of Charles Savage Homer

57 *Two Figures in a Rowboat*, probably 1880
watercolor over graphite
10 x 14 in (25.4 x 35.6 cm)
Cooper-Hewitt Museum, The Smithsonian
 Institution's National Museum of Design,
 New York. Gift of Charles Savage Homer

58 *Two Boys Rowing*, 1880
watercolor over graphite on cream wove paper
9⅞ x 14 in (25.1 x 35.6 cm)
Museum of Fine Arts, Boston.
 Gift of James J. Minot, 1974

*59 *Eastern Point Light*, 1880
watercolor over graphite
9⅝ x 13⅜ in (24.5 x 34.0 cm)
The Art Museum, Princeton University,
 Princeton, New Jersey.
 Gift of Alastair B. Martin

*60 *Sunset Fires*, 1880
watercolor
9¾ x 13⅝ in (24.8 x 34.6 cm)
The Westmoreland County Museum of Art,
 Greensburg, Pennsylvania

61 *Schooner at Sunset*, 1880
watercolor over graphite
9¾ x 13¹¹⁄₁₆ in (24.8 x 34.8 cm)
Harvard University Art Museums (Fogg Art
 Museum), Cambridge, Massachusetts.
 Bequest of Grenville L. Winthrop

*62 *Gloucester Sunset*, 1880
watercolor
9½ x 13½ in (24.1 x 34.3 cm) (sight)
Mr. and Mrs. George M. Kaufman

*63 *The Houses of Parliament*, 1881
watercolor
12¾ x 19¾ in (32.4 x 50.2 cm)
Hirshhorn Museum and Sculpture Garden,
 Smithsonian Institution, Washington

JOZEF ISRAELS (Holland, 1824–1911)
64 *Waiting for the Fishing Fleet*, c. 1875
oil on canvas
12 x 8¾ in (30.5 x 22.2 cm)
Photograph courtesy of Sotheby's, Inc.

JAMES CLARKE HOOK (England, 1819–1907)
65 *Two Children Picking Mushrooms on the Cliff*,
 1879
oil on canvas
42½ x 57½ in (108.0 x 146.1 cm)
Photograph courtesy of Christie's

MATTHEW AUTY (England, dates unknown)
66 *View of Cullercoats*, c. 1900
photograph
Newcastle-upon-Tyne City Libraries,
 Newcastle, England

J. D. LIDDELL (England, dates unknown)
67 *Cullercoats*, c. 1900
oil on canvas (?)
Location unknown; repr. Frank Graham,
 *Tynemouth, Cullercoats, Whitley Bay,
 Seaton Delaval* (Newcastle-upon-Tyne, 1973)

68 *Fishergirls on the Beach, Cullercoats*, 1881
watercolor
13⅛ x 19⅜ in (33.4 x 49.2 cm)
The Brooklyn Museum.
 Museum Collection Fund

69 *Afterglow*, 1883
watercolor over graphite on cream wove paper
15 x 21½ in (38.1 x 54.6 cm)
Museum of Fine Arts, Boston. Bequest of
 William P. Blake in memory of his mother,
 Mary M. J. Dehon Blake

JULES ADOLPH BRETON (France, 1827–1906)
70 *The Gleaner*, 1875
oil on canvas
29 x 21½ in (73.7 x 54.6 cm)
Aberdeen Art Gallery and Museum, Scotland.
 Macdonald Bequest, 1901

71 *Study for "Four Fisherwives,"* 1881
graphite
3⅝ x 5½ in (9.2 x 14.0 cm)
Formerly Collection of Lois Homer Graham

72 *Fisherfolk on the Beach at Cullercoats,* 1881
watercolor
13½ x 19½ in (34.3 x 49.5 cm)
Addison Gallery of American Art, Phillips
Academy, Andover, Massachusetts.
Gift of Anonymous Donor

73 *Fisherwomen, Cullercoats,* 1881
watercolor
13½ x 19⅜ in (34.3 x 49.2 cm)
Honolulu Academy of Arts. Purchase, 1964

*74 *Four Fisherwives,* 1881
watercolor
18 x 28½ in (45.7 x 72.4 cm)
Scripps College, Claremont, California. Gift of
General and Mrs. Edward Clinton Young,
1946

75 *Sparrow Hall, Cullercoats,* 1882
oil on canvas
15½ x 22½ in (39.4 x 57.2 cm)
Private Collection. Photograph courtesy of
Hirschl & Adler Galleries Inc., New York

76 *Mending the Nets,* 1882
(exhibited American Water Color Society,
1882, as *Far Away from Billingsgate,* and in
1891 as *Mending Nets*)
watercolor and gouache over graphite
27⅜ x 19¼ in (69.5 x 48.9 cm)
National Gallery of Art, Washington.
Bequest of Julia B. Engel

*77 *Fishergirls,* 1881
watercolor
17 x 23 in (43.2 x 58.4 cm)
Ogden Mills Phipps
Shown in Washington only

*78 *Looking over the Cliff,* 1882
watercolor
20½ x 13½ in (52.1 x 34.3 cm) (sight)
Plainfield Public Library, Plainfield,
New Jersey

79 *Fisherman's Family (The Lookout),* 1881
watercolor over graphite on cream wove paper
13½ x 19⅜ in (34.3 x 49.2 cm)
Museum of Fine Arts, Boston.
Bequest of John T. Spaulding, 1948

80 *The Breakwater, Cullercoats,* 1882
watercolor
13¼ x 19¾ in (33.7 x 50.2 cm) (sight)
Portland Museum of Art, Portland, Maine.
Gift of Charles Shipman Payson, 1980

81 *Study for "Wreck of the Iron Crown,"* 1881
charcoal
8½ x 12½ in (21.6 x 31.8 cm)
Mr. Carleton Mitchell

82 *Men and Women Looking out to Sea,* 1881
graphite on cream wove paper
6¹¹⁄₁₆ x 5⁹⁄₁₆ in (17.0 x 14.1 cm)
Cooper-Hewitt Museum, The Smithsonian
Institution's National Museum of Design,
New York. Gift of Charles Savage Homer

83 *Fishermen in Oilskins, Cullercoats,* 1881
charcoal and white chalk
14¾ x 12¹⁄₁₆ in (37.5 x 30.6 cm)
Cooper-Hewitt Museum, The Smithsonian
Institution's National Museum of Design,
New York. Gift of Charles Savage Homer

84 *Life Boat (Wreck of the Iron Crown),*
1881
black chalk, black wash, and white gouache
13⅞ x 19¹⁄₁₆ in (35.3 x 48.4 cm)
Cooper-Hewitt Museum, The Smithsonian
Institution's National Museum of Design,
New York. Gift of Charles Savage Homer

*85 *Wreck of the Iron Crown,* 1881
watercolor
20¼ x 29⅜ in (51.4 x 74.6 cm)
Mr. Carleton Mitchell

86 *Watching the Tempest,* 1881
watercolor over graphite
13⅞ x 18¾ in (35.3 x 47.6 cm)
Harvard University Art Museums (Fogg Art
Museum), Cambridge, Massachusetts.
Bequest of Grenville L. Winthrop

87 *Mannikin*
h. 13½ in (34.3 cm)
Bowdoin College Museum of Art,
Brunswick, Maine

88 *Head of a Woman,* 1882
graphite
6 x 7½ in (15.2 x 19.1 cm)
Photograph courtesy of M. Knoedler & Co.,
New York

89 *After the Storm*, 1882
 charcoal and brown crayon with touches of white
 11 7/16 x 8 7/16 in (29.1 x 21.4 cm)
 The Art Museum, Princeton University,
 Princeton, New Jersey.
 Gift of Frank Jewett Mather, Jr.

90 *Girl with Red Stockings (The Wreck)*, 1882
 watercolor over graphite on cream wove paper
 13 3/8 x 19 1/2 in (34.0 x 49.5 cm)
 Museum of Fine Arts, Boston.
 Purchase, John T. Spaulding Collection

91 *First Sketch*, 1881
 charcoal on cream wove paper
 6 3/4 x 9 5/8 in (17.1 x 24.5 cm)
 Cooper-Hewitt Museum, The Smithsonian
 Institution's National Museum of Design,
 New York. Gift of Charles Savage Homer

92 *Figures in Lee of a Building with Ocean
 Beyond*, 1881 (recto)
 charcoal and graphite on cream wove paper
 6 1/2 x 9 7/8 in (16.5 x 25.1 cm)
 Cooper-Hewitt Museum, The Smithsonian
 Institution's National Museum of Design,
 New York. Gift of Charles Savage Homer

93 *Groups of Figures and Two Small Framed
 Sketches*, 1881 (verso)
 charcoal and graphite on cream wove paper
 6 1/2 x 9 7/8 in (16.5 x 25.1 cm)
 Cooper-Hewitt Museum, The Smithsonian
 Institution's National Museum of Design,
 New York. Gift of Charles Savage Homer

94 *House at a Railing with Beached Dories*, 1881
 pen and brown ink
 6 11/16 x 7 1/8 in (17.0 x 18.1 cm)
 Cooper-Hewitt Museum, The Smithsonian
 Institution's National Museum of Design,
 New York. Gift of Charles Savage Homer

95 *Three Women and a Child Stand behind a
 Railing Looking out to Sea*, 1881 (recto)
 pen and brown ink
 6 11/16 x 7 1/16 in (17.0 x 17.9 cm)
 Cooper-Hewitt Museum, The Smithsonian
 Institution's National Museum of Design,
 New York. Gift of Charles Savage Homer

96 *Figures Landing in a Dory*, 1881 (verso)
 pen and brown ink
 6 11/16 x 7 1/16 in (17.0 x 17.9 cm)
 Cooper-Hewitt Museum, The Smithsonian
 Institution's National Museum of Design,
 New York. Gift of Charles Savage Homer

97 *Perils of the Sea*, 1881
 watercolor, over light sketch in black chalk
 14 5/8 x 21 in (37.2 x 53.3 cm)
 Sterling and Francine Clark Art Institute,
 Williamstown, Massachusetts

98 *Two Women and a Child at a Rail, Overlooking
 the Beach at Cullercoats*, 1881
 charcoal
 8 3/8 x 11 3/4 in (21.3 x 29.9 cm)
 Cooper-Hewitt Museum, The Smithsonian
 Institution's National Museum of Design,
 New York. Gift of Charles Savage Homer

99 *The Last Boat In*, 1881
 charcoal and chalk
 8 1/2 x 12 3/16 in (21.6 x 31.0 cm)
 Addison Gallery of American Art, Phillips
 Academy, Andover, Massachusetts

100 *A Dark Hour*, 1881–1882
 charcoal heightened with wash
 8 1/8 x 12 1/4 in (20.7 x 31.1 cm)
 Sheldon Memorial Art Gallery, University of
 Nebraska, Lincoln.
 Gift of Mrs. Olga N. Sheldon

*101 *Fisherwoman*, probably 1882
 watercolor
 14 1/2 x 21 in (36.8 x 53.3 cm) (sight)
 Mr. and Mrs. Brayton Wilbur
 Shown in Washington only

102 *Two Figures by the Sea (The Storm)*, 1882
 oil on canvas
 19 3/4 x 35 in (50.2 x 88.9 cm)
 The Denver Art Museum, Denver, Colorado.
 Helen Dill Collection

103 *Looking out to Sea*, 1881
 watercolor over graphite
 13 1/8 x 18 15/16 in (33.4 x 48.1 cm) (sight)
 Harvard University Art Museums (Fogg Art
 Museum), Cambridge, Massachusetts.
 Anonymous Gift

104 *Fisherwives*, 1883
 watercolor
 18 x 29 1/2 in (45.7 x 74.9 cm)
 The Currier Gallery of Art, Manchester,
 New Hampshire

105 *Fishing off Scarborough*, 1882
 gouache and wash
 18 5/16 x 24 5/16 in (46.5 x 61.7 cm)
 The Art Institute of Chicago.
 Mr. and Mrs. Martin A. Ryerson Collection

*106 *Returning Fishing Boats*, 1883
watercolor and white gouache over graphite
15⅞ x 24¾ in (40.3 x 62.9 cm)
Harvard University Art Museums (Fogg Art
Museum), Cambridge, Massachusetts.
Anonymous Gift

107 *On the Beach, Cullercoats*, 1881
watercolor over graphite
12⅝ x 18⅞ in (32.1 x 48.0 cm) (sight)
Private Collection

*108 *Inside the Bar*, 1883
watercolor
15⅜ x 28½ in (39.1 x 72.4 cm)
The Metropolitan Museum of Art.
Gift of Louise Ryals Arkell, in memory
of her husband, Bartlett Arkell, 1954
Shown in New Haven only

109 *Hark! The Lark!*, 1882
oil on canvas
36⅜ x 31⅜ in (92.4 x 79.7 cm)
Layton Art Collection, Milwaukee Art Museum.
Gift of Frederick Layton

110 *Sketch for "Hark! The Lark!,"* 1881–1882
black chalk
3⅝ x 5½ in (9.2 x 14.0 cm)
Formerly Collection of Lois Homer Graham

*111 *A Voice from the Cliffs*, 1883
watercolor
20⅞ x 29¾ in (53.0 x 75.6 cm)
Private Collection

112 *Incoming Tide*, 1883
watercolor
21½ x 29½ in (54.6 x 74.9 cm)
Collection of the American Academy and
Institute of Arts and Letters, New York

*113 *Maine Cliffs*, 1883
watercolor over charcoal
13⅜ x 19³⁄₁₆ in (34.0 x 48.7 cm)
The Brooklyn Museum. Bequest of
Sidney B. Curtis in memory of S. W. Curtis

114 *The Ship's Boat*, 1883
watercolor
16 x 29 in (40.6 x 73.7 cm)
The New Britain Museum of American Art,
New Britain, Connecticut.
Charles F. Smith Fund

115 *The Life Line*, 1884
oil on canvas
29 x 45 in (73.7 x 114.3 cm)
Philadelphia Museum of Art.
The George W. Elkins Collection

116 *The Incoming Tide, Scarboro, Maine*, 1883
watercolor
15 x 21½ in (38.1 x 54.6 cm)
National Gallery of Art, Washington. Gift of
Ruth K. Henschel, in memory
of her husband, Charles R. Henschel

*117 *Rest*, 1885
watercolor
14 x 14 in (35.6 x 35.6 cm)
Private Collection

118 *Native Huts, Nassau*, 1885
watercolor
14⅜ x 20⅞ in (36.5 x 53.0 cm)
Collection of Mr. and Mrs. Paul Mellon,
Upperville, Virginia

119 *Cabins, Nassau*, 1885
watercolor and graphite
13½ x 19½ in (34.3 x 49.5 cm)
Private Collection

*120 *Sponge Fishing*, 1885
watercolor
14 x 20 in (35.6 x 50.8 cm)
Canajoharie Library and Art Gallery,
Canajoharie, New York

121 *Sponge Fishing, Nassau*, 1885
watercolor and graphite
10½ x 19½ in (26.7 x 49.5 cm) (sight)
Private Collection

*122 *Oranges on a Branch*, 1885
watercolor
13½ x 18¾ in (34.3 x 47.6 cm)
Erving and Joyce Wolf

*123 *Orange Tree, Nassau*, 1885
watercolor
14½ x 20¾ in (36.8 x 52.7 cm)
Lano Corporation

124 *Spanish Bayonets*, 1885
watercolor and gouache over graphite
14⅞ x 22⁷⁄₁₆ in (37.8 x 57.0 cm)
Harvard University Art Museums (Fogg Art
Museum), Cambridge, Massachusetts.
Bequest of Grenville L. Winthrop

125 *Boy Climbing a Coconut Tree*, 1885
watercolor
20 x 14 in (50.8 x 35.6 cm)
Private Collection. Photograph courtesy of
Kennedy Galleries, New York

126 *Hemp*, 1885
watercolor over graphite
13½ x 19¼ in (34.3 x 48.9 cm)
Private Collection. Photograph courtesy of
Wildenstein & Co., Inc., New York

127 *Glass Windows, Bahamas*, 1885
watercolor over graphite
13¹⁵⁄₁₆ x 20¹⁄₁₆ in (35.4 x 52.3 cm)
The Brooklyn Museum. Museum Collection
Fund and Special Subscription

*128 *The Coral Divers*, 1885
watercolor over graphite
13 x 20¾ in (33.0 x 52.7 cm)
Private Collection

129 *The Conch Divers*, 1885
watercolor
13¹⁵⁄₁₆ x 20 in (35.4 x 50.8 cm)
The Minneapolis Institute of Arts. The
William Hood Dunwoody Fund, 1915

130 *Sea Garden*, 1885
watercolor over graphite
8⅞ x 15⅜ in (22.6 x 39.1 cm)
Harvard University Art Museums (Fogg Art
Museum), Cambridge, Massachusetts.
Bequest of Grenville L. Winthrop

131 *Sea Garden* (reconstructed), 1885
watercolor over graphite
12¼ x 20⅛ in (31.1 x 51.1 cm)
Yale University Art Gallery, New Haven,
Connecticut. Gift of Allen Evarts Foster,
B.A. 1906; and Harvard University Art
Museums (Fogg Art Museum), Cambridge,
Massachusetts. Bequest of Grenville L.
Winthrop

132 *The Sponge Diver*, 1889
watercolor over graphite on cream wove paper
15 x 21½ in (38.1 x 54.6 cm)
Museum of Fine Arts, Boston. Gift of
Mrs. Robert B. Osgood, 1939

133 *The Gulf Stream*, 1899
oil on canvas
28⅛ x 49⅛ in (71.5 x 124.8 cm)
The Metropolitan Museum of Art. Wolfe
Fund, Catherine Lorillard Wolfe Collection,
1906

134 *The Gulf Stream*, 1889
watercolor
11⁷⁄₁₆ x 23¼ in (29.1 x 59.1 cm)
The Art Institute of Chicago.
Mr. and Mrs. Martin A. Ryerson Collection

135 *The Derelict (Sharks)*, 1885
watercolor over graphite
14½ x 20 in (36.8 x 50.8 cm)
The Brooklyn Museum.
Bequest of Helen B. Sanders

136 *Study for "The Gulf Stream,"* probably 1885
watercolor
14½ x 10⅛ in (36.8 x 25.7 cm)
Cooper-Hewitt Museum, The Smithsonian
Institution's National Museum of Design,
New York. Gift of Charles Savage Homer

*137 *Shark Fishing*, 1885
watercolor
13⅝ x 20 in (34.6 x 50.8 cm) (sight)
Private Collection
Shown in Washington only

138 *View of Santiago de Cuba*, 1885
watercolor over graphite and pen and black ink
11½ x 19¹⁵⁄₁₆ in (29.2 x 50.7 cm)
National Gallery of Art, Washington.
Bequest of Julia B. Engel

139 *Morro Castle*, 1885
watercolor
13¼ x 19⅛ in (33.7 x 48.6 cm)
West Point Museum Collections, United States
Military Academy, West Point, New York

140 *Street Corner, Santiago de Cuba*, 1885
watercolor
14 x 20 in (35.6 x 50.8 cm)
Museum of Fine Arts, Boston. Anonymous gift
in memory of Horace D. Chapin

*141 *St. Johns River, Florida*, 1890
watercolor
13½ x 19⅞ in (34.3 x 50.5 cm)
The Hyde Collection, Glens Falls, New York

142 *Spanish Moss at Tampa*, 1886
watercolor over graphite
12¼ x 19¾ in (31.1 x 50.2 cm) (sight)
Private Collection

*143 *At Tampa*, 1886
watercolor
14 x 20 in (35.6 x 50.8 cm)
Canajoharie Library and Art Gallery,
Canajoharie, New York

*144 *Coconut Palms, Key West*, 1886
watercolor
16 x 13 in (40.6 x 33.0 cm)
Collection of Thelma and Melvin Lenkin

145 *Redwing Blackbirds*, 1886
watercolor
20½ x 13½ in (52.1 x 34.3 cm)
Philadelphia Museum of Art.
 Gift of Dr. and Mrs. George Woodward

146 *In a Florida Jungle*, 1886
watercolor over traces of graphite
14 x 20 in (35.6 x 50.8 cm)
Worcester Art Museum, Massachusetts

*147 *A Norther—Key West*, 1886
watercolor
13³⁄₁₆ x 19½ in (33.5 x 49.5 cm)
The Fine Arts Museums of San Francisco,
 Achenbach Foundation for Graphic Arts.
 Gift of Mr. and Mrs. John D. Rockefeller 3rd

*148 *Woods at Prout's Neck*, 1887
watercolor
11 x 20 in (27.9 x 50.8 cm)
Private Collection.

*149 *Among the Vegetables (Boy in a Cornfield)*,
 1887
watercolor
13½ x 17½ in (34.3 x 44.5 cm)
Murjani Collection

*150 *Rowing Home*, 1890
watercolor
13¾ x 19⅞ in (34.9 x 50.5 cm)
The Phillips Collection, Washington

*151 *Hunter in the Adirondacks*, 1892
watercolor over graphite
13⅞ x 22⁷⁄₁₆ in (35.2 x 57.0 cm)
Harvard University Art Museums (Fogg Art
 Museum), Cambridge, Massachusetts.
 Anonymous Gift

*152 *Adirondack Lake*, 1889
watercolor over graphite on cream wove paper
14 x 20 in (35.6 x 50.8 cm)
Museum of Fine Arts, Boston.
 William Wilkins Warren Fund
Shown in Washington and Fort Worth only

*153 *Sunrise, Fishing in the Adirondacks*, 1892
watercolor
13½ x 20½ in (34.3 x 52.1 cm)
The Fine Arts Museums of San Francisco,
 Achenbach Foundation for Graphic Arts.
 Mildred Anna Williams Fund

*154 *Leaping Trout*, 1889
watercolor
13¾ x 19¾ in (34.9 x 50.2 cm)
The Cleveland Museum of Art.
 Anonymous Gift
Shown in Fort Worth and New Haven only

155 *Leaping Trout*, 1889
watercolor
13⅞ x 19 in (35.3 x 48.3 cm) (sight)
Portland Museum of Art, Portland, Maine.
 Gift of Charles Shipman Payson, 1980

*156 *Boy Fishing*, 1892
watercolor
14⅝ x 21 in (37.2 x 53.3 cm)
Private Collection

157 *Adirondack Catch*, 1889
watercolor
19¼ x 13⅜ in (48.9 x 34.0 cm) (sight)
Private Collection. Photograph courtesy of
 Hirschl & Adler Galleries Inc., New York

*158 *Leaping Trout*, 1889
watercolor over graphite on cream wove paper
13⅞ x 19⅞ in (35.3 x 50.5 cm)
Museum of Fine Arts, Boston. Warren
 Collection
Shown in Washington only

HOKUSAI (TOKITARO KAWAMURA) (Japan,
 1760–1849)
159 *Carp*, 1813
scroll painting, color on silk
Akira Nakayama Collection, Japan

160 *Mink Pond*, 1891
watercolor over graphite
13⅞ x 20 in (35.2 x 50.8 cm)
Harvard University Art Museums (Fogg Art
 Museum), Cambridge, Massachusetts.
 Bequest of Grenville L. Winthrop

*161 *An October Day*, 1889
watercolor
13⅞ x 19¾ in (35.3 x 50.2 cm)
Sterling and Francine Clark Art Institute,
 Williamstown, Massachusetts
Shown in Washington only

162 *Guide Carrying a Deer*, 1891
watercolor
14 x 20 in (35.6 x 50.8 cm)
Portland Museum of Art, Portland, Maine.
 Gift of Charles Shipman Payson, 1980

163 *Huntsman and Dogs (The Hunter)*, 1891
oil on canvas
28¼ x 48 in (71.8 x 121.9 cm)
Philadelphia Museum of Art.
 The William L. Elkins Collection

*164 *On the Trail*, 1892
watercolor
12⅝ x 19⅞ in (32.1 x 50.5 cm)
National Gallery of Art, Washington. Gift of
 Ruth K. Henschel, in memory
 of her husband, Charles R. Henschel, 1975

*165 *Dog on a Log*, 1889
watercolor
13¾ x 19¾ in (34.9 x 50.2 cm) (sight)
Addison Gallery of American Art, Phillips
 Academy, Andover, Massachusetts.
 Bequest of Candace C. Stimson

*166 *Dogs in a Boat (Waiting for the Start)*, 1889
watercolor
14 x 20 in (35.6 x 50.8 cm)
Museum of Art, Rhode Island School of
 Design, Providence. Gift of Jesse Metcalf
Shown in Washington only

*167 *The End of the Hunt*, 1892
watercolor and graphite
15⅛ x 21⅜ in (38.4 x 54.3 cm)
Bowdoin College Museum of Art,
 Brunswick, Maine.
 Gift of Misses Harriet and Sophia Walker

*168 *After the Hunt*, 1892
watercolor
18¾ x 24¾ in (47.6 x 62.9 cm)
Los Angeles County Museum of Art.
 Paul Rodman Mabury Collection

*169 *Burnt Mountain*, 1892
watercolor
15½ x 19¹¹⁄₁₆ in (34.3 x 50.0 cm)
The Fine Arts Museums of San Francisco,
 Achenbach Foundation for Graphic Arts.
 Gift of Mr. and Mrs. John D. Rockefeller 3rd
Shown in Washington only

170 *The Blue Boat*, 1892
watercolor over graphite on cream wove paper
15⅛ x 21½ in (38.4 x 54.6 cm)
Museum of Fine Arts, Boston.
 Bequest of William Sturgis Bigelow, 1926

171 *The Guide*, 1889
watercolor
13¾ x 19¾ in (34.9 x 50.2 cm)
Portland Museum of Art, Portland, Maine.
 Gift of Charles Shipman Payson, 1980

172 *Camp Fire, Adirondacks*, 1894
watercolor over graphite with touches of
 gouache
14⅞ x 21 in (37.8 x 53.3 cm)
The Art Institute of Chicago.
 Mr. and Mrs. Martin A. Ryerson Collection

*173 *Sketch for "Hound and Hunter,"* 1892
watercolor
13¹⁵⁄₁₆ x 20⅞ in (35.4 x 53.0 cm)
National Gallery of Art, Washington. Gift of
 Ruth K. Henschel, in memory
 of her husband, Charles R. Henschel, 1975

174 *Hound and Hunter*, 1892
oil on canvas
28¼ x 48⅛ in (71.8 x 122.3 cm)
National Gallery of Art, Washington.
 Gift of Stephen C. Clark

CURRIER & IVES
175 *The Death Shot*
colored lithograph
8⅜ x 12½ in (21.3 x 31.8 cm)
Yale University Art Gallery, New Haven.
 Whitney Collection of Sporting Art. Given
 in memory of Henry Payne Whitney, B.A.
 1894, and Payne Whitney,
 by Francis P. Garvan, B.A. 1897

GUSTAVE COURBET (France, 1819–1877)
176 *Stag Taking to the Water (Stag at Bay)
(Le Cerf à l'eau, chasse à courre)*, 1861
oil on canvas
8¹¹⁄₁₆ x 10⅞ in (22.1 x 27.6 cm)
Musée des Beaux-Arts, Marseilles, France

*177 *A Good Shot*, 1892
watercolor
15¹⁄₁₆ x 21¹¹⁄₁₆ in (38.2 x 54.5 cm)
National Gallery of Art, Washington. Gift of
 Ruth K. Henschel, in memory
 of her husband, Charles R. Henschel, 1975

*178 *Deer Drinking*, 1892
watercolor
14¹⁄₁₆ x 20¹⁄₁₆ in (35.7 x 51.0 cm)
Yale University Art Gallery, New Haven.
 The Robert W. Carle, B.A. 1897, Fund

*179 *Fallen Deer*, 1892
watercolor over graphite on cream wove paper
13¾ x 19¾ in (34.9 x 50.2 cm)
Museum of Fine Arts, Boston.
 Charles Henry Hayden Fund

*180 *The Woodcutter*, 1891
watercolor over graphite
13¾ x 19⅞ in (34.9 x 50.5 cm) (sight)
Private Collection
Shown in Washington and New Haven only

*181 *Old Friends*, 1894
watercolor
21½ x 15⅛ in (54.6 x 38.4 cm)
Worcester Art Museum, Massachusetts

*182 *Hudson River, Logging*, 1897
watercolor and graphite
14 x 20⅝ in (35.6 x 52.4 cm)
The Corcoran Gallery of Art, Washington.
Museum Purchase

183 *Hudson River*, 1892
watercolor over graphite on cream wove paper
14 x 20 in (35.6 x 50.8 cm)
Museum of Fine Arts, Boston.
Bequest of William Sturgis Bigelow, 1926

*184 *The Pioneer*, 1900
watercolor
13⅞ x 21 in (35.3 x 53.3 cm)
The Metropolitan Museum of Art.
Amelia B. Lazarus Fund, 1910.
Shown in Washington only

*185 *The Portage*, 1897
(exhibited 1898 as *The Return up the River*)
watercolor
13¾ x 20½ in (34.9 x 52.1 cm)
Yale University Art Gallery, New Haven.
Bequest of Doris M. Brixey

186 *Log Cabin, Tourilli Club*, 1895
watercolor
14 x 10 in (35.6 x 25.4 cm)
Photograph courtesy of
Kennedy Galleries, New York

187 *Wolfe's Cove*, 1895
watercolor, gouache, and graphite
13¾ x 20⅛ in (34.9 x 51.1 cm)
Bowdoin College Museum of Art, Brunswick,
Maine. Museum Purchase

*188 *Montagnais Indians (Indians Making Canoes)*,
1895
watercolor
14 x 20 in (35.6 x 50.8 cm)
Henry E. Huntington Library and Art
Gallery, San Marino, California. Gift of the
Virginia Steele Scott Foundation
Shown in New Haven only

189 *A Good Pool, Saguenay River*, 1895
watercolor over graphite
9¾ x 18⅞ in (24.8 x 47.9 cm)
Sterling and Francine Clark Art Institute,
Williamstown, Massachusetts

*190 *Three Men in a Canoe*, 1895
watercolor and gouache over graphite
13¾ x 19⅜ in (34.9 x 49.2 cm)
Collection of Mrs. Wellington Henderson

*191 *Canoe in the Rapids*, 1897
watercolor over graphite
13⅝ x 20½ in (34.6 x 52.1 cm) (sight)
Harvard University Art Museums (Fogg Art
Museum), Cambridge, Massachusetts.
Purchase, Louise E. Betten Fund

192 *Shooting the Rapids*, 1902
watercolor over graphite
14 x 21 in (35.6 x 53.3 cm)
The Brooklyn Museum. Museum Collection
Fund and Special Subscription

*193 *Ouananiche, Lake St. John*, 1897
watercolor
14 x 20 in (35.6 x 50.8 cm)
Private Collection

*194 *Fishing the Rapids, Saguenay*, 1902
watercolor
13½ x 20 in (34.3 x 50.8 cm)
Private Collection

*195 *End of the Portage*, 1897
watercolor over graphite
14 x 21 in (35.6 x 53.3 cm)
The Brooklyn Museum.
Bequest of Helen B. Sanders

*196 *West India Divers*, 1899
watercolor
14⅞ x 21⅜ in (37.8 x 54.3 cm)
Helen F. Spencer Museum of Art,
University of Kansas, Lawrence
(The William Bridges Thayer Memorial)

*197 *Hurricane, Bahamas*, 1898/1899
watercolor
14½ x 21 in (36.8 x 53.3 cm)
The Metropolitan Museum of Art.
Amelia B. Lazarus Fund, 1910.
Shown in Washington only

*198 *A Wall, Nassau*, 1898
watercolor
14¾ x 21¼ in (37.5 x 54.0 cm)
The Metropolitan Museum of Art.
 Amelia B. Lazarus Fund, 1910.
Shown in Fort Worth and New Haven only

*199 *Nassau, January 1st, 1899*, 1899
watercolor
15 x 21⅜ in (38.1 x 54.3 cm)
The Metropolitan Museum of Art.
 Amelia B. Lazarus Fund, 1910.
Shown in Fort Worth only

*200 *Sloop, Nassau*, 1899
watercolor
15 x 21½ in (38.1 x 54.6 cm)
The Metropolitan Museum of Art.
 Amelia B. Lazarus Fund, 1910.
Shown in Washington only

*201 *Under the Coco Palm*, 1898
watercolor over graphite
14¹⁵⁄₁₆ x 21³⁄₁₆ in (38.0 x 53.8 cm)
Harvard University Art Museums (Fogg Art
 Museum), Cambridge, Massachusetts.
 Purchase, Louise E. Bettens Fund

*202 *The Turtle Pound*, 1898
watercolor over graphite
14¹⁵⁄₁₆ x 21⅜ in (38.0 x 54.3 cm)
The Brooklyn Museum. Sustaining
 Membership Fund, A. T. White Memorial
 Fund, A. Augustus Healy Fund

*203 *Nassau*, 1898/1899
watercolor
14⅝ x 21 in (37.2 x 53.3 cm)
Private Collection

*204 *After the Hurricane*, 1899
watercolor
15 x 21⅜ in (38.1 x 54.3 cm)
The Art Institute of Chicago.
 Mr. and Mrs. Martin A. Ryerson Collection

*205 *Salt Kettle, Bermuda*, 1899
watercolor
14 x 21¹⁄₁₆ in (35.6 x 54.9 cm)
National Gallery of Art, Washington. Gift of
 Ruth K. Henschel, in memory
 of her husband, Charles R. Henschel, 1975

206 *House and Trees in Bermuda*, probably 1899
watercolor over graphite
14 x 21 in (35.6 x 53.3 cm)
The Brooklyn Museum. Museum Collection
 Fund and Special Subscription

*207 *Flower Garden and Bungalow, Bermuda*, 1899
watercolor and graphite
14 x 21 in (35.6 x 53.3 cm)
The Metropolitan Museum of Art.
 Amelia B. Lazarus Fund, 1910
Shown in Washington only

*208 *Coral Formation*, 1901
watercolor
14⅛ x 21¹⁄₁₆ in (35.9 x 53.4 cm)
Worcester Art Museum, Massachusetts

209 *North Road, Bermuda*, 1900
watercolor and graphite
13½ x 20¾ in (34.3 x 52.7 cm) (sight)
The Pennsylvania Academy of Fine Arts,
 Philadelphia.
 Collection of Mrs. John Wintersteen

210 *Inland Water, Bermuda*, 1901
watercolor
13¾ x 21 in (34.9 x 53.3 cm)
Photograph courtesy of
 Hirschl & Adler Galleries Inc., New York

*211 *Bermuda Settlers*, 1901
watercolor
13¹⁵⁄₁₆ x 20⅞ in (35.5 x 53.0 cm)
Worcester Art Museum, Massachusetts

212 *Bermuda*, 1901
watercolor over graphite
14 x 21 in (35.6 x 53.3 cm)
Ellen Battell Stoeckel Trust, Norfolk,
 Connecticut

213 *West Point, Prout's Neck, Maine*, 1900
oil on canvas
30¼ x 48¼ in (76.8 x 122.6 cm)
Sterling and Francine Clark Art Institute,
 Williamstown, Massachusetts

*214 *Key West*, 1903
watercolor over graphite
13¾ x 21⅝ in (34.9 x 54.9 cm)
Harvard University Art Museums (Fogg Art
 Museum), Cambridge, Massachusetts.
 Gift of Edward W. Forbes

*215 *Stowing the Sail*, 1903
watercolor
13¹⁵⁄₁₆ x 21¹³⁄₁₆ in (35.3 x 55.4 cm)
The Art Institute of Chicago.
 Martin A. Ryerson Collection

216 *Fishing Boats, Key West*, 1904
watercolor
13¹⁵⁄₁₆ x 21¾ in (35.3 x 55.2 cm)
Worcester Art Museum, Massachusetts

*217 *Fishing Boats, Key West*, 1903
watercolor and graphite
13⅝ x 12½ in (34.6 x 31.8 cm)
The Metropolitan Museum of Art.
 Amelia B. Lazarus Fund, 1910.
Shown in New Haven only

*218 *Key West, Hauling Anchor*, 1903
watercolor
13⅞ x 21⅞ in (35.3 x 55.6 cm)
National Gallery of Art, Washington. Gift of
 Ruth K. Henschel, in memory
 of her husband, Charles R. Henschel, 1975

*219 *In the Jungle, Florida*, 1904
watercolor over graphite
13⅞ x 9¹¹⁄₁₆ in (35.2 x 24.6 cm)
The Brooklyn Museum. Museum Collection
 Fund and Special Subscription

*220 *Life-size Black Bass (Large-mouth Bass)*, 1904
watercolor
17½ x 24½ in (44.5 x 62.2 cm)
Mr. and Mrs. Brooks McCormick

*221 *Homosassa Jungle*, 1904
watercolor over graphite
14 x 22 in (35.6 x 55.9 cm)
Harvard University Art Museums (Fogg Art
 Museum), Cambridge, Massachusetts.
 Gift of Mrs. Charles S. Homer, in memory
 of the late Charles S. Homer and his brother,
 Winslow Homer

*222 *Black Bass, Florida*, 1904
watercolor over graphite
10⅞ x 19⅜ in (27.6 x 49.2 cm)
Private Collection

*223 *Diamond Shoal*, 1905
watercolor
13⅞ x 21¾ in (35.3 x 55.2 cm)
IBM Corporation, Armonk, New York

Index

Edited by Mary Yakush
Typeset in Monotype Walbaum
by Michael and Winifred Bixler, Skaneateles, New York
Mechanical art by Page Rhinebeck, Orange, Connecticut
Printed by Eastern Press, Inc., New Haven
on Warren's Lustro Dull Enamel paper
Bound by Mueller Trade Bindery, Middletown, Connecticut
and Zahrndt's, Inc., Rochester, New York
Designed by Greer Allen, New Haven